Masters of Traditional Arts

A BIOGRAPHICAL DICTIONARY

Masters of Traditional Arts

A BIOGRAPHICAL DICTIONARY

VOLUME TWO K–Z

Alan Govenar

ABC ● CLIO

Santa Barbara, California Denver, Colorado Oxford, England

A CIP catalog record for this book is available from the Library of Congress.
ISBN 1-57607-240-1
ISBN 1-57607-545-1 (e-book)

06 05 04 03 02 01 10 9 8 7 6 5 4 3 2 1

This book is also available on the World Wide Web as an e-book.
Visit abc-clio.com for details.

ABC-CLIO, Inc.
130 Cremona Drive, P.O. Box 1911
Santa Barbara, California 93116-1911
This book is printed on acid-free paper.

Manufactured in the United States of America

Contents

VOLUME TWO

Masters of Traditional Arts

A BIOGRAPHICAL DICTIONARY

Meali'i Kalama

NATIVE HAWAIIAN QUILTER

Life dates: January 30, 1909–July 29, 1992

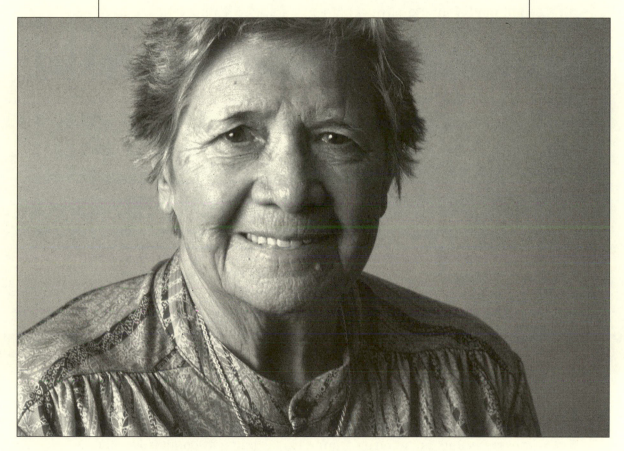

Meai'i Kalama, 1985 (Courtesy National Endowment for the Arts)

MEALI'I KALAMA WAS BORN JANUARY 30, 1909, into a family of quilters. As a child, she often lay under the quilting frame, listening to her grandmother and other women talk as their needles flew back and forth. When she was a teenager, she expressed an interest in quilting. Her grandmother sent her into the yard to create her own design based on the breadfruit tree. The choice was intended as a lesson based on the dual meaning of the word *ulu*, which is the noun for the staple food breadfruit and the verb "to grow." That breadfruit quilt took Kalama a year and a half to complete.

After attending the University of Hawaii for two years, Kalama took a teaching job in the public schools in 1943. She also taught quilting for the Department of Parks and Recreation. When a playground and recreation center opened in 1950, she left her public school job to become its first director. Until her retirement in 1975, she taught quilting at Papakolea Playground and at other parks. In retirement she continued teaching at Papakolea and at Kawaiahao Church, where she was a lay minister.

When the Maunakea Hotel was being planned on the Kona coast of the island of Hawaii, the interior decorator approached the church's pastor and asked that the ladies of the church create quilts for display at the hotel. With help from other women in the church, Kalama designed and produced 30 quilts, each eight-feet square, in 18 months. They were displayed as permanent wall hangings. Kalama contributed her fee to the church as part of her tithe. She also did other work on commission, including a quilt for the bed that belonged to Queen Liliuokalani, whose home became the governor's mansion.

Hawaiians adapted the basic techniques of New England patchwork quilting to the ancient Polynesian tradition of making the *kapa*, or bed coverlet, of bark cloth. Hawaiian quilting has been described as "a kaleidoscope on cloth." Each quilt has a large, symmetrical design, usually of one color. It is based and overcast on material of a complementary color, then quilted through a layer of batting and a cloth backing with tiny stitches. These stitches average between six and ten to the inch, and a single quilt may contain 500,000 stitches. Rows of stitching half an inch apart follow the pattern, creating a ripple effect.

Kalama liked designing quilts, she said, because "it opens me up to nature, to the world around me. Nearly all my designs are from nature. . . . The patterns must be flowing. All nature has a gracefulness. Not even the coconut tree stands straight. It bows its head in the breeze. All nature acknowledges its creator. And all designs must show that flowing gracefulness of nature. All must acknowledge the breeze and the air. All must display *ulu*, growth."

After she cut out a design for a quilt, Kalama had someone else baste and appliqué it to the material that would cover the quilt. But she did all the actual quilting herself. "I cannot quilt when I am troubled or under stress," she said. "I make mistakes and must undo the work. I make quilts with loving thoughts of the persons who will receive and use the quilts. Quilting requires clean thoughts as well as clean hands. You would not want a quilt that was soiled by dirty hands, and you would not want a quilt which was not made with love."

Danongan Sibay Kalanduyan

Filipino-American Kulintang Musician

Born: May 1, 1947

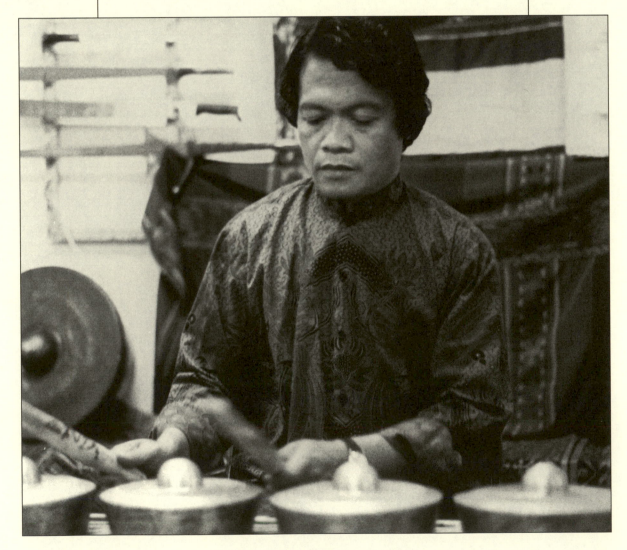

Danongan Kalanduyan (Jerome Academia)

DANONGAN SIBAY KALANDUYAN WAS BORN May 1, 1947, in the fishing village of Datu Piang in the Cotabato area of the Mindanao region of the southern Philippines. There he was raised in a strongly traditional musical environment, rooted in the culture of Maguindanao tribal traditions. "If you were born in my village you'd hear no Western music, just traditional music," he said. "The music was everywhere and for everyone—not just for entertainment, but also as an accompaniment to rituals and ceremonies. I didn't need a tutor; it just automatically came into my head, day and night. I learned it through exposure, through listening."

Kalanduyan began playing Maguindanao music as a child, focusing on the traditions of *kulintang* (literally meaning "golden sound moving" in English). *Kulintang* refers to the gong and drum ensemble indigenous to the Sulu and Mindanao islands in the southern Philippines and northern Borneo. The ensemble is named after the principal kettle gong instrument. *Kulintang* ensemble music is characterized by intricate rhythmic patterns achieved through the combination of a repeating bass rhythm above which a spontaneous, but tightly controlled, improvisation is played. Traditional ensembles varied from three to seven or more players, depending on the area. The main instrument, the *kulintang*, is a row of from five to eleven brass and bronze gongs graduated in pitch. The number of gongs depends on the ethnic group. Kalanduyan plays the *kulintang* with eight tuned, knobbed gongs. The gongs are played with two sticks of soft wood.

The *kulintang*, thought to have been brought from China in the third century of the Christian era, is looked to as the oldest of the performing-arts traditions. Related to the Indonesian *gamelan*, it is today rooted exclusively in the Muslim cultures of the islands of Mindanao and Maguindanao.

Kalanduyan's earliest training, like that of many musicians, involved steadying the large *agung* gongs when they swayed back and forth as older musicians struck them. At age seven, he started to study other instruments—the *dabakan*, a goblet-shaped drum; the small *babandir*, a "timekeeper" gong; and the *gangingan*, a four-gong set—under his grandmother, father, uncles, and cousins. As a young man, he won islandwide competitions on the *gangingan* and was recognized as a master musician. In 1971, he toured the Far East with the Darangan Cultural Troupe.

In 1976, a Rockefeller grant brought Kalanduyan to the University of Washington in Seattle as an artist-in-residence in the ethnomusicology program headed by Dr. Robert Garfias. After completing an eight-year residency, he undertook formal study at the university. In 1984 he was awarded a master's degree in ethnomusicology. Later

that year he moved to California, where he became the musical director of the Kalilang Kulintang Arts of San Francisco.

Word of his presence spread among Filipino communities, and he was soon very much in demand as a performer and a teacher. He has taught and performed with virtually all the American *kulintang* ensembles. It is ironic to some that *kulintang* music, almost entirely confined to a small Muslim minority in the Philippines, has been enthusiastically embraced by scores of young Christian Filipino-Americans for whom, through its pre-Hispanic, pre-Muslim roots, it now serves as a cultural icon of pan-Filipino-American unity.

Since 1989, Kalanduyan has worked as the director of the Filipino Kulintang Center of San Francisco. He also serves as an advisor to the World Kulintang Institute and Research Studies Center and is a consultant to several dance troupes.

Kalanduyan is committed to the perpetuation of his cultural traditions. He says, "I feel that transmitting the knowledge I possess is important for Filipino-Americans everywhere, not only to preserve what may be the only authentic Filipino musical form, but also to encourage Filipino-Americans to maintain their cultural heritage. To the majority of Filipinos, this music is foreign to them. Three hundred and fifty years of Spanish colonization influenced so much of the Philippines that this ancient music practiced by the tribes in the south is not recognizable to them."

Nalani Kanaka'ole and Pualani Kanaka'ole Kanahele

Native Hawaiian Hula Masters

Born: March 19, 1946 (Nalani) and
September 14, 1937 (Pualani)

Nalani and Pualani Kanaka'ole (Lynn Martin)

NALANI KANAKA'OLE, BORN MARCH 19, 1946, and Pualani Kanaka'ole Kanahele, born September 14, 1937, are daughters of the chanter and *hula* master Edith Kanaka'ole (1913–1979), who was awarded the status of "Living Treasure of Hawaii" in 1979. The sisters are the inheritors of Halau 'O Kekuhi, the *hula* school founded by their mother in 1953, and are considered *kupuna,* respected elders, in their own right. They bear the title *kumu hula,* or hula master. Based in Hilo, on the "big island" of Hawaii, they are looked to as guardians of the ancient style of *hula* that predates commercial forms of the dance that emerged in the twentieth century.

The traditional *mele hula,* or "danced poetry," of the Kanaka'ole sisters is led by the chanter, who beats a large gourd as percussive accompaniment while seated near the dancers. The vigorous, bent-knee style of dance called *'aiha'a* that pantomimes the poetry is difficult and requires considerable experience and physical conditioning. Also challenging is the *mele oli* (free verse chanted poetry), which requires mastery of the Hawaiian language, poetic meanings, vocal manipulation, historical knowledge, and a sense of traditional protocol.

Prior to European contact in Hawaii, *mele oli* were used to record genealogies, recount creation myths, celebrate the birth of a child, or mark the death of a loved one, or to commemorate other important occasions. In the ancient style of *mele hula,* the chant sometimes speaks of Polynesian gods or Hawaiian deities, such as the volcano goddess *Pele;* celebrates the deeds of revered chiefs; or recounts romantic encounters. The dance, referred to today as *hula kahiko,* enhances the chant narrative through stylized movement.

In the 1870s, after the introduction of Western music and stringed instruments, Hawaiians developed a variation on their ancient *mele hula* tradition. This led to growth of *hula 'auwana,* which has become the most popular form of *hula* performed at local parties and hula competitions and for the tourist industry.

By the early 1990s, there were over 200 *hula hulau* (*hula* schools) in Hawaii, drawing students from virtually every ethnic group within the multicultural population living in the Hawaiian Islands. The Kanaka'ole sisters are among the most respected teachers and practitioners of the indigenous Hawaiian art forms of chant and dance. For them, participation in the *hulau* involves a serious commitment to Hawaiian culture.

The value of *mele* (chants) to Hawaiian identity cannot be overestimated. "Sometimes it pervaded all domains of society, as during the reign of Kamehameha I (1795–1819)," scholar Ricardo Trimillos has stated. "At other times it was the only thread that held Hawaiian identity together, as during two decades of assimilation following

statehood in 1959 . . . and it has been a tool for the reclaiming of Hawaiian language by the present Hawaiian population."

The year 1993 marked the hundredth anniversary of the overthrow of the last Hawaiian monarch, Queen Lili'uokalani, and is now recognized as a watershed year for the Hawaiian cultural and sovereignty movement. The Kanaka'ole sisters are at the forefront of this initiative and have emerged as leaders. Through their dedication to *hula* and chant, their commitment to the Hawaiian language, and their efforts to ensure the protection of the natural resources of their homeland, they are working to preserve and perpetuate their culture and traditions.

Raymond Kane

Native Hawaiian
Slack Key Guitarist and Singer

Born: October 2, 1925

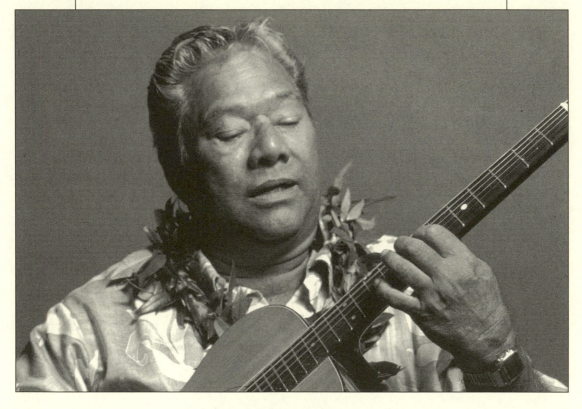

Raymond Kane, 1987 (Courtesy National Endowment for the Arts)

RAYMOND KALEOALOHAPOINAOLEOHELEMANU KANE was born October 2, 1925, in Eleéle on the island of Kauai in Hawaii, but grew up in Nanakuli, a district on the island of Oahu with a large ethnic Hawaiian population. His father captained a fishing crew, and growing up the young Kane was forever playing around the beach. It was a time, Kane said, when money was scarce: "People traded what they had for what they didn't . . . vegetables for fish; fish for meat."

Around the age of nine, Kane learned to play the *ki ho'alu*, slack key guitar, from one of the cowboys on nearby Makua Ranch. "He brought his guitar down on weekends," Kane said. "They used to have a ball. They'd suck 'em up, have a good time. One time, I got up early in the morning and I heard this beautiful music. I thought there were three guys playing and it was only him. I asked him to teach me, and he said, 'No, no, no . . . I can't because you're not in my family.' So, I told him, 'You get tired of eating mackerels,' and I gave him the names of some other fish that he liked. He said, 'Well, if you get those fish, I can teach you how to play the slack key guitar.'"

In slack key guitar, some strings are loosened, or slackened, to create open chords and to allow a musician to accompany his own melody line with a simultaneous bass line. Central to the particular sound of slack key is the use of these open tunings, whereby the six strings are changed from the classical guitar tuning to ones based upon open chords. This remarkable and creative style is traditionally passed on by imitation (without notation or scores); many of the tunings are standard, but others are kept secret—slack key guitarists often turn away from the audience to tune their instrument so that no one can copy them.

Kane learned quickly and began to entertain his friends and family when he wasn't working. During World War II, he served in the United States Army as part of the occupational forces in Europe. "I took my guitar everywhere I went," he said. "All my buddies wanted me to play for them. I put them to sleep."

After the war, Kane returned to Hawaii and began playing his distinctive slack key guitar at *luaus,* parties, and evenings on the beach. He worked with Albert Kawelo and Henry Kapuana from the island of Ni'ihau, the only island of the Hawaiian chain where ethnic Hawaiians are still the majority population and the Hawaiian language is dominant.

Kane jammed with Gabby "Pops" Pahinui at Wakiki nightspots and recorded an album in 1960 with Leonard Kwan. But it was not until 1973, when he gave the first-ever solo concert devoted entirely to slack key music, that Kane attained widespread public attention. "I don't know what you call my style," he said, "but I haven't met anyone who can play my style. My music is just straight, there's no

break. The chord changes, you can't tell. It's smooth; one smooth movement." While Kane's left hand finds the chords he learned by watching others play, his right hand plucks casually along at the base of the guitar. Sometimes his left hand hammers at the strings, and sometimes the right one does.

In the 1980s, Kane's health deteriorated, but with the unrelenting support of his wife, Elodia, he found treatment that enabled him to perform again. In the 1990s, the couple toured together throughout Hawaii, Australia, Samoa, Tahiti, Guam, and elsewhere.

"I used to be bashful," Elodia said, "and didn't want to sing in public, but he kept coaxing me. 'Go ahead. Go ahead.'"

Everett Kapayou

NATIVE AMERICAN SINGER
(MESQUAKIE)

Born: May 13, 1933

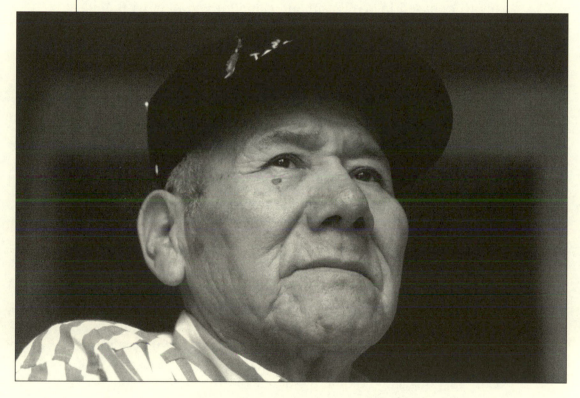

Everett Kapayou (William K. Geiger, Courtesy National Endowment for the Arts)

EVERETT KAPAYOU WAS BORN MAY 13, 1933, in the Mesquakie settlement in Tama, Iowa, the last of five children. His mother, Lucille Kapayou, was a flute player of Mesquakie sacred and secular melodies. Everett learned much of his repertoire from her, first learning the melody from her flute playing, then having his mother—who did not sing—recite the texts for him to memorize, and finally putting the two together to sing the song. Kapayou's parents taught him their Native language at home, and he learned English at school.

Stylistically, the Mesquakie, meaning literally "Red Earth People," have been influenced by a variety of neighboring tribal cultures and contemporary pan-Indian trends. During the seventeenth century, they were based in Wisconsin and came into contact with Algonquin-speaking tribes, such as the Potawatomi and Menominee. By the nineteenth century, they had resettled in Iowa and absorbed some of the cultural traits of the Eastern Plains and Prairie buffalo-hunting tribes such as the Omaha and eastern Sioux.

In the twentieth century, the homogenizing effects of non-Indian and pan-Indian popular culture threatened the integrity of indigenous traditions. Through his singing, Kapayou worked to maintain the Mesquakie way of life. "In the old times," Kapayou said, "songs were connected with anything an Indian did. Like the songs I sing are love songs; that's for courting. And [songs] for the ceremonies for health and everything for the people, and then, for harvest dances . . . when you had an abundance of pumpkins and corn . . . when your garden came up pretty good, then they had dances for that, and so forth. Everything that an Indian did had a song to it."

Kapayou's songs are a strong reflection of the distinct identity of the Mesquakie people. Though he was forced to labor long hours as a mason and construction worker, he actively participated in tribal ceremonies, but never sang religious songs outside of the context for which they were intended. "The ceremonial songs are sacred," he said. "We don't sing them to the public or nothing. They stay with where they're being sung at. At the moment, we have about six different clans. And I'm of the Fox clan and they have the Wolf clan and the Eagle clan and the Thunder clan and on down the line. And each of them, when they conduct a ceremony, they fast all day. The ones [the clan] that put on the ceremony, they're the ones that do the singing."

Despite his reluctance to sing sacred songs in public, Kapayou did feel his secular songs might serve as a catalyst for preservation and a vehicle for increasing awareness of Mesquakie traditions. "Most of the songs that I sing are called mood songs," he said. "Whatever you feel like, if you want to serenade somebody or if you want to console

somebody or if you want to make them feel bad with a song, you can." In addition, Kapayou sings at social dances and powwows; he especially likes to sing 49 songs.

"A 49 song is a entertainment song. The people dance around a drum and there's another dance they call a round dance that's similar to that, but a 49 is a faster beat than a round dance beat."

Kapayou is most renowned for the love songs he learned from his mother. These songs are especially significant because they recount intimate aspects of cultural heritage and demonstrate the enduring strength of the oral tradition.

Genoa Keawe

Native Hawaiian Falsetto Singer and Ukulele Player

Born: October 13, 1918

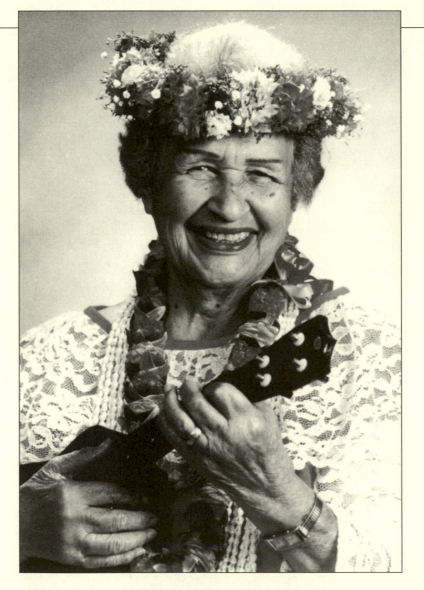

Geona Keawe (Courtesy Genoa Keawe)

GENOA KEAWE WAS BORN OCTOBER 13, 1918, in the area of Oahu known as Kaka'ako. She began her musical training at age 10, when she started singing in the choir of the Mormon church. She left school after the eighth grade, married her husband, Edward, when she was 16, and began her family of 12 children.

Keawe learned the Hawaiian language from her mother-in-law and began singing Hawaiian music in both Hawaiian and English for military clubs before World War II. She also appeared on the radio with John Kamealoha Almeida and the Honolulu Rapid Transit musicians. Alice Namakelua in particular helped Keawe with her Hawaiian language phrasing and vocal style.

The human voice has always been at the center of native Hawaiian music, from the ancient *mele* chant to the lively social music known by the pidgin term *chalangalang*. With the rise of radio and the recording industry in the first half of the twentieth century came the opportunity for *chalangalang* musicians to be recorded and heard more widely. Some of the most successful recording artists became the models for the tradition in the second half of the century. Keawe is among the most celebrated and influential of these musicians.

In 1946, Keawe recorded the first of more than 140 singles on the 49th State label. Her groups, Genoa Keawe and Her Hula Maids and Genoa Keawe and Her Polynesians, backed other singers on many recordings. Many of her songs recorded between the late 1940s and early 1960s became standards in the Hawaiian repertoire and have been reissued on anthology recordings in recent years. In 1966 she started her own label, Genoa Keawe Records.

Keawe operated a hula studio in Pauoa for years and has served as a resource for many Hawaiian musicians. She has received numerous awards, but perhaps her greatest award is her continued ability to sing, which she calls a "gift from God."

"It's a gift I asked for," she said. "I wanted to be a singer, so I prayed every night, and thank God I still have it." She continues to perform weekly at the Hawaiian Regent Hotel, sharing her gift with others. "Hawaiian music must go on. As long as Genoa Keawe is alive, it will still live."

Maude Kegg

Native American Storyteller and Craftswoman (Ojibwe)

Life dates: August 26, 1903–January 6, 1996

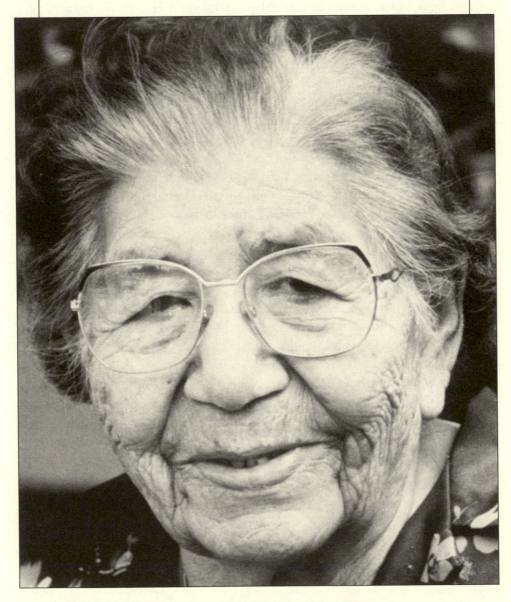

Maude Kegg (Courtesy Minnesota Historical Society)

MAUDE KEGG WAS BORN ON AUGUST 26, 1903, to Ojibwe parents in a bark and cattail mat wigwam near Portage Lake in northern Minnesota. She was brought up by her grandmother, Margaret Pine, who taught her the things she should know about her Ojibwe people and their long history—the language, myths and tales, customary beliefs, and traditional skills. Kegg's mother died in childbirth; her grandmother was never quite sure about the date, so she told her granddaughter to choose her own birthday. "I was born on land my grandmother homesteaded," she said. "I always heard it was riceing [gathering wild rice] time on the lake, so I picked August 26th [the start of harvest season]."

Growing up, Kegg listened intently to everything her grandmother told her. "At nighttime, in the evenings when everything is done, she start talking to me, teaching me the name of that and the name of that—I don't know how to write it, but she didn't write it either. She just told me the things which I remember." In time, Kegg became a storyteller herself, following the ways of her people and sharing them with others. She wrote three books on the Ojibwe (sometimes called Chippewa) people: *When I Was a Little Girl* (1976), *At the End of the Trail* (1978), and *What My Grandmother Told Me* (1983). She also contributed language data and special Ojibwe terms to linguists.

Over the years, Kegg explained and demonstrated the agricultural techniques that are traditional to the Ojibwe, such as maple sugaring and their special methods of harvesting and processing the wild rice that grows in the northern lake country of Minnesota. "We didn't live very far from the lake. Just about a mile or two . . . to Rice Lake. So, my grandmother would tell me to go and hitch the horses. I look for the horses and put all our belongings in there we gonna use. We had to camp over there. So, we go over there, and she'd make a wigwam with a hole in it. Cover it up with birch bark, and the next day we go out as soon as the dew is gone, gone off the rice."

In addition to her exceptional store of traditional Ojibwe tales and legends, Kegg is perhaps best known for the beauty and elegance of her beadwork. She was a master of Ojibwe floral designs and geometric loom beadwork techniques, and one of the very few Ojibwe competent to produce a fully beaded traditional bandolier bag, a symbol of prestige and leadership once commonly worn by tribal leaders.

Kegg worked for many years at the Minnesota State Historical Society at Mille Lacs, and helped to construct a large diorama of the seasonal life of the Ojibwe, making every artifact in the exhibit. She was a staff member at the museum and often acted as docent, taking groups of schoolchildren and other visitors through the diorama.

Several of Kegg's pieces are in the Ojibwe craft collection of the Smithsonian Institution, and one of her beaded bandolier bags formed a centerpiece for the American Federation of Arts' touring exhibition "Lost and Found: Native American Art, 1965–1985." In 1986, Minnesota governor Rudy Perpich proclaimed August 24th of that year to be "Mrs. Maude Kegg Day" in tribute to "her many years of knowledge, wisdom, and efforts in the preservation of Ojibwe culture and language."

Ilias Kementzides

GREEK AMERICAN LYRA PLAYER
(PONTIC)

Born: April 2, 1926

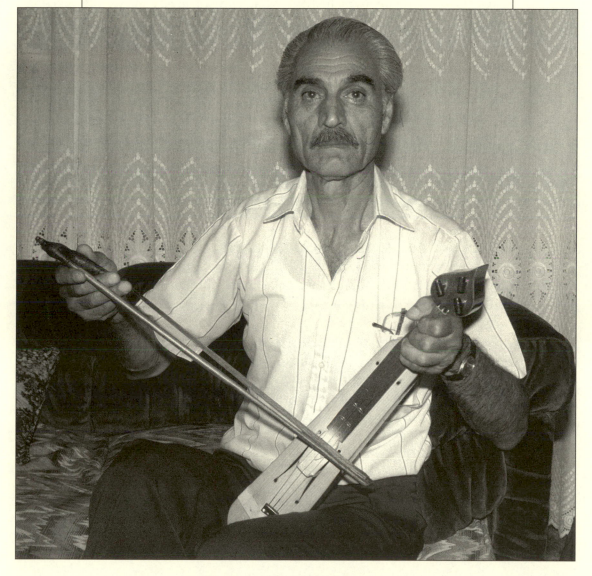

Ilias Kementzides, 1991 (Alan Govenar)

*I*LIAS KEMENTZIDES WAS BORN APRIL 2, 1926, in Kazakhstan in the Soviet Union, of Greek parents from Sampsunda, Pontus. The Pontic Greeks lived from ancient times in the Pontos area of Asia Minor (Turkey), on the southeastern coast of the Black Sea. The community resettled in Greece as part of the compulsory exchange of populations between Greece and Turkey in the early 1920s, but some families also relocated into areas under Russian rule.

Kementzides began playing the *lyra* (a bottle-shaped violin with three strings) when he was eight, learning from his uncle, who was a professional musician. About his upbringing, Kementzides said, "In Russia, every weekend the whole neighborhood would gather in the courtyard. There was nothing else to do, no theater, no movies, only music. If someone heard an instrument starting up, everyone would come running. It was joyous. That's how it was in Greece, too. Not a blade of grass could grow in our courtyard, there was so much dancing."

In 1940, Kementzides moved with his family to Greece and settled in a small town near Thessaloniki, an area heavily populated by Pontic Greeks. During World War II, this region of Greece was occupied by the Germans, and during this difficult period, Pontians were often treated as outsiders, even by the Greeks, forcing the Pontian community to bind more closely together to preserve its cultural traditions.

Kementzides became a professional musician, playing at social clubs and theaters. He also farmed a small plot of land, but eventually realized that he could not make enough money in Greece to support his family. He was determined to immigrate to the United States, and in 1974 he and his wife and three children settled in Norwalk, Connecticut, where he found employment in an electronics factory.

In Connecticut, Kementzides began playing almost at once at Pontic social occasions. Word spread quickly throughout the Greek community that a powerful new musician had arrived who was a talented dance musician and a strong singer with an extensive repertoire of songs in the Pontic dialect. In addition, he was fluent in Greek, Turkish, and Russian and made his own instruments. Kementzides was invited to perform at weddings, christenings, baptisms, and other events in his community, most notably those held at the local Pontic American Club of Astoria in Queens, New York. Typically, the *lyra* heads a three-piece orchestra ensemble, but Kementzides has also preserved the strong solo *lyra* tradition he learned as a child.

Will Keys

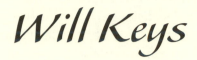

ANGLO-AMERICAN APPALACHIAN
BANJO PLAYER

Born: October 4, 1923

Will Keys, 1996 (Robert Cogswell, Courtesy Tennessee Arts Commission)

WILL KEYS WAS BORN OCTOBER 4, 1923, in the Blackley Creek area of Washington County in eastern Tennessee, the 10th of 11 children in a musical family. His mother knew a repertoire of old songs, his sisters played piano, and his brothers, Jay and Howard, played guitar and sang. Jay started Will on the banjo when he was eight

years old. "I got stuck with the banjo," Will recalled, "because all the good instruments were already taken by my brothers and sisters. We made do with what we had. My brother Jay strung an old banjo for me that we'd had for many years with wire from the screen on the back door."

Will learned the two-finger style first, repeating the melodies Jay played on the guitar, and in a relatively short time he was playing weekend jam sessions with his brothers, usually in someone's house or at the local general store. At these sessions, Will got to know many of the region's leading banjo players. "Back in those days, there wasn't much to do on a Saturday night," he said, "except play music. We didn't even know it was bluegrass or country, whatever. We didn't care; it was just music. I remember one time we played for a house-warming party, and they opened up two whole rooms for people to dance and we picked up a storm."

For a brief period, Keys tried the three-finger banjo style, but he eventually went back to playing the way he had learned. "I realized I was doing the same thing with three fingers," he said, "that I had been doing all my life with two fingers. Most young people today are being taught the clawhammer style. I'm afraid what I'm doing is a dying art. I've tried to teach people how to play the two-finger style like I do, but there's really no tried-and-true method."

After serving in the Marine Corps during World War II, Keys returned home and continued to play the banjo in the Tri-Cities area of Tennessee and Virginia. He played in the Home Folks, for many years the house band at Janette Carter's Carter Family Fold. In 1978, he won the old-time banjo contest at the prestigious Galax Fiddler's Convention, and in 1982 he played at the World's Fair in Knoxville.

To earn a living, he worked for 42 years for the Eastman Chemical Company, "38 of those [years] being shift work," he said. "Why, I'd come home late at night and pick in my sleep. My wife would get up and find me up and find me sound asleep in the chair with the banjo still in my hands." After his retirement from Eastman in 1984, Keys began accepting invitations to teach workshops and perform at folk festivals.

Over the years, Keys developed a reputation as a "creative traditionalist," whose playing is well known for the bell-like quality of its tone. His repertoire includes old-time tunes as well as more contemporary songs, everything from fast breakdowns to waltzes and show tunes. He never uses finger picks, preferring instead the feel and sound of bare fingers plucking the strings. "The tone of this old banjo and the little different lick I got sort of sets me apart," he said. "Far as I'm concerned, this banjo can talk better than I can."

Ali Akbar Khan

ASIAN AMERICAN SAROD PLAYER AND
RAGA COMPOSER (NORTH INDIAN)

Born: April 14, 1922

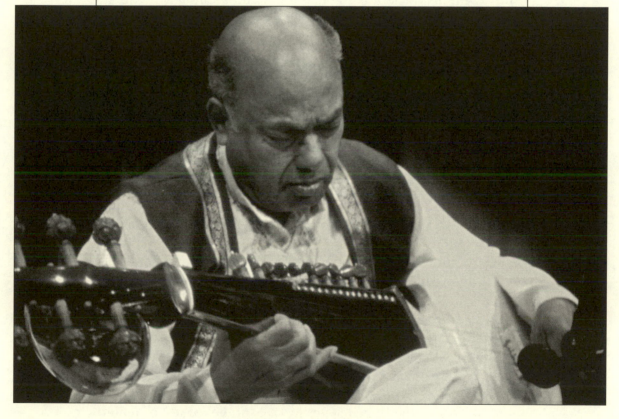

Ali Akbar Khan (Kamal Bakshi)

ALI AKBAR KHAN (KAHNSAHIB) WAS BORN April 14, 1922, in Bangladesh, India. His family traces its North Indian tradition to Mian Tansen, a musical genius and court musician of Akbar, a Moghul emperor of the sixteenth century. Tansen is regarded as a *rishi*, or saint, who gave new life to the classical instrumental music of India. Ali Akbar's father, the late Allaudin Khan, was the chief disciple of Wazir Khan, a direct descendant of Tansen, and is acknowledged as one of the greatest figures in North Indian music in the twentieth century. A strict teacher, Allaudin Khan taught some of the most celebrated Indian artists, including sitarist Ravi Shankar, flutist Pannallal Ghosh, his daughter Annapurna, and his son Ali Akbar.

Ali Akbar began his musical training at the age of three, studying under his father's tutelage, first learning vocal music, then studying drums with his uncle, Fakir Ftabauddin, and eventually being directed toward the *sarod*. The *sarod* is a 25-string, lutelike instrument made of a teak or mahogany body with a goatskin hide stretched over it, and a metal fingerboard. Ten of the strings are played with a coconut-shell plectrum and 15 are sympathetic strings, which vibrate while the melody is being played on the primary 10 strings. The *sarod* has two resonating chambers that produce contrasting types of sound.

Over the course of 20 years, Ali Akbar learned more than 75,000 *ragas* from his father. *Ragas* are the melodic motifs that are the basis of Indian music and have remained part of an oral tradition that is customarily passed along within families. The *ragas* are keyed to a particular time or day or year. Although they are a primary component of a disciplined improvisation, the musician must learn the techniques to improvise from them. Like most Eastern musical traditions, Indian music is intimately connected with religious meditation and spiritual healing.

Ali Akbar Khansahib (as he is properly called) gave his first public performance when he was 14. In his early twenties he became the court musician for the Maharaja of Jodhpur and was eventually conveyed the title "*Ustad,*" the Persian word meaning "master musician."

He first visited the United States in 1955, at the request of Yehudi Menuhin, and performed at the Museum of Modern Art in New York City. That same year, he also made the first American recording of Indian music and the first television performance of Indian music, on Alistair Cooke's *Omnibus* show. Subsequently, he toured extensively in Asia, Africa, Europe, Australia, and North America. Performance highlights include the East–West Encounter in Tokyo and at Carnegie Hall and Town Hall in New York; the Festival of India at

Philharmonic Hall; Expo '67 in Montreal; and the Berkeley and Monterey jazz festivals with saxophonist John Handy.

In addition to being a prodigious performer, composer, and recording artist, he has continued the teaching tradition of his father. He settled in the United States in the early 1960s with his wife, Mary J. Kahn, who plays the *tabla*, the drum that traditionally accompanies the *sarod* or *sitar*. His son, Alam, is learning to play the *sarod*.

In 1967, inspired by the extraordinary interest and abilities of his Western students, Khan founded the Ali Akbar College of Music in San Rafael, California. Through the college, more than 7,000 American devotees have seriously pursued North Indian music. He continues to teach there nine months of the year, and during his annual world tour he also teaches at the branch of his college in Basel, Switzerland.

Learning the *ragas* and mastering the instrument are both difficult challenges. Ali Akbar says, "If you practice for 10 years, you may please yourself, after 20 years you may become a performer and please the audience, after 30 years you may please even your guru, but you must practice for many more years before you finally become a true artist—then you may please even God." He has been practicing for more than 70 years.

Peou Khatna

ASIAN AMERICAN DANCER,
CHOREOGRAPHER, AND COSTUMER
(CAMBODIAN)

Born: 1915

Peou Khatna (Dexter Hodges)

PEOU KHATNA WAS BORN IN PHNOM PENH, Cambodia, in 1915. She began her training in Khmer dance at the age of seven under the patronage of her aunt, a wife of King Norodom. Khmer dance originated over 1,200 years ago and flourished in the twelfth century during the height of the Angkor Empire in Cambodia. Although its origins are from India and Java, the Khmers developed a unique dance style that has become a focal point of Cambodian culture and a source for most other Southeast Asian dance forms.

Khmer dance was eclipsed in Cambodia for several hundred years until its revival by the Royal Court in the nineteenth century. The palace supported the training of hundreds of dancers, like Khatna, for performances in Cambodia and around the world. She performed lead roles with her troupe until about 1945, when she retired and became a choreographer, costumer, and dance instructor. She continued to work in this capacity until the downfall of Prince Sihanouk forced a halt to the troupe's activities. The Pol Pot regime, which took over Cambodia in 1975, killed nearly one-third of the country's population as part of a policy that destroyed institutions of the "old regime," such as the Royal Ballet of Khmer dance.

Khatna, her daughter (also a palace dancer), and her family escaped from Cambodia by disguising themselves as peasants. They were forced out of Phnom Penh and spent the next several years working in rice paddies as members of communal work units around the country. With the invasion of the Vietnamese in 1979, more than one million war-weary Cambodians fled to the border of Thailand and settled into makeshift refugee camps. Among them were Khatna and a few surviving teachers and dancers of the Royal Ballet. Within a few months, a core group of performers pulled together an ensemble of 25 former dancers, singers, musicians, and a mask maker and formed the Khmer Classical Dance Troupe. They practiced in the refugee camps and brought hope to the ravaged Cambodian survivors; thousands gathered to watch them practice.

In 1980 and 1981, with the help of the U.S. State Department, international refugee organizations, and the National Council for the Traditional Arts, many Khmer dancers and musicians immigrated to America and settled in the Silver Spring, Maryland, area. With dedication and courage, they organized for a third time, improvising costumes and re-creating from memory the dances of the palace. The new troupe, inspired, disciplined, and directed by Khatna, who had appeared in the United States as part of the Royal Ballet in 1971, has been presented across the country. They were featured in the documentary film *Dance of Tears* and together and individually have revitalized the Khmer dance tradition.

Don King

ANGLO-AMERICAN SADDLE MAKER

Born: August 19, 1923

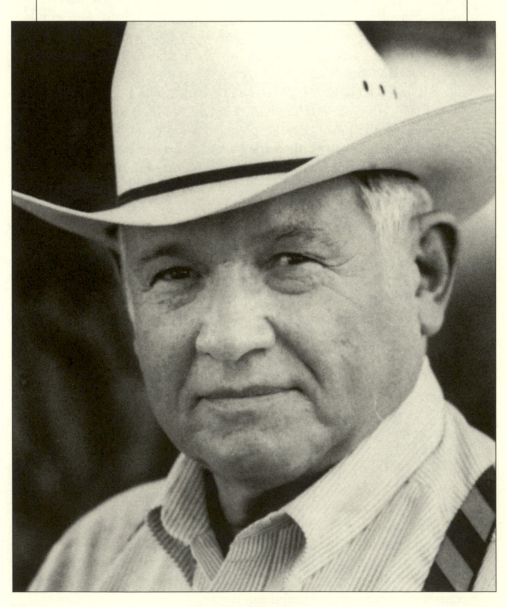

Don King (Debbie King)

DON KING WAS BORN AUGUST 19, 1923, in Douglas, Wyoming, on the North Platte River about 100 miles north of Laramie. His father, Archie King, was a cowboy and itinerant ranch hand who traveled all over the Western United States. By the age of 14, King was beginning to support himself doing odd jobs on ranches and at rodeos, and trying to learn to tool leather in his spare time. Within a year, he was selling and trading belts, wallets, and various small gear of his own making. "Cowboys always trade," King said. "I traded for pants, shirts, hats, spurs, anything. Sometimes I ended up with nothing."

For years, King worked in saddle shops and on ranches in California, Montana, and Arizona before returning to Wyoming, where, in 1946, he married and settled in the town of Sheridan. There, he became an apprentice to his friend Rudy Mudra, an expert saddle maker, doing piecework and assisting in the building of saddles for the local cowboys. Later, King was able to acquire his own 200-acre ranch, where for several years he raised cattle and horses while working only part-time at the leather trade.

In 1957, King devoted himself full-time to saddlemaking and leather tooling, focusing primarily on highly ornamental trophy saddles, which are given as prizes in rodeo competitions. He developed his own style of tooling, characterized by wild roses with a distinctive shape (as though they were viewed from a 45-degree angle), arranged in complex, scroll-like patterns of interlocking circles.

King became known for his impeccable craftsmanship and incredible precision that were demonstrated in the making of what is now known as the "Sheridan-style" saddle, a type of saddle he is credited with almost single-handedly developing. The Sheridan-style saddle is, in its general form, a classic high plains roping saddle: short, square skirts; a low cantle with a broad Cheyenne roll; large swells and a prominent horn; small side jockeys; and relatively narrow fenders that are at a 90-degree angle to the skirt. King was one of several saddle makers who were responsible for the increasing popularity of this saddle, although its most distinctive element is the characteristic wild rose tooling he created. In addition, King used unusually deep stamping to give greater three-dimensional depth to his tooling and relied more heavily on the swivel knife to emphasize the lines of detail more than the shading.

By the late 1950s, King had established his reputation among ranchers and rodeo cowboys. Sheridan, where he lived, had been a center of the cattle industry since the late nineteenth century and has supported numerous leather workers and saddle makers. King's apprentices have included a number of top-notch saddle makers, including Billy Gardner, Chester Hape, and Bob Douglas. His sons,

Bruce, Bill, Bob, and John, have all become accomplished leather toolers.

Over the years, King's saddles have been acquired by working cowboys and celebrities alike, such as Queen Elizabeth, Ronald Reagan, and the Crown Prince of Saudi Arabia. He has made trophy (prize) saddles for virtually every rodeo event, working regularly to meet the needs of the PRCA (Professional Rodeo Cowboys Association). His work has been exhibited widely in museums and festivals, such as the Edward-Dean Museum of Decorative Arts (Cherry Valley, California), the Nicolaysen Art Museum (Casper, Wyoming), and the Pro Rodeo Hall of Fame (Colorado Springs).

Riley "B.B." King

AFRICAN AMERICAN BLUES GUITARIST AND SINGER

Born: September 16, 1925

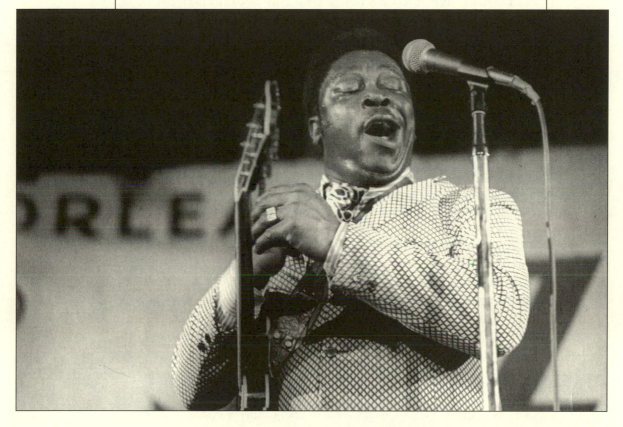

Riley "B.B." King, 1972 (Michael P. Smith)

RILEY KING WAS BORN SEPTEMBER 16, 1925, on a cotton plantation in northwest Mississippi between the towns of Indianola and Itta Bena, about 100 miles south of Memphis in the Delta bottoms. His schooling was sporadic; like many other black country children of his area, he worked in the fields when he was needed. After the death of his mother when he was in the 10th grade, he quit school and worked as a farmhand on a nearby plantation.

King was interested in music at an early age. He sang in local churches when he was four, and his uncle taught him a few chords on the guitar as soon as he was old enough to hold the instrument. His aunt had an old Victrola, and he heard the 78 rpm recordings of Blind Lemon Jefferson, Lonnie Johnson, Peetie Wheatstraw, and Leadbelly on her machine, along with the recordings of his older cousin, Bukka White, the famous "bottle-neck" guitarist. The neck from a glass bottle was often cut or broken off to use on one's finger as a slide to bend and slur the notes on the guitar to create the harsh, sometimes haunting Mississippi Delta style of blues.

In the early 1940s, King honed his guitar skills and formed a gospel quartet, called the Elkhorn Singers, and performed at local churches. He served for about a year in the U.S. Army during World War II, and sang blues for the troops stationed at Camp Shelby, in Hattiesburg, Mississippi, and at Fort Benning, Georgia. After the war, he returned to Indianola and continued to do odd jobs, and occasionally sang gospel in church and on the streets. In 1945 and 1946, he sang with the St. John Gospel Singers in broadcasts on WJPM radio in Greenwood and WJPR radio in Greenville.

A year later, King hitchhiked to Memphis and stayed with Bukka White until he was able to support himself. After working amateur shows at the W. C. Handy and Palace Theaters, his first professional breaks came in radio, where he performed as the "Beale Street Blues Boy," later shortened to Blues Boy King, and finally B.B. King, under which name he gained his remarkable reputation.

King first recorded in 1949 for the Bullet label in Nashville, and a year later he signed with the Bihari Brothers' RPM label. In 1952, his cover of "Three O'Clock Blues," a song originally recorded by Lowell Fulson, topped the R & B charts for 15 weeks. This record was followed by several R & B hits in the 1950s, including "You Didn't Want Me/You Know I Love You" (1952), "Woke Up This Morning" (1953), "You Upset Me Baby" (1954), and "Sweet Little Angel" (1956). Between 1950 and 1961, King recorded more than 200 sides for RPM and Kent, many of which were on albums in the low-priced Crown catalogue.

King performed extensively on the Southern black club circuit, and also appeared at major venues like the Apollo Theater in New

York City. In 1962, he signed with the ABC label, and five years later he launched the ABC Bluesway series with *Blues Is King*.

In 1969, his recording of "The Thrill Is Gone" was a crossover hit, appealing to both black and white audiences. "My audience had started mixing before that, " King said, "but that really pushed it over the top. . . . It was soon after that the Rolling Stones invited me to tour with them. . . . A lot of people heard me on that Rolling Stones tour that hadn't heard of me before."

Throughout his career, King has toured incessantly, often averaging more than 275 concerts a year. He was among the first American musicians to tour to the Soviet Union, and has traveled to Africa several times. Over the last two decades, King has been a profound influence on both rock and roll and rhythm and blues. Many imitate his economical phrasing, his precise slurred or bent notes, and his unique left-hand vibrato.

Fatima Kuinova

JEWISH AMERICAN SINGER (BUKHARAN)

Born: December 28, 1920

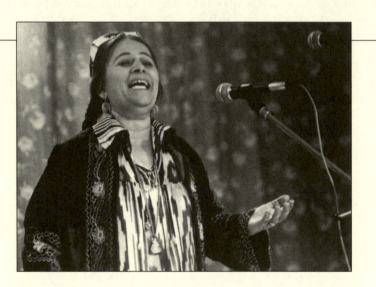

Fatima Kuinova
(Panos Papanicolauo, Courtesy Ethnic Folk Arts Center Archives)

FATIMA KUINOVA WAS BORN ON DECEMBER 28, 1920, in Samarkand, Tajikistan, in Soviet Central Asia, one of ten children. She grew up speaking Russian, but her cultural life was rooted in Bukharan Jewish traditions. Though her father, cantor of the local Bukharan Jewish synagogue, died when she was six years old, she credits him with her earliest and deepest musical influence. She began singing as a child and started vocal studies when she was 14, performing as a teenager in school choirs and at festivals in Dushanbe, the capital. She sang on Soviet radio as early as 1941.

Because of the widespread discrimination against Jews under Stalin, she took the name Kuinova to hide her true identity. Her Jew-

ish name was Cohen, and throughout her life she has retained the Kuinova. She even sang for Stalin himself, but he probably didn't know she was Jewish.

During World War II she sang for soldiers throughout Central Asia and in war zones. In 1948 she was named Honored Artist of the Soviet Union. In 1949 she began studying *shashmaqam*, the traditional music of her region. She worked with both Muslim and Jewish musicians. Kuinova explains that the texts, many of which date from the fifteenth century and deal with mystical love, are as important as the melodies.

Shashmaqam is related to, but recognizably different from, Persian, Ottoman, and Arabic court music. Kuinova's repertoire reflects the multifaceted role that Bukharan Jewish singers fill in Central Asia, playing music for a wide range of functions. They were among the most distinguished musicians in the courts of the Muslim emirs and khans who ruled the region prior to its incorporation into the Soviet Union. The Bukhara emirate was taken over by the Soviet Union in 1920 and became part of the republics of Uzbekistan and Tajikistan. In the Soviet period, traditional singers worked alongside Uzbek and Tajik musicians in radio station ensembles, music schools, and concert halls. They also provided music for a variety of ceremonial and ritual occasions in the Jewish community and for the majority Moslem population. Since the 1920s, when the musical tradition was first documented by Soviet ethnomusicologists, it has been transcribed and taught from one generation to the next.

In some ways similar to the Indian *raga*, *maqam* (as it is known among Arabic, Turkish, and Central Asian Jewish peoples) or *dasgah* (among Persians) is based on a system of modal scales with associated melodic themes, rhythmic modes, and extensive improvisation. Although the similarities of principles and musical practice suggest the connectedness of a great tradition shared by Ottomans, Arabs, Persians, and others, the particulars of regional and local practice vary significantly, and there are many distinctive localized styles.

For 27 years, Kuinova belonged to an ensemble of women *rebab* (vertical violin) players. She toured widely with her ensemble to Kiev, Leningrad (St. Petersburg), and Moscow, within the former Soviet Union, and abroad to Europe, Afghanistan, and Iran, where she sang for the late shah.

She immigrated to the United States from Tajikistan in 1980 to join relatives who were already settled in New York. There, she soon became a well-established member of the Bukharan Jewish musical community. Kuinova first worked in a trio or quartet in which her vocal line was accompanied by two or more *doire*—the Central Asian frame drum or *tar*, a plucked-string instrument of the re-

gion—and this ensemble has become a focal point of the growing Bukharan Jewish community centered in Queens and Brooklyn.

In New York, Kuinova performs for a variety of social occasions and concert events, and she is in demand among Moslem emigrés as well as in her own community. In 1986, her *shashmaqam* ensemble was invited to perform in the Salute to Immigrant Cultures at the Statue of Liberty Centennial.

Ethel Kvalheim

NORWEGIAN AMERICAN ROSEMALER

Born: March 5, 1912

Ethel Kvalheim
(Lewis Koch, Courtesy Wisconsin Folk Museum)

DURING THE DEPRESSION YEARS OF THE 1930S, an unemployed wagon-stripper in southern Wisconsin named Per Lysne turned to *rosemaling*, or rose painting, as a source of desperately needed cash. The art was a tradition in his family, and he had utilized some of its techniques in the gilt decorations and signs he had painted on the horse-drawn wagons of his youth. Using designs he remembered from his father's work and adapting them to wooden objects, he eventually developed a *rosemaled* wooden "smorgasbord plate" designed for mail-order sales. It became very popular.

Among the many young Norwegian Americans who came to watch him paint in his studio in Stoughton, Wisconsin, was a neigh-

bor, Ethel Kvalheim, who was born March 5, 1912. She became the key link in the American revival of the art form and the premier senior *rosemaler* in the United States. In addition to learning from Lysne, she took care to observe and learn from the many examples of old-world *rosemaling* in her neighbors' homes.

Rosemaling traditionally was done on furniture, on small wooden household items, and occasionally on architectural features such as doors, lintels, and ceilings. It came to America with the wave of Norwegian immigration, roughly from 1840 to 1915, but the art was in decline until its revival by Lysne and his disciplines, including Kvalheim. It spread through the upper Midwest and eventually experienced a national revival, with support and encouragement in the late 1960s from the Vesterheim Museum of Decorah, Iowa.

National shows in the art of *rosemaling* are evaluated by a trio of judges: American and Norwegian senior *rosemalers* and a senior artist from another field. Such a panel is used because of the varied aesthetic traditions that have grown up in the art. The American style utilizes solid blocks of color often outlined in black, cross-hatching, pastel colors, and central floral designs. Norwegian *rosemaling*, on the other hand, includes a number of distinctive regional styles that generally feature traditional dark colors, careful shading, brushwork effects, and a frequent use of abstract, stylized designs.

Kvalheim learned to work in all styles, but said that any artist, including herself, interprets the designs individually. She was commissioned in 1976 to *rosemal* the entire interior of the Stoughton Home Savings and Loan Bank. But afterward, she preferred to paint for her own enjoyment rather than by commission. She taught few classes, preferring to teach by example.

The king of Norway granted Kvalheim the Medal of St. Olaf in recognition of her artistry. She received the Vesterheim Museum and National Rosemaling Association's first Gold Medal Award in 1969.

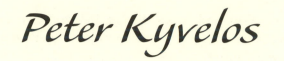

Peter Kyvelos

GREEK AMERICAN OUD MAKER

Born: November 2, 1943

Peter Kyvelos (Courtesy Peter Kyvelos)

PETER KYVELOS WAS BORN NOVEMBER 2, 1943, in Fitchburg, Massachusetts. His father, a Greek immigrant, worked with wood as a hobby. Kyvelos describes his dad as "a hands-on kind of guy who taught me how to use the tools." His mother, the daughter of Greek immigrants, "was always very creative" and supported his own creative efforts. "We got *National Geographic* when I was a kid, and I'd see things I liked and would try to make them," he says. "So while other kids were out playing baseball and football—I was eight or nine at the time—I'd be on the back porch carving things out of wood."

His father also played traditional Greek tunes on the violin, and Kyvelos was intrigued. He took lessons for several years until forced to stop by a medical condition involving his neck. Inspired by Elvis Presley, he saved up for a $19 guitar. He taught himself to play it but didn't like the feel of the metal strings. His quest for an instrument to play ended when he went to a dance with an Armenian friend and heard an *oud* being played. "I said, 'That's it, that's the instrument I've been looking for,'" he says, "and I just had to have one. It was love at first sight—or sound."

The *oud,* a precursor of the lute, is probably Byzantine in origin. It was introduced into Europe by the Moors and exists in various forms throughout Turkey, Armenia, Iran, Bulgaria, Greece, and many Arabic nations.

After getting his first *oud* at 16, Kyvelos learned to play it and make minor repairs. By the time he started college in California in 1962, he was playing professionally and had restored almost 100 *ouds,* as well as other instruments. He paid his way through college by continuing his repair work, restoring violin bows and playing *oud* in nightclubs in San Francisco's North Beach area.

Kyvelos returned home in 1970 and set up shop in his mother's basement. The next year, he moved to Belmont, near Watertown, known as "Little Armenia." He has built at least 165 *ouds* at an average of 150 hours of work per instrument. His creations are known in particular for their distinctive rosette designs. He has received considerable recognition, but says the highest compliment came in 1989 when his friend Richard Hagopian received the National Heritage Fellowship and performed with one of Kyvelos's *ouds.* Hagopian refers to his friend as "the Stradivarius of *oud* making."

After years of making instruments, Kyvelos still derives considerable satisfaction from the process. "Then, when the instrument is scraped and sanded down to the point where it's ready to receive its varnish or lacquer, you know that the next thing you're going to do is see the whole thing come alive. It's almost like a birth. You're hand-applying a coat of varnish, and the moment you do, the wood starts

to sparkle with all those little things you knew were in there—the little knots, the little twists, and the little characters in the wood. It's magic," he says. "But the most important thing, of course, is when you've created an instrument and strung it up and it goes into the hands of a professional, and then you see that professional sitting up on a stage playing your instrument. There's a certain amount of pride that you get; nobody has to say anything. . . . What matters is between me, the instrument, and the person playing."

Lily May Ledford

ANGLO-AMERICAN BANJO PLAYER
AND SINGER

Life dates: March 17, 1917–July 14, 1985

Lily May Ledford (Jim Broadwater)

*L*ILY MAY LEDFORD WAS BORN MARCH 17, 1917, and grew up on a tenant farm in Powell County, Kentucky, 50 miles east of Lexington. Her family made its own music, and by the time she was a teenager she had joined her sister Rosie and brother Cayen in a string band they called the Red River Ramblers. They played for square dances up and down the Red River Gorge area. Lily May played both banjo and fiddle and picked up many old songs from her father and other relatives. In 1936, when the Ramblers played for some talent scouts, she was selected to come to Chicago and appear on the WLS Barn Dance radio show.

The producer, John Lair, soon discussed with Lily May an idea he had long wanted to try: forming an all-girl string band. When the Barn Dance moved to Cincinnati in 1937, he brought together Lily May, Rosie, and two other young female instrumentalists. Another Ledford sister, Minnie, later joined the group. It was called the Coon Creek Girls "so that people will know at once what kind of music they're going to hear," Lair said. The group made its broadcast debut on October 9, 1937. "Then it was our time," Lily May recalled later. "We startled the audience by being all girls—our sound was drowned out by the uproar of applause and yelling."

Listeners were not responding merely to the novelty. Lily May's driving clawhammer banjo playing, Rosie's strong guitar work, and the high mountain harmonies of the group were an exciting contrast to the sentimental home-and-mother styles of the period. The Coon Creek Girls performed across the country and appeared at the White House, at the invitation of Franklin and Eleanor Roosevelt, to play for the king and queen of England. Lily May later reported that the king had "rather a long-faced, dour, deadpan look, and he worried me a little. Then as I glanced down, I caught him patting his foot, ever so little, and I knew we had him."

The Coon Creek Girls broke up in 1957, though they reunited several times at festivals during the 1960s folk boom. Until her sudden death in 1985, Lily May Ledford continued to appear at schools and colleges. She was an inspiration to generations of younger musicians, including Pete Seeger.

Esther Littlefield

Alaska Native Regalia Maker
(Tlingit)

Born: 1907

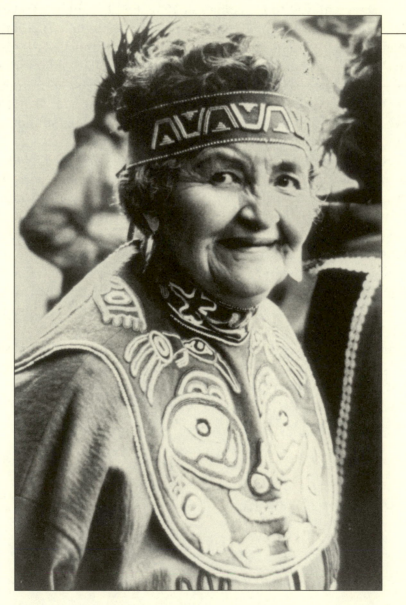

Esther Littlefield (Ernenst R. Manewal)

ESTHER LITTLEFIELD (AANWOOGEEX) WAS BORN in 1907 in Sitka, a city in southeast Alaska in the lacelike archipelago of islands that tail away southward hugging the British Columbia mainland. This is the historic home of the Tlingit and Haida tribes, expert hunters and fishermen, boatbuilders, and wood carvers of great renown who set their clan insignias into totem poles that once towered throughout the forests of the Pacific Northwest as far south as Oregon.

Littlefield belongs to the Kiksadi, a Tlingit clan whose members can wear the Raven emblem. Among her people young men are instructed in building and woodworking; young women are responsible for learning to work with fibers—basketmaking, sewing, and the construction of clothing and ceremonial robes. Littlefield's mother taught her the traditional techniques of beadwork, button design, and the handling of felt and leather. More important, she imbued her with a deep respect for the meaning behind the forms. Littlefield said: "A long time ago Mama saw beauty in the leaves from season to season. She'd sit somewhere and sew or weave. She'd look around her surroundings and see all the beautiful things. So, she'd create that. . . . Art should be respected. And it should be handled with care. People come and want to buy this . . . and they want information. They want to pay me. No. It's not worth all the money in the world. I don't want their money because this is my dignity. It represents my family."

Through the years, Littlefield applied the skills she learned as a child to make traditional Native costumes and other regalia. She adapted new materials and designs while maintaining the traditional Native art style. In making button robes, for example, she used wool blankets, felt beads, and buttons, sewn onto the blanket in a detailed design. All of her designs were symbolic of different clans and carried specific meanings related to their purpose and spiritual significance.

In recent years, Littlefield has accepted commissions from museums and other cultural institutions. She has taught bead and button work at the Southwest Alaska Indian Cultural Center since it was founded in 1969. She has demonstrated and interpreted Tlingit culture in many Alaskan cities and towns. In 1983, she received a special award from the United States Department of the Interior, National Park Service, for her commitment to Tlingit culture; a year later, she was presented with the Governor's Award for the Arts in Alaska.

She has continued to participate in arts conferences and symposia around the country, and above all to teach. Her lessons are straightforward and demanding. Though she knows the designs for bear, eagle, killer whale, frog, raven, and thunderbird, she works with students to help them identify their own particular identity and to understand the meaning of the designs and the occasions on which ceremonial robes may be worn.

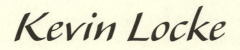

Kevin Locke

Native American
Lakota Flute Player and
Hoop Dancer (Hunkpapa Sioux)

Born: June 23, 1954

Kevin Locke (Paul Slaughter)

KEVIN LOCKE WAS BORN JUNE 23, 1954, on the Standing Rock Reservation in South Dakota. He is a Hunkpapa Sioux, and he was trained from an early age in all forms of Lakota musical, oral, and dance traditions. As a young man, he lived with an elderly uncle at Wakpala, South Dakota. The uncle spoke only Lakota and taught his nephew both the language and traditions of his culture. He learned many courting and love songs by hearing them sung. From elders in the tribe, he learned to make and play traditional wooden flutes.

In the late 1970s, he attempted to "revive and diffuse an appreciation for the Lakota/Dakota flute tradition." He said, "At the time I started this revival, the last exponent of the flute-playing tradition, Richard Fool Bull, had already departed from this life. My only recourse was to seek out those who could still recall the vocal traditions from which the instrumental flute melodies are derived. . . . Lakota/Dakota courting songs were once an essential expression of our intricate social customs and were used in specific situations during the courting process. The social conditions which gave rise to this expression are no longer in force. However, the tradition is a distinct treasure of South Dakota, and the values which gave rise to the use of the flute are those which our current society would do well to heed."

Locke has devoted much of his life to preserving the traditions of his people and has traveled the world in doing so. "There is a great need to continue the work of bridging the gap between the Indian and non-Indian cultures of South Dakota," he said. "I have been able to teach countless Indian and non-Indian children to sing, to dance, to stand inside the hoop of Indian culture, and I know that this experience will have lasting influence with regard to future positive race relations within the state."

In his presentations, Locke performs on his flute and demonstrates the Sioux hoop dance, using 28 wooden hoops. He often sings Lakota songs in English, though he professes not to be a good singer. But he clearly is a master of the eight flutes he brings along. "I see myself strictly as a preservationist," he said. "I base my repertoire on the old songs. I try to show younger people what was there, and maybe some of the younger people will pick up from there [and compose new music]. There's a point at which you can't express yourself with pure words, and that's where the music comes in."

Locke received a Bachelor of Science degree in Elementary Education from the University of North Dakota and a Master's in Education Administration from the University of South Dakota, and has pursued doctoral studies. He spends much of his time, when not performing, working in different aspects of education. Locke has performed in Native American ceremonies, concerts, and festivals across the United States and has toured Europe, Japan, the South Pacific, Australia, and Africa.

Robert Jr. Lockwood

African American
Delta Blues Guitarist

Born: March 27, 1915

Robert Jr. Lockwood (James Fraher)

BLUES GUITARIST ROBERT JR. LOCKWOOD was born March 27, 1915, in Turkey Scratch, Arkansas, and lived at various times in Helena, Arkansas; Memphis, Tennessee; and St. Louis, Missouri. As a child, he learned to play organ. He liked the blues but didn't play them when his grandfather was around. "I couldn't play when he was there because he was a preacher," Lockwood said. "I liked the blues and was playing them on organ. We all [in the family] played them on organ. My grandfather didn't know it."

Lockwood's life changed when he was 13 years old. His mother, long separated from her husband, met Robert Johnson, an itinerant blues guitarist and singer who would become an early blues legend. They lived together off and on for 10 years, until Johnson's death. When young Lockwood heard Johnson's powerful, haunting guitar style, he realized, "This is what I want to do. . . . I learned how to play the guitar like Robert. And I didn't touch the organ no more." Lockwood even inverted his name, from Robert Lockwood, Jr., to Robert Jr. Lockwood, because of his relationship with Johnson.

Within a couple of years, Lockwood was playing at local house parties and gambling establishments and on street corners to help support his mother. When he was 16, he teamed up with another blues great, Sonny Boy Williamson, who is sometimes called Sonny Boy II to distinguish him from a Tennessee musician of the same name. Together, the two recorded and performed on the influential radio show *King Biscuit Time,* broadcast from Helena's KFFA radio. "We were the first to play amplified blues over the radio," Lockwood said.

Robert Johnson died in 1938, apparently poisoned by a jealous husband at a Delta juke joint. He became a legend because of his singing and playing, which combined rhythm and lead and often, through the use of a slide, made notes seem to hang in the air. Contributing to the legend were his mysterious death and the tale that he had met the devil at a crossroads and sold his soul in order to play so beautifully.

Lockwood's long musical career took him to many places in the United States and abroad. When he lists the people he has played with, it sounds like a Who's Who of the blues, including B.B. King, Muddy Waters, and Otis Spann. He performed with the late singer and guitarist Johnny Shines for many years. But Lockwood wasn't content to play in one style. He also took a liking to the music of Count Basie and Ray Charles. His chord progressions and improvisations go beyond the blues into jazz. "*Rolling Stone* [magazine] says I'm not a blues musician," Lockwood said. "Some people might say that Ray Charles isn't, either, but he can play blues better than most, because he knows more. I'm the same way, a craftsman of music. I

can play all different styles, and I'm very grateful that I had the ability to learn."

Also atypical is his use of the 12-string guitar. "My wife, Annie, bought me that 12-string," he said. "I ignored it at first, but when I heard the great chord sound it got, I loved it. Now that's all I play."

Lockwood worked for 17 years as a studio musician at the premier blues label Chess Records in Chicago. He recorded for Chess and a number of other labels. In 1960, he and his wife settled in Cleveland, Ohio. He has continued to record and perform in concerts and at festivals around the country. One of his favorites is the King Biscuit Blues Festival, held each October in Helena, the Mississippi River town that played such a vital role in his career.

Valerio Longoria

MEXICAN AMERICAN CONJUNTO
ACCORDIONIST

Life dates: February 13, 1924–December 15, 2000

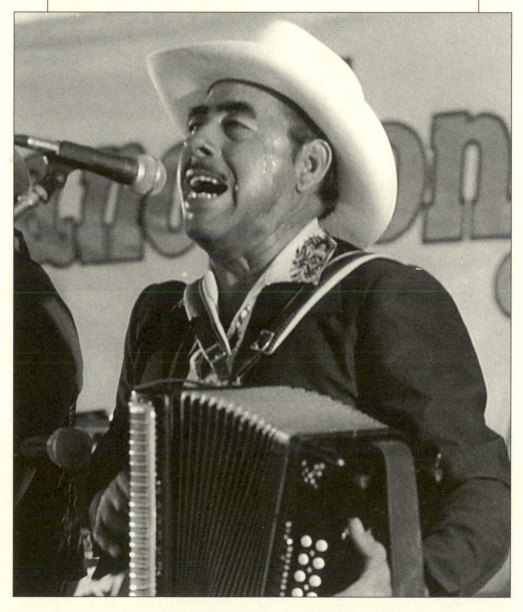

Valerio Longoria, 1986 (Chris Strachwitz, Arhoolie Records)

VALERIO LONGORIA WAS BORN FEBRUARY 13, 1924, in Kenedy, Texas. As a young boy, he took apart a harmonica to see how it worked, and when he was eight years of age, his father, Valerio Longoria, Sr., bought an accordion for him for $10. In a short time, he taught himself how to play and gradually learned the intricacies of his instrument. He dismantled and rebuilt the instrument to learn about its construction and the creation of its sounds. Within months, he was playing on the streets of his South Texas hometown of Kenedy for friends and passersby and soon was hired for area weddings and parties, playing waltzes, schottisches, and polkas.

In the early 1930s, Longoria traveled with groups of migrant farm laborers. He worked in the fields by day and played stage dances at night. He was inspired by strolling musicians he saw in Mexico and devised a system of straps that allowed him to play and sing standing up.

In 1942, when he was 18 years old, Longoria enlisted in the Army. He put his accordion aside until he resettled in San Antonio in 1946. There he formed his own *conjunto* (ensemble) comprising accordion, guitar, stand-up bass, and drum set. He made his first recording, *"El Pokerito,"* in 1947 for the Corona label, and over the next decade he recorded for nearly every Spanish-language label in Texas.

Longoria became known for his innovative accordion stylization, resulting not only from the instrumentation of his bands, but also his ability to renovate instruments and experiment with new sounds. To one of his accordions, he added a fourth row of buttons (the contemporary standard has three rows). Another has reed pairs tuned an octave apart to produce a rich, organlike sound. He also removed a standard set of bass stops, which he found insufficient, and replaced it with a larger set.

He was the first accordionist to combine his singing talents with his instrumental skills. He was also the first to tune and alter the accordion's metal reeds to give it a new hoarse sound and facilitate the immediate transition to keys other than the original key. He introduced modern dance band drums into the *conjunto*, and was the first to record the slow-paced *bolero,* a genre long associated with the genteel tradition, but that demanded more vocal finesse, greater technical skill, and more rhythmic and harmonic complexity.

In 1959, Longoria left Texas to record and tour the Midwest under the sponsorship of the Firma label in Chicago. He moved to Chicago, planning to be there for three months, but ended up staying eight years. From there, he moved to Florida, then back to Chicago. He traveled wherever people wanted to hear his *conjunto* music. After some time in Colorado and Idaho, he went to Los Angeles. Once

again, he thought he was going to stay for only a few months, but remained eight years.

In the 1980s, Longoria moved back to Texas upon hearing rumors that he had died and that his friends and fans were planning a memorial album for him. He settled in San Antonio and steadily regained his musical reputation in the state. With the founding of the Guadalupe Cultural Center in San Antonio, Longoria became active in teaching accordion to children and aspiring musicians.

George Lopez

Hispanic American Santos Carver

Life dates: April 23, 1900–December 23, 1993

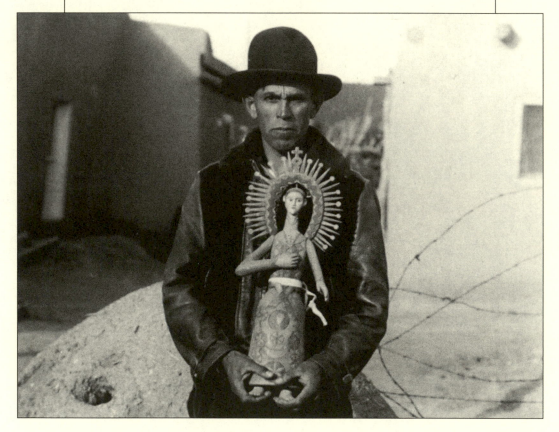

George Lopez (Courtesy George Lopez)

GEORGE LOPEZ WAS BORN ON APRIL 23, 1900, in the village of Cordova, situated in a small valley of the Sangre de Christo mountain range north of Santa Fe, New Mexico. Cordova, one of the early Spanish settlements dating from the sixteenth century, has become widely known throughout the United States and Europe for its tradition of religious wood carving.

Lopez grew up in the fervent Catholicism of the region, and as a boy he watched his father, José Dolores Lopez, carving *santos*, in the manner he had learned from earlier generations of the Lopez family. *Santos*, literally "saints" in Spanish, include not only images of saints, but apparitions of the Virgin Mary, depictions of the life of Christ, and other religious scenes, Bible stories, and characters.

The craft of the *santero* arose from the Counter-Reformation in Spain, and the work there of its greatest artists—El Greco, Velázquez, and Murillo. These painters were at the peak of their careers when New Mexico was settled and copies of their oil paintings were brought to the New World. Then, after indigenous Indians destroyed many of these models during the Pueblo Rebellion of 1680, a folk art emerged that depicted in wood carvings the effigies of Catholic saints. Often, the saints were represented in scenes that had a particular relevance to where they were made in New Mexico during the periods of Spanish colonial and Mexican rule. For example, San Ysidro Labrador with plow and oxen became the farmer's aid in arid land. St. Michael killing the devil and St. Francis were also very popular.

Although Lopez liked whittling as a boy, he did not pursue a career as a *santero* until later in life. He left Cordova at the age of 19 and worked with the Denver and Rio Grande Western's narrow-gauge lines in New Mexico and Colorado. Later, he got a job with the Union Pacific Railroad in Rawlins, Wyoming. Then, during the long, lonely nights in railroad camps between jobs, he started making small figurines similar to the ones he had seen his father and grandfather make. His first significant piece, he recalled, was the "Tree of Life," which he originated as a kind of Adam and Eve creation story "without the snake." He got the idea from a Garden of Eden carving his father once did, showing a serpent wrapped around a tree of forbidden fruit.

Lopez worked in Los Alamos through World War II and until 1952 when he decided to devote himself full-time to woodcarving. Working mostly with a penknife, a handsaw, and sandpaper, he was able to produce a simple figure in about an hour. Other figures took several weeks or months to finish.

"It's part of my life, and part of my name . . . I'm a sixth-generation *santero*," Lopez said, "but I guess I'm the last because I've got no kids

of my own." However, to perpetuate this venerable tradition, Lopez passed on his skills to his nieces and nephews. Like his forebears, Lopez did other woodwork in addition to his religious subjects, and carved animals, such as burros, sheep, and goats, but he always preferred the traditional *santos* figures—St. Francis, St. Joseph, San Ysidro Labrador, St. Michael, the Virgin of Guadalupe, and Santo Niño de Atoche. He viewed his work as a distinct mix of Catholic tradition, medieval Spanish art, mountain isolation, and *Penitente* ritual. Of these, the influence of the *Penitentes* was perhaps the most pronounced.

The *Penitentes* (penitent brothers) are an offshoot of the Third Order of Saint Francis, a Catholic lay body known for benevolent acts. Members attend the sick, bury the dead, and hold devotional services where there are no resident priests. "All my life," Lopez said, "I've seen *Penitente* processions pass my house. In the old days, they'd have a procession when somebody died or even to say prayers at a sick person's home. Nowadays, they just have processions in Holy Week."

Israel "Cachao" López

AFRO-CUBAN AMERICAN BASSIST, COMPOSER, AND BANDLEADER

Born: 1918

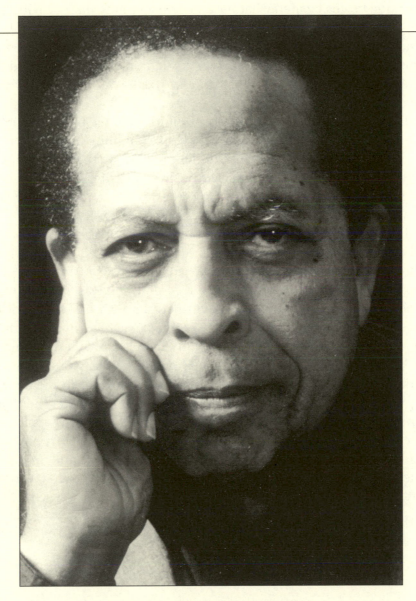

Israel "Cachao" López (Sidney Baldwin)

375

*I*SRAEL LÓPEZ WAS BORN IN 1918 in Havana, Cuba, into a family of musicians. At least 35 family members played the bass, which became Cachao's primary instrument. He had a brother and sister, both of whom were musicians before Cachao was born.

As a young boy, López gained recognition as a performer. When he was 13 years of age, he joined the Havana Philharmonic, where he remained as a bass player for 31 years. While in his teens, he also became a member of the pioneering *orchestra tipica* Arcaño y Sus Maravillas and worked as a bass player, composer, and arranger. His brother, Orestes López, served as musical codirector of the group.

Cachao introduced several new elements through his compositions into *danzón,* a Cuban ballroom dance in rondo form. In 1937 he and Orestes created what became known as the *mambo.* Gradually, the public accepted this general Africanization of Cuban music, and Afro-Cuban music emerged. *Mambo* played on Cuban radio for the first time in 1938. By 1939, with the addition of a *conga* drum to the ensemble, the Afro-Cuban structure of the *mamba* had solidified.

In 1957 Cachao again had a profound influence on traditional Cuban music when he introduced jazzlike jamming into the (until then) highly structured format of the traditional repertoire. López left Cuba in 1962, and for two years he lived in exile in Spain before moving to the United States. He settled in New York, where he worked with several of the leading Latin or *salsa* bands.

In 1983 López moved to Miami, but his work on the cutting edge of professional music declined. In Miami, he played only at weddings, christenings, and bar mitzvahs for several years. In the 1990s, however, he became more active in recording and was featured in a documentary film made by Cuban American actor and former Miami resident Andy Garcia. The film, entitled *Cachao—como su ritmo no hay dos* (Cachao: Like His Rhythm There Is No Other), focused primarily on the July 1992 "Cachao Mambo & Descarga" concert in Miami, but also explored López's role as an innovator in the development of Cuban music. Also in 1992, López played with other legendary Latin musicians on Gloria Estefan's Grammy-winning recording *"Mi tierra."* Later he played on the anthology *Forty Years of Cuban Jam Sessions.* In 1994 some of his compositions and arrangements appeared on the first of a multivolume series called *Master Session, Volume 1,* the first of a multivolume series.

Ramón José López

HISPANIC AMERICAN SANTERO AND METALSMITH

Born: October 23, 1951

Ramón José Lópéz
(Miguel Gandert, Courtesy National Endowment for the Arts)

RAMÓN JOSÉ LÓPEZ OF SANTA FE, NEW MEXICO, sees his direct link to tradition in his *santero* grandfather, who died two years before López was born on October 23, 1951. He continues to use many of his grandfather's carving tools. Like his grandfather, he is inspired by his deep religious faith and is committed to perpetuating the *santero* tradition, carving three-dimensional sculptural representations of Catholic saints.

In the 1970s, López, then a carpenter, began making jewelry. By 1981, his mastery of Spanish colonial metalworking methods had spurred a revival of that craft. He expanded his repertoire to include silver hollowware candlesticks, ecclesiastic vessels such as chalices, and domestic utensils. After studying the works of the nineteenth-century master *santeros,* he began to carve and paint using traditional hand-adzing and polychrome techniques to create *retablos* (two-dimensional portrayals of saints and other sacred images, usually on wood panels), *bultos* (three-dimensional images), and *reredos* (large carved and painted altar screens). He coats local aspen or piñon pine with gesso made from gypsum and rabbit-skin glue and works directly on the wood with paint he makes from natural pigments and dyes. His metalwork, carving, and painting skills are now also employed in the creation of diminutive *relicarios,* metal-framed images painted on wood, often with a hidden drawer at the bottom to hold a rosary. In addition, he has taken up the rare colonial art of hide painting.

In all that he does, López credits his cultural heritage and the earlier generations of masters that set the standards toward which he strives: "My traditional work lets me see how influenced I really was by my heritage, my history. It showed me my roots in this area—opened my eyes. It's all inspired by my upbringing here, my Catholic religion and my interest in the churches of New Mexico, with all their beautiful altar screens. I want to achieve the level of quality of those old masters—what they captured on wood, emotions so powerful, so moving."

López has passed his skills on to his four children and has served as a master artist in the New Mexico Arts Division's state folk arts apprenticeship program. He has won Santa Fe's Spanish Colonial Market's grand prize and first prize on many occasions and has exhibited widely in dozens of venues, including the Albuquerque Museum, the Taylor Museum in Colorado Springs, the New Mexico State Capitol and the Smithsonian Institution.

Albert "Sunnyland Slim" Luandrew

AFRICAN AMERICAN BLUES PIANIST AND SINGER

Life dates: September 5, 1907–March 17, 1995

Albert "Sunnyland Slim" Luandrew (Courtesy Airway Records)

\mathcal{A}LBERT LUANDREW WAS BORN SEPTEMBER 5, 1907, in Vance, a small Delta town near Clarksdale in the cotton-growing area of northwestern Mississippi. As a boy, he plowed with a mule and did other farmwork, but developed an interest in music early. He tried to listen to all the local blues musicians. He taught himself to play piano and organ and began playing in a local church when he was 14. By 1924 he was playing piano in a small movie theater in nearby Lambert, Mississippi. The tall, slender youth soon got the nickname he would keep: Sunnyland.

In the mid-1920s, Luandrew moved to Memphis to try his hand in the barrelhouses and honky-tonks that lined Beale Street. Memphis remained his home base for 15 years, though he played all over the South. He appeared briefly in Ma Rainey's Arkansas Swift Foot Revue and worked with many important blues artists of the period, including Blind Blake, Blind Boy Fuller, Roosevelt Sykes, Memphis Slim, and Little Brother Montgomery.

In 1942, according to Luandrew, "Memphis got a little rough, and they closed the joints, and they was the places where they had pianos, and you can be damn sure a piano player is going to be closed with them." After working in Missouri for a short time, he got an offer to record in Chicago. He moved there, supporting himself by factory work, truck driving, and an occasional club appearance. The original record deal fell through, and it was five years before he made his first recording. During that time, he established himself as one of the artists who made Chicago virtually synonymous with the blues.

Sunnyland Slim's music never strayed far from its Mississippi Delta origins, though he enjoyed throwing in musical quotations from Count Basie and Duke Ellington. In Chicago he worked extensively with Little Walter and Muddy Waters, as well as with Tampa Red and other musicians in local clubs. He made his first recordings for the Victor label in 1947, but they were released under the cognomen "Doctor Clayton's Buddy," because he was then touring with Peter "Doctor" Clayton.

Throughout his career, Sunnyland Slim was highly regarded by his Chicago contemporaries. Among those who recorded with him were Big Bill Broonzy, Muddy Waters, Little Walter, Lonnie Johnson, and bassist Willie Dixon. From 1947 to 1956 Sunnyland had at least one or two releases a year, though they were seldom on the same label. Aristocrat (on which he recorded with Muddy Waters) was followed by Hytone, Mercury, Apollo, JOB, Sunny, Regal, Opera, Chance, Constellation, Blue Label, Vee Jay, Club 51, and Cobra.

Luandrew was an urban bluesman who recorded songs with topical references, such as "Back in Korea Blues," and those with tradi-

tional origins, including "Brown Skin Woman" and "Woman Trouble Blues." He had a barrelhouse piano style that augmented the light-textured growl of his singing, sometimes punctuated by a rising falsetto and enhanced by the running monologue he kept up with the audience. About his distinctive approach, he said, "I lay it down hard on the piano. The way I do it, I get a person to tap his foot just like a Baptist preacher."

During his later years, he continued to record, performing in festivals and concerts across the United States and abroad.

Joaquin "Jack" Lujan

GUAMANIAN CHAMORRO BLACKSMITH

Born: March 20, 1920

Joaquin Lujan (Courtesy Joaquin Lujan)

*J*OAQUIN FLORES LUJAN WAS BORN MARCH 20, 1920, in Guam. He was nicknamed "Jack" and known as "Kin Bitud" by friends and relatives. He learned his forging techniques from his father, who in turn had learned them from his uncle. Jack was the only child to learn his father's skills. He mastered the graceful lines and fine finishes of the short Guamanian machete with inlaid buffalo horn or imported Philippine hardwood handles; the preferred angle and bevel of the *fosino* (hoe); and the practical applications of the other tools.

"We were basically a farming community, and the people need tools to aid them during work," Lujan said. "There was always a great demand for basic tools such as machetes, *fosinos,* and *kamyos* (coconut graters), and we also made metal rims for carts, knives, and betelnut cutters, as well as other essential and decorative items." As late as the World War II era, blacksmithing played an essential role. But Lujan became the sole surviving link to Guam's blacksmithing past, an aspect of the island's *Chamorro* culture that combines Spanish colonial and local influences. The time-consuming work of learning the craft and the diminishing economic incentive to produce hand-forged tools discouraged others from taking it up as a profession.

Lujan himself took up work as a welder before World War II and as a U.S. immigration officer after the war. When he retired, he again took up blacksmithing and set out to let others know of the beauty he found in this aspect of Guam's heritage. He demonstrated in schools and at festivals and other public events. He was driven by excellence in craftsmanship and the future of his tradition. "If I make something, it's for life," he said. "Nobody can beat the quality of my handiwork. It's first-class."

In 1985, Lujan took on three apprentices, all members of the Guam Fire Department who were used to heat and hard work and who had developed a passion for Lujan's art after seeing him at a demonstration. Others came to him to hone their skills. Television programs, newspapers, and magazines featured his work, and he was invited to exhibit and demonstrate in Australia, Taiwan, and the mainland United States. He received the annual Governor's Art Award on numerous occasions and the Governor's Lifetime Cultural Achievement Award in 1996. The Consortium of Pacific Arts and Cultures honored him by including his work in the American-Pacific crafts exhibit "Living Traditions."

In the words of Lujan's apprentice Frank Lizama, "Without Jack here guiding us, this art would have died. Hopefully, we'll continue to move on. The more we make, the more we want to do."

Wade Mainer

ANGLO-AMERICAN APPALACHIAN
BANJO PLAYER AND SINGER

Born: April 21, 1907

Wade Mainer (Courtesy National Endowment for the Arts)

WADE MAINER WAS BORN APRIL 21, 1907, near Weaverville, North Carolina, in the Blue Ridge Mountains north of Asheville. "It was kind of rough back in the days that I grew up," he said. "We were raised poor people back in the mountains, lived in an old log cabin, read the Bible at night by the old oil lamp."

When Mainer was about 12 years old, he went to work at a sawmill with his brother-in-law, who was also a fiddler. "He and his brother, they would go out to dances. So, when they would lay their music down, why I'd pick up the banjo and I'd start trying to play it. I must have started in clawhammer, because later on, I wanted to change my style of playing, and I went to trying to pick the music out with two fingers. My dad was a good singer—real stout voice. I do a lot of his old songs. He sung that old tune that I put on a record called *Take Me in Your Lifeboat,* and he knew a lot of those old, old songs."

In the 1930s, Mainer moved with his family to Concord, North Carolina, to join his brother, J. E. Mainer, at a cotton mill. There, the brothers formed a string band, with Wade on banjo and J. E. on fiddle, to play at local fiddlers' conventions and social gatherings. In 1934, J. W. Fincher, head of Crazy Water Crystals (a patent medicine), asked them to appear on the *Crazy Water Crystal Barn Dance,* a radio program broadcast from Charlotte. The popularity of the group performing under the name J. E. Mainer and the Crazy Mountaineers led to radio appearances throughout the South. One year later, the group was invited to record 14 songs for the RCA Bluebird label, including their biggest hit, "Maple on the Hill," a song originally composed in the 1890s by Gussie L. Davis, a popular black lyricist.

In 1936 Wade formed his own group, called The Sons of the Mountaineers, and continued to perform on the radio and to make recordings. Between 1935 and 1941 various Mainer brother combinations recorded over 165 songs for RCA Victor, making them some of the most heavily recorded country artists of that era.

Wade left the music business in 1953 and, along with many Appalachians of his generation, migrated north to Flint, Michigan, where he worked for General Motors until his retirement in 1972. He continued to play music, but refocused his attention to religious songs, which he performed at local church functions.

During the 1970s, with the renewal of interest in old-time music, and with some persuasion from fans who were familiar with his early recordings, Wade began to perform in public again, accompanied by his wife, Julia May, a guitarist and a fine traditional singer in her own right. "She just has to get in a certain key that she can sing in," Mainer said, "and she has a voice, it's a beautiful voice, don't never hear nobody else sing with a voice like she sings with."

Mainer's music was always noted for its traditional repertoire and his distinctive melodic two-finger banjo picking style that was a personal trademark. This style became the basis for the three-finger banjo styles developed by Snuffy Jenkins and Earl Scruggs. His music is an antecedent of modern bluegrass, a form he easily distinguishes from his own. "It's a higher pitch music, harder drive, faster music, but the music I play is mostly old-timey ballads and hymns, and stuff that we had done back when I was a boy."

Mary Jane Manigault

African American Basket Maker

Born: June 13, 1913

Mary Jane Manigault (Tom Pich)

MARY JANE MANIGAULT WAS BORN JUNE 13, 1913, outside Mt. Pleasant, South Carolina, north of Charleston. Growing up, she learned about the tradition of coiled basketry from her parents, Sam and Sally Coakley. "My mother taught me how to make baskets when I was eight years old," she said. "I made a hot plate, made it out of sweetgrass, palmetto, and pine needles for color."

The craft of coiled basketry has been practiced in the sea islands off the coast of the southeastern United States since the late seventeenth century, when it was brought over by African slaves. At that time, European colonists in the Carolinas were trying to establish agriculture in the coastal wetlands and experimented with the growing of rice. Unfamiliar with the proper cultivation techniques, the European settlers depended on the knowledge of the enslaved Africans, who were experienced in tropical farming and who introduced specialized agricultural practices and tools, including various kinds of work and winnowing baskets.

The earliest baskets were made for field use. Stiff bundles of bulrushes were tied together with strips of oak, hickory, or palmetto butt in a coiling technique to make produce baskets and what were called *fanner* baskets. Produce baskets were large and round, with high sides, and fanners were wide, circular, shallow trays, about two feet in diameter, and used to winnow rice after it had been hulled.

Although the use of field baskets declined during the nineteenth century, domestic basketry flourished among African Americans. Over time, basket makers slowly modified the old styles, and the range of sizes, shapes, and decorative motifs increased. Among the styles that continued into the twentieth century are clothes baskets, church collection baskets, sewing baskets, picnic baskets, traveling baskets, hot pads, and bread trays. The methods for making baskets has essentially remained the same, though the styles themselves have become more individualized.

For many years, Manigault sold her baskets in the open-air Market Square in Charleston. Often she had 30 to 50 coiled grass baskets on display at any given time. She liked to demonstrate and explain her techniques to interested shoppers, as she twined narrow palmetto strips around bundles of sweetgrass and pine needles. As the basket ages, she said, the pine needles turn brown and contrast with the gold and yellow of the other fibers.

Manigault's baskets have attained widespread recognition because of the sculptural quality of the forms she created and the imaginative use of natural design and color. She often experimented with different forms, but never overdecorated, understanding the value of the plain, unadorned traditional designs. Throughout her

life, she was an exemplar in her community, teaching children and anyone interested to make baskets. She believed in "good, honest workmanship." In December 2000 she suffered a stroke, but said, "I'm going to keep making baskets, as long as I can."

Elliott "Ellie" Mannette

TRINIDADIAN AMERICAN STEEL DRUM BUILDER, TUNER, AND PLAYER

Born: November 5, 1927

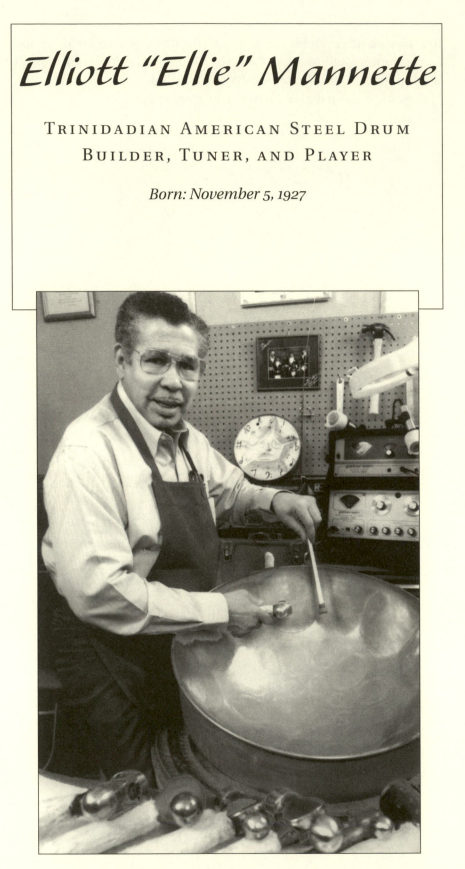

Elliott "Ellie" Mannette (Courtesy Ellie Mannette)

ELLIOTT "ELLIE" MANNETTE WAS BORN NOVEMBER 5, 1927, in Trinidad. As a child, he was attracted to carnival festivities and music. At age 11, he had his first opportunity to perform in a carnival parade with a group called the New Town Cavalry Tamboo Bamboo (later renamed Alexander's Ragtime Band). The group used traditional parade instruments, but these were subsequently banned by the British colonial government. Band members began experimenting with paint pans and biscuit drums and found that they could vary the pitch by striking different areas. Mannette and some other younger members formed their own band, the Oval Boys, the predecessor to the Woodbruck Invaders, one of Trinidad's best and longest-lasting groups.

When the British lifted the wartime carnival ban after World War II, Mannette became the leader of the Invaders. About the same time, oil drums became the standard source material for the instruments, and Mannette, a machinist by trade, became a pioneer of the new technology. He sank the lid to create a tensed playing surface and fired the metal to improve the acoustic properties. A variety of steel drums was created, and entire orchestras were formed. These changes helped to propel the instrument into wide popularity. Over the next several decades, Mannette brought an even more sophisticated approach to pan tuning, using a stroboscope to analyze and shape the harmonic blend.

In 1951, the Trinidad government organized the Trinidad All-Steel Percussion Orchestra, a national steel band, to represent the country at the Festival of Britain. Mannette was among the musicians chosen to be trained by Lt. Joseph Griffith of Antigua's Police Band. Of the experience, Mannette said, "Look, we were 11 pan men who had no formal training in music theory. Mr. Griffith . . . was a disciplined band director and insisted that we be disciplined musicians. We practiced for hours a day and, along with playing dozens of gigs to raise money, even had to build new instruments for the trip! . . . Mr. Griffith told me that I would have to build a bass pan from a 55-gallon drum. Now prior to that, we used only the light caustic soda barrels to make our bass, and only one barrel at that. . . . I told him I didn't believe I could build a bass from a 55-gallon drum; they were just too heavy and would not sound. I have to laugh when I think about this now, so many things in pan have come about—quite by accident. Anyway, he refused to take no for an answer. . . . I guess he knew what he was talking about, because I did do it."

By 1959, the Invaders had a contract with Columbia Records. Mannette came to the United States in 1963 in response to an invitation to develop a U.S. Navy steel band, build the instruments, and train the players. He returned for good in 1967 to work with inner-

city youth in New York City. He started more than 10 new bands. His company, The Mannette Touch, has become the main source of steel-band instruments in the United States. He has worked with more than 350 school programs and in recent years has served as an artist-in-residence at West Virginia University. His innovations, musicianship, teaching, and advocacy for his tradition have earned him the title "Father of the Modern Steel Drum."

Frankie Manning

AFRICAN AMERICAN LINDY HOP DANCER, CHOREOGRAPHER, AND TEACHER

Born: May 26, 1914

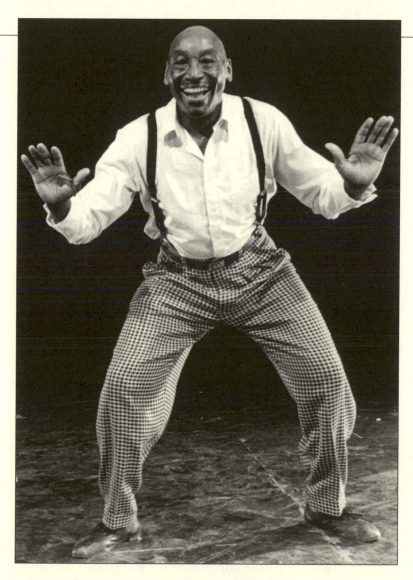

Frankie Manning (Ralph Gabriner)

\mathcal{F}RANKIE MANNING WAS BORN MAY 26, 1914, in Jacksonville, Florida. At age three, he moved with his family to Harlem in New York City, where he grew up with the social dances in vogue at the time. When he was about 14, he started skipping his Sunday afternoon church activities to go to dances for teenagers at the Alhambra Ballroom. There he learned the Lindy Hop, which emerged in Harlem around 1927 and was named for aviation hero Charles Lindbergh.

Of his early years as a dancer, Manning has said, "When I was older, I started going to the Renaissance Ballroom. The Alhambra was like elementary school, the Renaissance was high school. And by the time you got to the Savoy [Ballroom], that was the big time, you was at college."

In its first years, the Lindy Hop was synonymous with "jitterbug" or "swing dance." But that was to change, thanks to Manning. In 1934, he was invited to join Whitey's Lindy Hoppers, formed by Savoy bouncer Herbert "Whitey" White. Manning soon became the group's choreographer and introduced synchronized ensemble dancing; a more horizontal dance posture, evoking a sense of wild abandon; and "freeze" steps, in which the dancers would stop suddenly. In a dance competition at the Savoy, he premiered one of his more flamboyant inventions—the "aerial"—in which he and his partner locked arms back to back and he catapulted her in a somersault over him, ending with the two standing face to face.

Manning's innovations catapulted Whitey's Lindy Hoppers to fame and professional careers. They appeared at the Alhambra Theater with the Cotton Club Revue. The group appeared with the leading swing bands of the time, including Count Basie, Louis Armstrong, and Benny Goodman, and in dance scenes of movies such as *Radio City Revels, Hellzapoppin',* and the Marx Brothers' *A Day at the Race*s. A *Life* magazine cover featured Manning and Ann Johnson doing the Congaroo, a combination of the conga and the Lindy Hop. During his long career Manning has also appeared with Bill "Bojangles" Robinson, Josephine Baker, Sarah Vaughn, Ella Fitzgerald, Tony Bennett, Sammy Davis, Jr., and many others.

Manning resumed his dance career after service in World War II, but as the swing vogue faded, he took a job with the post office, where he worked for the next 30 years. During that time he danced only socially. The swing dance revival of the mid-1980s led to his rediscovery. Since then, he has performed and taught steadily, both in the United States and abroad. He consulted on and appeared in the film *Malcolm X,* directed by Spike Lee. He became the choreographer for the New York Swing Dance Society; choreographed shows in the United States, England, and Sweden; was profiled on the television show *20/20*; and won a Tony Award for his choreography of the Broadway show *Black and Blue.*

Miguel Manteo

ITALIAN AMERICAN MARIONETTIST
(SICILIAN)

Life dates: September 2, 1909–September 22, 1989

Miguel Manteo (Martha Cooper)

MIGUEL "MIKE" MANTEO WAS BORN September 2, 1909, in Medosa, Argentina. His parents, originally from Catania, Sicily, moved to Argentina around 1900, bringing with them the marionette theater they had inherited from their forebears. In 1919, the family, led by grandfather Agrippino Manteo, moved to New York City, where they opened another theater, Papa Manteo's Life-Sized Marionettes, in Little Italy. Agrippino ran an electrical business by day and staged marionette performances at night, assisted by his wife, Catarina,

who collected quarters at the door, and his four sons and a daughter helping backstage.

"I started out as a kid cranking the pianola—an old hurdy-gurdy," Mike said. "But whenever my grandfather wasn't around, I'd practice handling the puppets. All the while he pretended not to know. I guess he figured it would kill my interest if he was always looking over my shoulder. Eventually, I was allowed to manipulate the marionettes onstage, and my father came down to direct the show from the wings."

For more than a century, five generations of the Manteo family have performed episodes from the *"Un Avventura d'Orlando Furioso"* (the epic adventures of the knight Roland in defense of Charlemagne's empire) and *"L'Amore di Isabella e Zervino"* with life-sized marionettes. This distinctive form of marionette theater emerged in Sicily in the early nineteenth century, though the tradition of performing the Orlando cycle with marionettes was known as early as the sixteenth century.

True to tradition, the Manteos performed 394 episodes from the Orlando cycle in installments, taking 13 months of nightly performances to complete the series. For many years, however, Mike supported himself, like his father and grandfather before him, as an electrical contractor, and was forced to do far fewer performances, though the marionettes remained his chief passion.

Mike held the coveted title of "Papa Manteo" and carefully preserved the tradition of his great-grandfather, also named Michael. Working in the family's Brooklyn warehouse, where they stored and repaired hundreds of characters needed for the pageant, Manteo hammered the armor for his shining knights from old hubcaps, broken toasters, and other pieces of scrap metal. His sister, Ida, made gowns for the courtly heroines of silks and velvets from discarded wedding dresses, cautiously avoiding print fabrics, because they looked too modern. The marionettes they clothed were four to five feet high, depending on the importance of the character, and weighed well over 100 pounds each.

The method for constructing the marionettes, known and used in Roman times, is based on "rod control." One rod controls the marionette's head movements, while a second rod is attached to its right arm. The arm is controlled by a cord, and the legs, which swing free, move by their own weight. In this way, the puppeteer is able to manipulate the marionette and to create various special effects and movement.

Manteo enlarged the family's collection of marionettes from about 50, brought by his grandfather from Argentina, to more than 200, making new wooden figures out of mahogany, oak, and cherry, which he preferred. "They're works of art," he said. "No machine can

make them. They were made with the hands and with the heart." In addition to building the puppets, Manteo also created the dialogue for the knights, dragons, ogres, and eagles. He "threw the voices" and improvised the dialogue, based on the stories he had heard from his father and grandfather.

Narciso Martínez

MEXICAN AMERICAN CONJUNTO ACCORDIONIST AND COMPOSER

Life dates: October 29, 1911–June 5, 1992

Narciso Martínez (left) and Antonio Ramirez, 1986 (Alan Govenar)

Narciso "Chicho" Martínez was born October 29, 1911, in Reynosa, Tamaulipas, Mexico, across the border from McAllen, Texas, in the Lower Rio Grande Valley. His family migrated to Texas when he was still an infant, seeking work in the citrus and vegetable fields of the fertile Rio Grande Valley. Like many Mexican Americans

of their generation, his parents were migrant farmworkers, following the crop harvests around Corpus Christi and small communities such as Bishop, Chapman Ranch, and Riviera.

Growing up, Martínez received no formal education. As a young man, he adapted the tunes he heard the Mexican American farmworkers whistling to his brother's button accordion. The instrument had been brought to Texas in the late 1800s by German and Bohemian immigrants.

He began working dances in the late 1920s using a one-row button accordion, what he called *"una murgrita"* (a little piece of junk). It was about 1930 before Martínez was able to set aside this junk instrument and buy his own two-row button accordion, a new Hohner that he found in a shop in Kingsville, Texas. He collaborated with Santiago Almeida, who played rhythmic accompaniment for his accordion on the *bajo sexto* (a 12-string bass guitar). The response of the people at the dances where they played was enthusiastic, and with the encouragement of a Brownsville furniture dealer, Enrique Valentín, they went to San Antonio to play for a representative of Bluebird Records. They were given a recording contract and their first 78 rpm record, with the songs *"La Chicharronera"* and *"El Tronconal,"* was an immediate success. Between 1935 and 1938, Martínez earned his reputation as "Hurricane of the Valley" by making 59 records with Almeida, including *redowas,* polkas, *valses altos, vals bajitos, huapangos,* schottisches, and mazurkas.

In the 1940s, Martínez acquired the now-standard three-row model button accordion. Unlike many of his contemporaries, who used a more Germanic style of playing that relied heavily on the left hand for accompaniment, Martínez began to concentrate on a right-hand virtuosity that gave the new *norteño* style a treble, staccato quality in marked contrast to its Germanic counterpart.

During World War II, most musicians, including Martínez, were unable to record because of government restrictions on shellac and other materials needed by the recording industry. After the war, Martínez was one of the first musicians to be recorded by Ideal Records, a small Mexican American label founded by Armando Marroquín and Paco Betancourt in Alice, Texas, which recorded his own compositions and hired him to play on the sessions of others.

With the success of Martínez's recordings came increased demand for public performances. In the 1950s, he toured the southwestern United States from Texas to California, playing hundreds of performances while actually earning a living as a farmworker. By the 1960s Martínez had settled back in the Rio Grande Valley in the small town of San Benito, where he continued to play at hundreds of Saturday night dances, weddings, fiestas, and other community celebrations.

Sosei Shizuye Matsumoto

ASIAN AMERICAN CHADO (TEA CEREMONY) MASTER (JAPANESE)

Born: February 11, 1920

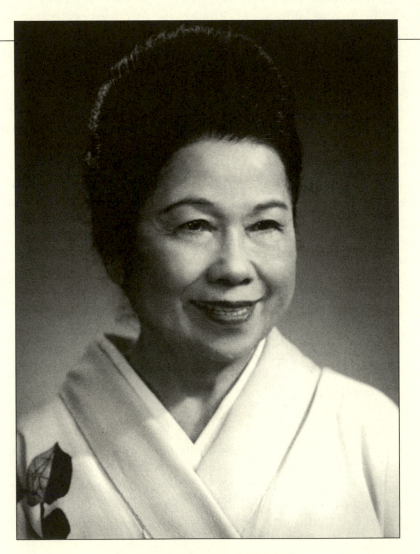

Sosei Shizuye Matsumoto (Mr. Miyatake)

*I*N EAST ASIAN CULTURES, many artistic traditions are considered to be ways of achieving self-discipline as well as a means of producing aesthetically engaging expressions of creativity. There are numerous venerable examples of these "meditative arts," but in Japan none is more highly esteemed or inclusive of different artistic media than *chado,* or "way of the tea." About the tea ceremony, Gerald Yoshitomi says, "the art of the tea has been characterized as the very essence of Japanese culture, embodying as it does the various artistic disciplines of ceramics, architecture, visual art, literature, and calligraphy, not to mention the mental discipline which goes into the formation of one's character."

Chado is a complex series of hundreds of steps designed around the act of serving tea and requires a connoisseurship of all the necessary physical accoutrements as well as acute sensitivity in the disciplined interaction among its participants. When properly practiced, the natural setting, the delicately wrought tea utensils, the simple elegance of the decorations, and the smooth, regulated movements of the participants combine to remove the host and guests from the pressures of the outside world and place them in an atmosphere where each finds inner peace and tranquility. Historically, *chado* has left its mark on many other art forms. In the sixteenth and seventeenth centuries, for example, tea masters influenced the shaping of some of the most beautiful of ceramic tea ware, always preferring the simple, rustic, and spare over the highly finished and refined.

In the United States, the most influential teacher and accomplished master of *chado* is Sosei Shizuye Matsumoto. She was born February 11, 1920, in Honolulu, Hawaii. After attending high school in Los Angeles, she enrolled in the French American Fashion Design School and graduated in 1941. At that time, she also began training in the "way of the tea" ceremony. She moved to Kyoto, Japan, and for six years she trained under Tantansai, Fourteenth Generation Grandmaster of the Urasenke School of Chado, and Soshitsu Sen, Fifteenth Generation Grandmaster.

Following World War II, Matsumoto saw that there were few practitioners of the tea ceremony in her new home of Los Angeles, but her desire to start a school was thwarted by the unsettled times, with Japanese Americans returning from wartime internment camps. In 1951, she was invited to the signing of the United States–Japan peace treaty in San Francisco, where over a four-day period she served tea to more than 3,000 American and Japanese officials, including President Truman and Prime Minister Yoshida. Later that year, she started teaching the Urasenke Tea Ceremony in Los Angeles, convening the first tea ceremony classes ever held in the United States;

one of her ceremonies is shown in the Twentieth Century Fox film *East Is East.*

In the 1950s, Matsumoto introduced millions of Americans to *chado* through appearances on CBS and NBC television programs. In 1968, she was invited to present the tea ceremony at the Olympic Arts Festival in Mexico City. Her more than 40 years of teaching and lecturing throughout the country has resulted in over 120 *chado* teachers and thousands more tea ceremony devotees. Over the years, her students have included Japanese- and American-born people interested in learning the ancient Japanese tea ceremony.

Matsumoto exemplifies the character of a *chajin* or "tea person." She not only knows (and can teach) all the procedures for *chado,* but she also manifests the true spirit of self-discipline and compassion for others, which only a few students are ever able to attain. In 1989 she received the title *Meiyo Shan,* Honored Master, from her instructor Soshitsu Sen. This is the highest teaching certificate available for instructors of the Japanese tea ceremony. She has lectured and demonstrated widely throughout southern California as well as the Southwest. In recognition of her long service to preserving Japanese culture, Matsumoto received the Fifth Order of the Merit (The Order of the Sacred Treasure, Gold and Silver Rays) from the Emperor of Japan in November 1990.

Eva McAdams

Native American Craftswoman and Beadworker (Shoshone)

Born: 1927

Eva McAdams (Courtesy Eva McAdams)

Eva Washakie McAdams was born in 1927 in Fort Washakie, Wyoming, on the Wind River Reservation, the great-granddaughter of the renowned nineteenth-century Shoshone leader Chief Washakie. As a child, she learned beadwork, an integral part of Shoshone life that is passed on through generations within families. "All of the women in the Washakie family are noted for their bead-work," she said. "I was taught at home by my mother. It's something that was handed down."

In time, McAdams was able to do exquisite beadwork and buck-skin sewing. The teachings of her mother were augmented by her grandmother Mary Washakie and her aunt Virginia Norseep.

Using a palette of fine seed or cut ceramic beads applied either to Indian smoked and tanned buckskin or to commercially available white buckskin, she crafts a wide variety of items—ceremonial vests, pants, dance dresses, belts, purses, pendants, and other traditional wares. Among her most prized creations are moccasins, both lowtop and hightop, with elaborately decorated leggings. She applies the beads with either a "lazy" or an overlay stitch. Some of her beads are extremely small, only a little larger than a pinhead. She prefers ceramic beads, but also makes extensive use of cut-glass beads, many of which are imported from Czechoslovakia.

Floral patterns—especially the rose, long preferred among her Eastern Shoshone people—and traditional geometric designs shape most of her work. Although Plains moccasin designs and customs are often gender-specific and vary from tribe to tribe, many of McAdams's popular designs are worn by both men and women.

Eva and her late husband, Alfred "Dutch" McAdams, operated a ranch near the Little Wind River in the foothills of the Wind River Mountains west of town. She raised six children and taught her daughter to sew and bead, but also continued to make ceremonial and dance regalia, which she often sold to other members of her tribe. As her reputation grew, so did the number of commissions she received. To supplement her regalia making and beadwork income, and to contribute to the betterment of her community, she has worked a number of jobs. For five years she managed the tribally owned Warm Valley Arts & Craft Store. Later, she started a small business supplying beads, buckskin, and other natural materials to other artists because she was dissatisfied with the quality of some commercially produced goods needed for traditional Shoshone crafts. In addition, she worked as a federal magistrate for the Law and Order Court System operated by the Bureau of Indian Affairs on the Wind River Indian Reservation. She was a counselor to Indian inmates at the Wyoming State Penitentiary in Rawlins, and served as an election judge for Fremont County and as a researcher for Title IV projects on traditional foods and medicines.

Beadwork remains central to her life. While working in these various jobs, she continued producing Shoshone regalia and beaded garments. Although her designs are based on older traditions, she does not do historic reproductions. If she is asked to reproduce old designs, she makes them subtly different. She believes that the old designs should not be duplicated if they have lost their meanings and personal associations. Her designs incorporate traditional Plains Indian aesthetics while embracing personal and contemporary concerns.

Sewing buckskin is referred to as a survival technique among the Shoshone. Buckskin was traditionally the primary material available for garments, and skilled buckskin sewers were essential to the tribe's survival, especially during the long, cold Wyoming winters. Beaded clothing like that McAdams creates is now used mainly in Indian pageantry, but garments with minimal beadwork may be used for everyday wear.

Marie McDonald

NATIVE HAWAIIAN LEI MAKER

Born: 1926

Marie McDonald (Courtesy Smithsonian Institution)

MARIE MCDONALD WAS BORN IN 1926 and spent most of her childhood on the rural island of Molokai in the Hawaiian chain. She is descended from two great traditions: on her mother's side, the Mahoe line of Hawaiian chiefs; on her father's side, the distinguished Adams family of New England. She journeyed to Texas for her advanced education, earning a degree in art from Texas Woman's University in Denton. Since then, she has lived in Hawaii, where she has taught art to Hawaiian students for many years in the public schools. She also owns and operates the Honopua Flower Growers in Waimea, on the big island of Hawaii.

McDonald is not only the islands' best-known practitioner of the art of Hawaiian *lei* making, but she is also its primary scholar. Her research and documentation of the tradition in her 1985 book *Ka Lei—The Leis of Hawaii* is the authoritative source on the subject. After the book's publication, she conducted field research on *lei* traditions associated with Hawaiian ranching. She finally located a *lei* maker on Maui who could tell her about the *leis* once made of sisal fiber scraps—the *lei malino*. At her own ranch on the big island, she experiments regularly with raising older plants and flowers.

Hawaiian cowboys wear *leis* in parades and rodeos and at other times when the spirit moves them. *Leis* are used to welcome others, whether they be strangers or friends; to celebrate holidays, weddings, and birthdays; and to honor the dead. High school boys give their dates *leis* to match their dresses, and at graduation the students are piled "to the eyebrows" with *leis,* in McDonald's words.

There are a number of *lei*-making techniques. *Hili* is a simple braid of one material. *Haku* is the most difficult, in which the *lei* maker braids ferns or other leaves and mounts flowers into the plait. A thread of hibiscus bark or raffia binds a *wili lei.* A *kipu'u lei* is knotted, whereas a *humupapa lei* is sewn to a base of bark or fabric. Because Hawaii has a virtually seasonless climate, a variety of buds, blossoms, fruits, and leaves are available year-round. Because many native species are endangered, McDonald encourages her students to grow *lei* gardens. "Orchids, carnations, and other things, you can buy in the supermarket," she said.

Materials for traditional *leis* are actually chosen first for fragrance. Texture and the feel of the material against the wearer's skin are also considered. Movement is important for *leis* worn by *hula* dancers and for head *leis.* "They are very intriguing and graceful and enhance the beauty of men and women," McDonald said.

Least important is how long a *lei* will last. "Some Westerners have trouble understanding that the meaning of the *lei* is in the making and giving, perhaps because they live in such a plastic world," McDonald said. "The *lei* is an expression of love, affection, honor, and

respect. It's the most beautiful thing I can make, from the most beautiful material at hand. As long as the *lei* is at its peak when I give it to you, it shows that I care."

Through her work as a resource specialist for the Department of Parks and Recreation, McDonald devoted many years to educating Hawaii's youth. She also worked as an art teacher in North Kohala, an isolated area on Hawaii. She has rarely turned down a request to provide *leis* and floral decorations for a special occasion. She also has consulted on displays and presented numerous demonstrations, both at home and on her extensive travels.

Brownie McGhee

AFRICAN AMERICAN BLUES GUITARIST

Life dates: November 30, 1915–February 16, 1996

Brownie McGhee (Tom Pich)

*W*ALTER "BROWNIE" McGHEE WAS BORN November 30, 1915, in Knoxville, Tennessee. When McGhee was five years of age, he was stricken by poliomyelitis. Although he walked with crutches and a cane for some time, his recovery was nearly a complete success; the only lingering visible effect of the illness was that he walked with a limp throughout his life.

His father, George Duffield McGhee, was a skilled guitarist and singer. The senior McGhee often teamed up with his brother-in-law, John Evans, a fiddler, to play for local dances and parties. When Brownie was seven years of age, Evans built him a five-string banjo as his first instrument. Within a year, McGhee also began learning to play the piano and the guitar. He recalled his father telling him never to strum the guitar, but to pick it as he did, using his bare fingers: "My daddy forbade me to play with a straight pick, and he was absolutely against me playing with a slide."

Following his father's directive, McGhee developed his own style, characterized by picking patterns and syncopated melodies played over a thumb-picked bass. "My thumb is another hand," he explained. "My father always told me something should be happening on the guitar all the time. . . . I was 14 or 15 before anybody knew I could play the guitar. But my daddy knew I was foolin' with his guitar, because I'd get it out of tune."

McGhee's family moved several times while he was growing up. He attended elementary school in Lenoir City, and while there he sometimes played the organ at the Solomon Temple Baptist Church. Later, he sang in the choir at the Sanctified Baptist Church. A few years later, the family relocated to Marysville, Tennessee, where McGhee started high school, but during the summer after his freshman year he quit to become an itinerant musician. He entertained at resorts in the Smoky Mountains, and then earned a living traveling throughout Tennessee playing and singing, working with the Hagg Carnival and in medicine and minstrel shows.

In the early 1930s, McGhee rejoined his family on their farm in Kingsport. He stayed there for a few years helping with farmwork and singing in his spare time with The Golden Voices, a gospel quartet. As pressures of the Depression began to ease, he moved to Knoxville, and over the next few years he formed a series of small bands to play at local affairs in and around the city.

In 1937, McGhee took advantage of a March of Dimes program to have an operation on his foot to reduce or eliminate his dependency on crutches and the cane. He was in the hospital for nine months. While there, he made up his mind to walk without a crutch. "I just wanted to pick up my guitar and start walking. And that's just what I did."

After staying in Knoxville a few years, he started traveling again. He made his way through North Carolina as a street performer, and in Winston-Salem he teamed up with harmonica player Jordan Webb. Then he moved on to Burlington, where he met George "Oh Red" Washington, a friend of Webb's. Washington suggested the musicians go on to Durham to play for Okeh Records talent scout J. B. Long.

Long was impressed with McGhee and set up his first recording date in Chicago in 1940. McGhee recorded first with Webb, and later with harmonica player Saunders Terrell, better known as Sonny Terry, after Terry's previous music partner, Blind Boy Fuller, died. Long sought to capitalize on the popular "Fuller–Terry" sound by placing McGhee and Terry together. This partnership proved very successful, and in the early 1940s McGhee moved to New York, where Terry lived, and the pair quickly became popular in local nightclubs, coffeehouses, and folk concerts.

In 1942, McGhee opened the Home of the Blues Music School in New York, where he taught young musicians the intricacies of finger-picked blues guitar. He operated the school until 1950, but also continued his recording career. In 1944, McGhee had signed with Savoy Records, and the following year with Alert. During World War II, he performed with Woody Guthrie and Terry on the Office of War Information (OWI) radio shows broadcast by the BBC in London, and he also appeared in short wartime films produced by OWI.

In 1947, McGhee performed on the soundtrack for the motion picture *The Roosevelt Story*. Around this time he also began writing his own compositions. Among his better-known songs are his recordings of "Sportin' Life" (Alert) and "My Fault" (Savoy). He said, "'Sportin' Life' was based on the last letter I got from my mother. My sister went and told her what kind of life I was living, and she sent me a message that said, 'I want you to change your ways.'"

Throughout the 1950s and into the 1960s, McGhee and Terry recorded for several other labels. McGhee sometimes performed under one of several pseudonyms, including Spider Sam, Big Tom Collins, Henry Johnson, and Blind Boy Williams. In addition to touring with Terry and recording, McGhee appeared in Broadway shows, such as *Finian's Rainbow*, Tennessee Williams's *Cat on a Hot Tin Roof*, and Langston Hughes's *Simply Heaven*. Also during this period, he fronted a band called the Mighty Rockers that played in clubs and at house parties in New York and New Jersey. In the 1960s McGhee and Terry were featured on many major network television shows and several folk music special programs. They also toured with Harry Belafonte.

McGhee's busy and diverse performing schedule continued into the 1970s. He recorded the soundtrack for the film *Buck and the*

Preacher and appeared in two French films, *Blues Under the Skin* and *Out of the Blacks and Into the Blues.* In the early 1970s, McGhee moved to California, where he built his own home in 1974 in Oakland. He continued to perform across the United States and abroad until his death.

Hugh McGraw

ANGLO-AMERICAN SHAPE-NOTE SINGER AND TEACHER

Born: February 20, 1931

Hugh McGraw (right) (Aimee Schmidt, Courtesy Georgia Council for the Arts)

*H*UGH McGRAW WAS BORN FEBRUARY 20, 1931, in Central Hatchee in Herd County, Georgia. His father, John McGraw, worked for the railroad and his mother, Lillie Ashley, was a seamstress at the Sewell Manufacturing Company. When Hugh was about three months old, his family moved to Villarica, Georgia, where he grew up until the age of 12, when they relocated to Bremen, Georgia.

Hugh's parents introduced him to shape-note singing. "The Mc-Graw family has been involved in Sacred Harp music for well over a hundred years," he said, "but I didn't get involved until I was 25 years old. I'd go to a singing with my mother and father, but I thought it was more important to stay outside and play in the spring and run around the house than it was to learn this tradition."

In 1952, McGraw changed his mind. "I walked into a singing—after I was done married and had a family. And I heard this music, and something just petrified me. Says you got to do your thing. So I began studying and teaching, composing, and singing this music all over the country."

The Sacred Harp shape-note songbook, compiled by B. F. White and E. J. King and first published in 1844, is a collection of American choral religious music that emphasizes settings of tunes transcribed from oral tradition. Some of the melodies originated in the Old World, and others stemmed from eighteenth-century American composers. It employs a system of symbols for notes that is simpler than conventional musical notation. The book began as a text for rural singing schools and, by the 1850s, gained an additional function as the focus of periodic singing conventions. This tradition continues today in Georgia, Alabama, Mississippi, Florida, Tennessee, and Texas.

Several generations of McGraw's family have taken part in the Sacred Harp tradition, but none with more enthusiasm and skill than Hugh. He taught many singing schools and organized singers to revive the tradition in their own communities. In addition, he helped groups of Sacred Harp singers travel to national festivals.

To support his family, McGraw worked as the manager of a Bremen clothing manufacturing plant, but in his free time he served as executive secretary and treasurer of the Sacred Harp Publishing Company. Over several decades he was respected as a charismatic leader of a diverse group of singers, and in 1991 he was the inspiration for the revision of the Sacred Harp songbook. For the revision, he convened a committee of Alabama and Georgia singers and coordinated the addition of a number of songs; some were recently composed and others were selected from older books, many of which were already being sung from photocopies. The committee solicited and reviewed this material, and then chose 60 songs, 37 of which

were written by authors who were then alive. Nearly half of the songs use the poetry of Isaac Watts (1647–1748), and many were from Colonial American composers already familiar to singers, including William Billings (1746–1800) of Boston, Daniel Read (1757–1836) of New Haven, and Timothy Swan (1758–1842) of Northfield, Massachusetts.

For McGraw, the preservation of music and community is integral to his life. "A lot of people don't sing this old music because it's 'old fogey.' You know 'old fogey' means a caretaker. A caretaker preserving something that's worth preserving. And that's what we're trying to do in preserving this music, our national heritage."

Sylvester McIntosh

CRUCIAN SINGER AND BANDLEADER

Born: August 17, 1934

Sylvester McIntosh (Courtesy Sylvester McIntosh)

SYLVESTER MCINTOSH WAS BORN AUGUST 17, 1934, on St. Croix in the U.S. Virgin Islands, the son of Ivan McIntosh, a respected Crucian saxophonist. When he was 12 years old, his father taught him the musical scale. Soon after he started playing in a small neighborhood "scratch band," as the local ensembles of cane flute, gourd rasp, guitar, drum, and bass were called. At the age of 15, Sylvester began playing guitar in his father's band, and as they traveled the long distances on foot across the island, guitar in hand, he learned the tunes in his father's repertoire.

His mother, Ethel McIntosh, also Crucian born, knew many of the local songs and song texts. As she worked around the house, she taught Sylvester the ancient melodies that had been passed from older generations to her. Growing up, Sylvester was intrigued by the different traditional performers and folk orators around the Frederiksted area, near where he lived. He became an active member in the Wild Indians, a "masquerade" troupe that was prominent in organizing the costuming, music, and dance activities of the annual carnival celebrations.

"There used to be different kinds of masquerade troupes whenever there was a holiday," he said. "One was the Mother Hubbard troupe and it was all women and they all had whips, cut from the tamarind tree. They would dance with the whip over the heads in both hands. They'd stop at the corner of each block, and the band would perform and the people would throw money on the ground. And then somebody in the group would pick up the money and put it in a little bag. Another was the Wild Indian group that did the Wild Indian dance. When I was eight, my mother got me my first Indian suit, mail order. The company's name was Walter Field, and they used to send catalogues to the Virgin Islands.

"Then I began to dance Wild Indian. She also made a purse to collect the money people would throw or give me. At that time, there were lots of sailors and marines, and I was youngest and they would give me some money."

In the mid-1950s, McIntosh formed his first scratch band, the Pond Bush Hot Shots, taking their name from their neighborhood, the Pond Bush section of Frederiksted. McIntosh played guitar in the Hot Shots and in the next group he organized, the Clefs.

In the 1960s, McIntosh was invited to join the island's leading quadrille band, the Joe Parris Hot Shots, as its lead alto saxophone player. He recorded three albums with Joe Parris in the 1970s, in which he performed as lead vocalist and saxophonist. After a stint with the influential scratch band Jamsie and the Happy Seven in the late 1970s, McIntosh went on to form his current group, Blinky and the Roadmasters, taking its name from his own daytime profession

with the St. Croix Department of Public Works. He worked for the department for 41 years, starting out as a laborer and progressing through the ranks to truck driver, heavy equipment operator, road crew boss, and director of roads and highways, a position he held until his retirement in December 1993.

McIntosh continues to play traditional Crucian music with the Roadmasters, performing regularly at quadrille dances, weddings, festivals, private parties, and nightclubs. He is the father of seven children and an avid sports fan. McIntosh is widely respected among island residents, especially other musicians, and is considered the authoritative source for information on older Crucian musicians. In recent years, he has decided to take classes to read music, and has expanded his repertoire to play with the community band.

"The music I play now is different from what old-timers used to play," he said. "I'm playing basically the same, but I'm playing it with an alto saxophone instead of a flute, and in my band, I have an electric guitar, an electric bass, a conga drum, a triangle, a scratch made from a gourd, and a full drum set with cymbals."

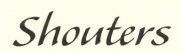

McIntosh County Shouters

AFRICAN AMERICAN SPIRITUAL AND SHOUT PERFORMERS

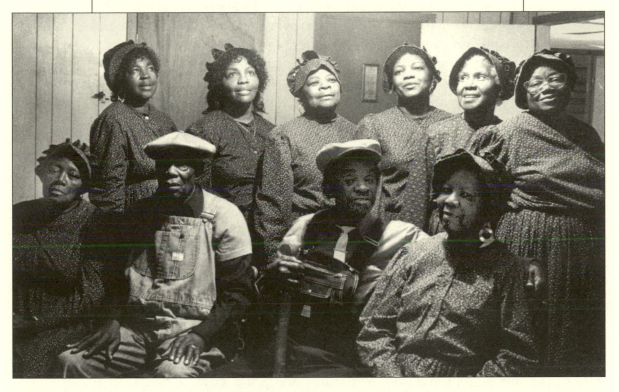

McIntosh County Shouters (Margo Newmark Rosenbaum)

THE McINTOSH COUNTY SHOUTERS ARE the principal, and one of the last, active practitioners of one of the most venerable African American song and movement traditions—the "shout," also known as the "ring shout." The ring shout, associated with burial rituals in West Africa, persisted among African slaves and was perpetuated after emancipation in African American communities, where the fundamental counterclockwise movement used in religious ceremonies integrated Christian themes expressed often in the form of spirituals. First written about by outside observers in 1845, and described during and after the Civil War, the shout was concentrated in coastal areas of South Carolina and Georgia.

The patriarch of the McIntosh County shouters is Lawrence Mc-Kiver, who was born in 1915 and grew up with the other members of the group in the rural area around Briar Patch, Georgia. In explaining the origins of the shout, he said, "in slavery times, the old folks couldn't talk to each other. They had to make signs . . . make the sounds we singing. That's why we sing in these old slavery sounds . . . they couldn't talk so they sang a song and they'd get together underneath the song that we're gonna sing."

McKiver is the group's lead singer or "songster," the one who starts, or "sets," a song before the shouters join in. He often improvises on the song's theme, and then ends the song at the right moment. Accompanying him is the "stickman" Benjamin Reed, born in 1931, who beats on the wooden floor with a thick hickory stick to control the rhythmic pace. "I can set 'em, and once they get it," Reed said, "I can turn 'em loose . . . and I can bring 'em back right where I want 'em." Other members clap their hands in an interlocking rhythmic pattern. Joining in the singing are the lead "baser," Doretha Skipper, born in 1926, who guides the shouters in the choral refrain; the shouters themselves; and possibly a third man who improvises solo on the text or joins in the refrain.

When the song hits its stride, the shouters, women dressed in head-rags of their grandmothers' day, begin to move counterclockwise in a ring. Religious rules prohibit the shouters from raising their feet high off the floor or crossing one foot over the other, so they move in the shuffling fashion characteristic of the "holy dance," often stooping over and moving their arms to pantomime the song in a fashion reminiscent of African custom. The songs are sung to many different melodies, their themes ranging from Biblical vignettes, to Biblical themes transmuted to speak of worldly conditions such as those under slavery, to contemporary topics, such as the scourge of drugs and the death of a fellow shouter.

Shouts were frequently planned to coincide with holidays and other special occasions. Elizabeth Temple, born in 1934, learned the

shout when she was a child, and recalled that "long time back . . . they used to have a shout at the church, Mt. Calvary Baptist Church, every Christmas, they would have a big shout. And we would follow them. I would follow my mother ever since I was seven, eight, up until now." McKiver also remembered the Christmas shout and added, "Christmas Eve . . . we'd start shouting from 10 [at night] until daylight, and then we'd go from house to house and shout until New Year's coming and be singing these sounds and drinking coffee and eating biscuits or cornbread—that's all we got to eat, or sweet potato."

The McIntosh County Shouters first began performing outside their community around the Mt. Calvary Baptist Church in Briar Patch in 1980, when they appeared at the Georgia Sea Islands Festival on St. Simons Island. Since then, McKiver said, "I resigned from my church choir . . . and I decided that I would teach the songs on the road, and that's what I've been doing." The McIntosh County Shouters have presented the shout at the National Black Arts Festival and elsewhere around the United States.

Wallace McRae

ANGLO-AMERICAN COWBOY POET

Born: 1936

Wallace McRae (Courtesy Wallace McRae)

WALLACE McRAE WAS BORN IN 1936, the son of a second-generation rancher from the Rosebud Creek area near Colstrip, in southeastern Montana. McRae's family ranch is bordered on the east by the Tongue River and lies just north of the Northern Cheyenne Indian Reservation. Both of his parents were born and raised on Rosebud Creek, and his family has raised sheep and cattle in this region since 1885.

McRae grew up working on his family's ranch and spent much of his time as a cowboy. He attended local schools and then enrolled in Montana State University, where he received a Bachelor of Science degree in zoology. In 1958, he was commissioned as a naval officer and served in the Atlantic and Mediterranean fleets. After the death of his father in 1960, he returned to Montana with his wife, Ruth Hayes, and took over the operations of his family ranch.

Growing up in Montana, McRae was fascinated by the records left by early settlers—diaries, letters, journals, and even such fripperies as new words to old tunes. They also left a distinctive style of poetry that recounted their exploratory adventures and the day-to-day life in their settlements. In this context, a tradition of public recitations arose, featuring narrative verse, often dramatic and sometimes comic. This "frontier" style, as it was called, was evident in the writing of Robert W. Service and was carried on in an oral tradition among working cowboys and ranchers.

McRae recalled that he recited his first poem, a "Christmas piece," delivered at the local one-room schoolhouse that his sisters attended, when he was four years old. Since then, McRae has written more than 100 poems, among them the enormously successful "Reincarnation," a poem destined to outlive him; it has already become part of oral tradition and is recited by cowboys around the country who have never met the author.

McRae has published three books of poetry: *It's Just Grass and Water, Up North and Down the Crick,* and *Things of Intrinsic Worth.* Like the tradition he honors, he has written not only on humorous and romantic topics but on matters of public concern as well, such as the need for environmental protection and the effects of strip mining in the West. Another group of poems, such as "A Conversation with Albert," deal with his Cheyenne neighbors. McCrae's work preserves the tradition of oral narrative poetry and infuses it with originality and unforgettable turns of language and inspiration.

Jim and Jesse McReynolds

ANGLO-AMERICAN BLUEGRASS MUSICIANS

Born: July 9, 1927 (Jim) and February 13, 1929 (Jesse)

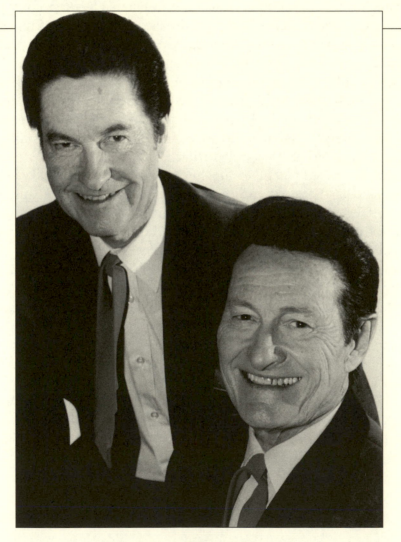

Jim and Jesse McReynolds (Larry Hill)

*J*IM AND JESSE MCREYNOLDS WERE RAISED in a family of coal miners and farmers who were also accomplished musicians. Jim was born July 9, 1927, and Jesse on February 13, 1929, in Coeburn, in the Clinch Mountains of southwestern Virginia. Their grandfather, Charles McReynolds, was a fiddler who headed a string band from the 1890s to the 1930s and recorded for RCA during the Bristol Sessions of 1927. Their father, Claude, also a fiddler, performed with his guitar- and banjo-playing brothers in their father's string band. Their mother, Savannah, played banjo and harmonica and sang ballads and gospel songs. She loved vocal harmony and taught it to her sons.

By the early 1940s, Jim and Jesse McReynolds were playing mandolin and guitar and singing together. After winning a talent contest, they began performing publicly. Upon Jim's return from military service in 1947, they performed on a noontime radio show in Norton, Virginia, as the McReynolds Brothers and the Cumberland Mountain Boys.

Most of the music they played as youngsters was "whatever we heard on the radio," Jesse said. Their musical versatility served them well. Like most Appalachian bands of the era, they roamed widely from one radio station to another throughout the Southeast, performing a variety of styles of music. Playing the Western songs of the Sons of the Pioneers helped forge the McReynolds's distinctive harmony sound.

In the early 1950s, Jesse developed a mandolin cross-picking technique that added a syncopated effect similar to that of Scruggs-style banjo playing. It was widely imitated by his peers. He also created an even more adventurous "split-string" technique in which the little finger frets only one of a double course of strings. Few players could duplicate this style. Later, he played a new instrument, a mandolobro, which was tuned like a mandola (C, G, D, A from bass to treble strings) with a resonator guitar body.

In 1952, the brothers signed a contract with Capitol Records and changed the name of their act to Jim & Jesse and the Virginia Boys. Their career was interrupted by Jesse's service in the Korean War era from 1952 to 1954. Their big break did not come until 1964, when they were invited to join the Grand Ole Opry in Nashville. This led to a lifelong career with the Opry. They issued recordings on their own labels, Old Dominion and Double J, and on other independent labels as well. They performed widely in the United States and abroad.

The brothers appeared on a nationally syndicated television show for several years through the mid-1970s, and they were inducted into the Bluegrass Hall of Fame in 1993. "We were just carrying on the tradition that our grandfather started when he recorded on the Bristol Sessions," Jesse McReynolds said. "We're still doing it after 50 years, and I guess that made an impression on someone somewhere."

Lanier Meaders

ANGLO-AMERICAN POTTER

Life dates: October 4, 1917–February 5, 1998

Lanier Meaders (John Burrison)

Q UILLIAN LANIER MEADERS WAS BORN on October 4, 1917, near
Cleveland, in northern Georgia. At one time, the area had been
among the most concentrated pottery centers in the state. Meaders's
grandfather John Milton Meaders started Meaders Pottery in 1892,
and all six of his sons learned the craft. But only Lanier's father,
Cheever, made it a lifelong profession. He produced churns, mo-
lasses and whiskey jugs, food-storage jars, milk pitchers, and other
utilitarian vessels. They were glazed with wood-ash or lime (alka-
line) glazes. Later, he produced face jugs, or "whimseys," which were
much in demand, though he didn't like them much.

Lanier Meaders helped his father run the shop but didn't become
a full-time potter until 1967, when he was 50, around the time a
Smithsonian crew arrived to document the work of Cheever Mead-
ers. They wanted his face jugs for the first Festival of American Folk-
life. When he became ill, Lanier stepped in and made enough of the
jugs to fill the order. They sold for $2.50 each and became a hit.
When his father died that year, Lanier took over the business. Later,
his face jugs sold for as much as $3,000 apiece. He is said to have cre-
ated more than 10,000 of them. All his life, he continued the alka-
line-glazed stoneware tradition of the area, working alone with a
foot-powered treadle wheel and a rectangular wood-fired "tunnel"
kiln.

The face jugs produced by Lanier underwent a considerable evo-
lution. The first ones featured blobs of clay representing eyes, nose,
and mouth applied to a jug wall. Later ones featured careful atten-
tion to facial details. He also worked to craft more functional vessels
such as churns used for pickling beans and sauerkraut.

Lanier continued to use his father's favorite "Shanghai" ash or
lime glazes, but modified them so they were easier to make. His ash
glaze consisted of Albany slip and regular stoneware clay (to replace
what his father had called "settlin's," a special silt dug from a dried-
up mill pond near his shop), as well as whiting (powdered calcium
carbonate instead of pulverized bottle glass) and sifted ashes from
the kiln fire box. Because these materials were readily available, it
wasn't necessary to grind them in the glaze mill, thus eliminating
what Lanier called "man-killing work."

Over the years Meaders worked to maintain the regional ceramic
tradition of his community of Mossy Creek, Georgia. He rarely
strayed from the strong earth-brown, olive-green, and rusty-gray
stoneware pieces that he had learned to make growing up. As he
grew older, he realized that the continuity of this tradition probably
would cease with his generation. "This place here will go when I go,"
he said. "This place will go with me 'cause they'll be nobody to carry
it on. And without it, what they can get here, they can't get anywhere
else."

John Henry Mealing & Cornelius Wright, Jr.

AFRICAN AMERICAN WORK SONG SINGERS

Born: 1911 (Mealing) and 1930 (Wright)

Cornelius Wright, Jr. (Ken Reynolds, Courtesy Alabama Center for Traditional Culture)

John Henry Mealing (Joyce Cauthen, Courtesy Alabama Center for Traditional Culture)

*J*OHN HENRY MEALING AND CORNELIUS WRIGHT, JR., both of Birmingham, Alabama, were callers on railroad section gangs, leading songs and chants to inspire the workers, known as gandy dancers, to perform their tasks with strength and precision.

Mealing was born in 1911. He went to work for the Western Railroad as a waterboy when he was 15. It wasn't long before he joined the section gang as a track laborer and caller. Being a caller was a prestigious position, especially for one so young. He recalls that many times his foreman would instruct him to drop his tools and take his turn at railroad calling with the order, "Come over here and talk your Latin!"

Cornelius Wright, Jr., was born in 1930. When he was 17, he began working as a track laborer for the Tennessee Coal and Iron Railroad Company, which later became U.S. Steel. Like his father, he developed a reputation as a good caller. He explained, "Now a good caller, he does it the same as a conductor of an orchestra. Before he would call, the men would begin to rap the bars. And this is to catch the rhythm, everybody gained momentum. Like that conductor, he stands there and listens for that sound. He's ready to wave his baton."

The workers had a rich repertoire of songs and chants used for their various tasks. These men, working in crews of 8 to 14, were responsible for laying and maintaining the tracks. The term "gandy dancer" apparently came from two sources: the Chicago-based Gandy Manufacturing Company, maker of railroad tools, and the dancelike movements of the men who worked with them. Songs were tailored to the task at hand: "lancing calls" to coordinate the dragging of 39-foot rails; slower, speechlike "dogging calls" to direct the lifting and laying of the steel rails; and more rhythmic songs for spiking the rails, tamping the bed of gravel beneath them, or aligning the rails with long iron crowbars. The lead singer or caller would relay the white foreman's instructions to his crew. His job was to uplift the workers, both physically and emotionally, to do their best work.

Mealing recalled an incident from his early days of calling in Birmingham when the crew was having trouble moving the track. "Those boys was tired and couldn't do no good," he said. "The foreman called me over and said, 'You go down there and talk your Latin.' I started to singing, and that track started to move . . . the fellows got uplifted. That's what the song was for, to make a man feel good." At times the songs also served another purpose, as a private language to convey messages that the white overseers would not understand.

Topics of songs could range from Bible verses and other religious matters to overtly sexual content. As Wright said, "If you really had to

move that track . . . some callers would talk about the lingerie that a woman wore. Now that caused the crew to really shift that track." The songs of gandy dancers were in the tradition of work songs used in the fields of the South during slavery. And like these field songs, the railroad songs are a close cousin to the blues.

By the 1960s, as machines replaced the section gangs, the tradition was dying out. Both men retired, Wright with the title of track foreman. After their retirement, Mealing and Wright devoted much of their time to keeping the tradition alive. In their everyday lives, at public festivals in the Deep South and through the public television film *Gandy Dancers,* they continued to teach younger generations and the general public the beauty of their very functional music.

In Wright's words, the gandy dancers "demonstrate that man, through songs and strength, [and] coordination was able to claim victory over seemingly insurmountable odds [moving railroad tracks] and tasks." These workers, he said, "were men of many talents and callings. They were musicians, preachers, athletes, actors, etc., who used all these skills simultaneously at times to achieve tasks that machines are called upon to do now. . . . Before the machine came man and men of vision and dreams."

Leif Melgaard

NORWEGIAN AMERICAN WOOD CARVER

Life dates: January 15, 1899–March 9, 1991

Leif Melgaard (Phil Nusbaum, Courtesy Minnesota State Arts Board)

*L*EIF MELGAARD WAS BORN JANUARY 15, 1899, in Sor-Fron, Gud-brandsdal, Norway, into a peasant family, and spent his childhood working on the homestead. With the encouragement of an uncle, a talented local wood carver, he began to carve as a child. Melgaard's father discouraged it as a waste of time. "He was a slave driver, my father was, so I didn't have much time for carving, only in the evenings," Melgaard said.

At age 17, he enrolled at the Craft School of the Museum of Industrial Arts at Dakka, Norway. The six-week course was his only formal training. It included two weeks of cabinetmaking and two weeks of carving under the tutelage of Lillevik, the master Gudbrandsdal carver of the time. Gudbrandsdal carving is a traditional Norwegian style that is elaborately improvised, imaginative, and technically very difficult. It centers on the acanthus leaf and vine motif and includes grotesque animals and other figures.

Melgaard came to the United States in 1920, assuming that he could continue his artistic training. But opportunities were limited. After several years in the farming region of western Minnesota, he settled in Minneapolis in 1926. There he found employment as a carpenter and cabinetmaker at the Lake Street Sash and Door Company. He remained there until his retirement in 1964. He continued carving at home and on occasion at work, when commissions involving ornamental carving were received. One of his best-known pieces done for the company is the altar at the Norwegian Lutheran Memorial Church. After his retirement Melgaard devoted all his time to carving.

He also took great pride in his work outside the traditional style. One such piece was a relief panel carved from mahogany in the 1940s and featuring an Italianate rococo design. "I was working with some Swiss and Germans, you know, and they were always talking about how clumsy Scandinavian wood carving was," he said. "I just wanted to show them."

Melgaard used a variety of materials, including birch, oak, mahogany, maple, apple, and buckthorn. He went to great lengths to find the right wood for particular objects. Several spoons and bowls, for instance, were made of wood he cut from a tree where the stump merges with the trunk so that the pieces would feature the contrasting textures.

On a visit to his homeland in 1980, Melgaard found a birch spoon he had begun carving before he emigrated. He took it back to Minneapolis and completed it. The spoon was later presented to King Olav V of Norway when he visited the United States. Melgaard was also proud of a small oval box with a dragon on its lid that he began in Norway and completed in America.

His carving has been displayed at Norwegian gatherings around the state, and several pieces were included in an exhibition at Vesterheim, the Norwegian American museum in Decorah, Iowa. Many students of the tradition say that Melgaard's work would be better known if he had been willing to sell and exhibit more, and they rate him equal or superior to the finest European carvers. Apparently it was difficult for him to overcome the widespread characterization of "whittling" as an idle activity and to recognize his own work as an art form. He was also reluctant to teach. "I don't have any workshop to teach in," he said. "And besides, they're always trying to learn my secrets."

D. L. Menard

Cajun Musician and Songwriter

Born: 1932

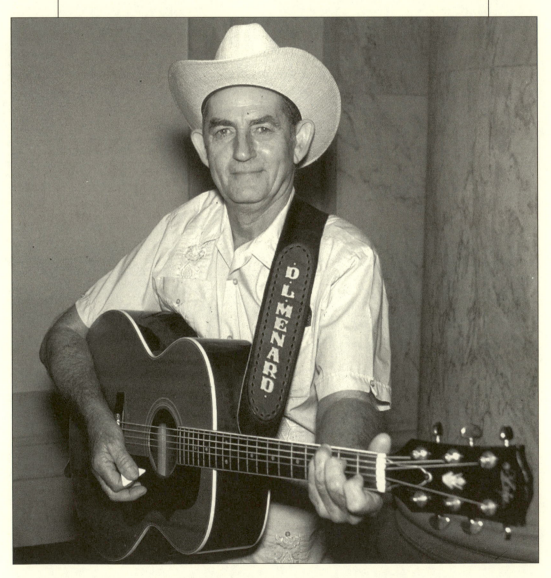

D.L. Menard (William K. Geiger, Courtesy National Endowment for the Arts)

D. L. Menard was born in 1932 outside of Erath, Louisiana, near the sugarcane farms and saltwater marshes of Vermilion Parish. His father was a popular harmonica player in the area, but he didn't sing or play very much at home. Growing up, Menard was a fan of Hank Williams and early country music. He says, "I first learned to sing by listening to an old battery-powered wooden radio that we had. Every night I turned it on to listen to Del Rio, Texas, and I learned those songs that I heard on the radio. The battery would die every year about a month or two before we sold the cotton. . . . That was the hardest time, without the radio. I didn't play the guitar yet, but that's where I learned all my first songs. And all those songs were in English. I couldn't hear any French songs on the radio."

When Menard was 16, his parents quit farming and moved into the town of Erath. There he heard his first live Cajun music and, he says, "fell immediately in love with the guitar" after hearing the guitarist in his Uncle Edwin's band. The guitarist agreed to teach him to play if he got his own instrument. Excited, Menard ordered a guitar for $11 from the Montgomery Ward catalog, and after the first week of lessons, he knew most of the chords he needed to perform. Within two months, Menard was ready for another guitar and bought one from the Sears Roebuck catalog. Shortly thereafter, he played his first dance job, accompanying Elias Badeaux and the Louisiana Aces.

At first, Menard specialized in singing English-language songs and left the Cajun ones to the more experienced singers. Soon enough he was not only applying his heartfelt voice to songs in French, but adding French words to instrumentals. Cajun French had been forbidden in school while Menard was growing up, and consequently he never paid as much attention to Cajun music as he might have otherwise.

With the Louisiana Aces, Menard learned the words to the songs his band was singing and listened to record albums of other Cajun musicians. Gradually, he started to compose his own lyrics in French, and in 1960 the band recorded his *"Vales de Jolly Roger"* for Swallow Records. The following year he composed *"La Porte d'en Arriere"* ("The Back Door"); he says that writing down the lyrics took him all afternoon. "The story just came to me all at once, but I was working in a service station at the time. I had to fix flats and pump gas and serve the people, so I was only able to get to the song between jobs. I knew exactly what I wanted to say, but I didn't have time to sit down and write it all out at once. Every little chance I had, I would get my notepad and write down what I could. I wrote the words in English because I don't know how to write in French, but the song was in French." Within a week of being recorded, the song

was a huge success with local listeners. Its popularity surprised everyone, including Menard.

"In those days," he said, "a [recording] session cost $175, which included 300 records, you understand, and you could sell them. *La Porte d'en Arriere*" came out on a Wednesday and by Saturday I had my $175 back already and some extra money to split among the guys in the band. . . . That night, we had to play it seven times on the bandstand."

"La Porte d'en Arriere" and many of his songs, such as *"Un Homme Marie"* and *"La Vie d'un Vieux Garcon,"* have become part of the standard traditional repertoire. In time, Menard quit his service station job to find a more flexible job. He learned to make rocking chairs from ash lumber and dry hardwood rounds, and opened a shop next to his house. His wife, Louella, weaves the seats. His rockers can now be found in homes throughout southwest Louisiana, and when he appears at festivals, he often demonstrates chairmaking when he's not playing music.

Nellie Star Boy Menard

NATIVE AMERICAN QUILTER
(LAKOTA SIOUX)

Born: 1910

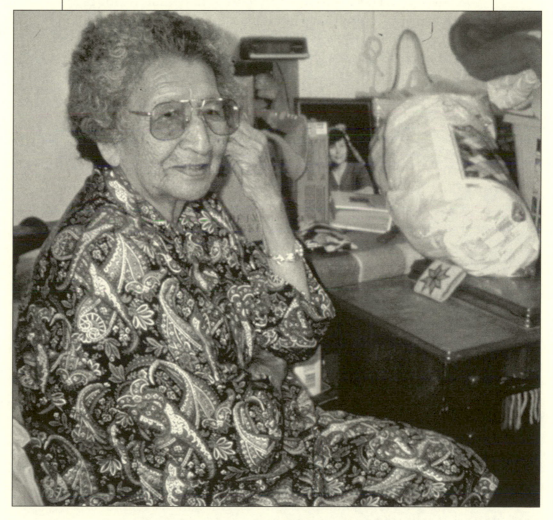

Nellie Star Boy Menard (Courtesy Michigan State University Museum)

NELLIE STAR BOY MENARD WAS BORN IN 1910 on the Rosebud Reservation of South Dakota. While still a teenager studying at Flandreau Indian School, she was awarded a Pendleton robe for the blanket design that she had submitted to Pendleton Woolen Mills in Pendleton, Oregon. After graduating in 1929, she was invited back to the school as a teacher of Indian arts.

Although Menard was never officially credited, she is widely known as the collector of most of the Sioux designs in the historic 1935 book *Quill and Beadwork of the Western Sioux* by Carrie Lyford. In 1937, Menard started the Arts and Crafts Shop in Rosebud out of a concern for the vitality of Lakota arts and for the economic well-being of Lakota artists. In 1941, she was one of four Indian representatives selected from across the nation as delegates to the Museum of Modern Art and the Museum of the American Indian in New York City.

Menard operated the Arts and Crafts Shop in Rosebud until 1942, when she moved to Browning, Montana, to manage Northern Plains Arts and Crafts. After World War II, she returned to South Dakota, where she was employed by the federal Bureau of Indian Affairs in Rapid City. She kept this position for the next 30 years, and attracted considerable attention for her mastery in quiltmaking.

Quiltmaking may be both the most widespread and the least known of Native American traditional arts. Although the full details of when and how Native Americans took up this European domestic art form are not known, it is clear that by the mid-nineteenth century quilting was fairly widespread among different Indian tribes. Churches and church schools of various Christian denominations, government Home Extension Service agents, the wives of resident Indian Service agents, and crafts training for economic development were undoubtedly important vehicles for introducing Anglo-American needlework skills to Native women. Over time, a variety of distinctive styles of quiltmaking emerged, each reflecting tribal, regional, or local preferences for design, color, and social function of the quilts. One of the most celebrated of these styles is that of the Sioux of the Northern Plains, distinguished by the prominent use of the star pattern as its basic motif.

In Sioux culture, an accomplished traditional quiltmaker is measured not only by a mastery of needlework techniques, of the creative use of the star motif, and of traditional aesthetic principles, but also by her dedication to the community in the practice of her art. Over her lifetime, Menard produced scores of quilts for such traditional family and community purposes as fundraisers for local organizations; gifts for weddings, baptisms, graduations, and funerals; and for honoring and naming ceremonies.

Her other artistic skills included featherwork, tanning, quillwork, beading, crochet, and the making of handwoven shawls. In addition, she worked as a manager of craft sales and as a curator, with the responsibility of purchasing items from other craftspeople for resale and for selecting objects for museum display. In this capacity, she was highly regarded, demonstrating a deep knowledge of Native American values and traditional artistic standards.

Lydia Mendoza

MEXICAN AMERICAN SINGER

Born: May 13, 1916

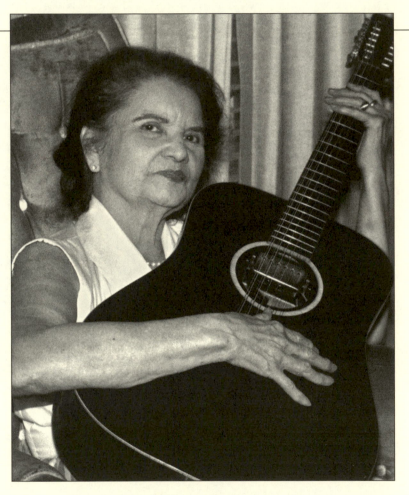

Lydia Mendoza (Alan Govenar)

*L*YDIA MENDOZA WAS BORN MAY 13, 1916, in Houston, Texas. Her father worked as a mechanic on the rail line that linked Laredo, Texas, with Monterrey, Nuevo León, Mexico. He was assigned to work both sides of the border and usually took his family with him. Lydia did not attend school as a young girl, but her mother, Leonor, taught the girls to read at home. Leonor Mendoza also enjoyed playing the guitar and singing, and Lydia took an interest in music at an early age. When she was seven, she began learning to play from her mother.

Once Lydia had learned to play guitar, she began teaching her sister Maria. Lydia also took up mandolin and violin. The Mendozas formed a family band and by the late 1920s were entertaining Mexican and Mexican American workers in restaurants and barbershops in Texas's Lower Rio Grande Valley. Lydia Mendoza recalled: "Dad would go in and ask permission to play, and then, if folks were there, we'd sit down and sing, and people would give us tips. And later on, when harvesting season came along, we'd go to the little town where the workers were, where there would be gatherings of Mexican people. We'd sing there and get some pocket money." Since the family did not own a car, they often hitchhiked from one community to the next.

In 1928, the family saw an announcement in *La Prensa,* a popular newspaper in South Texas, that the Okeh label was looking for singers to record. They borrowed a friend's car and made the trip to San Antonio, where Okeh Records recorded 10 of their songs. They received $140.

Shortly thereafter, the family moved to Detroit, where they worked as professional musicians for over a year. In Detroit they found receptive audiences among Mexican Americans who had migrated north to work in the automobile industry. In 1930, along with scores of other Mexican workers, the Mendoza family headed back south. They stopped in Houston, where they had family and friends. The family continued to entertain within the city's Mexican communities, notably at Magnolia Park, a subdivision a few miles east of Houston. The Mendozas moved to San Antonio in 1932, when Lydia was 16. It was in San Antonio that she began playing the *guitarra doble,* the 12-string guitar. Hers was not a standard 12-string, however. At her request, her father rearranged the strings so that the top four pairs were in alternating notes rather than in pairs of the same notes. This personalization of the instrument created a distinctive sound.

For two years, beginning around 1934, the Mendozas struggled to earn their living playing at San Antonio's open-air market, Plaza del Zacate. By this time Lydia was singing solo. After hearing her sing

with her family, Manuel J. Cortez, a local radio announcer, invited her to sing on his 30-minute program, *La Voz Latina.* She won the program's amateur competition. Her radio debut made her so popular that Cortez appealed to her family to allow her to be a regular on the radio. He secured a commercial sponsor willing to pay her $3.50 a week for her radio performances, and her parents agreed. Meanwhile, the family continued to sing in area restaurants.

In 1934, Lydia had her first solo recording session for Bluebird Records, an independent label. Her first record was *"Mal Hombre,"* whose lyrics she had learned from a chewing-gum wrapper. The record was so successful that Bluebird offered her a contract and continued to record her for the next 10 years. During the late 1930s and early 1940s, between recording sessions she toured with her family throughout the Southwest playing in parish halls and theaters to predominantly Mexican American audiences. By this time the family owned its own automobile, so touring was less of a strain.

Gasoline rationing during World War II made touring impossible, and recording stopped for several years as well. Lydia married Juan Alvardo, a cobbler, who supported her career. They had three daughters.

The Mendoza family resumed touring in 1947, and Lydia continued her recording career. After her mother died in the early 1950s, she began touring as a soloist, accompanied only by her 12-string guitar. She played with bare fingers, using thumb-brush and arpeggio styles.

Mendoza's husband died in 1961. The resulting depression severely affected her career. But her second husband, Fred Martinez, also a shoemaker, helped renew her spirits, and she resumed playing and performing. Despite arthritis in her hands, she continued to perform until the late 1980s, when a stroke left her partially paralyzed. In retirement, she lives with her husband in Houston.

Mendoza earned many honors in her long career, during which she became known as *"La Alondra de la Frontera"* (the meadowlark of the border) and *"La Cancionera de los Pobres"* (the songstress of the poor). In 1971, she performed at the American Folklife Festival in Montreal, Canada; in 1978, she performed for President Jimmy Carter at the John F. Kennedy Center in Washington. She was inducted into the Tejano Music Hall of Fame in 1984 and into the Conjunto Music Hall of Fame in 1991.

Elmer Miller

ANGLO-AMERICAN BIT AND SPUR MAKER AND SILVERSMITH

Life dates: February 25, 1914–October 10, 1992

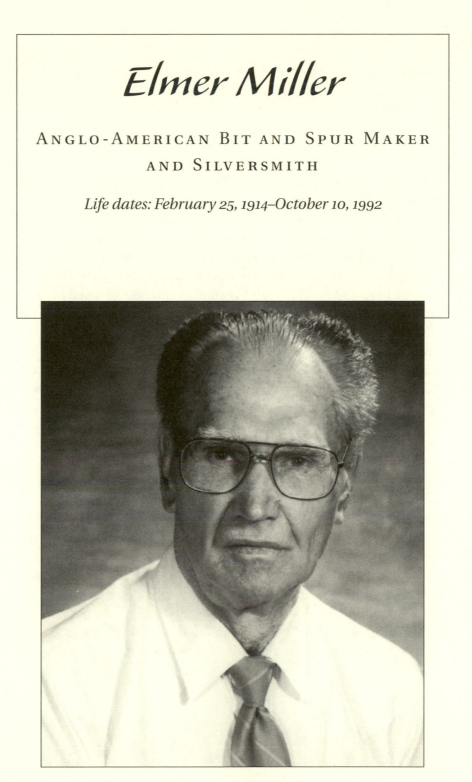

Elmer Miller (Ray Pickthorn)

ELMER MILLER WAS BORN FEBRUARY 25, 1914, and reared on a cattle ranch in Nevada's Paradise Valley. He first learned about horses and those who rode them through direct observation. After learning basic blacksmithing skills, he began making bits and spurs, essential cowboy equipment. While learning the trade, he moved to San Francisco and associated himself with an older and highly skilled Mexican bit maker, Filo Gutiérrez. By 1950, Miller was back in Paradise Valley, ranching and silversmithing.

In 1963, Miller set up shop in Nampa, Idaho. His shop became a famous source of the highest-quality spurs and bits, belt buckle sets, bolo ties, and other functional and decorative items associated with cowboying. He became known worldwide. In the mid-1980s, his concern for tradition led Miller to establish a school to teach his arts. It attracted students from as far away as Australia. He died before the 1993 National Heritage Fellowship could be awarded.

Miller's spurs were featured in at least two major catalogs and exhibitions, "We Came to Where We Were Supposed To Be: Folk Art of Idaho" and "Buckaroos in Paradise: Cowboy Life in Northern Nevada," at the American Folklife Center of the Library of Congress. He was an invited artist at the Coconino Center for the Arts festival and exhibit "Trappings of the American West," in Flagstaff, Arizona. In 1985, a pair of his spurs was featured in the Idaho Commission on the Arts exhibit that toured Idaho and Morocco. In 1989, he was inducted into the Buckaroo Hall of Fame in Winnemucca, Nevada.

Miller said of his work: "The selection of the metals that go into the bit—iron for the mouthpiece, steel for the cheeks and pure copper and brass for the rollers and braces—needs to be properly understood to provide a bit that will keep the mouth moist and tender. From the formation of the mouthpiece iron to the engraving of the silver, inlaid in the blued-steel cheeks, my designs go back to the early California bit makers—designs that have been tested by 150 years of use on the finest bridle horses in the world."

Art Moilanen

FINNISH AMERICAN ACCORDIONIST

Born: December 21, 1916

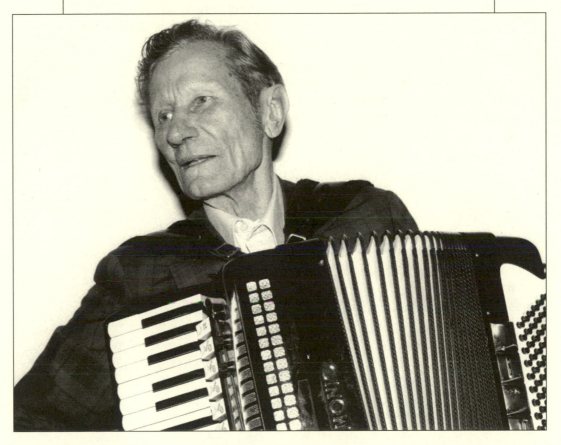

Art Moilanen, 1990 (Alan Govenar)

445

ART MOILANEN WAS BORN DECEMBER 21, 1916, in Mass City in Michigan's Upper Peninsula. His parents came from northern Finland early in the twentieth century as part of the enormous migration of more than 300,000 Finns to the mines, mills, and factories of the United States. More than half moved to the western Great Lakes region, settling particularly in Minnesota's Mesabi Iron Range and the Michigan "Copper Country." Life in these communities was difficult, and in July 1913, the Western Federation of Miners called a strike for a shorter work day and higher wages against Upper Michigan's mining companies. Although supported strongly by the local Finnish migrants, the strike was bitter, violent, and largely unsuccessful. At its close, the Moilanens, along with many other Finnish families, moved to the area near Mass City, where they took up farming and logging. It was there that Art Moilanen grew up.

Moilanen worked with his father on the family farm and as a logger in the woods. As a boy he played the harmonica, and then he became interested in the button accordion, and later the piano accordion. From early recordings, he learned Finnish tunes and augmented his repertoire by listening to the singing of the lumberjacks and miners, and to the musicians who played in the small dance halls near where he lived. By his teens, Moilanen was performing at local dances, and after serving in the Air Force during World War II, he returned to Michigan to form his own logging company and continued to play music in his spare time.

In 1965, he retired from logging and bought a tavern near Mass City, where, he said, there was "dancing three, four nights a week, sometimes all day and night long—it was packed all the time." At age 60, Moilanen retired again, and purchased Art's Bar in Mass City, with an adjacent motel catering to hunters and maintenance crews. Though he was successful, Moilanen sold these properties in the late 1980s, when he decided for a third time to try to retire and devote more time to his music.

Throughout the 1990s, Moilanen played regularly for dances in and around Mass City. He became renowned for his comic songs that hark back to Finnish humorous couplets but combine a range of styles, even country and western. Overall, Moilanen's music reflects the stages and changes in the traditional Finnish repertoire from nonstanzaic epic songs and ballads to romantic waltzes. In the 1870s, Italian musicians had introduced the diatonic accordion to Finland, and in the 1920s and 1930s, the piano accordion invigorated the tradition through live performances, most notably by an earlier Michigan accordion virtuoso, Viola Turpenan.

"It's rather unusual, how I learned to read music," Moilanen said. "Reading a country-western magazine story, and they had an ad in

there about 'learn to read music,' and it showed the A, B, C, D, E, F, G, the notes, the scale. And I cut that out and I took it downstairs to where the organ was, and I picked out a song that I knew in the hymnbook, figured out. 'So, that's why they write these things out.' So, you had to learn on your own, and just by listening and . . . when we got an accordion in the house, well, I started on that, and stayed with it."

Mick Moloney

IRISH AMERICAN MUSICIAN

Born: November 15, 1944

Mick Moloney (Tom Pich)

MICK MOLONEY WAS BORN NOVEMBER 15, 1944, in Limerick, Ireland. He began playing tenor banjo at 16 years of age. As a teenager he listened to American folksingers and especially enjoyed the music of the Weavers and Burl Ives. He remembers that there was not a lot of traditional instrumental music being played where he lived. As he got older, he used to go to neighboring Ennis, just over the River Shannon in County Clare, to listen to music in the pubs. He tape-recorded the tunes so he could "bring them home" with him to learn them.

Growing up, he learned to sing traditional songs and to play guitar as well as mandolin and tenor banjo. During his formative years in Ireland, he played with the Emmet Folk Group, and later the Johnstons. His participation with those bands shaped his perspective on and honed his skills in Irish music. He spent five years touring and recording with the Johnstons.

Moloney came to the United States in 1973 to pursue graduate studies in folklore at the University of Pennsylvania in Philadelphia, where he later earned a doctorate. Since then, he has devoted much of his time to the documentation and presentation of traditional Irish music and musicians.

Moloney has been a driving force in Irish music in the United States. Much of the national exposure received by traditional Irish musicians, such as Martin Mulvihill, Donny Golden, and Jack Coen—all National Heritage Fellows—is the result of Moloney's work as mentor, producer, performer, and scholar. By recognizing and recording skilled musicians, he was highly influential in bringing Irish music out of pubs and parlors and placing it on stages and in concert halls. In 1977, Moloney cofounded the Irish music group Green Fields of America.

Over the years, Moloney has taught Irish music and culture at universities around the country and conducted annual tours to Ireland to expose the general public to Irish folk culture. He has made numerous recordings in partnership with other Irish musicians, including Derry fiddler Eugene O'Donnell, button accordionist James Keane, and singer-guitarist Robbie O'Connell. To date, Moloney has released three solo albums.

Bill Monroe

ANGLO-AMERICAN BLUEGRASS
MANDOLIN PLAYER AND BANDLEADER

Life dates: September 13, 1911–September 9, 1996

Bill Monroe (Courtesy Smithsonian Institution)

BILL MONROE WAS BORN NEAR ROSINE, Kentucky, on September 13, 1911. He was the youngest of eight children. His father, James Buchanan Monroe, was of Scots ancestry and possibly a descendant of James Monroe, fifth president of the United States. James B. Monroe farmed, cut and hauled timber, operated a sawmill, and mined coal on his 600-acre farm. He did not sing or play music, but Bill Monroe recalled that his father was a fine dancer who enjoyed doing a local dance called the Kentucky backstep. His mother, Melissa Vanderver Monroe, sang and played the fiddle, harmonica, and accordion. Her brother Pendleton Vanderver was a fiddler of considerable talent and local renown who taught Bill the essentials of the mandolin, fiddle, and guitar.

James and Melissa Monroe died within a year of each other, and from age 11 Bill was raised by his Uncle Pen, whose name later became the title of one of Monroe's most popular songs. Bill often played guitar at local dances while his uncle fiddled.

Another strong influence was Arnold Schultz, a black fiddler and guitarist. Monroe said Schultz played fiddle in a bluesy, syncopated style, getting sounds out of the instrument not commonly heard in country playing. Bill often accompanied Schultz on guitar as well. The young musician also heard black workers whistle and sing while they toiled.

When Bill was 16, he joined his brothers Charlie and Birch in a musical group. They settled in Hammond, Indiana, in 1930 and performed on radio shows in the area for several years. When Birch Monroe left the group in 1934, Bill and Charlie continued as the Monroe Brothers, performing on radio and gaining considerable polish. They first recorded for Victor's Bluebird label in 1936. Their offstage relationship was tumultuous, and in 1938 they split up the act. Charlie Monroe formed the Kentucky Pardners, which became quite successful. Bill Monroe formed the Blue Grass Boys. The following year, he joined the Grand Ole Opry.

Monroe's music continued to evolve toward what eventually became bluegrass. In 1945, he signed with Columbia Records and recorded the first version of "Kentucky Waltz," one of his signature tunes. The bluegrass sound came together in 1946 when the band included Earl Scruggs on banjo, Lester Flatt on guitar, Chubby Wise on fiddle, and Howard Watts on bass. Scruggs's three-finger picking style became an essential ingredient of the music, which drew on such diverse sources as the blues and old-time fiddle tunes. It featured Monroe's singing in a style he called "high lonesome."

Flatt and Scruggs left the band to start their own group in 1948. In 1949, Monroe left Columbia because it had begun recording the Stanley Brothers, a group he believed was imitating his music. Mon-

roe signed with Decca, which later was absorbed by MCA. Over the years, a number of talented musicians passed through the Blue Grass Boys, and the group toured and recorded extensively at home and abroad. In 1963, the band began playing college campuses. It also became popular at the bluegrass festivals that began springing up, and in 1967 Monroe established his own festival at Bean Blossom, Indiana, and it became the most popular bluegrass event.

In 1970, Monroe was elected to the Country Music Hall of Fame. In his later years, the fiery, competitive musician mellowed considerably. In 1986, he recorded the album *Bill Monroe and Stars of the Bluegrass Hall of Fame,* which included Ralph Stanley of the Stanley Brothers, Jim and Jesse McReynolds, Mac Wiseman, Carl Story, and the Washington, D.C., group the Country Gentlemen.

Allison "Tootie" Montana

African American Mardi Gras Indian Chief and Costume Maker

Born: December 16, 1922

Allison "Tootie" Montana (Kathy Anderson, Courtesy The New Orleans Times-Picayune)

ALLISON "TOOTIE" MONTANA WAS BORN December 16, 1922, in New Orleans, Louisiana. His father, Alfred Montana, was a baker. He served as Big Chief of the Yellow Pocahontas Mardi Gras Indian tribe from the 1920s until 1941, when World War II forced the cancellation of the carnival. After the war, Tootie began masking with the Eighth Ward Hunters, and in 1947 he became Big Chief of the Monogram Hunters, a tribe he founded with some friends. In 1956, Montana married Joyce Francis, who never masked herself, but who has helped Tootie make his costumes, which might cost several hundred, and even thousands, of dollars to make.

In the late 1950s, Tootie returned to his position as Big Chief of the Yellow Pocahontas, which he held until 1998, when his son, Darryl Montana, replaced him. The next year, Tootie made a new Indian suit and masked as the Executive Counsel of the Yellow Pocahontas. For most of his adult life, he worked as a lather, building frames for plaster structures, made first of wood and then metal. Over the years, in his spare time, he has devoted himself to perpetuating the Mardi Gras Indian tradition. His individual artistry is recognized by all; he is a gifted costume designer, a brilliant dancer and song leader, and an eloquent artistic director of his group.

Montana traces his tradition back to 1880, when his great-uncle, Chief Becate, founded the Yellow Pocahontas tribe; it is believed he was part African American and part American Indian. The organization of the tribal parade reflects a humorous and fantasy-filled interplay between two cultures, bringing together an African cultural style with Indian motifs. The various chiefs, representing different tribal groups, march in the rear followed by a large group of supporters not in costume and referred to as the "second line." Ahead of them runs the "Spyboy," a costumed scout who moves down the center of the street a block or two ahead and sends back signals to "Flagboy," a bearer of the tribal banner, who in turn relays signals announcing "trouble" or "all clear" to the chiefs.

In earlier times, the tribes were often known as gangs, and there used to be physical trouble—even bloodshed—when two tribes met; in recent years, Montana said, "they try to outdress one another." Costumery, songs, and dancing are planned, prepared, and practiced for months before Mardi Gras Day, and thus the black neighborhoods of New Orleans gather in collective aesthetic Sunday rehearsals, held after church obligations have been met, for three or four hours of intensive dance and musical practice.

On Mardi Gras Day, numerous Black Indian tribes debut their new costumes. Hundreds of people parade through the streets accompanied by tambourines and drums, singing in call-and-response style, following groups of black men who are fantastically arrayed in cos-

tumes of thousands of hand-sewn beads, plumes, feathers, and rhinestones.

The ancestors of today's Black Indians were Native Americans of the southeastern United States and African slaves who met in places like the New Orleans French Market. These groups interacted while buying and selling spices, foods, and other goods, and over time developed social networks. The Mardi Gras Indian tribes of New Orleans embody a melding of Native American, Afro-Caribbean, and Afro-American culture. They have retained distinct cultural identities amid the urban environment of New Orleans.

In addition to traditional dress, dance, and music, performance is an integral part of their cultural expression. Contemporary costumes represent African and Native American influences, as well as elements of American popular culture. The Black Indians appear in their elaborate costumes traditionally only twice a year: on Mardi Gras Day and on the Feast of St. Joseph, three weeks later. In recent years, however, many tribes have also appeared at the Jazz and Heritage festival in April and on a special parade day, called Super Sunday, in May.

Alexander H. Moore, Sr.

AFRICAN AMERICAN BLUES PIANIST

Life dates: November 22, 1899–January 20, 1989

Alex Moore, Sr., 1987 (Alan Govenar)

*A*LEXANDER H. MOORE WAS BORN November 22, 1899, in Dallas, Texas. When he was three years of age, the family moved to El Paso. They returned to Dallas three years later, again following a job opportunity for his father, a professional candy maker. Although the Moore family didn't have a piano, Alex recalled there was "an old piece of piano in every shack and alley." He developed an interest in piano as a young boy watching others who played for fun, and occasional tips, in chockhouses. "Chock" was a home-brewed alcoholic beverage; chockhouses were usually in someone's home or in the back of a store. At chockhouses, local and itinerant musicians often took turns playing the piano while patrons drank, danced, and sometimes sang.

The first person Moore heard play piano was a cousin. He remembered that she played piano while he played marbles. "They danced and sang, doin' the belly rub," he said, "while she just played the piano." Moore had a vivid memory and liked to recount the piano players who were his contemporaries and who had preceded him, including Mary Wright, Blind Bennie, The Allen Family, "Squatlow" Washington, the Maloney brothers, and Lovie Bookman. The music they played was a mixture of ragtime and blues.

Moore taught himself how to play by watching others, though he said he learned the notes on the piano when he was a boy. "I was delivering groceries to white folks' houses," he recalled. "Well, they had pianos too. I'd always hit one note, and then sometime when I was in my teens, 15, 16, 17, 18, that's when I would try to play. Some of them people didn't care if I fooled around on that piano."

As a boy, he also learned how to play the harmonica and was an avid tap dancer and whistler. He never learned how to read music; he practiced wherever he could. Sometimes he accompanied himself singing, improvising the lyrics as he went along, augmenting the tune with long whistling interludes. In 1915 he played on the WRR radio station in Dallas. He continued to play at social gathering places all over Dallas, in chocks, "joints," and restaurants and bars.

By the time he recorded for the first time for the Columbia label in 1929, he had earned the nickname "Whistlin' Alex Moore." Columbia scouts brought Moore to Chicago, where he recorded six sides, including "Blue Bloomer Blues," "Ice Pick Blues," and "West Texas Woman."

As much as he enjoyed playing the piano, Moore never considered himself a full-time musician. He worked nonmusical jobs to earn his living until his retirement in 1965. During the course of his adult life, he worked hauling gravel, driving mule teams, washing dishes at a packinghouse and a hospital, as a porter at hotels, and as a custodian at office buildings. After working all day at one of these jobs,

Moore would play piano gigs, performing a "one-nighter" or a year-long engagement.

Moore recorded four songs for the Decca label in 1937, and accompanied "Blind Norrie" McHenry on two others. The latter piece was "Katy Blues," a song Moore composed for McHenry for that recording session. In 1947, he recorded at the KLIF studio in Dallas, although only two sides from this session were ever issued. In 1951, he made four titles for RPM Records, and in the 1960s he recorded two albums for the Arhoolie label that featured original new material as well as remakes of tunes from the 1920s and 1930s. Moore continued to perform in the 1970s and 1980s, traveling to festivals in Texas and around the country.

Vanessa Paukeigope Morgan

Native American Regalia Maker
(Kiowa)

Born: October 5, 1952

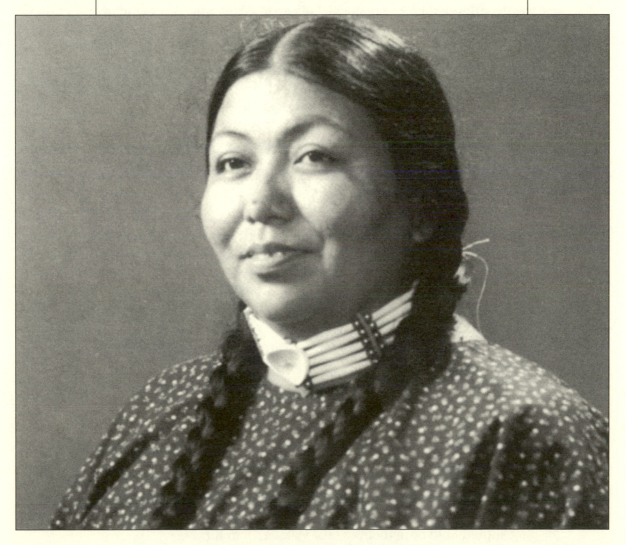

Vanessa Paukeigope Morgan (Manley Settle)

459

VANESSA PAUKEIGOPE MORGAN WAS BORN October 5, 1952, in the Gila River Indian community near Tempe, Arizona, the daughter of Clifford Santos of the Gila River Pima Tribe and LaQuinta Mopope, a Kiowa. She spent most of her childhood with her grandparents, and at age 11, she began learning Kiowa artistic techniques from her grandmother, Jeanette Berry Mopope. "Beadworking was never separate from daily life for me. My grandmother beaded every day and my grandfather [Stephen Mopope] painted every day. It was just something that they did. 'Watch me. . . ,'" she remembered her grandmother saying, "'pay attention . . . know why you are doing things a certain way . . . I won't be here forever!'"

Morgan listened intently to her grandmother and learned all she could from her and from other tribal elders. Later, she read historical reports and examined archival photographs, museum pieces, and any cultural materials she was able to find.

She attended high school and college in Oklahoma. After graduation she started working with the Bureau of Indian Affairs and settled on the allotment land granted to her grandmother in the Red Stone area between Fort Cobb and Anadarko, Oklahoma, deep in the Kiowa territory. On this property, Morgan and her husband built an earth lodge, which she uses as a studio and makes available to tribal members for cultural activities. Given its spiritual significance, she feels it provides an environment that is especially conducive to the needs of tribal elders and to discussions of historical and cultural issues. "A Kiowa woman shows the status of her husband by the way she keeps camp and the way she dresses her family," Morgan said.

Over the years, Morgan has participated in numerous special exhibitions and has been commissioned by the Kiowa tribal leaders to make ceremonial regalia for important ritual occasions, but she has often had to work other jobs in Anadarko so that she can afford to bead tribal regalia for her own clan. In a brief statement about her work, she once said, "My work is traditional Kiowa work. . . . It frightens me that our Kiowa heritage that was so powerful and beautiful has almost disappeared. It is more important that I continue my traditional work than to take artistic liberties at this time."

Morgan continues to work actively in her tribal community and is a willing teacher to serious students. She is known outside her tribe for making what otherwise might not be found: Kiowa saddles, fur quivers, dolls, and the elaborate buckskin dresses of the Plains tribes. "As Kiowa people we loved our parents and grandparents," she said. "Because of this love, we buried our elders in their best old finery with honor and dignity. We did not, and we should not have kept their beautiful clothes to hand down to our families. However, we should hold onto their ways of making them Kiowa."

Genevieve Mougin

LEBANESE AMERICAN LACE MAKER

Born: May 5, 1911

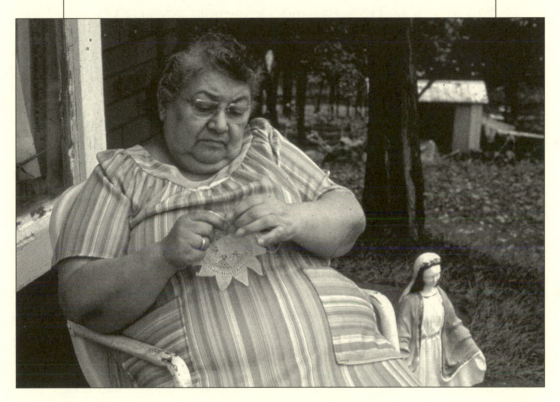

Genevieve Mougin (Steve Ohrn)

GENEVIEVE MOUGIN WAS BORN MAY 5, 1911, in Kewannee, Illinois. Her father, Hassan Nahra, had immigrated to the United States in 1905, but later went back to Lebanon to get married. When he returned to America, he settled first in Illinois, then in 1921 moved to Iowa, where he operated an eight-acre truck farm north of Davenport.

At home, the family spoke Lebanese and the 11 children were brought up with Lebanese traditions. The boys and girls received different training. "The boys were with their dad," Mougin recalled, "the girls stayed with their mom." At the age of seven, Mougin learned to do needlework. Later, her mother taught her how to make lace using a sewing needle and fine linen thread, a craft known throughout the Middle East and called Phoenician, Syrian, Armenian, Arabian, or simply knotted lace. Each piece begins with a center ring of 20 stitches and works in concentric designs, each stitch forming a single knot, knot upon knot. Older pieces were made with number 150 thread, which is no longer available.

Mougin never used pattern books or printed material; her designs, she said, "come straight from my head." And for this reason, every one of her pieces—like a spider web—was different from every other. She never named her designs or stitches, and it was usually difficult for her to carry on a conversation about her work because she "simply did it."

Throughout her life, Mougin worked different full-time jobs to help support her family, first as a tailor for 26 years, then in a Detroit defense plant during World War II, and for 26 years on the assembly line of the Bendix factory soldering tiny parts for guided missiles. She did her needlework in the evenings and in her spare time on weekends until she retired in 1973.

In her later years, she said that her time spent with lace was "just something to do with my old age." Her most ambitious piece, a 48-inch drum tablecloth, took her 28 months to complete, and even an 8-inch doily or snowflake required as many as 40 hours.

Mougin needed to wear two pairs of glasses because of the delicacy of her work. Although she might have been able to sell her wares, she preferred to pass her work along to her nieces, nephews, and other close relatives. She never had children of her own, and tried to hand down the tradition to the next generation. "I tried to teach my nieces," she said, "they won't go for it."

Bua Xou Mua

ASIAN AMERICAN MUSICIAN AND SPIRITUAL LEADER (HMONG)

Born: 1915

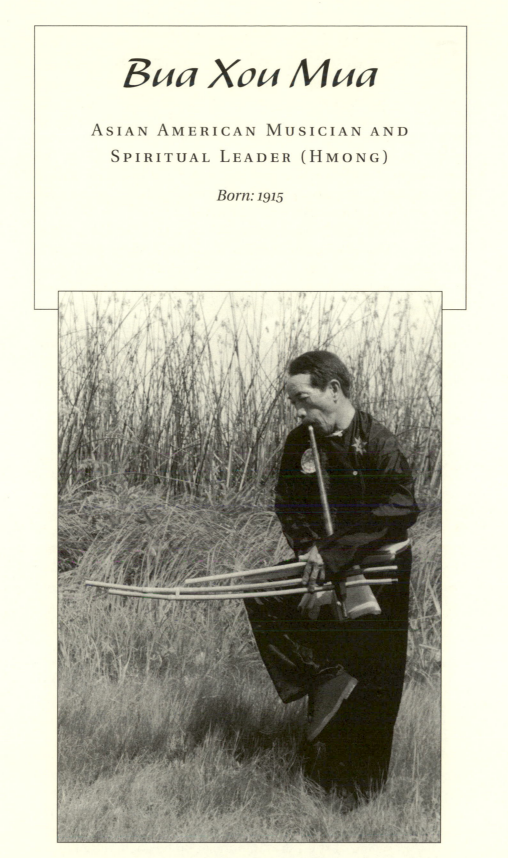

Bua Xou Mua, 1991 (Alan Govenar)

Bua Xou Mua was born in 1915 in Ban Whoi Na, a village in northeastern Laos where his family had lived for generations. When he was 15, he began studying the oral texts of his people, the Hmong, with an uncle. The uncle also taught him to play the *gaeng* bamboo mouth organ, which is unique to Hmong culture. It consists of six curved bamboo pipes inserted into a wooden wind chest. The instrument is used to accompany both funeral texts and New Year's song and dance. Bua also learned the traditional courtship and wedding songs and shamanistic healing rituals.

He learned to recite from memory the story of his people's migration from China to Vietnam and Laos and their resistance to Chinese oppression. This includes the tale of his own extended family, which numbers 150 families and has been traced to a common ancestor who came to Laos in 1800, six generations ago, after a Hmong uprising in Yunnan. The Hmong had no written language until the 1950s. Some of their history was recorded in Chinese characters, but history was transmitted primarily in an oral tradition by highly respected figures such as Bua. He raised a large family and became known throughout the area as a legal and religious practitioner. In 1960, he became chief of his clan of about 400 people.

In the 1960s, Bua and two of his sons were recruited into the U.S. Central Intelligence Agency's secret war against the communist Pathet Lao. Casualties were heavy among Hmong soldiers, and Bua was wounded twice. After the United States pulled out in 1973, Bua, his wife, and two of their children began attempting to flee their homeland to avoid communist reprisals. Bua feared for his life. In 1976, they walked across the mountains. During the 10-day journey they ran out of rice and were robbed of money and jewelry before reaching the Thai border. They spent two years in a refugee camp with other Hmong people.

In 1978, the family immigrated to the United States and settled in Portland, Oregon. They faced hardship and discrimination in their new home. Bua's daughter was assaulted, and he got into a fight with a neighbor. But Bua worked hard to maintain his cultural traditions. In 1980, he sang and danced in a public concert involving Asian refugees in the Portland area. He received an enthusiastic response. Later, he participated in an apprenticeship program.

In addition to working with young Hmong, Bua assumed the responsibility of explaining the unfamiliar ways of Southeast Asia to the schoolchildren of Portland. He has stepped forward to present Hmong music and dance in neighborhoods where otherwise the arts of his people would never be known. Though he enters the classroom saying, "I shy. I shy. Pronunciation no good," children respond to the depth and passion of Hmong poetry:

I, the only child, have no relative.
The sky will darken.
I, the only child, will go with the wild spirits
To embrace a drowsiness.
The sky will dim.
I, the orphan child, will go with the ghosts
To embrace a sleep.

Martin Mulvihill

IRISH AMERICAN FIDDLER

Life dates: 1923–July 23, 1987

Martin Mulvihill (Jesse Winch)

MARTIN MULVIHILL WAS BORN IN 1923 in Ballygoughlin, County Limerick, Ireland. His mother, Brigid Flynn, played the concertina and fiddle, and his first instruction came from her when he was about eight years old. Later, he learned the rudiments of reading and writing music from a local teacher, Tom O'Reilly, who "was more of a classical player," but his mother's style remained his primary influence.

By the time Mulvihill was 10 years of age, he had become an accomplished traditional fiddler. In the 1930s traditional music flourished in the Kerry–Cork–Limerick border lowlands, and the young Mulvihill picked up tunes and instrumental techniques from local musicians at weddings, parties, and dances. In time, Mulvihill added piano and button accordion to his instrumental skills.

He joined the Irish Army in 1940, when he was 17 years old, and after his discharge, he played piano accordion with Meade's Dance Band in Glin, Ireland. In 1951, he moved to Northampton, England, where he met and soon married Olive McEvoy. Together, they had four children, all of whom Mulvihill taught to play musical instruments.

In 1971, Mulvihill and his family immigrated to New York City, where he began teaching Irish music to a few Bronx neighborhood children. His versatility and superb traditional repertoire soon attracted so many students that he was able to quit his regular job and teach full-time. For Mulvihill, that meant working seven days a week, commuting to Irish communities in Brooklyn, New Jersey, Connecticut, and Pennsylvania, while still maintaining the original Martin Mulvihill School in the Bronx, where he taught children from 6 to 18 years old the basics of music notation and the traditional Irish instruments: fiddle, tin whistle, drums, piano, and button and piano accordion. Over the years, his reputation steadily grew and hundreds of his pupils have achieved remarkable success in competitions and festivals in both the United States and Ireland.

Throughout his life, Mulvihill continued to learn new tunes on frequent trips to his homeland, but nonetheless retained the traditional purity he was taught as a boy. He used the long bowing technique, common to southern Ireland, playing rolls rather than triplets, holding to the long, elegant lines of the old melodies, and adding subtle variations in timing, phrasing, or intonation to provide a "lilt" to the music.

Mulvihill recorded for the Green Linnett Record Company and Global Village of New York in the 1970s and early 1980s. He was often joined in performance by his four children: Dawn on fiddle and tin whistle, Gail on tenor banjo, Brian on drums, and Brendan on fiddle. Brendan Mulvihill has become a noted performer and recording artist in his own right, carrying on the folk violin tradition that began with his grandmother.

Mabel E. Murphy

ANGLO-AMERICAN QUILTER

Born: 1907

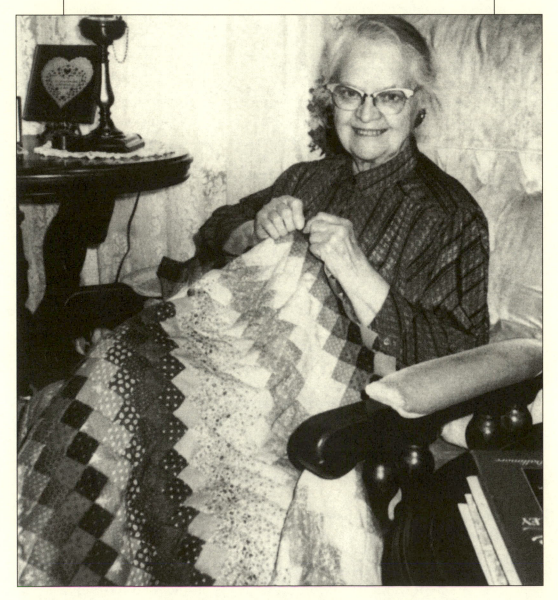

Mabel E. Murphy (Jerry Baumeister)

*M*ABEL MURPHY WAS BORN IN 1907 in Callaway County, in the agricultural heartland of Missouri. She began school at age six in a one-room schoolhouse that served children in the area from first through eighth grades. When she was eight years old, she pieced her first quilt top—a Four Patch pattern, the standard design usually taught to children in those days. Following instructions from her mother, Murphy set the blocks, each four squares of freely selected variegated material, into a checkerboard pattern, stitching them together with nine stitches to the inch. When all the blocks of four had been joined into a single large square, Murphy's mother and a neighbor helped her to quilt the completed top.

From then on, Murphy made quilting an integral part of her daily life—through her years in school and later as homemaker, mother, and a public-spirited citizen of her community. She made more than 100 quilts, all in the same basic style. After deciding on the general idea of the quilt she wanted to make, she selected the design and the materials needed, and then started the process of piecing the quilt together. When that was completed, she usually called in her neighbors and friends to help with the lengthy job of quilting. Each finished quilt is a kind of map of the social relationships that created it, between the individual artist and the supporting family or community.

Murphy taught hundreds of women to quilt, and opened her home every Thursday and Friday morning to quilting circles for many years. She never received any compensation for her services or advice, nor did she ever sell one of her completed quilts. She said she made them to give away to her children and grandchildren. Each received a quilt upon graduation from college. When the boys in the family turned 21, she gave each of them a Bow Tie quilt to signify their attainment of manhood. Each also received two matching quilts upon his or her wedding day.

Murphy's Thursday morning quilting group made numerous quilts as donations for community causes; some were used in fundraising auctions for the local hospital or colleges. Murphy's neighbors supported and encouraged her work. To show their appreciation, they organized a local exhibition, entitled "A Lifetime of Love," featuring 41 of her most cherished quilts. In explaining her motivations for spending so much of her time quilting, Murphy said, " I just don't like to sit and hold my hands."

John Naka

ASIAN AMERICAN BONSAI SCULPTOR
(JAPANESE)

Born: August 16, 1914

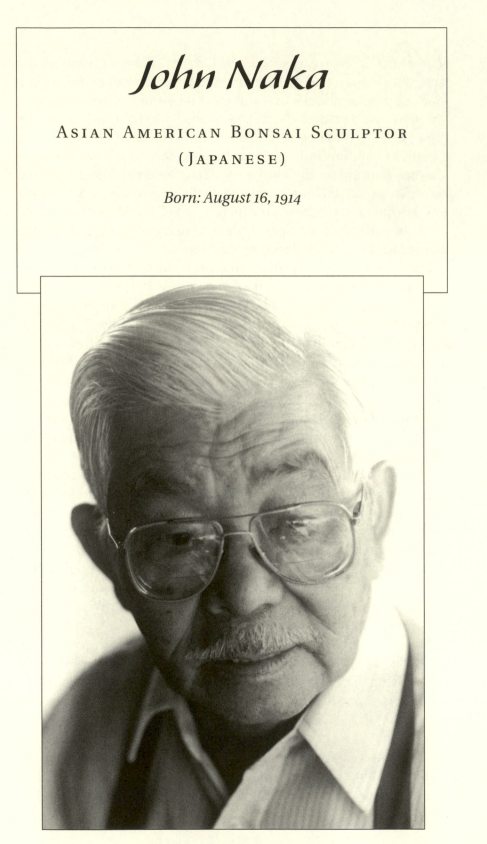

John Naka (Courtesy Los Angeles Times)

JOHN YOSHIO NAKA WAS BORN AUGUST 16, 1914, in Ft. Lupton, Colorado. When he was eight years of age he moved to Fukuoka, Japan, with his parents to care for his aging grandfather. While there, he learned about bonsai (miniature trees), an art form that dates back to as early as A.D. 700 in China. Bonsai was brought to Japan by Buddhist monks about 500 years later. The Chinese form, *penjing* ("pot plants with landscape"), is still in use, though there are physical, aesthetic, and philosophical differences between the two traditions. In its early years in Japan, bonsai was the sole property of the samurai aristocracy. Later it spread to the middle classes and became a widely accepted art form by the 1800s. Most bonsai today are based on five styles: formal upright, curved trunk, slanting, cascade, and "literati" (slender trunk and fewer branches), each with subvariations totaling more than 30 in all.

Naka returned to the United States in 1935 and settled in Wattenberg, Colorado, where he worked as a farmer with his brother Sadao (Sam). He remained in Colorado until 1946, when he moved to Los Angeles with his wife, Alice. In Los Angeles, Naka lived next door to a disciple of the bonsai teacher Sam Takekichi Doi, and under Doi's tutelage, he studied all facets of the art form.

In the early 1950s, he began exhibiting his works to great acclaim and lectured widely on bonsai in Japanese and English. In 1973, after 14 years of preparation, his book *Bonsai Techniques* was published. In 1976, he helped launch the National Bonsai Foundation, which aimed to establish a permanent public display of North American bonsai at the National Arboretum in Washington, D.C. The multimillion-dollar viewing pavilion became a reality and was named after Naka. The foundation has developed a program for comparative bonsai collections, exhibits, education, research, and exchange, and the pavilion will provide a setting for peaceful intercultural exchange.

Naka published a second book, *Bonsai Techniques II*, in 1982, and in 1985 the emperor of Japan conferred upon him that country's highest award given to a noncitizen, The Fifth Class Order of the Rising Sun. Over the years Naka became active in many nonprofit bonsai organizations, participated as a teacher and speaker at numerous conferences and programs, and was guest curator for exhibitions on bonsai. Throughout his life, he has continued to teach and promote his art. "What I like about bonsai is that it has a beginning, but no end," he says. "A bud today becomes a branch tomorrow. It is like searching for the rainbow's end; the farther it is pursued, the farther away it is. There are no borders in bonsai. The dove of peace flies to palace as to humble house, to young as old, to rich or poor. So does the spirit of bonsai."

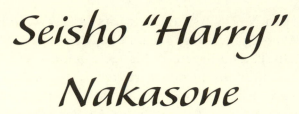

Seisho "Harry" Nakasone

ASIAN AMERICAN MUSICIAN
(OKINAWAN)

Born: 1912

Harry Nakasone, 1991 (Alan Govenar)

SEISHO "HARRY" NAKASONE WAS BORN IN O'AHU in 1912; his mother, Nae Nakasone, herself a *koto* instructor, took him back to Okinawa to be reared by his grandparents. His family had migrated to Hawaii long before World War II. Hawaii offered great promise, but ultimately the opportunities for advancement were few. Work in the cane and pineapple fields was hard and wages were low.

In Okinawa, Nakasone learned about his native culture, and at the age of nine he began playing the *sanshin*, a three-stringed instrument with a skin-covered soundbox. He was attracted to the distinctive sound of the instrument, but was discouraged at times in his efforts to play. "They don't want you to play *sanshin* [in Okinawa]," he said, "because [they think] you going to be a lazy boy, you don't want to work on the farm. The only time my uncle can play *sanshin* was a rainy day when he cannot work on the farm. That was fun, those days."

The *sanshin* was introduced into the Ryukyu Islands from China during the fifteenth century, or perhaps even earlier, and from there it moved to Japan, where it is called the *samsien*. Nakasone's uncle was an accomplished player and presented the young Nakasone with his first instrument when he returned to Hawaii in 1925. "He [my uncle] was one of the best in our village," Nakasone said. "The music . . . I thought . . . was a wonderful thing. You could play in happy occasions. You can sing your blues away."

Nakasone did not start his formal instruction on the *sanshin* until 1933, and for the next 20 years he took lessons from every available grand master of the instrument, visiting Okinawa as often as possible. In 1938, Nakasone helped his father to establish a wholesale produce business, which helped to stabilize life for his family. "My parents," he said, "were very poor, and I have to work at the plantation store from six o'clock in the morning until ten o'clock in the night. No Sunday, no holiday."

For more than 60 years, Nakasone performed *sanshin* at community gatherings for the Okinawan community in Hawaii, playing music for festivals, celebrations, birthday parties, anniversaries, and weddings. In addition, he taught *sanshin* in college classes and in private lessons. He was the head of the Seifu Kai, an Okinawan classical music ensemble, and a member of the faculty of ethnomusicology at the University of Hawaii. In that capacity, he prepared recordings and music books for the instruction of Okinawan musicians in San Francisco and Los Angeles.

In 1988, a special recital program was presented in Okinawa to honor Nakasone, featuring an unprecedented performance by five of the most important musical organizations in Okinawa and involving 200 musicians. About his life as a *sanshin* player and singer,

Nakasone said, "Music has kept me going. A lot of people ask me how come I look so young. When you start singing, you not singing from just the neck up. You just have to sing from the bottom of your stomach, just like inhaling exercise."

Julio Negrón-Rivera

PUERTO RICAN INSTRUMENT MAKER

Born: 1925

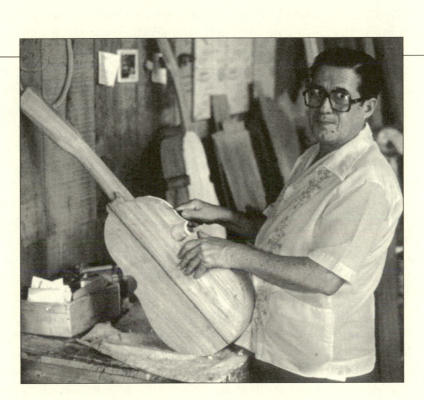

Julio Negrón-Rivera (Walter Murray-Chiesa)

*J*ULIO NEGRÓN-RIVERA WAS BORN IN 1925 in Morovis, Puerto Rico. He was raised in a family of traditional musicians and artisans from this region situated high in the island's mountainous hinterlands. His grandparents, Tomás Negrón and María Prágedes, were musicians and singers who throughout their lives performed the heartfelt songs dedicated to the Virgen del Carmen that the people of Morovis had created and passed down through the generations. His parents, Euseblo and Carmen Negrón, carried on the local musical tradition, but worked as small farmers skilled at cultivating coffee and subsistence crops on the steep highland slopes. Euseblo hand-crafted his own tools to pit and process his coffee beans, and also made the *cuatro*, the uniquely shaped 10-string guitar that has become known as the national instrument of Puerto Rico.

Growing up, Julio worked alongside his father and learned to make the *cuatro*, as well as the *tiples* (a small soprano guitar), six-string guitars, and *bordonuas* (bass guitar), in the small workshop next to his home. Julio's wife, Doña Mercedes, also grew up in a musical family. Her grandmother, Doña Balbina Díaz, was a noted singer of *rosarios* and *aguinaldos* (rural carols) and her father, Anselmo Rivera, was a maker of *cuatros* who, people believed, was able to heal the sick with his playing. Julio also had this ability and said that once "they made some good music for a son of Avelino, and not only did he get up, but also sang." In the Negrón-Rivera household, Doña Mercedes assisted her husband, but usually made use of herbs and medicinal plants for illness in her own family.

Although Negrón-Rivera played secular music, such as *aguinaldos, seis, valses,* and *décimas* for healing, the songs in honor of the Virgen de Carmen were performed as part of the traditional country *velorio,* a religious ceremony held almost every night at homes in rural Puerto Rico. The *velorios* (wakes) were usually associated with the deaths of family members or with the days when certain *santos* (saints) were honored—July 15 for the Virgen del Carmen festivities, during Holy Week before Easter, or during special masses held at 5:00 A.M. at the town church in December.

Negrón-Rivera and his family sustained the traditions of their homeland and imbued their children with a deep respect for the folklife of the rural region in which they live. His sons work with him, as he did with his own father.

Doc Tate Nevaquaya

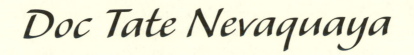

NATIVE AMERICAN FLUTE PLAYER
(COMANCHE)

Life dates: 1932–March 5, 1996

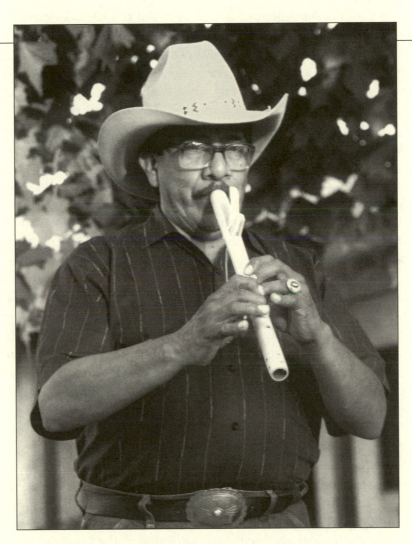

Doc Tate Nevaquaya, 1991 (Alan Govenar)

Doc Tate Nevaquaya was born in 1932 to Comanche parents in Fletcher, Oklahoma. He was delivered by Dr. C. W. Joyce, after whom he was named, although the name "Joyce" was replaced by "Doc" at an early age. The name "Tate" was taken from his grandfather's partner when a Christian name was required upon entering the Fort Sill Indian School. His Indian name is Nevaquaya, which in English means "well-dressed."

As a child, Doc Tate loved to hear the elders talk about the historical landscapes where his Comanche forefathers lived and worked, roaming in search of game and settling in the grassy, well-watered prairie lands that roll southwest from Oklahoma City toward the Texas border.

Growing up, Nevaquaya learned to make traditional Comanche crafts and became interested in the courting flute, a traditional instrument common to many American Indian tribes. The courting flute is an end-blown instrument generally made of wood and constructed with a movable block through which the musical intonation can be changed. Archeological evidence suggests that it was once found throughout the Americas, and in the Northern Hemisphere among the Southwestern, Eastern Plains, Plateau, and Woodland tribes. It is one of the few Native American instruments reserved for solo performance. Traditionally, it is played only by men in contexts of courtship, love, magic, or fertility rituals.

Around the turn of the century, the traditional role of the courting flute began to wane, and although a few individuals continued to make and play it, flute music was rarely heard outside the home or an occasional powwow. In the 1970s, however, a few Indian musicians began to explore the flute tradition in greater depth and bring it to wider public attention. Nevaquaya was one of the leaders of this revival, researching construction and playing techniques, learning, popularizing the old repertoire, and elaborating upon the characteristic ornamental instrumental graces. He also developed two new compositional styles, one of which he called "a modern courting song style," and the other, a creative mode through which an individual musician can improvise while still remaining within the aesthetic parameters of Plains Indian musical forms.

Nevaquaya released two recordings, *Indian Flute Songs from Comanche Land* (1976) and *Comanche Flute Music* (1979), and appeared in numerous performances around the United States and abroad. In addition to his efforts as performer and researcher, he was also an important teacher, working among the Comanche people as well as among other American Indian tribes. He taught his three sons how to make and play the courting flute; all are committed to keeping the tradition alive and vital.

Ng Sheung-Chi

ASIAN AMERICAN TOISSAN MUK'YU FOLKSINGER (CHINESE)

Born: 1910

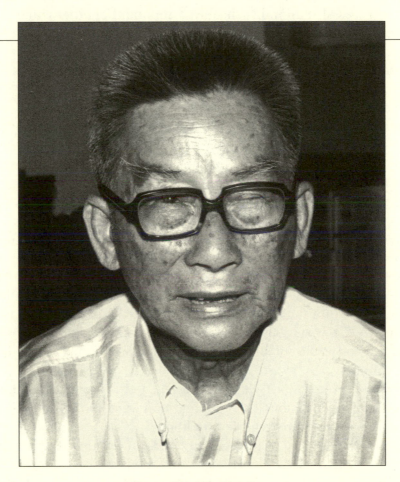

Ng Sheung-Chi, 1992 (Alan Govenar)

*N*G SHEUNG-CHI WAS BORN IN 1910 in the small village of Jinhjuan in Toissan (Taishan) County, a rural area situated in the Pearl River Delta, southwest of Canton in southeast China. Ng began school when he was nine years of age, but only stayed for three years because he had to work with his family as a farmer.

Ng grew up listening to villagers sing *muk'yu (muyu),* a type of narrative song, while working or when they gathered together in the evenings. Eventually, he began imitating them and practicing his singing while he worked in the fields. By the age of 18, Ng was well known as a *muk'yu* singer among fellow villagers. He was frequently invited to sing traditional wedding songs, including the *san neung go (xin niang ge),* the bride's song, performed at the bride's home. *Muk'yu* was also an indispensable component of other ritual and ceremonial activities, such as those held at the Chinese New Year and other lunar calendar holidays. Ng prided himself in his ability to preserve his regional tradition of *muk'yu* without instrumental accompaniment, always singing from memory and never utilizing song sheets or textbooks in public.

Muk'yu has been popular among rural people of this region for more than 300 years. *Muk'yu* stories, which are sung as rhymed texts, are drawn from the national or local history, myths, legends, and folk tales. *Muk'yu* texts are usually hand-copied into booklets or are printed into textbook-type collections. The earliest extant printed *muk'yu* textbook dates from 1713. The texts are sung to repeated tunes with improvisational variations. *Muk'yu* can be performed *a cappella* or accompanied by music. It can be sung by one singer or by multiple voices singing in turns. The length of *muk'yu* varies from several dozen lines, which can be performed in a few minutes, to thousands of lines, which require hours or days to perform. *Muk'yu* is sung by both men and women. Traditionally, older women sing as part of funeral rituals; young people sing in wedding ceremonies.

Following the political changes of the 1940s in China, most singing of *muk'yu* was prohibited and the tradition went into sharp decline. The Communist party regarded traditional arts as a threat to its political hegemony and restricted many traditional forms of artistic expression. Ng persisted nonetheless, and in later years, when Communist party members realized how popular Ng's singing was, they incorporated him into political programs to draw villagers to meetings. "These meetings," he said, "were very large meetings, often with three or four thousand people. Usually, it took a long time to have folks gathered for these meetings; but when they knew Uncle Ng [as he was called] was coming to sing, they would all come very early, waiting at the meeting place."

After the Cultural Revolution (1966–1976), people started singing again and songbooks began to reappear. However, nearly 20 years of censorship had weakened the tradition of *muk'yu* singing considerably. Ng devoted himself to reviving the repertory of *muk'yu* songs, but interest among the villagers had waned.

In 1979, Ng left China, going first to Hong Kong and then on to the United States. He settled in the Chinese community of New York City and worked for several years in the garment industry. He continued to sing *muk'yu* at work and at home. His repertoire includes traditional love stories as well as songs that recount the experiences of the Chinese forced to leave their homeland. He has also composed songs, many of which vividly describe his personal experiences as an immigrant.

Since retiring, Ng has devoted more of his time to *muk'yu*. In recent years, he has produced his own selection of *muk'yu* hand-copied text sheets and photocopied bound booklets of songs. Ng sings regularly at the monthly birthday parties organized by the New York Chinatown Senior Citizen Center, where many of the seniors originate from the Toissan area. Because they are from the same region, and many of them know the songs in Ng's repertoire, they can take turns singing parts of the lyrics. In 1986, Ng started making cassette tapes of himself singing, and over the years he has completed 20 different tapes, which are sold with handmade text sheets or booklets on the streets of Chinatown.

Phong Nguyen

ASIAN AMERICAN MUSICIAN AND SCHOLAR (VIETNAMESE)

Born: July 15, 1946

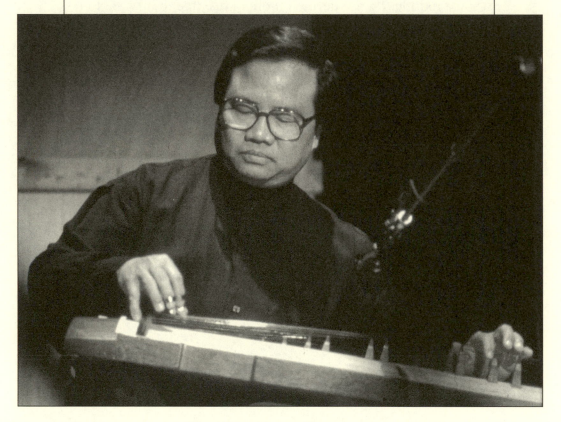

Phong Nguyen (Courtesy Phong Nguyen)

PHONG NGUYEN WAS BORN JULY 15, 1946, in Vietnam. He is a traditionally trained musician who studied with a village master beginning at age five. As a Buddhist novice for 10 years, he learned the chant and instrumental accompaniment of *nhac le* (ritual music). He took up Vietnamese theater music at age 13 and went on to perform both the *cai luong* (reformed theater) and *hat boi* (court musical) styles professionally. He sings a large repertoire of *dan ca* (rural folk songs) and is a master of *dieu,* the complex modal system of *nhac tai tu* music, a more formal tradition still active in the United States. He has studied with mountain tribal musicians and learned the *klong put* (bamboo tubes) and *t'rung* (bamboo xylophone).

Nguyen points out that because separation of social classes is minimal in Vietnamese society, folk music and art music are more similar than in Western societies. "The folk music is principally vocal," he said. "Meanwhile, in art music, there's vocal and instrumental music together. Folk songs are sung without accompaniment. They're chanted in the fields while people are working. They don't bring instruments with them." Nguyen is competent on many Vietnamese instruments but often focuses on the 17-string *dan tranh* zither and the two-string *dan nguyet,* the long-necked "moon" lute.

"In Vietnam, the music is played with added elements in order to improvise," Nguyen said. "So, the performing style may change according to the artist. We cannot say that Vietnamese music is classical music. It evolves according to a period of time. A piece composed in the sixteenth century, when it is interpreted by a present-day musician, takes a new form because it is improvised upon."

Nguyen left South Vietnam in 1974, the year before its fall to the Communists. He first stayed in France, where he performed frequently and earned a doctorate in music from the Sorbonne University in 1982. He then moved to the United States and taught at Kent State University, the University of Washington, and UCLA. He has performed and taught extensively across the United States, reaching both American audiences and Vietnamese Americans, who have limited access to their musical heritage. He also has recorded for several labels.

In the 1990s, Nguyen made research trips back to Vietnam, which enabled him to work with many local artists, village masters, and scholars whose life work has focused on indigenous musical traditions. Through his fieldwork, he has documented different performances as well as substantial historical information, much of which was lost or forgotten during the war years. He has also helped to introduce Western musicians to audiences in Vietnam. He presented the American concert pianist Margaret Baxtresser at Hanoi's National Theatre in 1994 and met with Vietnam's minister of culture and representatives from the Hanoi Conservatory of Music.

"In any country in the world, there are influences from foreign countries," Nguyen said. "So, there are two currents—an indigenous current, from the country itself, and the elements from other countries: Indian and Chinese music. Vietnam was a kind of confluence between these two musical civilizations. But the indigenous elements are always predominant."

Yang Fang Nhu

ASIAN AMERICAN WEAVER (HMONG)

Born: February 11, 1911

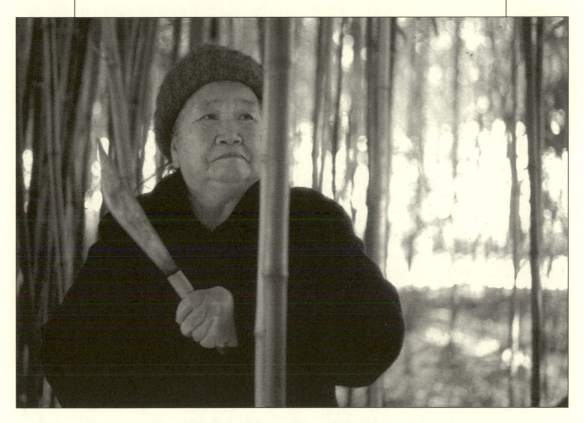

Yang Fang Nhu (Courtesy Yang Fang Nhu)

YANG FANG NHU WAS BORN FEBRUARY 11, 1911, in a small Hmong mountain village of 10 households in northern Laos. As a child, she stood close to her mother's loom and watched her push the sword shuttle carrying the bobbin of weft thread back and forth.

By the age of 15, Fang Nhu had learned many of the intricacies of making cloth. She knew how to grow the hemp, harvest it, break it down into fibers, soak it, spin it, set up the loom, and weave the hemp into the traditional white cloth, well-suited for indigo dyeing, batiking, embroidery, appliqué, and pleating.

Traditionally, the Hmong used the backstrap loop, on which the warp is stretched between a stationary object and the body of the weaver. In this way, the backstrap weaver is herself a part of the loom and can fine-tune the tension of the warp by moving her body. The Hmong loom is similar to the loom of the Zhuang people living in southern China and to the peasant looms in Korea and Japan.

Making hemp fiber for the Hmong loom is a complicated process. Hemp is grown for the thread because it holds pleats and has a substantial weight. The hemp plant grows for about $2 \frac{1}{2}$ months before it is harvested. All the leaves are stripped and the stalk is carved off. After drying in the sun for 15 days, the stalks are broken in half; the greenish brown fibers are pulled from one side to the other, and later pounded with a wooden mallet. The fibers are then rolled onto a stick and prepared for a spinning wheel with four spindles that twist the fibers into tight skeins of thread, which in turn are bleached white and rinsed. The resulting yarn is sized with wild beeswax and flattened while still damp with a wooden roller. Once dried, the yarn is wound loosely into a ball and put in baskets until needed on the loom.

When Fang Nhu was 16 years old, she married Nouyi Yang, and, as is customary, moved to her husband's village—a larger one of 50 households. There she raised a family of seven children, worked in the fields, carried water, and cultivated the fields of hemp for her weaving. Every year, she wove three skirts, two for everyday use and one to be worn for the annual New Year's celebration. She also wove the cloth to make shirts and pants for the men in her family and village.

In 1978, Fang Nhu and her husband were forced to leave Laos, their livelihood threatened by the Communist regime. At the time, they lived in Vientiane, the Laotian capital, and in secrecy they fled by boat across the Mekong River to Thailand. Her husband had been trained by the French military in 1943, and they were thus able to immigrate to France. In 1984, they moved to Providence, Rhode Island, to join their youngest son.

In Providence, Fang Nhu became active in the immigrant Hmong community and was eager to teach her weaving skills to her daughter-in-law Ia-Moua Yang. For Fang Nhu, weaving was not just making cloth, but was representative of a social fabric. Her care for the craft paralleled her nurturing of people and their customs. Weaving was the thread that linked her to her ancestors and to each of the Hmong people.

In Laos, the Hmong divided themselves into different groups, identifying themselves by noting the distinctive colors of women's dress—the White Hmong, the Blue Hmong, and the Striped Hmong, all living in different regions of the country. In the United States, however, these distinctions are less significant. Given the dislocation of the Hmong people, a pancultural identity has emerged that has brought these cultural groups closer together.

Fang Nhu likes to tell the story of an old woman who died in Providence. She felt culturally dislocated before her death, and neither she nor her family knew what she should wear for her funeral dress. In desperation, this old woman was buried in Western clothes, but her spirit came back in nightmares to her family because she was lost and was unable to find her ancestors. For Fang Nhu, this story was a means to impress upon her family and community the importance of not only making traditional funeral clothes, but of the essential need to know "how to die" and "rest in peace."

Glenn Ohrlin

ANGLO-AMERICAN COWBOY SINGER, STORYTELLER, AND ILLUSTRATOR

Born: October 26, 1926

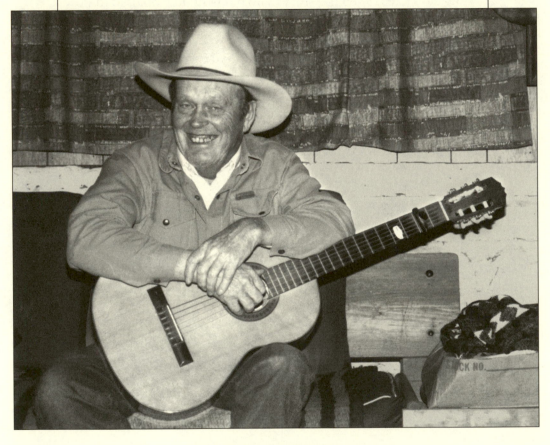

Glenn Ohrlin, 1990 (Alan Govenar)

GLENN OHRLIN WAS BORN OCTOBER 26, 1926, in Minneapolis, Minnesota. As a boy, he heard and liked cowboy songs, and by the age of five, he was singing himself. "In Minnesota, where I was born," Ohrlin said, "everyone sang cowboy songs, even my aunts and uncles. My father was musical; my mother wasn't particularly. I used to listen to the radio a lot. When I was growing up in the 1930s, every reasonably big radio station had its own singing cowboy. In those days, it wasn't too hard to find one. If a station wanted a cowboy singer, they'd go out and find a working cowboy who knew a few songs."

Ohrlin started to play the guitar when he was about 10 years old and became interested in horses. "My mother's folks always had a lot of horses," he said. "They used to trail broncs from Montana and North Dakota and sell them to the farmers. And even when I was a little boy, I was fascinated by the horses. I've never been too interested in anything else in my whole life."

When he was 14 years of age, Ohrlin's family moved from Minnesota to California. Two years later, Ohrlin left home to become a buckaroo (working cowboy) in Nevada. He often made extra money by sign painting "Welcome Cowboys" and pictures of broncos and bull riders on the windows of local establishments that wanted the business of rodeo cowboys.

Ohrlin sings in an unornamented Western style, accompanying himself on the guitar with understated rhythms, sometimes embellishing his introductions with his harmonica. Most of his repertoire stems from the period 1875 to 1925 and includes traditional British ballads carried west, sentimental melodies, journalistic poetry, bawdy songs, hobo ditties, and border Spanish tunes he learned as a working cowboy. He also performs a number of folk songs that he learned while in the Army during World War II, as well as many popular country and western songs.

Over the years of doing cowboy work and collecting cowboy songs and lore, Ohrlin put together a book, *The Hell-Bound Train*, published by the University of Illinois Press in 1973 and containing 100 of his favorite cowboy songs and poems. He also produced an album of the same name that consists of cowboy lore and songs.

In 1983 and 1984, Ohrlin was host and a performer for *The Cowboy Tour*, a group of eight working and retired cowboys who traveled over 30,000 miles by road in the western United States, bringing tall tales, fiddlings, songs, jokes, and cowboy poetry to small towns with ranching traditions. During that same period, he worked with a group of western folklorists who organized the successful Cowboy Poetry Gathering in Elko, Nevada, in 1985. Throughout his life, Ohrlin has preferred to travel by pickup truck with a "highway rule":

If there was more than one road to a place, he always went by the one he had never traveled, even if the distances were longer and the road narrower. After several years in Nevada, Ohrlin moved to Mountain View, Arkansas, where he operates a cattle ranch and lives in a stone house that he built.

João Oliveira
dos Santos
(João Grande)

BRAZILIAN AMERICAN
CAPOEIRA ANGOLA MASTER

Born: January 15, 1933

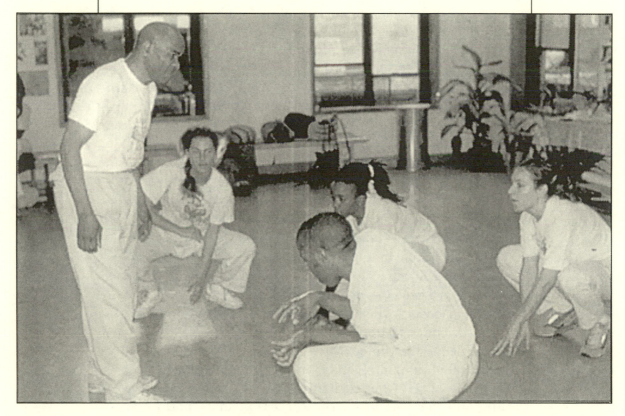

(Courtesy João Oliveira dos Santos)

João Oliveira dos Santos (João Grande) was born January 15, 1933, in the small village of Itagi in the southern part of the state of Bahia, Brazil. His family eked out a living as farmers; João and his siblings did not attend school, but were expected to work alongside their parents.

When João was 10 years old, he saw someone demonstrating a movement called *corta'capim* (cut the grass), which the man identified as "the dance of Nagos." It was not until years later that João realized that this movement was part of what was known as the *capoeira*. The *Capoeira Angola* combines music, dance, martial arts, ritual, and belief in a tradition that defines Afro-Brazilian cultural identity. Believed to have originated in Angola among the Nagos and Yoruba in central Africa, it was brought to Brazil by slaves who then adopted *capoeira*'s many forms as a means of defense and solidarity. *Capoeira* is usually performed by two players who dance and maneuver in the center of a *roda* (circle) of musicians who sing and play the *berimbau*, a one-stringed, bowlike instrument.

At about the age of 20, João traveled to the city of Salvador, the center of *capoeira* activity, and studied with Mestre Pastinha, who gave him the name João Grande (Big John). "Pastinha was my father, my grandfather," João said, "my everything in *capoeira*." In 1966, João Grande accompanied his master in a performance at the first International Black Arts Festival in Dakar, Senegal. Two years later, João was awarded his Diploma of *Capoeira*, making him a full-fledged master. In 1973, he toured Europe and the Middle East with other *capoeira* troupes, and continued to work as a teacher at the aging Pastinha's academy.

After Pastinha's death, João Grande dropped out of the *capoeira* world and took a job working in a gas station. He continued to perform in a limited capacity as a dancer and musician in a folkloric show for tourists. Mestre Morales (Pedro Morales Trinidade), who had been João's prize student, tried to persuade João to join him and the Grupo de Capoeira Angola-Pelourinho (GCAP) that he had co-founded with Cobrinha Mansa. Finally, after a six-year absence from *capoeira*, João agreed to work with Morales.

In 1989, João was invited by Mestre Jelon Vieira to tour the United States to discuss and demonstrate *Capoeira Angola*. A year later, João returned to the United States to perform at the National Black Arts Festival in Atlanta, Georgia, and to participate in an international conference, "Dancing Between Two Worlds: Kongo-Angola Culture and the Americas." The success of these performances prompted João Grande to settle in New York City and to found his own *capoeira* academy, which is devoted to carrying forth the teachings of Mestre Pastinha and the traditions of his homeland.

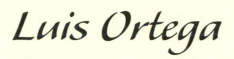

Luis Ortega

HISPANIC AMERICAN LEATHER WORKER AND SADDLE MAKER

Life dates: 1897–?

Luis Ortega (Jill Scopinich)

493

LUIS ORTEGA WAS BORN IN 1897 in an area of California settled by his Spanish ancestors. "My people were from Spain," he recalled. "The Ortegas were the first to establish the Presidio of Santa Barbara; also Jose Francisco de Ortega is credited with discovering San Francisco Bay by land in 1769 . . . my mother is descended from the Peralta family of Arizona and New Mexico."

In 1905, his father became the foreman of the Spade S Ranch, near where Vandenberg Air Force Base is located today. Ortega grew up speaking both Spanish and English. "When I was a kid on the old Ortega Ranch," he said, "my cousins that lived across the road and I were alone a lot. For my pastime, I played cowboy—I used to ride a broomstick and pretend I was a 'buckaroo.' When it was time for me to start school, we moved to Lompoc, and in October of the following year we moved out to the Spade S Ranch and I went to the district school there."

On the Spade S Ranch, Ortega met some buckaroos who worked with rawhide, and when they started to prepare the hide for braiding, he helped them pull the strands through for cutting, beveling, and sometimes fleshing. Later, he said, an Indian of the Tulare tribe who was about 110 years old started him out working with rawhide. From him, Ortega learned about the basics of leatherwork: how to select hides, how to divide them up properly, how to tan, bleach, and make buckskin, and how to start building a saddle.

Ortega left home in 1911, at age 14, and worked as a cowboy in the region between Santa Maria and Salinas, California. During World War I, he went to Mexico, to the state of Chihuahua, to bring cattle to the United States by train and also served in the United States Army. After the war, as a buckaroo on ranches from Arizona to Oregon, he began to braid leather again, making *reatas,* ropes, hackamores, headstalls, and bridles essential to his trade. In time, he was able to braid a 24-strand pair of reins, a skill, he said, that was "hard on the eyes and the disposition—when I start I have no time to answer questions or hold a conversation with anyone."

In 1932, with the encouragement of a Santa Barbara artist, Edward Borein, he gave up cowboying and set up Ortega's Rawhide Shop in Santa Barbara. Two years later, he met a schoolteacher from Oregon named Rose, whom he married in 1938. Over the years, he moved the shop to Walnut Creek and then to Cottonwood. There he started doing "fancy" work and invented the dyeing of rawhide, allowing him to introduce color to his braiding without using tanned leather. He had promised himself when he left cowboying that he was going to "get so high up in the rawhide game that nobody would ever catch up," and ultimately, he succeeded. His extraordinary precision distinguished his rawhide work from that of others and was prized by

collectors and museums. The Cowboy Hall of Fame in Oklahoma City acquired 24 pieces of his work.

In his later years, Ortega published two books, *California Hackamore* (1949) and *California Stock Horse* (1949), about his reminiscences of early ranch days, and numerous articles that appeared in periodicals such as *Quarter Horse Journal* and *Western Horseman*. In 1968, Ortega and his wife moved to Paradise, California, where he retired from his full-time business, but still continued with rawhide work when he wasn't traveling or visiting with friends.

"Although I've been working with rawhide for many years," he said, "there's always something different to work out. I learned the tricks of my trade as I went along, and they would be difficult to show anyone. The selection of good skins, and the curing and preparation of them, are the foundation of a quality product. I will never release any of my secrets. I use a process which I have developed over the years, and when I die, it all goes with me. I guess it's too bad, but I think if a person wants to know these things, he can take the dedication and time to learn them as I did."

Nadjeschda Overgaard

DANISH AMERICAN HARDANGER
NEEDLEWORKER

Born: December 23, 1905

Nadjeschda Overgaard, 1998 (Alan Govenar)

NADJESCHDA OVERGAARD WAS BORN Nadjeschda Lynge on December 23, 1905, in Tara, Siberia, where her Danish parents were living. Her father worked to establish creameries that would use Danish equipment. In 1910, the family returned to Denmark. In 1915, they immigrated to the Elk Horn, Iowa, area, where Nadjeschda attended school and eventually taught in rural elementary schools. She married Niels Overgaard in 1933, and they raised seven children. From 1951 to 1956, she returned to teaching in rural schools.

Overgaard took every opportunity to pass along the artistic skills and cultural knowledge she had learned from her mother. "We certainly were American, but I treasure my Danish heritage," said Overgaard, who lives in the nearby village of Kimballton. "It embarrasses me when people say it's Danish and they don't know. I was brought up Danish, and I'm not satisfied with a substitute."

Hardanger embroidery is a three-dimensional, open, "counted thread" needlework. Traditionally, white cotton thread is applied to an even-weave white linen, often 22 threads per inch. The fabric is cut in squared, geometric patterns determined precisely through the counting of threads in each cut. Then a traditional repertoire of stitches, such as the basic satin stitch, consisting of five stitches covering four threads of fabric, are applied around the edges of the cutwork. This creates a range of delicate, precise, and minutely detailed patterns. The loose ends of the cut fabric are then interwoven into the embroidery, adding texture.

Overgaard's knowledge of the technique of Hardanger embroidery and its place in Danish heritage, as well as her lifelong efforts to keep many other Danish traditions, has earned her a special place among Danish Americans. She has volunteered to pass along her knowledge of embroidery, the Danish language, culinary arts, choral music, folk dance, *papirklip* "paper-cutting," and Danish folk plays. "Anyone who admires the work and wants to start, I help them," she said.

Her six daughters have followed in her footsteps, practicing, demonstrating, and teaching Danish traditions. Her work was exhibited in the milestone exhibition of Iowa folk crafts, "Passing Time and Traditions," and is included in the collection of the State Historical Society of Iowa.

Jack Owens

AFRICAN AMERICAN BLUES GUITARIST AND SINGER

Life dates: November 17, 1904–February 9, 1997

Jack Owens (Axel Kustner)

498

JACK OWENS WAS BORN NOVEMBER 17, 1904, in Bentonia, Mississippi, the son of Celie Owens and a man named George Nelson. "When I was growing up," he said, "I fooled around on the guitar. My old folks had a guitar and I would drag it around when I was crawling. When I got to crawling on the floor, dragging the guitar, the strings would break, and I just crawl and crawl. The old folks could play. My uncle, Will, he was a head player, but all of them could play. And I played around and played around until I learned. I stayed in the cotton patch in the fields and I just kept playing."

Soon Owens was able to play songs and, in time, taught himself to play blues. He supported himself as a sharecropper farmer by day and as proprietor of a small country "juke house" at night. On weekends, he'd clear the furniture out of one room of his house (where he had a jukebox) so that people could dance, and in another room his wife, Mabel Owens, sold sandwiches and drinks. For a time, he sold bootleg whiskey, but eventually was able to get a liquor license.

Owens only operated his juke house on weekends. After people arrived, he'd unplug the jukebox, get out his guitar, and sit down with Benjamin "Bud" Spires, his harmonica player. Together, they'd perform old country blues, such as "It Must Have Been the Devil," a favorite among people in his community of Bentonia. "They'd be here every night," he said. "But I told them don't come till Friday evening. Some of them come in every now and then through the week. I get my stuff on Friday evening. Get a hog or goat or something like that and kill him and sell him there, barbecue and make sandwiches out of it. The jukebox, that belong to me. You see, I got it rented here. I don't do too much playing when it's going, you know. I turn it off and play sometimes. Yessir, we have plenty fun up here. Start on Friday evening and run till over Sunday night."

For years, Owens was the only regularly performing musician in Bentonia. He played a kind of blues that was at once personal and traditional and representative of a local style. He shared many lyrics, melodies, and guitar figures with other blues musicians in the area—from older bluesmen like the Stuckey brothers, Adam Slater, Rich Griffin, and his father and uncle to his contemporaries, Skip James, Cornelius Bright, and Bud Spires. Of these, James is probably the most well known, as a result of his recording for the Paramount label as early as 1930.

The Bentonia style developed apparently in isolation on the edge of the Mississippi Delta between Jackson and Yazoo City. It is characterized by high melismatic singing and complex melodies, as well as by minor-keyed intricate guitar parts and often haunting lyrics with themes such as loneliness, death, and the supernatural.

Owens groomed Bud Spires (born May 20, 1931) as his harmonica player. Spires, the son of Chicago bluesman Arthur "Big Boy" Spires,

is nearly blind and learned to play the chromatic harmonica after Owens bought him one in the early 1960s. He accompanied Owens with a droning chordal style that complemented the overall country blues sound. Although Owens and Spires were invited to perform at festivals around the country, they preferred to play mostly for their own community in the Bentonia area.

Vernon Owens

ANGLO-AMERICAN POTTER

Born: July 15, 1941

Vernon Owens (C.N. Chatterley, Courtesy Folklife Program, North Carolina Arts Council)

VERNON OWENS WAS BORN JULY 15, 1941, in a rural area near Sea-grove, North Carolina. He learned to become a potter by watching his father, Melvin Owens, work in the pottery that his grandfather, J. H. Owens, had founded around 1895. "I was playing in the shop for as long as I remember," Vernon said. "I made my first pots when I was about seven or eight. It would have just been a little something, like a bowl, that didn't amount to much. Back then, my daddy didn't have electricity. He just had a kick wheel. That was back in the late 1940s. We didn't have electricity until the 1950s."

When Vernon was 12 years old, he started using an electric potter's wheel in his father's shop, where he worked for about six years. In 1960, he took a job at the Jugtown pottery as principal turner and went back to the kick wheel, because, he said, "Jugtown was more traditional and using a wood-fired kiln."

Jugtown had been established in 1921 by Jacques and Juliana Bus-bee of Raleigh, inspired by a pie plate Juliana had purchased in 1915 at a North Carolina county fair made by Vernon's uncle, Rufus Owens. The Busbees sought to preserve the pottery tradition in Moore and Randolph counties, and produced salt-glazed stoneware, particularly the orange earthen kitchen and tableware known locally as "dirt dishes."

One of the first potters to work with Jacques Busbee was Vernon's grandfather, who helped to establish the Jugtown pottery style, developing the particular process of turning and firing pieces, and the ware itself. After Jacques died in 1947, the pottery remained open under the guidance of Juliana and local potter Ben Owen until 1959. A year later, New York businessman John Maré reopened the pottery, hired Vernon to turn pots, and his brother, Bobby Owens, and Charles Moore to glaze and burn the ware.

Country Roads, a not-for-profit organization devoted to conserving Southern crafts, bought Jugtown Pottery in 1968. In collaboration with Nancy Sweezy, Vernon began to develop new and safer glazes, identify appropriate firing temperatures for new materials, and implement refined marketing strategies, all while creating the highest-quality functional pottery. Also at this time, Country Roads initiated an apprenticeship program to help perpetuate the local pottery tradition.

In 1983, Vernon purchased Jugtown Pottery from Country Roads. Working with his wife, Pam Lorrette Owens, their two children, Travis and Bayle, and his brother, Bobby, Vernon has turned Jugtown into a cultural center. There are now about 70 potteries in the Sea-grove area, many run by families from Piedmont counties. They are committed to preserving the legacy of more than 250 potters, who have produced salt-glazed stoneware since the Colonial era. The tra-

ditional clear, lead glazes, however, were phased out around 1970, and were replaced by semiclear glazes that use other natural minerals, such as feldspar and flint, to make higher-temperature pottery with color variations.

Although pottery today is bought more by choice than necessity, Jugtown has attracted a diverse clientele that includes tourists and pottery buyers from around the country. "I'm always wondering why those people buy this much pottery," Owens said. "It's just hard for me to believe that it's possible for me to be able to make pottery and there be a demand for it. A lot of times it's really hard for me to put the price I have to have out of it, especially wood-fired pottery. Because, I think, well, there might be somebody . . . who'd come up here and to buy that, and they just wouldn't have that much money. I guess that's why I keep prices to where people can buy it."

Harilaos Papapostolou

GREEK AMERICAN BYZANTINE CHANTER

Born: April 22, 1932

Harilaos Papapostolou (Courtesy Harilaos Papapostolou)

*H*ARILAOS PAPAPOSTOLOU WAS BORN APRIL 22, 1932, in the city of Agrinion, Greece, a longtime center of Byzantine chant. He comes from a long line of priests, including his father. He apprenticed with a traditional *psalti,* or chanter, at age five, and eventually spent long hours each day mastering the enormous liturgical repertoire that was part of the day-to-day liturgical cycle.

Papapostolou holds degrees in both Byzantine and Western music from the Athens Conservatory and a theology degree from the University of Athens. This knowledge is a crucial factor that provides the insight needed to understand and interpret the ecclesiastical hymns of the Orthodox Church.

In his hometown Papapostolou became the head chanter *(protopsaltis)* of the cathedral. He also founded and directed a musical conservatory and directed performances of both sacred and secular music on radio and in public concerts. In the mid-1960s, Papapostolou accepted the position of *protopsaltis* at St. Sophia's Cathedral in Washington, D.C., where he remains. In the United States, he found that the Western-based four-part harmony choral style with organ accompaniment had nearly eclipsed the more traditional chant, which is marked by a single melody line juxtaposed with a drone voice, or *ison.* The melody is governed by a complex system of eight modes, or scales.

The chanter improvises an interpretation of the melodic skeleton, applying melodic ornamentation and other nuances of performance that express *ifo*—a mood that reflects the meaning of the sacred text, the liturgical movement, and the immediate context. In the words of Papapostolou, the chanter directs his creativity to the purpose of devotion, creating "the sound that facilitates prayer, that becomes the bridge between man and God, not a showcase for the performer." Ironically, the complex "Oriental"-sounding modes and melodies were thought too "primitive" by many Greek Americans who had little prior exposure to the tradition.

"We have really strayed," Papapostolou has said. "On the one hand, we are the Orthodox Church, and we have our own tradition in all aspects: iconography, church art, and architecture from the chandelier and candles to the priest's robes, the music . . . but we have remained Orthodox in name only. In everything else, we have lost our tradition."

Papapostolou has played a large part in the revival of Byzantine chant, which is rooted in the music of medieval Byzantium and of ancient Greece. He has taken on dozens of apprentices and offered public demonstrations. He receives the greatest praise from connoisseurs for his expressive ability. He currently teaches chanting and traditional Greek folk music, and his wife, Rena, teaches dance.

Eddie Pennington

ANGLO-AMERICAN GUITARIST

Born: March 22, 1956

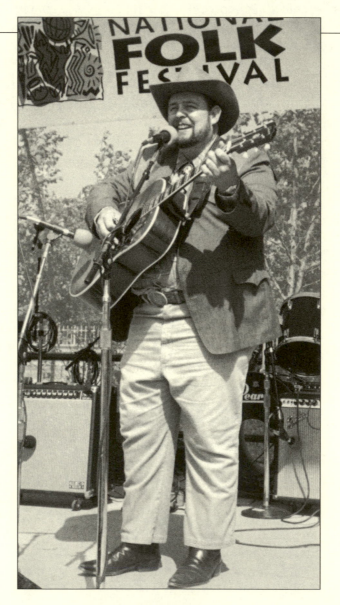

Eddie Pennington
(Courtesy National Council for the Traditional Arts)

EDDIE PENNINGTON WAS BORN MARCH 22, 1956, near Muhlenburg County, Kentucky. His father, a coal miner, played fiddle and exposed him to songs about the hard life of men who labored in the mines. Family members say that Eddie's great-great-grandfather, Edward Alonzo Pennington, was a fiddler who was unfairly convicted of a murder and who played a tune still played today called "Pennington's Farewell" as he sat on his coffin watching the hangman prepare the noose.

Muhlenburg County is an area known as the birthplace of a complex guitar playing style called thumb-picking. This instrumental technique requires the thumb to keep a regular rolling rhythm while the fingers pick the lead melody. Muhlenburg was popularized in John Prine's song "Paradise," and the county is also associated with guitarist Merle Travis, composer of "Dark as a Dungeon" and "I Am a Pilgrim." Travis, Ike Everly, and Chet Atkins are credited with bringing the thumb-picking style to a national audience.

Pennington began playing the guitar when he was 11. When he was 18, he heard Travis play and decided to devote himself to the thumb-picking style. Pennington also learned thumb-picking from his friend Mose Rager of Drakesboro, Kentucky, the guitarist whom Travis credited as a major influence. Merle Travis's brother once said of Pennington, "He plays so much like Merle. If you didn't see them, you wouldn't know who was playing."

In performance, Pennington likes to tell humorous stories in between his songs that often recount the lives and experiences about mining in his western Kentucky homeland. He makes his living as a funeral director and county coroner in Princeton, Kentucky. Over the years, he has continued to develop his musical talent, playing both acoustic and arch-top electric guitars, and has won two national championships in his country ragtime style.

Irván Pérez

ISLEÑO AMERICAN SINGER
(CANARY ISLAND)

Born: December 29, 1923

Irván Pérez (Tom Pich)

*I*RVÁN PÉREZ WAS BORN DECEMBER 29, 1923, in the lower Mississippi Delta region of Louisiana, which had been settled in the late 1700s by an immigrant colony sent by Spain from the Canary Islands. Pérez's family, like earlier generations of *Isleños* (islanders), as they called themselves, eked out a living in the swampy terrain by hunting, fishing, and farming. It was an isolated area, and to this day the older folks continue to speak and sing in a dialect that combines Old World Spanish, eighteenth-century maritime Spanish, and borrowings from Louisiana French.

Pérez has spent all of his life on or near Delacroix Island in lower St. Bernard Parish. In Delacroix, Pérez is recognized as a vital representative of *Isleño* culture and one of the few remaining people who know the old songs. Pérez performs a repertoire that includes songs dating back to the fifteenth century, such as *"Don Fernando,"* and preserves countless *décimas*. The *décima* is a distinctive narrative song of 10-line stanzas rooted in sixteenth-century Spain. Often satirical, it is both entertaining and a form of social commentary. Although some of Pérez's *décimas* hark back to the Middle Ages and speak of lords and ladies and the Crusades, others recount the timeless struggle with the natural elements in St. Bernard Parish.

Pérez says that "if something happened in the community, it didn't matter what it was, the *décima* singers . . . would pick it up and make a *décima* out of it. Well, the first stanza or the first wording, or whatever festival came along, they would go ahead and sing it. The people were waiting to see [hear] what happened in the community."

In some instances, explains Pérez's wife, Louise, the *décimas* are comical. "One song . . . tells the story of things that would happen on the job to make ends meet. Sometimes the words bring tears to your eyes because I think of his [Irván's] father a lot when I hear those songs. They would have been so proud to know the little songs that they put together, thinking they were just fun, would be so important to the heritage today."

Like his father, Pérez is also a composer of *décimas*. He wrote one as a way to preserve the story of his community's origins. "The story is from the time they left the Canary Islands, which was 1776, how they came over. They were given part of the land. 1812, they fought for our liberty. And then from there on, they got together with other Spanish people and they moved into the little part of the parish. The song ends by saying, 'Even though we're of Spanish blood, we are Americans.'"

Pérez is an accomplished singer, but he also knows many oral narratives—tales, riddles, and proverbs—and makes traditional crafts. He is a skilled wood carver of both aesthetic and utilitarian duck de-

coys, using cypress to make miniatures of Delta birds. In addition, he is an active keeper of his ancestral history, a community scholar, who interviews elders and has contributed to research for the *Isleño* Museum at Jean Lafitte National Park.

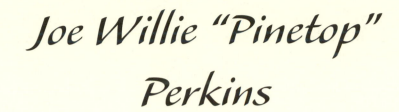

Joe Willie "Pinetop" Perkins

AFRICAN AMERICAN BLUES PIANIST

Born: July 7, 1913

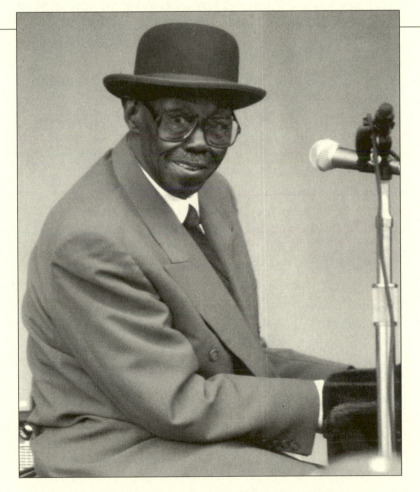

Joe Willie "Pinetop" Perkins (Courtesy Joe Willie "Pinetop" Perkins)

\mathcal{J}oe Willie "Pinetop" Perkins was born July 7, 1913, into a farming family in Belzoni, Mississippi. His first musical instrument was the only one he could afford, the diddley bow, a wire stretched between two nails driven into a wall and fretted with a bottle. "The way I learned was listening to records: Leroy Carr, Pinetop Smith, Robert Johnson," he said. "I could hear the (chord) changes coming. Never had a piano in the house, guitar either, just that thing on the wall. I was about 12 when I started playing piano. I was playing guitar before I was playing piano, y'know. I bought me a Stella, then sold that. Got me a Harmony electric."

Soon Perkins was working professionally, playing dances, house parties, and even chicken fights. He got his nickname because of his fondness for "Pinetop's Boogie Woogie" by Pinetop Smith. "They used to call me 'Pinetop' because I played that song," he recalled. He also played drums, often switching back and forth from percussion to piano while working with pianist Willie Love in the 1930s.

In 1943, Perkins, on guitar, teamed up with slide guitarist and singer Robert Nighthawk's band, playing parties around Helena, Arkansas. They also played on Helena radio station KFFA, on a show that advertised Bright Star Flour. Soon Perkins joined harmonica great Sonny Boy Williamson (Rice Miller) on a rival KFFA show, *King Biscuit Time*. The musicians from the show also made local appearances, advertising King Biscuit products. "After we got through with the show, it wasn't but 15 minutes a day, then we would get in the trucks and go to different towns, set up and play. . . . We used to go 'round to different towns, advertising the flour and meal and stuff. They had a piano sitting on the back gate of a truck, and I would be playing up there. Sonny Boy and them would be down on the ground. With Sonny Boy, we was always on the run. We do this here, then gone somewhere. They kept us over in Mississippi all the time. We played down in Bruce, Lambert, and stuff. That kept us going all the time. We worked hard for the company. He'd drive the wheels off the car. . . ."

During that time, a drunken woman, mistaking Perkins for someone who had pulled a prank on her, attacked him with a knife in a Helena cafe, badly injuring his arm. "I played with one arm a pretty good time on the air," he said. "The people said I played more with that one hand than I did with two of them." He became a two-handed pianist again but never regained enough strength in his left hand to chord a guitar.

After leaving *King Biscuit Time*, Perkins moved to Memphis, where he played with B.B. King on WDIA radio, advertising Lucky Strike cigarettes. The pianist stayed a few months in Memphis, then moved to Cairo, Illinois, still playing with Nighthawk, whom he calls the

best slide guitarist he ever heard. Perkins's first foray into Chicago came in 1951, when he recorded with Nighthawk on the Chess label. Perkins says his name didn't appear on that record, "Jackson Town Gal" and "630," because he wasn't in the union.

Perkins worked in Cairo, then in St. Louis, before going to Chicago with guitarist Earl Hooker. In 1969, Muddy Waters hired him to replace Otis Spann. He stayed with the Waters band for 12 years. "Muddy carried me many a place, I can tell you that," Perkins says. "He carried me some places I never would have went because I was scared of airplanes, see. . . . We had some good times, some bad times, too. . . . I liked Muddy. He was like a brother, man."

In 1980, Perkins and other former Waters sidemen formed the Legendary Blues Band, which toured and recorded extensively. In the 1980s and 1990s, he recorded numerous albums and won W. C. Handy Awards for Instrumentalist of the Year. Age had dimmed little of the power of his playing, which over the years was characterized by percussive right-hand fills and an intricate "three-fingered boogie" style (three fingers carrying the entire boogie bass). Despite all the accolades, Perkins has remained matter-of-fact about his ability: "I just had musical talent, I guess. I got big ears. I can hear pretty good."

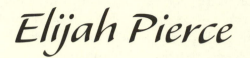

Elijah Pierce

AFRICAN AMERICAN WOOD CARVER

Life dates: March 5, 1892–May 7, 1984

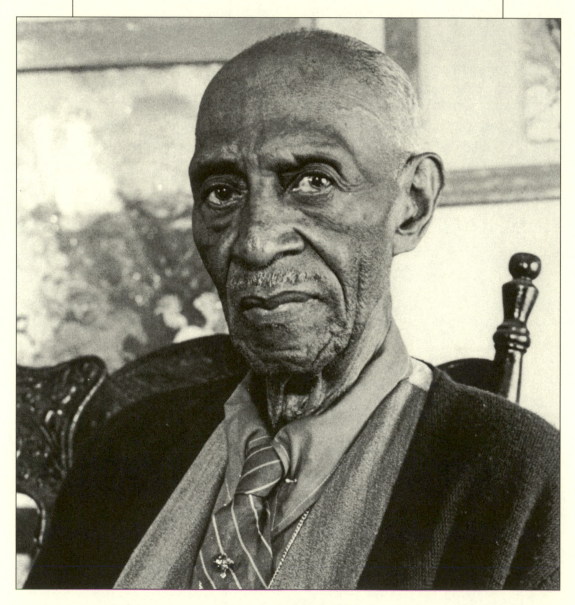

Elijah Pierce, 1982 (Rick Kocks)

*E*LIJAH PIERCE WAS BORN ON MARCH 5, 1892, into a farm family near Baldwyn in northeastern Mississippi. His father was a former slave. When he was nine, his older brother Tom gave him a pocket-knife. "When I was a boy I was always carving," he said. "I'd look at a tree, and I could hardly help it. I'd start carving. I carved pictures of cows, hogs, dogs, Indians with a bow and arrow shooting, girls' names . . . most anything I could think to put on the bark of a tree."

His siblings stayed on the farm, but Pierce didn't like farmwork. He left home in his teens, with a nickel in his pocket, "to see the bright city lights." In 1924 he moved to Columbus, Ohio, where he worked as a barber. He opened his own shop, which he operated until he retired in 1978. Pierce also preached in Baptist churches and continued carving. "One day I got a little piece of wood and I made an elephant," he recalled. "My wife liked it, and she put a ribbon around its neck and put it up on the mantel . . . and I told her, 'If you like that, I'll carve you a whole zoo,' and started to carve every kind of animal I'd ever seen, in pictures, or what I could think of, and from then on, I could see a picture that I liked, or a person would tell me a story; sometimes I'd hear a song or go to church and hear a man preach a sermon, and a picture would form in my mind, and—oh, sometimes it may be four or five weeks, that picture'd come back to me, and I'd get me a piece of wood and start to carve it."

Each summer, Pierce and his wife would load their car with his carvings and travel, displaying his work at fairs, shops, and churches. He would tell the story behind each piece to those who gathered. "Every piece of work I got carved is a message, a sermon, you might say," he said. Many of Pierce's works had religious themes. Perhaps his most extensive and powerful creation was "The Book of Wood," completed in 1932. It includes 33 scenes from the life of Christ. Other carvings depict folk tales, sports and political figures, and scenes from the artist's own life. "Slavery Time" is a panoramic view of plantation life, including a slave auction.

In 1968, an Ohio State University professor attended an exhibit that featured Pierce's work and began a campaign to have the artist recognized. After that, he won numerous honors and his work was widely exhibited. He graciously received a steady stream of visitors to his shop, which he converted to a gallery when he retired.

Konstantinos Pilarinos

GREEK AMERICAN BYZANTINE-STYLE
WOOD CARVER

Born: June 27, 1940

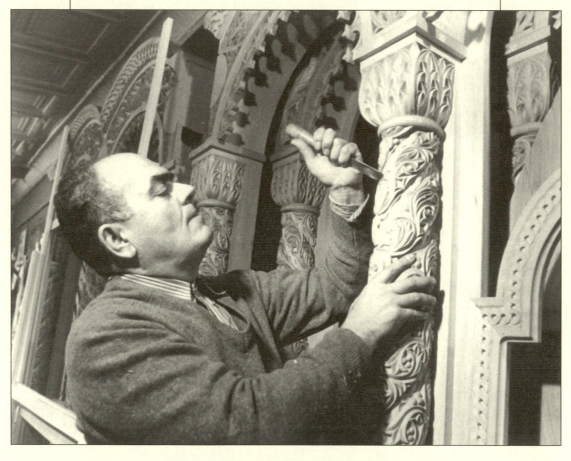

Konstantinos Pilarinos (Courtesy Konstantinos Pilarinos)

KONSTANTINOS PILARINOS WAS BORN JUNE 27, 1940, in the Greek province of Nafpaktos. Orphaned at the age of 13, he was sent to the Zannion Orphanage in Piraeus, where he was apprenticed to the master wood carvers George Kaloudis and Nick Patsakis. At 16, he won first place in an orphanage woodcarving competition judged by the country's minister of culture, Lina Tsaldazis. By age 18, he had established his own workshop.

In 1974, Pilarinos immigrated to New York City. To his knowledge, he is the only traditional Byzantine-style wood carver in North America. He estimates that there are 10 such artists in Greece. The Byzantine style of carving dates back to the fourth century, and while Pilarinos strives to preserve the tradition, he is also an innovator who imbues his work with his own creative spirit.

At his workshop in Astoria, Queens, called the Byzantion Woodworking Company, he and his apprentices carve icon screens, bishops' thrones, pulpits, chanters' pews, and candle stands for Greek Orthodox churches throughout the United States and Canada. He has made more than 60 *iconostasia,* intricately carved icon screens that separate the congregation from the altar. The *iconostasia* screens are 8 to 13 feet high and 32 to 56 feet long, and each holds several iconic paintings. He has also made *epitaphios,* a portable structure representing the funeral bier of Jesus, which is carried in a procession through the streets on Good Friday.

All of his work is done by hand, with an array of chisels. In addition to creating his own designs, he is involved in restoring churches damaged by fire. The New York Landmarks Conservancy gave him an award in 1988 for his restoration work at Brooklyn's Cathedral of SS Constantine and Helen. In 1995, the Greek Orthodox Church awarded Pilarinos the Archdiocesan Medal of St. Paul in recognition of his contribution to the community. Pilarinos is passing on his tradition to his daughter, Penny Pilarinos, who graduated from the architecture program at the New York Institute of Technology and who does preliminary drawings for her father's carvings.

Secular venues, including the Museum of American Folk Art in Manhattan and several museums in upstate New York, have exhibited his work. He also has displayed his art and demonstrated his technique at the Metropolitan Museum of Art and the American Museum of Natural History, and at programs sponsored by the Queens Council on the Arts.

"I like people to see my work," Pilarinos said. "I enjoy contributing to the Greek community so that they can see what they have left behind. You don't find this here. Even in Greece, this is something special. There are only a few who practice this art."

Adam Popovich

Adam Popovich, 1991 (Alan Govenar)

518

ADAM POPOVICH WAS BORN IN 1909 in Denver, Colorado. His father, Nikola Popovich, a Serbian immigrant from Lika (part of Croatia), worked on the railroads and in the coal mines of northern Colorado and Nevada. When Adam and his brothers were young, their parents instilled in them a love of traditional music by teaching them the epic songs of his homeland.

Adam and his brothers, Eli and Ted, began to take *tamburitza* lessons in 1924, walking five miles to an immigrant teacher in a nearby mining town. *Tamburitza* is the term for a family of five-fretted stringed instruments, the *prima, brac, celo, bugarija, and berda.* They range in size from smaller than a mandolin to larger than a string bass.

In 1925, the Popovich brothers formed their own *tamburitza* orchestra and began playing for Serbian celebrations throughout the western states, but they probably attained their greatest popularity in the steel towns of Indiana and in the Chicago area, where they finally settled. Adam played *celo,* and was recognized by his brothers as the "mentor" of the group. Together, they performed at social events—weddings, dances, church socials, and in neighborhood taverns and clubs. For them, "playing *tambura* is a song from the heart."

To support his family, Adam worked as a millwright in the steel mills, but managed to find the time to not only play *tamburitza* music, but to sing in the Sloboda Choir, the church choir at St. Archangel Michael Serbian Orthodox Church. He also studied piano, harmony, and composition with Joseph Kindl, Sloboda's choirmaster, and when Kindl retired in 1936, Popovich became choir director.

Under Popovich's direction, Sloboda became a widely respected choir, known throughout the Serbian American communities for its high musical standards and faithful membership, which included three and four generations of families. As choir director, Popovich led rehearsals and public performances, arranged music, and translated many pieces into the Serbian language.

During World War II, several of the brothers served overseas, and after the war the Popovich Brothers *tamburitza* orchestra resumed playing. The brothers also opened a tavern-nightspot, Club Selo. The club served Serbian food, and local *tamburashi* (*tamburitza* musicians) provided the entertainment. A few years later, they sold the club, and Adam returned to work in the steel mills, continuing his music in his leisure time.

In 1976, Popovich organized a large *tamburitza* orchestra to accompany the Sloboda Choir for their bicentennial concert. Prominent *tamburashi* from all around the Chicago area came to play for him, and together they formed the Chicago Tambura Ensemble with

the membership of about 25 established *tamburashi*. Ensembles of this kind originated in the European nationalistic movements of the late 1800s, when musicians worked to create what might be called a "national" classical music. Deriving their inspiration from these early efforts, the Ensemble built a repertoire that featured orchestral arrangements of traditional Serbian melodies and light classical music by Serbian and other composers. In addition to presenting large-scale concerts, the Ensemble offered musical instruction for young people and maintained associations with other adult groups, such as the Pittsburgh Tamburitza Philharmonic and the Detroit Tamburitza Symphony.

Qi Shu Fang

ASIAN AMERICAN
BEIJING OPERA PERFORMER (CHINESE)

Born: October 11, 1943

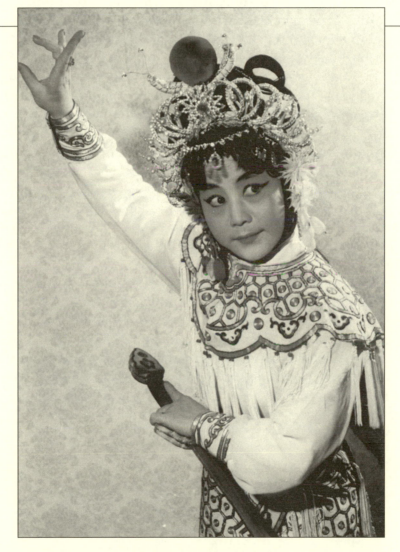

Qi Shu Fang (Courtesy Qi Shu Fang)

QI SHU FANG WAS BORN IN 1943 in Shanghai, China. She began studying Beijing Opera at age four. When she got older, she enrolled at the Shanghai Dramatic School and studied with her sister-in-law, a renowned actress and a skilled *wu-dan*, or woman warrior. Later, she studied with a male teacher and now can play roles of either sex with great skill. Beijing Opera roles are highly defined and stylized, and actors specialize. Qi Shu Fang is unique in mastering both the *wu-dan* and *hua-dan*, or vivacious young woman, roles because of her martial arts skills and exceptional voice.

Historically, Beijing Opera had been a masculine art form and female roles were played by males, but after 1949, women began to emerge as performers. Qi Shu Fang was central in that movement. During the Cultural Revolution, at age 18 she was picked by Madame Jiang Qing, Chairman Mao's wife, to play the female lead in one of the eight national "model operas." Overnight, she became a sensation throughout China.

Qi Shu Fang won first prize in a competition for rising actors, then garnered praise from the master female impersonator Mei Lan-Fang for her performance in *Fighting Thrice Against Chang Yeuh Wo*. Her performance in the *Flaming Phoenix* won acclaim at Hamburg's International Drama Festival, and she is a favorite performer in Japan.

Her reputation as a performer grew because of her skills in martial arts, singing, and acting. Professor Allen Kuharski says, "From a Western perspective, it would be as if one found the voice and acting of Maria Callas and the athleticism of Rudolf Nureyev in one performer's body." She was awarded the title of "National Treasure of China."

In 1988, she relocated to New York City, where she formed her own opera company. Though she did not speak English upon her arrival, she established herself as a star performer in America. The Qi Shu Fang Beijing Opera Company has earned acclaim in the Chinese community and has played to sold-out houses at Symphony Space. For six consecutive years the company took part in Lincoln Center's "From Chinatown With Love." The troupe has performed at many colleges and universities and regularly visits public schools.

Buck Ramsey

ANGLO-AMERICAN COWBOY POET AND SINGER

Life dates: January 9, 1938–January 3, 1998

Buck Ramsey (Courtesy Buck Ramsey)

BUCK RAMSEY WAS BORN JANUARY 9, 1938, in East Texas. His father worked in a munitions plant in the Texas Panhandle during World War II, and after the war he moved his family to the ranch country northwest of Amarillo, near what used to be the town of Middle Well. There his father worked stock and farmed. The family attended a Baptist church, where Ramsey learned shape-note hymns and acquired the rudiments of his musical education.

As a boy, he attended school in a two-room schoolhouse north of the Canadian River, not far from his home. Ramsey's boyhood dream was to become a cowboy; he learned to braid tack from his Uncle Ed, who also taught him to sing the old cowboy songs. When he was in ninth grade, his family moved to Amarillo.

After high school, Ramsey attended Texas Tech University in Lubbock, where his favorite classes were in literature. He even took private lessons in the Greek language from one of his professors. To support himself, Ramsey did some cowboy day work on ranches around Lubbock. Ultimately, his love of the outdoor life was stronger than his academic interests, and he dropped out of college and traveled around the country, doing odd jobs and "this and that."

He returned to West Texas and worked as a cowboy and rough rider on the big ranches along the Canadian River. In 1963, while he was working on the Alibates Division of the Coldwater Cattle Company, a bit shank snapped and the spoiled horse Ramsey was riding threw him to the ground. What he later called "just landing wrong" left him paralyzed and in a wheelchair for the remainder of his life.

With cowboy work no longer an option, Ramsey turned to writing to earn a living. He did freelance work for magazines and newspapers, and nurtured his interests in cowboy poetry. When he was younger he had tried writing poems, but never held onto them. During the rehabilitation after his accident, he began to recount his cowboy experiences in verse. After reading some of the poetry from the annual Cowboy Poetry Gathering in Elko, Nevada, he decided to submit some of his own poems for the following year. That submission helped to launch a second career for Ramsey as a professional cowboy poet, songwriter, and performer. He didn't start playing the guitar until after he was injured. He said, "I kept wanting to sing, but I never thought about singing in public. I started plunking around on the guitar and singing on the back porch with friends."

In 1991, Larry Fiel, host of *Roots Music,* a West Texas public radio program that explores the origins of traditional music, recorded 14 of Ramsey's songs for a cassette album entitled *Rolling Uphill from Texas.* In 1993, this recording won Ramsey the Western Heritage Wrangler Award for Outstanding Traditional Western Music Composition from the National Cowboy Hall of Fame. With Fiel's assistance,

Ramsey also made a sound recording of "And As I Rode Out on the Morning," a 50-page epic poem relating the experiences of a 14-year-old boy's initiation into the cowboy way of life during the middle-to-late 1800s in West Texas. This epic was published by Texas Tech University Press in 1993.

Hystercine Rankin

AFRICAN AMERICAN QUILTER

Born: September 11, 1929

Hystercine Rankin (Roland Freeman)

HYSTERCINE RANKIN WAS BORN SEPTEMBER 11, 1929, on a farm in the Blue Hill community of Jefferson County, Mississippi. "My mother's name was Laula and my daddy was named Denver Gray. My mother taught school about four or five months out of the year in a one-room schoolhouse with a woodstove that went up to the eighth grade. My daddy was a sharecropper who raised cotton, corn, anything else he could grow that we could eat. My father was killed in 1939. He was 33 years old. A white man shot him down in the highway and left him. No reason was ever given. So, we had to move to my grandmother's on my mother's side—Alice Whelman."

When Rankin was 12 years old, her grandmother declared, "Your playing days are over," and began teaching her to quilt to provide cover for her 10 siblings. "When you had 11 kids, that was a lot of cover," said Rankin. Her grandmother was a strict teacher of hand stitching, Rankin said: "If you did something wrong, you pulled it out."

By the time she married Ezekiel Rankin in her late teens, her mother had also died, leaving seven of Rankin's siblings to raise. Rankin and her husband raised them and their own seven children. She helped her husband farm, raising "everything," she said, "cabbage, green beans, peas, whatever ever could grow in the fields and I did canning." In the evenings, or whenever she wasn't working outside, she created three to four quilts per bed and maintained the family tradition of giving each child a quilt when he or she left home.

Because of the utilitarian nature of her quilting, Rankin never thought of herself as an artist. That began to change in 1981 when she was invited to be a resident artist at the junior high school in her hometown of Lorman, Mississippi. That experience helped open her eyes to the artistic dimensions of her work. The rich repertoire of traditional patterns that she learned from her grandmother and other women in the community is beautifully elaborated. These styles include star quilt, string quilt, nine patch, and flower garden.

In 1982, Camille Cosby, wife of entertainer Bill Cosby, bought several of Rankin's quilts. "I never would have thought that when you *had* to quilt, you would ever get a nickel from them," Rankin said. With the help of Mississippi Cultural Crossroads, an arts organization in Port Gibson, she was soon filling orders for more quilts, providing money for her children's college tuition. All seven graduated from Alcorn State University.

Teaching and exhibiting her work heightened Rankin's creative sense. She fashioned a striking sunburst pattern, inspired by seeing the sun's rays break through the clouds one afternoon. Among her most moving works are the memory quilts that portray such vital recollections as picking cotton, plowing with a mule, going to

church in a horse-drawn wagon loaded with children, and her father's murder at the hands of a white man who was never brought to justice. The stitched narrative reads, "I will never forget that morning. He sent me to the spring . . . as I went to dip the water, I heard the 4 shots that killed my father." Other quilts are based on social themes, such as "Parchman Prison," an expression of her concern for "so many kids going to prison for drugs and things." In the center of the quilt is a "prison room" of four-inch squares. Surrounding the room are rows of three-inch multicolored squares representing the guards, the prison yard, and fences.

In 1988, Rankin became the master quilter and teacher at Mississippi Cultural Crossroads. Her solo exhibition "Visions and Dreams: A One Woman Show" was mounted there in 1992. In 1991, she received the state of Mississippi's highest arts award, the Susan B. Herron Fellowship. She has exhibited and demonstrated throughout the South, and has been featured in numerous publications. "The only thing that matters is quilting," Rankin said. "I feel free when I'm quilting."

Ola Belle Reed

ANGLO-AMERICAN APPALACHIAN
BANJO PLAYER AND SINGER

Born: August 17, 1916

Ola Belle Reed with Ralph "Bud" Reed (Courtesy Maryland State Arts Council)

OLA BELLE CAMPBELL REED WAS BORN AUGUST 17, 1916, in Lansing, North Carolina. Her ancestors had moved into the New River Valley area of western North Carolina in the 1760s. Her father, Arthur Harrison Campbell, a schoolteacher and storekeeper, was able to provide for his family of 13 children through frugality and hard work and by maintaining a summer farm in the New River Valley. But the Great Depression proved an insurmountable economic burden, and the Campbell family followed many Appalachian immigrants to northeastern Maryland, where there was good farmland and where jobs seemed more plentiful.

Music was an integral part of the cultural heritage on both sides of Reed's family. Her grandfather Alexander Campbell was a Primitive Baptist preacher and fiddle player. Her father played fiddle, banjo, guitar, and organ and formed a string band with his brother Doc and sister Ellen. An uncle, Herb Osborne, sang mining songs from the coalfields of West Virginia. Her grandmother and mother sang ballads and topical songs in the Appalachian tradition.

As a member of the North Carolina Ridge Runners, Ola Belle Campbell played old-time banjo and sang for the Appalachian migrant audience in the Maryland–Delaware–Pennsylvania area. By the mid-1930s, scores of music parks and picnic grounds had been established throughout the region, each with a sizable audience and concession money to pay and feed the house band. "Back home in the summertime we had carnivals—they were the main thing—and little parks," Reed said. "They were so little that the few times the Ridge Runners played down there, we would be the only show there. I remember one time we came back on a Monday after playing one of these parks. . . . We played every half-hour all day till the park closed. Up here [in Maryland] the parks were bigger and there were more of them, especially in Pennsylvania. There weren't big music parks like that back home."

In 1945, Reed declined an offer of more than $100 per week to join country music star Roy Acuff's backup group. After her marriage to Bud Reed in 1949, she organized a band, the New River Boys, with her brother Alex. In addition to performing, they sponsored musical programs at country music parks, including one they called the New River Ranch. In the mid-1960s, they received national exposure on WWVA, a popular radio station in Wheeling, West Virginia.

Reed continued to perform music with her family, including her husband and son David, often at informal gatherings she organized for her neighbors and friends. "I remember one time we were having a gathering," she said. "Everyone was coming . . . we bought a new linoleum rug for the kitchen . . . and we played and they danced round and round. . . . And I'll never forget, next morning—we never

noticed it at the time—next morning, there was nothing left but black. They wore the whole top off."

Through the years, Reed wrote a number of songs that speak of her Appalachian past and her commitment to family traditions, religious values, and social justice. In 1978, the University of Maryland awarded her an honorary doctorate of letters for her contributions to the arts and culture of Maryland and the United States. Her autobiographical song "I've Endured" perhaps best sums up her personal tenacity: "I've worked for the rich, I've lived with the poor; Lord, I've seen many a heartache, there'll be many more; I've lived, loved and sorrowed, been to success's door; I've endured, I've endured."

Reed suffered a major stroke in 1987 and has been incapacitated since that time.

Almeda Riddle

ANGLO-AMERICAN BALLAD SINGER

Life dates: November 21, 1898–June, 1986

Almeda Riddle (Courtesy Smithsonian Institution)

ALMEDA RIDDLE WAS BORN NOVEMBER 21, 1898, in the foothills of the Ozark Mountains and lived in White and Cleburne counties, Arkansas, for most of her life. During her childhood, her father's work, purchasing timber to be hewn into ties for the railroad, necessitated frequent moves. The family's itinerant life made school attendance nearly impossible. Most of Riddle's formal education took place at home under the supervision of her parents, who were very strict about her lessons.

"My father was J. L. James," she said. "He bought timber, cut timber, worked in the timber for years. And I used to follow him around in the woods. . . . My mother was insistent that I had my lessons—I mean in sewing and everything. She really tried to bring me up a lady. But my father, unfortunately, cooperated with me and brought me up to be a tomboy. He said he had six girls and a boy, and I was the boy."

Riddle's father was a singing teacher and taught Almeda to read musical notation before she was able to read books. He also gave her instruction in the principles of harmony and how to accompany songs on the fiddle and parlor organ. However, he worried sometimes that the old British ballads his daughter was learning "by ear" might keep her from practicing "note singing," and he stopping singing them "for a long period of years."

"My father was a vocal teacher," she said, "though for years he didn't practice it. He sang all the time. He'd go into any community that we went into, and if they didn't have a singing class, he immediately taught a 10-day school. . . . So he sang most of his songs from books, but he knew a lot of ballads."

Riddle learned "The House Carpenter's Wife" from her father when she was a child, but she forgot it until years later when "this old man from the hills of Missouri sang it and reminded me. . . . I don't know, you see, I think I've always had too much of a love of ballads, and it didn't particularly matter what they were about. Plain, bad, good or indifferent, I just loved ballads." Although her singing style was influenced by her father, Riddle often added falsetto leaps, breaks, and vocal decorations that embellished existing versions of traditional ballads.

After the tragic death of her husband and baby in 1926 in a cyclone in Heber Springs, Arkansas, she said, her ballad collection and "everything else was gone." From then on, she raised her three other children by herself and earned a living as a nurse. She stayed busy gardening, sewing, quilting, and reading, but her greatest solace and joy was her singing. She always sang without instrumental accompaniment in the old *a cappella* style of the Southern mountains. Some described her as "singing at the edge of her voice." Her singing

was never rigidly rhythmic, but always displayed a strong sense of pulse, which she frequently marked with her right hand as she sang.

As she got older, Riddle like to be called "Granny." She knew hundreds of ballads, and in performance her retentive memory sometimes churned up yet another stunning song, generally in response to a particular set of circumstances or to an enthusiastic audience. She usually knew several versions of particular songs, but sang the one whose lyrics she liked the best. She preferred the old ballads, or narrative songs, many of which dated back to the Middle Ages. In addition, she knew countless religious hymns and elegant versions of classic children's songs, such as "Frog Went A-Courting" and "Go Tell Aunt Rhody."

Georgeann Robinson

NATIVE AMERICAN RIBBON WORKER
(OSAGE)

Life dates: 1917–March 11, 1986

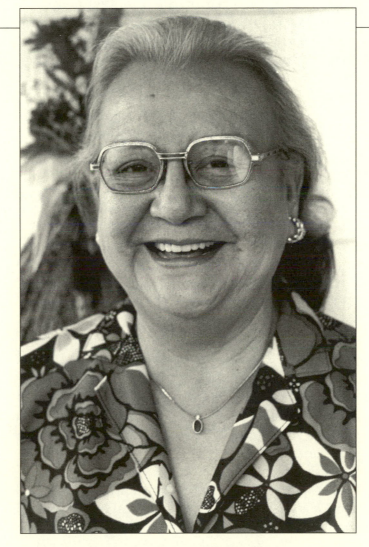

Georgeann Robinson (Daphne Shuttleworth)

GEORGEANN ROBINSON WAS BORN IN 1917 near Bartlesville, Oklahoma. She was a member of the Osage tribe and of the Deer Clan; her Indian name was "My Deer Is Running Pairs." Her parents taught her to honor her American Indian heritage but also to learn as much as possible of the larger world. Following this advice, she attended Webster College for Women in Webster Grove, Missouri, Northwestern State University in Telequah, Oklahoma, and the University of Northern Colorado in Greeley. She majored in history and physical education, and taught both subjects in Oklahoma's public schools for many years.

Robinson liked to say that she "thanked the French Revolution" for the creation of Native American ribbonwork, for it was in the wake of the French Revolution that merchants exported large stockpiles of silk ribbon to North America. During this period in France, silk ribbon and other aristocratic items had negative connotations and were rejected by the revolutionary politics of the day.

In 1958 Robinson established the Red Man Store in Bartlesville. There she and her two sisters, Genevieve Tomey and Louise Red Corn, began to produce the old design of Osage ribbonwork, a form of needlework that they had learned from tribal elders. Soon they were researching additional designs, digging into neighbors' trunks, and traveling to distant museums. In time, their trademark, "Ribbonwork a Specialty," attracted customers nationwide.

Robinson often credited the revival of interest in ribbonwork to the "hobbyists" who came to her store, placed orders for the old-style ribbonwork, and then wore their handmade garments at distant powwows, where others saw the craftsmanship. As the beauty of their ribbonwork became known across the country, interest in the traditional dress styles increased and other Osage people became involved.

By the early 1970s, Robinson's two sisters had died (Tomey in 1969 and Red Corn in 1972). Robinson continued to operate the Red Man Store by herself until 1978, when she had to close the business. During the subsequent years, she remained active as a demonstrator and teacher, participating in festivals at the Smithsonian Institution, the Buffalo Bill Historical Center in Wyoming, and the Wheelwright Museum in Santa Fe, New Mexico, where she exhibited the complete traditional attire she made for an Osage girl and boy.

For most of her life Robinson was active in the St. James Catholic Church and was a member of the City Federation of Women's Clubs, the Bartlesville Indian Women's Club, and the Parents Indian Education Committee. She presented style shows of traditional and contemporary Indian women's dresses to Girl Scout groups, civic groups, and colleges. She made a complete suit of men's straight dance attire for the Southern Plains Museum in Anadarko, Oklahoma.

LaVaughn Robinson

AFRICAN AMERICAN TAP DANCER

Born: February 9, 1927

LaVaughn Robinson (Patented Photos)

537

LaVaughn Robinson was born February 9, 1927, in South Philadelphia, Pennsylvania. He learned to dance from his mother at the age of seven. "My mother taught me my first time," he said. "She taught me in the kitchen of our house at the time, because it had hardwood floors." Soon he was dancing for tips on downtown and South Philadelphia street corners.

"Then I learned by being on the street with other dancers. We all came up on the streets of Philadelphia and had a tramp band where we played homemade instruments—a washboard that we played with our fingers, cymbals on our fingers, a big wash tub with catgut string . . . similar to a bass . . . and we always had a bazooka [toy instrument] with us. And danced on the street and passed the hat. We call that *busking* [impromptu appearances]. But to us it was going to work."

Robinson enlisted in the Army in 1945, and during his years of service he performed from time to time in military facilities around the country, honing his dance skills and picking up experience. After his discharge in 1947, he embarked on his professional career, and over the years he appeared with Cab Calloway, Tommy Dorsey, Maynard Ferguson, and Ella Fitzgerald. "Everything we did [with tap] at that time was with music. . . . I've had several dancing partners—Howard Blow, Henry Meadows, Eddie Sledge—and I've been with big bands . . . Ray Anthony's band, Louis Kramer's big band."

By 1972, Robinson was forced into temporary retirement, like many of his contemporaries, because the stage and nightclub life that had supported him had declined, as discotheques became increasingly more popular and electronic instruments drowned out the sounds of the tap dancer. Throughout his career, Robinson had maintained his base in the city of Philadelphia, where he kept strong ties with his family and community. In 1980, he entered upon what was to become almost a second career: He was invited by Philadelphia's College of the Performing Arts to help build its tap dance program. He also taught tap in Washington, D.C., Boston, and Portland, Maine. "I feel good about it [teaching] because I see a lot of the students," he said. "I get calls every now and then from a company that wants me to teach a piece of material. . . . Special material that I teach. Everybody teaches their own material and everybody teaches different. No two hoofers [tap dancers] are alike."

Unlike many of his peers, Robinson retained a solid appreciation of the street sounds from which tap emerged. He helped in the "discovery" of street poet and rhythmic artist Horace "Spoons" Williams and brought him to the attention of the International House of Philadelphia and the Philadelphia Folk Festival.

In performance, Robinson stresses the vernacular origins of tap, an art form grounded in community tradition and honed by generations of tap masters, many of whom, such as Honi Coles and the Nicholas Brothers, grew up in Philadelphia. Robinson has worked as a teacher and advocate for public understanding and appreciation of the tap dance tradition.

Emilio and Senaida Romero

HISPANIC AMERICAN CRAFTSWORKERS IN TIN AND EMBROIDERY

Born: July 18, 1909 (Senaida) and 1910 (Emilio)

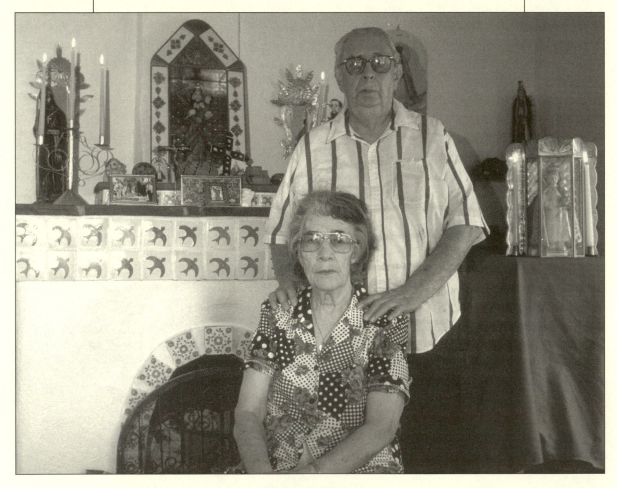

Emilio and Senaida Romero (Tom Pich)

SENAIDA AND EMILIO ROMERO HAVE WORKED TOGETHER as a team since they married in 1930. She was born July 18, 1909, in Ojo de Vaca, New Mexico, and he in 1910 in Santa Fe, New Mexico. Senaida recalled seeing her grandfather working with tin as a craftsman. He traveled through northern New Mexico for weeks at a time, returning in a wagon laden with beans, corn, and other goods he had traded for his wares.

Emilio learned tinsmithing in the Civilian Conservation Corps camps during the Great Depression. Because tin was hard to come by, he cut and flattened five-gallon cans still bearing the inscription of the product. In the late 1930s, he worked for the Forest Service. During the early 1940s, with the United States embroiled in World War II, the couple moved to San Diego, California, where Emilio worked in a factory building airplane wings. Then he worked as a sheet-metal worker for the Zia Company in Los Alamos for almost 30 years until he retired.

In the late 1950s, he began doing tinwork again to supplement the family income. He started by duplicating museum pieces, then developing his own patterns. After his retirement, he did tinwork full-time. He adapted sheet-metal tools for use with tin. His wife began helping him, and he trained her in the work as well. She also became proficient at the art of *colcha* (coverlet) embroidery, which has been used in northern New Mexico for more than 100 years to adorn churches and altar pieces. This led to her idea of placing her *colchas* in ornamented tin frames.

The Romeros specialized in traditional Spanish Colonial objects, such as candleholders and sconces, gilded mirror frames, and the little *nichos* for carved wooden saints. They also created many useful pieces, including light fixtures, switch plates, and telephone-book holders. Many of the works of tin or tin and *colcha* that the Romeros have created over the years are in the permanent collections of museums in the United States and abroad. Through their lives and work, the Romeros influenced many craftspeople, and several of their seven children have become traditional New Mexico *artesanos*, working with metal or other materials.

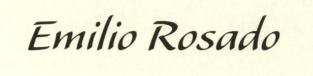

Emilio Rosado

PUERTO RICAN WOOD CARVER

Life dates: May 28, 1911–November 6, 1996

Emilio Rosado (Courtesy Emilio Rosado)

DON EMILIO ROSADO WAS BORN MAY 28, 1911, in the municipal-
ity of Utuado on the island of Puerto Rico. Friends and family say
that they remember the moment he was born: all of the roosters in
the neighborhood began to crow, and they continued to crow until
they became hoarse, honoring the infant who was to become the
greatest bird carver in Puerto Rican history.

Rosado came from a family of carvers. His grandfather's brother,
Tacio Ponce, carved oxen yokes and machete handles for a living
and walking sticks as a hobby. His father carved all the handles for
his tools, and his brother carved as well. Rosado began carving
around the age of 14, making small animals or balls to play with.
Sometimes, while he was learning, he carved a sweet potato until he
mastered the form he wanted. His first sale brought $5 for a dove.

Growing up, Rosado shifted his attention to the carving of roost-
ers, and his roosters soon earned him the reputation as a major
Puerto Rican craftsman. Over the years, he carved literally thou-
sands of roosters, each displaying his distinctive style. Rosado raised
roosters himself, and loved to talk about their different characteris-
tics—their varied shapes, colors, and tail feathers, and the angles of
their beaks and combs. Occasionally, when he was working on a par-
ticular rooster carving, he asked one of his sons to hold the actual
bird in his hand so that he was able to study its special qualities. In
the end, Rosado never strived to make an exact copy, but rather to
create a representation imbued with the presence of an individual
bird.

Rosado's roosters were carved from a single piece of cedar, and
were either mounted on a separate wood base or left free-standing.
Each bird shows the long, free swoop of line from the bird's crest
through to the tip of the tail feathers that is so characteristic of his
work.

The Institute of Puerto Rican Cultures owns more than 40 of
Rosado's birds, and invited him to join its sculpture division. Rosado
appreciated the invitation, but said he preferred to remain an inde-
pendent artisan working among the beloved roosters of his home-
town of Utuado. "Cedar," he said, "is a special wood with a special
story. When you cut down a cedar tree, there is always a small hollow
inside; that is where the Blessed Virgin hid on the flight from Egypt.
And that is why cedar smells so wonderfully good, too."

Mone and Vanxay Saenphimmachak

Asian American Weavers (Laotian)

Born: July 7, 1952 (Mone)

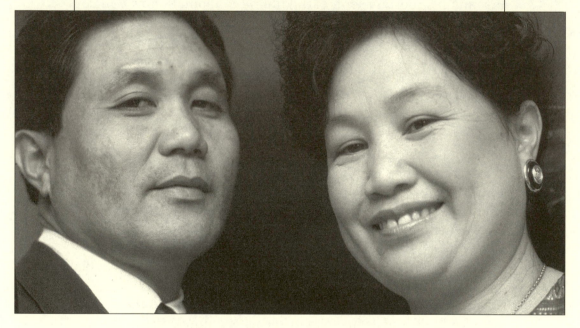

Vanxay and Mone Saenphimmachak, 1993 (William K. Geiger, Courtesy National Endowment for the Arts)

MONE SAENPHIMMACHAK, BORN JULY 7, 1952, was raised in Mahasai, a small village in central Laos. As a child, Mone observed her mother's skill at many forms of needlework. When she was 12, Mone began in earnest to learn the techniques of weaving and embroidery at which she was to become so skilled. "When I start weaving, it makes me sad," she said. "I remember when my mother teach me. I keep the weaving all the time because I am Lao people."

Many of the weavings Mone watched her mother make were decorated with traditional Lao embroidery, using one or two techniques: the tiny counted cross-stitch or the counted surface satin stitch. Both are accomplished on the closely woven grid of cotton *aida* cloth. The satin stitch is used primarily to embellish the solid-colored *sarong* worn by Lao women on special occasions. The cross-stitch, though sometimes used to make a border on a *sarong,* is traditionally applied in the decoration of bags, pillows, and other household items.

When Mone married her husband, Vanxay Saenphimmachak, he discovered that his own skills were lacking. "Usually a man learns how to make a loom from his father, but my father had a cargo boat, and he traveled a lot. I never learned from him," he said. "When I got married to Mone, her father laughed at me and said, 'Why did you get married if you don't even know how to make a loom?' I was embarrassed and studied with him very hard. After one year, I was able to make a pretty good loom for Mone. Then she could weave clothes for our family and sell some to make a little money."

The area in which the couple grew up was influenced strongly by Indian civilization. Part of this cultural legacy was a tradition of fine, highly decorative weaving and precisely executed embroidery marked by intricate geometrical designs and motifs of everyday life, such as elephants, deer, and roosters.

After the Communist takeover of Laos in 1975, the couple left the country. They and their four children were eventually resettled in St. Louis, Missouri. The culture shock was severe. But Mone soon found that her skills at weaving and embroidery could help to translate Lao culture to succeeding generations in her new homeland. She weaves, she says, "so Lao people love one another. . . . And we may recognize ourselves by those patterns."

Vanxay has made several looms, allowing his wife to teach others or to work on several pieces at once. His looms became more elaborately decorated works of art in their own right. "Only women weave, but they cannot weave unless men make looms for them. Men build the wood part and women tie the threads together to make a new warp. Then men and women work together to put the warp threads onto the frame he has built. Only men or only women is no good. You have to both finish the loom."

Marc Savoy

CAJUN ACCORDION MAKER AND MUSICIAN

Born: October 1, 1940

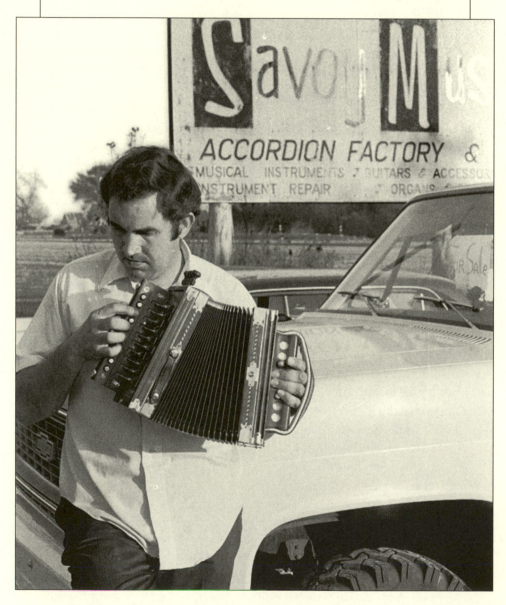

Marc Savoy, 1975 (Nicholas R. Spitzer)

546

MARC SAVOY WAS BORN OCTOBER 1, 1940, on an isolated rice farm near Eunice, Louisiana, in the rich cultural milieu forged by French-speaking Acadian (from which the term "Cajun" is derived) refugees from eastern Canada who immigrated to southwest Louisiana in the late eighteenth century. The first time music made an impression on him was when he was seven years old and visiting his grandfather. He recalls, "After a while, my father asked my grandfather, 'Pop, get out your fiddle and play us a tune.' My grandfather slowly got up, went into one of the back rooms, and returned with a small oblong black case which he proceeded to open with the most gentle affection. From the little black case, he removed a very odd-looking wooden object and began turning little pegs while plucking the strings. At this young age . . . I think the thing that impressed me as much as the sounds being emitted from the little wooden box was the look that came over my grandfather's face . . . it was as though he was no longer in the room with us. From that moment on, I remember thinking 'When I grow up, I want to be able to make sounds like that.'"

From that day on, Savoy spent nearly every afternoon with the French-speaking older men who gathered at his grandparents' home playing music and reminiscing. For him, those older folks represented "a way of life that was like a big, soft, warm blanket on a winter night." Growing up, he fell in love with the button accordion but couldn't find anyone to teach him to play it or to make one. When he was 12 years old, he made one himself from household items, such as his grandmother's tablecloth that he used to line the cardboard bellows, and toilet float rods to make the levers that attached to the keys.

Later, his father bought him a new instrument from the Sears Roebuck catalogue for $27.50. By the time the accordion arrived, Savoy said, he felt that he was already able to play. "With all the music that I had soaked into me before my new accordion arrived, it was only natural that some had leaked out through my fingers on the buttons. . . . There were certain things I wanted to do, but my instrument couldn't keep up with."

When Savoy was not playing his accordion, he was disassembling and reassembling his Hohner to see how it worked. One day, his family attended a party at his father's cousin's home. Cyprien Landreneau and his cousin Alton Landreneau, an extraordinary accordionist, were providing the music for the party. "The moment we arrived," Savoy says, "I jumped out of the car and, hearing the sound of the accordion, I told my family 'Wow! Listen to the sound of that accordion!' My father said 'What do you mean? It's just an accordion.' I replied 'Oh, no, it is not.'" Savoy eventually learned that this accor-

dion was a pre–World War II Monarch instrument from Germany. Later, he was able to purchase a dilapidated Monarch accordion, which he restored to mint condition. Word of his restoration skills spread, and soon he was repairing other people's instruments. Gradually, Savoy developed very specific ideas of what an ideal accordion's timbre, tone, and performance capacities should be.

While developing his ideal accordion, Savoy continued his formal education and earned a B.S. degree in chemical engineering. After graduation, he interviewed with a major chemical company in the Northeast and decided two things: He did not want to leave Louisiana, and he wanted to pursue his interest in accordions more than he wanted to be a chemical engineer. In 1965, he opened a music store and went full-time into the business of building accordions.

Over the next decade, Savoy's Acadian instruments became widely recognized and were in demand by musicians who appreciated their superior tonal quality. His accordions were used primarily, but not exclusively, by Cajun musicians. However, after Savoy heard French Canadian accordionist Philippe Bruneau play, he realized how limited his knowledge of accordion music actually was. Having been raised within the Cajun music tradition, Savoy didn't fully understand how varied the different accordion musical styles were. He was inspired by Bruneau's musical genius and applied that inspiration to building an accordion for Bruneau that would meet his personal needs. In addition to stimulating his interest in more diverse accordion musical performance styles, Savoy's exposure to Bruneau increased his awareness of how Cajun music had been influenced by the country and western style.

In 1977 Savoy married Ann Allen, a native of Virginia, and over the years they have performed together in the United States and abroad. Ann Savoy has written extensively on the history of Cajun music, and has worked and performed with her husband to preserve traditional Cajun culture.

Earl Scruggs

ANGLO-AMERICAN BLUEGRASS
BANJO PLAYER

Born: January 6, 1924

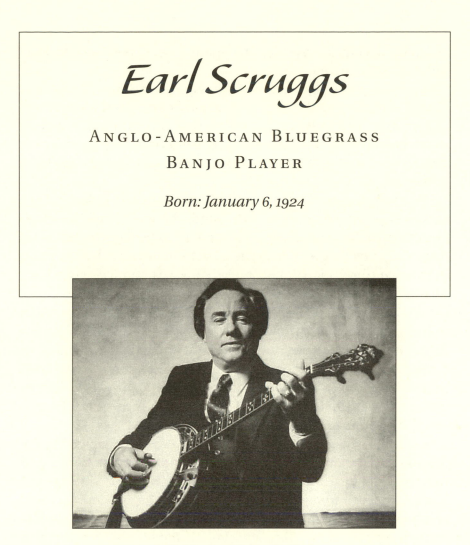

Earl Scruggs (Norman Seeff)

*E*ARL SCRUGGS WAS BORN JANUARY 6, 1924, near Shelby, North Carolina, in an area known as the Flint Hill community. His father, George Elam Scruggs, was a banjo player and fiddler, but Earl's memories of him are vague. He died when Earl was four years old, and although his mother, Lula Ruppe Scruggs, was not a musician, she encouraged him to learn to play. In a short time, Earl was teaching himself. His brothers, Junie and Horace, and his older sisters, Eula Mae and Ruby, all played banjo and guitar, but his biggest influence came from a relative, Smith Hammett.

Scruggs watched and listened to Hammett's banjo carefully, and by the age of six, he was able to play tunes and was starting to emulate Hammett's form of North Carolina three-finger picking. By the age 10, Scruggs had invented the basic syncopation that, superim-

posed on the older three-finger technique, was to become known as "Scruggs-style" banjo.

As a teenager, Scruggs took a job working in a textile mill, but continued to play his banjo. He played for local dances and social affairs and on area radio stations, but his musical aspirations at that time were mediated by his sense of responsibility to help support his mother after his brothers and sisters married and moved away from home.

The music business was, he said, "like looking into a dark room," and after playing with a few local bands, he was "forced to weigh carefully whether it would be stable or not." As he began to refine his three-finger picking technique, he wasn't sure whether he was going in the right direction with his music. "I wasn't happy about what I was doing," he said, "but I didn't know what to do about it."

In 1945, after the end of World War II, his mother encouraged him to pursue a career as a professional musician. He had the opportunity to meet Bill Monroe, who soon asked him to join his band, The Bluegrass Boys. Over the next three years, that band, which consisted of Monroe on mandolin, Scruggs on banjo, Lester Flatt on guitar, and Howard Watts on bass, was immensely successful and established the sound that became known as "bluegrass."

In early 1948, Scruggs quit The Bluegrass Boys, discouraged by the demands of the music business, and returned to North Carolina. A few weeks later, Flatt also resigned, and soon thereafter he and Scruggs decided to organize their own group, beginning on a radio station in Bristol, Tennessee. Their theme song was a Carter Family tune, "Foggy Mountain Top," and from it the new band derived its name, the Foggy Mountain Boys.

By the late 1950s, a combination of recordings, radio shows, extensive touring, and a syndicated television show had made the name Flatt & Scruggs synonymous with bluegrass. They recorded "The Ballad of Jed Clampett," the theme song for *The Beverly Hillbillies* television show, on which they made frequent guest appearances. Later, the Scruggs classic "Foggy Mountain Breakdown" was used as the theme of the film *Bonnie and Clyde,* and he received a BMI and Grammy Award for that tune.

In 1969 he separated from Lester Flatt and formed a new band, called the Earl Scruggs Revue, featuring his sons, Gary, Randy, and Steve. "The rhythm patterns for much of the Revue material were different from what I had done for so long," Scruggs said. "But Gary and Randy had been playing a lot . . . at home, and I was sitting in on a lot of jam sessions with them, and friends would drop by; so really it didn't jump out at me all that much. It has been a refreshing, happy, and rewarding challenge." Scruggs continued to perform into the 1980s, but he had to curtail the rigors of touring.

Duff Severe

ANGLO-AMERICAN SADDLE MAKER

Born: 1925

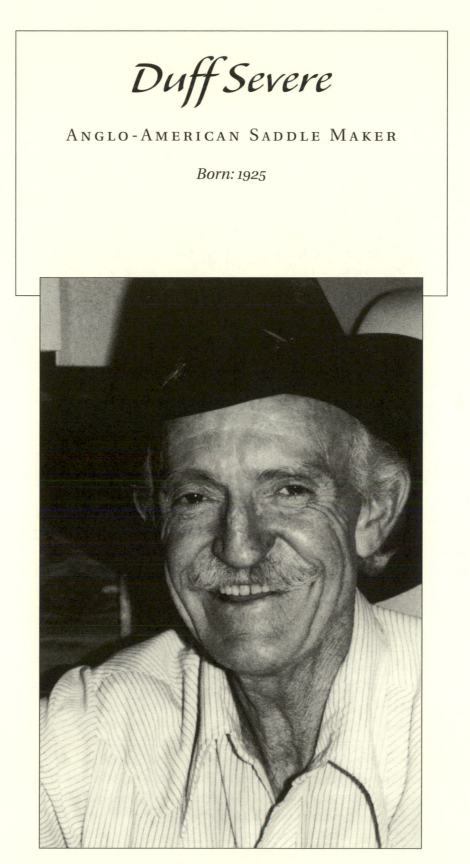

Duff Severe (Ormond Loomis)

DUFF SEVERE WAS BORN IN 1925 in the small Mormon town of Oakley, Idaho. His father and grandfather were ranchers, and Duff developed an interest in leatherwork early on. "They needed articles on the ranch," he said. "You just had to make your own things or go without. . . . I remember when I was about—must have been about 14, when I really observed—not only my father, but other old western cowboys that'd take these old bloody, hairy hides, and they'd take the hair off and clean 'em up. Pretty soon they'd have something beautiful braided out of it. It really impressed me, and I thought, that's something I'd really want to learn. So, I learned what I could from those old fellows. . . . All my life, I've been trying to add to what I learned from them."

During World War II, Severe served in the Navy and was stationed in the San Francisco Bay area, not far from the saddle shop of the legendary Luis Ortega in Walnut Creek, California. As a working cowboy and saddle maker who had moved with his family to Oregon, Severe was very familiar with the quality of Ortega's craftsmanship, but also knew that Ortega was very guarded about the specifics of his rawhide knowledge. In his free time, Severe went to see Ortega and talked to him about his experiences as a buckaroo (an anglicized form of the Spanish word *vaquero*, meaning cowboy) in the early 1900s, but was careful not to mention rawhide braiding because he thought Ortega might put away his work if he did. After each visit, Severe went back to the base and practiced what he saw Ortega doing, and over time he learned about Ortega's methods and technique without having to ask. Years later, Severe nominated Ortega for a National Heritage Fellowship, which he received in 1986.

Though Severe's interactions with Ortega were limited, Ortega had a profound influence. From San Francisco, Severe went to Hawaii and was at Pearl Harbor when it was attacked. He fought on Guadalcanal and was aboard the USS *Helena* when it was sunk. In 1946, he apprenticed himself to the Hamley Saddle Company in Pendleton, Oregon. He spent 10 years with that firm learning his trade, then went into business with his brother Bill, who also had worked at Hamley. Bill learned to build saddle trees, and Duff specialized in making the saddle on the tree. Severe saddles have an international reputation; orders have come in from as far away as Australia.

Over the years, Severe became renowned for his skill at braiding horsehair and rawhide. He also applied these skills to decorating bottles and creating jewelry, using the same basic knots found in horse gear. However, to enhance the effect, he often dyed the rawhide strips with laundry dyes.

Severe was willing to accept apprentices who wanted to learn saddlemaking, but resisted teaching them to braid. After receiving the

National Heritage Fellowship in 1982, he realized that his knowledge of rawhide braiding might die with him, and decided to take his nephew, Randy Severe, as an apprentice. Randy has become a skilled braider in his own right, and has devoted himself to helping to preserve the tradition of rawhide work.

Morgan Sexton

ANGLO-AMERICAN APPALACHIAN
BANJO PLAYER AND SINGER

Life dates: January 28, 1911–January 30, 1992

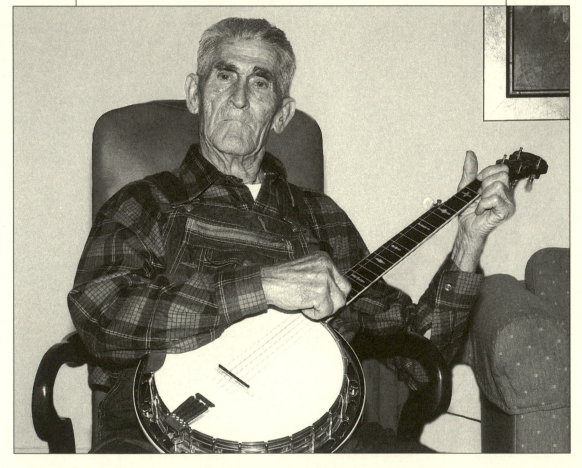

Morgan Sexton, 1991 (Alan Govenar)

*M*ORGAN SEXTON WAS BORN JANUARY 28, 1911, in Linefork, Kentucky, to Shaderick (Shade) and Harriet Cornett Sexton. As a young boy, he said, "my cousin, Press Whitaker, and me got some old lard buckets and cut the bottoms out and fixed us some banjos. They sounded awful, but we played them like they were real banjos."

Sexton's father was a banjo player and he began to teach his son to play, but shortly thereafter he became ill and died, leaving his wife with seven children and no source of income. "When I was about 11 years, I quit school to go to work for my uncle gathering crops. I was 13 when I worked in a sawmill for 50 cents a day. From there, I went to work cutting railroad ties," Sexton recalled.

Despite the long hours and hard labor, Sexton continued to play the banjo, helped along by his sister, Hettie. When he was 17, he bought his first real banjo for $10.86 from the Sears Roebuck catalogue. "I had to walk four miles to Ulvah to pick it up," he said. "I played it all the way back home. I would try to play it every day when I got home from work."

Sexton was 25 when he met and married his wife, Virgie Hayes. At that time, he was working "up on Bull Creek logging timber." A year later, he started working in the coal mines. "This was long before they started to use the rockdust [powdered limestone] they use now [to keep the coal dust down]." The conditions in the mines were oppressive, and by the time Sexton retired in 1976, he had contracted silicosis, a disease of the lungs caused by coal [or quarry] dust.

Over the years, playing the banjo was a great joy for Sexton. Throughout his lifetime, he played for his family and friends, keeping active his repertoire of hundreds of traditional ballads, love songs, and dance tunes. When neighbors came to his house, he liked to entertain them with his music and stories of his childhood in Kentucky. Everyone in Sexton's family played the banjo, including his mother, who died in 1947.

Both Sexton's singing and instrumental styles were unaffected by contemporary influences and musical ideas. His banjo picking was a delicate and absolute individualized version of the Appalachian two-fingered style, liquid and serene, each melody using its own particular tuning in the old-fashioned way. Although Sexton usually played by himself, he was sometimes joined by his neighbor Boyd Watts, a fiddler, at schoolhouse events, at Christmas, and in end-of-the-school-year programs. At square dances, however, the banjo alone was passed from one player to the next.

During the last decade of his life, Sexton began to play and sing in public, performing at the Celebration of Traditional Music at Berea College and the Seedtime on the Cumberland Festival in Whitesburg, Kentucky, in addition to demonstrating his talents on many ra-

dio programs and at local events. He was honored at the Banjo Institute in Lebanon, Tennessee. Sexton prided himself in preserving the old-time banjo styles he learned growing up and in teaching his nephew, Lee Sexton, to carry this tradition on for future generations.

Simon Shaheen

ARAB AMERICAN OUD PLAYER

Born: 1955

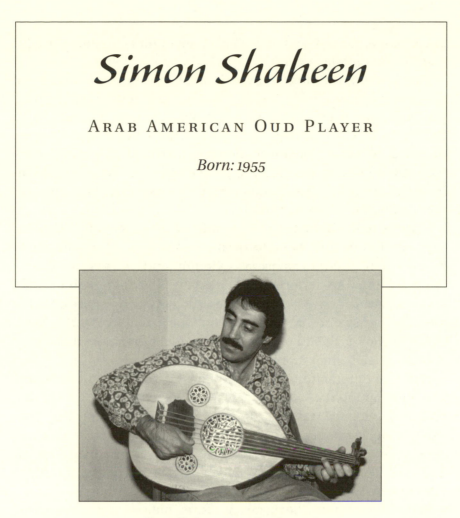

Simon Shaheen, 1991 (Alan Govenar)

SIMON SHAHEEN WAS BORN IN 1955 in Tarshiha, a Christian village in the Galilee region of northern Israel. He began playing the *oud* (also, *ud*), a pear-shaped, nonfretted Arabic lute, at age four. Under the tutelage of his father, Hikmet Shaheen, a renowned teacher and composer of Arabic music, Simon performed his first public improvisation at age six.

About his early years as a musician, Shaheen says, "What my father taught me was a very vast range of Arabic musical tradition. For example, I was exposed to classical genres and repertoires. I was exposed to traditional folkloric music. In the beginning, at four, I started to hold the instrument and play on it just by listening and watching my father, who was a great *oud* player. My whole family is

musical—so, to grow up in this kind of environment, automatically, you are susceptible to music."

After moving with his family to Haifa, Shaheen studied Western classical violin at the Rubin Conservatory and went on to Tel Aviv, where he earned a B.A. in music and Arabic literature. Between 1973 and 1978, he took part in the extended performance series of Arabic music for National Israeli Television and Radio, but then decided to move to the United States to complete an M.A. in Music Education from Columbia University and an M.A. in Music Performance from the Manhattan School of Music.

"I came [to the United States] to continue my education," Shaheen says, "and to be able to perform to a wider range of people. Back home in Israel, performance was kind of limited. I wanted to expand. I wanted to perform internationally. I wanted to go to Arab countries, which I was not permitted to do because I was living in Israel. The borders at that time were not open. So, it was only after I came to New York and obtained an American passport that I was able to travel to other Arabic countries."

Through interactions with people and performers in Syria, Lebanon, and Jordan, Shaheen enlarged his repertoire. "One of the unique qualities of Arabic music, especially when we improvise, is to play the quarter tones, or microtones—those are the tones that appear in between what Western music perceives as a complete or half-tone. So, these microtones, which may be difficult for the Western ear to recognize, give the music a richness and beauty."

In the United States, Shaheen has proven himself a versatile, virtuosic, and creative musician who knows few boundaries, social or musical. Upon his arrival, he made his living playing at a wide range of social occasions for Middle Easterners of many backgrounds. Increasingly, his exquisite talents have been recognized by critics and presenters, bringing him a greater opportunity to display his concert-oriented, creative skills.

Shaheen formed the Near Eastern Music Ensemble in 1982 to play high-quality traditional Arabic music from different regions of the Middle East. The ensemble consists of students and great musicians who share a passion for Arabic music. For most performances they perform with an ensemble of between 6 and 18 musicians, but they have used the larger ensemble of 27 musicians for festivals and other performances that can support more people and a larger sound.

In Arabic cultures, most musicians do not feel impeded by the boundaries of categories, such as "folk," "classical," and "popular," as they move freely between repertoires and styles intended for different occasions. This is especially apparent in the performance of the *ud*, which has been integral to Arabic musical tradition since at least the seventh century and continues to appeal to musicians of diverse

backgrounds, both rural and urban. The *oud* has great stature as a vehicle for highly developed artistry and remains an important source of identity and common ground among Arabs and other Middle Easterners. Over the years, Shaheen has emerged as a leader, not only in the performance and development of new compositions for the *oud,* but in the shaping of American attitudes about Arabic music.

Joe Shannon

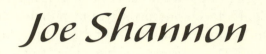

IRISH AMERICAN UILLEAN PIPER

Born: 1920

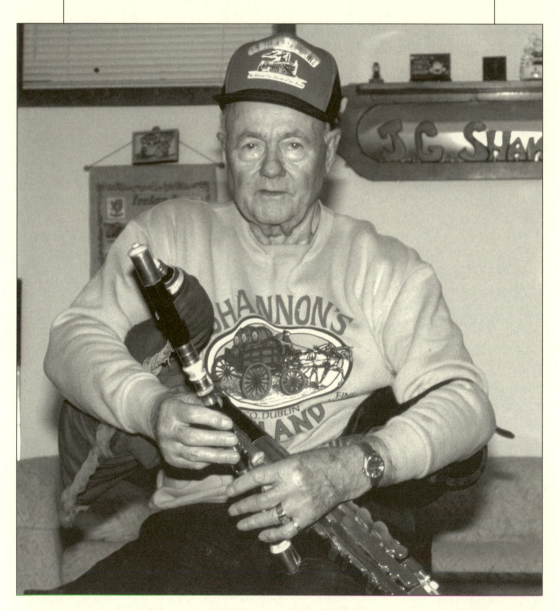

Joe Shannon, 1991 (Alan Govenar)

*J*OE SHANNON WAS BORN IN 1920 near Kiltimagh, in County May, Ireland. All of his seven older brothers played traditional music. When he was a young boy, his cousins and neighbors gathered at night at his family's home to play fiddles, flutes, tin whistles, and melodeons. Shannon began to play the tin whistle, but at first had a hard time keeping up with the others. "I had to learn," he said, "because there was nothing else, and at that time, when I was a kid, there was no radio. There would be people that would come from the villages around that would come into my house because they knew it was a musical house, see. I heard all this traditional music being played while I was growing up in Ireland, and I never lost it."

In 1926, his family immigrated to the large Irish community in Chicago, Illinois, looking for a better life. There, Shannon became interested in the *uillean* pipes, a distinctive form of the bagpipe that emerged in Ireland in the early eighteenth century. The *uillean* (the Gaelic word for elbow) pipes have a chanter with a two-octave range and a bellows instead of a blowpipe to inflate the bag. To play the instrument, a musician fingers the chanter with both hands, while using one elbow to work the bellows and the other elbow to operate a set of regulators or extra pipes to produce harmonic or rhythmic accompaniment. By the 1920s, the once-great tradition of playing the *uillean* pipes had almost vanished.

Shannon was introduced to *uillean* pipes by his uncle, Eddie Mullaney, who taught him the rudiments of playing this most difficult of Irish instruments. Encouraged by his cousin and using an instrument lent to him by another musician, flutist Paddy Doran, Shannon learned to play bagpipes while still in elementary school. "I was so small," he recalled, "I had to stuff books around my stomach to keep the pipes from falling off me."

Later, Shannon said, the pipe maker Patrick Henneley "provided" him with a full set of pipes. Although he never took formal lessons, he was heavily influenced by local musicians and especially by the early recordings of the famed *uillean* pipers Patsy Tuohey and Tom Ennis. In 1934, Shannon was invited to play in the Irish Village at the Chicago World's Fair with the *céilí* band organized by step dancer Pat Roche. After the World's Fair, Roche's Harp and Shamrock Orchestra made several recordings for Decca.

When the Roche group disbanded, Shannon continued playing at Irish functions throughout the Chicago area. However, opportunities for public performances of Irish music waned during the Depression, World War II, and the immediate postwar period. Local musicians played for fund-raisers and community events, but the significance of Irish music in the daily lives of the Chicago Irish seemed to fade. Shannon was part of this larger societal shift as the

priorities in his life changed. He married and had a family, and to earn a living he became a fireman and put aside his music.

In 1967, Eddie Mullaney gave him his set of pipes that were made by Taylor of Philadelphia around 1880, and Shannon began to play again with a renewed fervor. After retiring from the fire department, he devoted himself to his music. He played with the Chieftains, and resumed his local performances at community events.

Over the years, playing jigs, reels, and hornpipes, Shannon developed his own style, utilizing an American-influenced kind of ornamentation with single and double grace notes, passing tones, trills, single rolls, double-cut rolls, and staccato triplets. "They refer to my piping as the American style of piping," he said, "because we're different than what they do in Ireland, that's all. I learned from records, recordings of great pipes that were here in the early part of the century in the 1900s, guys that weren't never in Ireland. The tones are the same but it's just something that's in me, see. It seems that I grace every note, and I don't know, just fast movements of the fingers. I'm doing it, and I don't know I'm doing it."

Harry V. Shourds

ANGLO-AMERICAN
WILDFOWL DECOY CARVER

Born: July 24, 1930

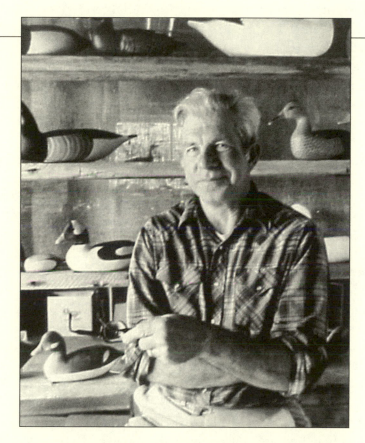

*Harry V. Shourds (Michael Bergmaen, Courtesy New Jersey State
Council on the Arts)*

*H*ARRY V. SHOURDS WAS BORN JULY 24, 1930, on the New Jersey coast He is a third-generation decoy carver. His grandfather Harry Vinuckson Shourds (1861–1920), for whom he was named, lived in Tuckerton, New Jersey, in the Barnegat Bay area. He has been described as perhaps the greatest professional decoy maker in New Jersey at a time when Tuckerton could be said to be the handmade duck decoy capital of the United States.

Though Harry never knew his grandfather, he did recall the stories people told about him. "He gunned [market hunted], shot ducks, picked them, packed them on ice, and shipped them on the railroad in barrels. They would save the feathers and my grandmother would make pillows and feather beds out of them. Everything was used from the duck in those times. . . . [My grandfather] he'd go down and get a haircut and while in the barber's chair, he'd whittle a duck head. By the time the barber was through cutting his hair, he was finished with the head. And with the decoys he made, he must have spent every spare minute of his spare time just carving." About 90 percent of his grandfather's decoys were Greater Scaup, Black Ducks, Brant, and Canada Geese.

Harry's father, Harry M. Shourds, died when Shourds was 12, so he is largely self-taught as a carver. "My father was a painting contractor, but in the winter he made decoys. Over the years, he made around three or four dozen decoys in the winter. They sold for approximately $25 a dozen. I remember sitting there watching him make decoys, and I would carve a little with him."

Despite that proud family history, Shourds said, "I hate to copy someone else, even if it's someone in my family. . . . I make my own ducks. And I think each one [in my family] did. You can tell my grandfather's duck from my father's duck, and you can tell my duck."

In describing his own distinctive style of carving, Shourds said, "I use Jersey white cedar, which grows in the swamp, for the wood. It is a wood that's used on boats and shingles. It's a durable wood for outdoor use. The decoys are made in two pieces, the top half and the bottom half. Both halves are hollowed out to make them light, and it gives them air space so they won't crack over the years. . . . Then, that's put together and caulked, just like you would a boat, so it won't leak. The head is put on separately and nailed from the top in case it is broken with usage. . . . There's an insert put in the bottom with a chisel where you put lead, about five ounces, in for ballast so that when the decoy is thrown out, if it lands upside down, it will roll over and sit right in the water. . . . You want it to ride right in the water so it swims like a duck." Once the construction is completed, Shourds adds a "little leather thong on the front of it to tie the anchor rope to" and then seals and paints the decoy to make it ready for use.

A working decoy, the type favored by hunters, must behave naturally in the water to lure a passing duck. But Shourds says there's a limit to the realism necessary. "Today, the carvers are getting real ducks. They're getting mounted or frozen ducks, and they copy them feather for feather. It's really model making instead of carving. It's a nice sculpture when it's finished. But I like to put a little dream into it."

Shourds says his own decoys represent "what I think a duck looks like. I don't copy off a real duck, and none of the old-timers did. They hunted duck and sold ducks in the wild and took their memories from them. They worked from those memories." Shourds has been carving full-time since 1962, and over the years he has written extensively on the subject.

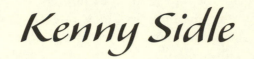

Kenny Sidle

ANGLO-AMERICAN FIDDLER

Born: July 20, 1931

Kenny Sidle (Phil Samuel)

KENNY SIDLE WAS BORN JULY 20, 1931, IN A LOG CABIN in Licking County in central Ohio. He grew up listening to his father, Vernon Sidle, and uncle, John Cromer, who were both fiddlers and encouraged him to play the tiny instrument they gave him as a child. At the age of five, Sidle made his first public appearance on the stage of a traveling medicine show. The first tune he performed was "The Mockingbird," which he played on one string with one finger. This performance, he recalled, was a roaring success, but he stopped playing in public immediately. Still, he continued to hone his skills, practicing at home and jamming with his family members.

In the 1950s, Sidle started playing professionally for local radio shows and for square dances, though he never was a full-time musician. Through the years, he developed a distinctive "contest" style that may feature the precise inclusion of many separate notes, but it is also smooth, melodic, and very sophisticated, reflecting some Texas and Canadian influences. Some feel his music has the "noteyness" of French Canadian fiddling, although it is difficult to place Sidle in any single line of development. He has performed around Ohio, and traveled frequently to Canada, where his fiddling is much admired. Overall, Sidle's repertoire includes primarily slow quadrilles and waltzes, reminiscent of an older generation of central Ohio fiddlers, such as Caney Perry and John Wiley.

Fiddling in Ohio has a long history. The earliest settlers brought the violin with them as they built their frontier towns along the Ohio rivers. As early as 1800, travelers reported hearing fiddling by both black and white musicians.

In the 1970s, Sidle played with the Cavalcade Cut-Ups, the house band for the *North American Country Cavalcade*, a program that aired every Saturday night from the Southern Hotel in Columbus, Ohio, and was broadcast on radio station WMNI. In his fiddling, Sidle displayed technical precision in his bowing and noting, while retaining the warmth and excitement of traditional fiddling. These abilities, combined with his affable personality, have made him immensely popular among musicians, callers, dancers, and his community.

In performance, Sidle is often accompanied by the innovative guitar playing of Troy Herdman. Herdman grew up in West Virginia and learned to accompany the fiddling of his father, uncle, and brother. Sidle and Herdman play together in the Independence Band, which performs regularly for square dances and other country music events at the Flowers Music Hall in Hanover, Ohio. Sidle has won numerous fiddle competitions and has placed repeatedly as one of the top 10 finalists in the Grand Masters fiddle championship in Nashville, Tennessee.

Philip Simmons

AFRICAN AMERICAN BLACKSMITH AND ORNAMENTAL IRONWORKER

Born: June 9, 1912

Philip Simmons (Tom Pich)

PHILIP SIMMONS WAS BORN JUNE 9, 1912, on Daniel's Island, South Carolina. When he was seven years old, he moved to Charleston to live with his mother, a domestic worker, and to attend school. Growing up, he earned pennies a day toting workers' lunch pails, shining shoes, and selling newspapers. At the age of 13, he apprenticed himself to Peter Simmons, who was born a slave in 1855 and had learned the trade from his father, Guy Simmons. Peter had a shop at the foot of Calhoun Street in Charleston, and from him Philip acquired the skills that sustained him throughout his long metalworking career.

"It was action what brought me to the shop," Philip said. "I liked to see sparks and the fire, and hear the hammer ring." In 1930, he became a full-fledged blacksmith; Peter was ill, and Philip was left to mind the shop. While Peter was in the hospital, Philip repaired three huge metal tubs for the Johnson Coal Company and made his first blacksmith salary: "It was a raise from $4.00 a week to $17.50," he said. "That was real money."

In the late 1930s, Philip started to shift his attention from blacksmithing to decorative wrought iron, although he tended to call himself a "general blacksmith," meaning that he did accept the special tasks of the angle smith, farrier, wheelwright, toolmaker, and ornamental ironworker. "I could mash out a leaf the same as a horseshoe," he said. "They both got the same principle. An angle is an angle."

The first decorative piece that Philip made in Charleston is installed at 9 Stolls Alley, and it exemplifies the local style of ornamental wrought ironwork in the city. Topped by an overthrow of spear points, it has S and C scrolls, two of the major motifs in the Charleston tradition. Since the 1940s, Simmons has had countless contracts for decorative ironwork, including gates, fences, handrails, window grills, and balconies. All of his work combines historical elements with specific functional needs. "You have to stay with what they have," he said. "Otherwise it'll look bad. You see, it won't be right."

In some instances, Simmons used sculptural motifs, such as those found in his "snake gate," in which he wanted a snake to appear alive, so he gave it eyes, and his "star and fish gate," made in 1976 for the Smithsonian Institution and designed to appear as though it were swimming, so he crafted it from several pieces of curved iron. These gates were requested by his clients, but ultimately he had to draw upon his own imagination to bring them to fruition.

In 1991, his friends formed the Philip Simmons Foundation, a nonprofit organization to develop and maintain the garden commemorating his work on the grounds of his church, St. John's Re-

formed Episcopal Church, in downtown Charleston. Pieces of his work have been acquired by the National Museum of American History, Smithsonian Institution; the International Museum of Folk Art, Santa Fe; the Richland County Public Library, Columbia, South Carolina; and the Atlanta History Center, Atlanta, Georgia.

Howard "Sandman" Sims

AFRICAN AMERICAN TAP DANCER

Born: January 24, 1917

Howard "Sandman" Sims, 1984
(Courtesy National Endowment for the Arts)

*H*OWARD "SANDMAN" SIMS may have been born on January 24, 1917, in Los Angeles, California, though he said he was uncertain about the year of his birth. His age, he maintained, was "a matter of opinion." He learned to dance from his father, a barber, as did his 11 brothers and sisters, who all became talented dancers. "Most people first crawl," Sims said, "then start walking. I went right from crawling to dancing. If you can walk, you can dance."

Sims turned professional at an early age and, in the late 1930s, he moved to New York City, after appearing in a film with Count Basie, *The Harlem Sandman.* In New York, Sims danced on street corners, worked at a variety of odd jobs, and was known as the California Refugee. "I knew people who danced on dinner plates," he said. "There was a man who could dance on newspapers without tearing them. And another who constructed a gigantic xylophone to tap on. I saw people doing the Palmerhouse Shuffle of Kansas City, Missouri."

In 1946, Sims began a career at the renowned Apollo Theatre in Harlem. He danced at the Apollo for 17 years and was acclaimed for his distinctive tap style, which combined the tradition of dance with some of the movement skills he had learned as a boxer. For years, Sims trained as a boxer, but "gave up the ring" after breaking his hand twice. However, it was in the boxing ring that he developed what was to become his specialty, the sand dance. "I used to do some fancy steps," he said, "when I was standing in the rosin box, and the people liked that better than my fighting." Eventually, he put together an act dancing on a board lightly sprinkled with sand, producing a cool, slippery sound, and it was the "sandman" act that kept him going when public enthusiasm for tap dancing waned. Sims felt that the changes in popular music in the 1960s contributed to the decline of tap: He believed that tap was too subtle for the "heavy beat of rock 'n' roll."

Despite diminishing opportunities as a dancer, Sims persisted and formed a group called The Hoofers with 11 other dancers. "It [tap] had died, but we still danced on the streets. People at first thought we was kind of wacky then." Also, around that time, the tap dancer Chuck Green fostered a successful Off-Broadway production called *Tap Happening.*

By the late 1970s, a revival of interest in tap had spread across the country. Sims appeared in the film *No Maps on My Taps* (1979), which featured musical direction by vibraphonist Lionel Hampton, with dancers Bunny Briggs and Chuck Green, and old film clips of the tap legends Bill "Bojangles" Robinson and John W. Bubbles. Sims toured to Africa with a troupe sponsored by the Arts America program of the United States Information Agency. Over the course of his

career, Sims never forgot his roots. When he had the time, he liked to return to Harlem and participate in "challenge dances" on street corners, just as he did when he was a young man starting out in the business, taking turns to show his skills. "I can dance to anything," Sims said. "I don't even need any music. Sometimes music can even be a hindrance."

For Sims, tap dancing was "most telling a story . . . a different story to each person because everybody takes it a different way. It takes a lot of skill because you have to be moving every muscle in your body. The dancing we'd do is what we feel and what we hear. You have to have a vast amount of imagination to be a hoofer. Anybody can be a tap dancer, but being a hoofer is like going over the bridge."

Willie Mae Ford Smith

AFRICAN AMERICAN GOSPEL SINGER

Life dates: 1906–February 2, 1994

Willie Mae Ford Smith (Courtesy Willie Mae Ford Smith)

*W*ILLIE MAE FORD SMITH WAS BORN IN 1906 in Rolling Fork, Mississippi, a little town between Vicksburg and Greenville in the central Mississippi Delta. She was the seventh child in a family of 14. "We were so poor our coats did double time as our blankets," she recalled. "We sometimes slept four in the bed, but we had so much happiness, so much love, so much fun. My father was a deacon, and now I can see he just kept us singing to keep from thinking."

As a child, Smith moved with her family to Memphis, Tennessee, and later to St. Louis, Missouri. Her father worked as a railroad brakeman and was a devout Baptist who organized Willie Mae and three of her sisters into a family quartet. They sang for the first time in public at the National Baptist Convention of 1922 and were well received, especially for their own arrangement of the song "Ezekiel Saw the Wheel."

Smith's sisters eventually retired from the quartet, and Willie Mae decided to pursue a career as a soloist. She had a high soprano voice, and even considered advanced study in classical music, but after hearing Artella Huchins sing gospel songs at the National Baptist Convention of 1926, she changed her career plans and devoted herself entirely to gospel music. She began singing professionally in churches in St. Louis and throughout the Midwest.

In addition to her virtuosic abilities as a singer, Smith was also an excellent organizer. Early on, she joined with Dr. Thomas Dorsey and Sallie Martin to set up the National Convention of Gospel Choirs and Choruses. She was its director for many years and performed an annual solo concert. In the late 1920s, she was ordained as a minister.

Over the years, Smith taught and influenced countless other singers: Myrtle Scott, Joe May, and Mahalia Jackson, among others. But the enormous energy and dedication she brought to organizing, teaching, and nurturing kept her from recording her own singing until she was in her sixties.

Throughout her career, Smith was renowned for her distinctive singing style, which brought to the gospel repertoire the range of vocal effects she heard as a young girl in country churches. She ornamented and bent the tones of the straightforward hymns that she preferred. She helped the great Mahalia Jackson develop the "flowers and feathers" that so adorned her vocal style. Like the country Mississippi preachers she heard so often as a child, she "talked it up" between songs, originating the style now called "sermonettes" that is used by many gospel singers. Above all, she sang out of emotion, using every vocal effect from growling to crooning to express her sense of the moment.

"The gospel song is the Christian blues," she said. "I'm like the blues singer; when something's rubbing me wrong, I sing out my soul to settle me down."

Eudokia Sorochaniuk

UKRAINIAN AMERICAN WEAVER AND TEXTILE ARTIST

Born: March 15, 1919

Eudokia Sorochaniuk (right) (Tom Pich)

EUDOKIA SOROCHANIUK (Evdokeeya Verstiuk Sorochaniuk) was born March 15, 1919, in Zhab'ye, a town in the Carpathian Mountains in the Ukraine. Eudokia, a daughter of a subsistence farmer, learned the arts of *nyzanka* (embroidery) and weaving as a young girl by watching her sisters. She began teaching herself embroidery at the age of six by stealing thread from an older sister and hiding away to practice. She developed most of her skills under the tutelage of the women in her own home. After a two-month apprenticeship with a master weaver when she was 16 years of age, Sorochaniuk gained recognition as a highly skilled weaver in her village.

During World War II, the Soviets took control of Zhab'ye, where Eudokia was working as a master weaver. Fearing deportation to Serbia, Eudokia and her husband, Dmytro, fled across the mountains to Hungary. After living in a displaced persons' camp in Germany for five years, the Sorochaniuks were sponsored by a Ukrainian group to come to the United States. Within a few months, they settled in Philadelphia. Eudokia quickly got a job in a garment factory, where she worked as a seamstress. Even after sewing all day, she wanted to resume her weaving. Dmytro, a skilled craftsman, built her a loom so that she could weave at home. Eventually, he had to build several more looms to accommodate some of the women from neighboring communities who wanted to learn Hutsul [Ukrainian] weaving. In 1952 the Sorochaniuks bought farmland in Pennsauken, New Jersey. After building the house in which they still live, Dmytro built additional looms for his wife, basing his construction design on the looms she had used in the Ukraine. Later, he invented machines to turn threads for Eudokia and her fellow weavers.

The ravages of World War II and the threat of cultural annihilation had heightened Eudokia's dedication to maintaining her weaving and embroidery skills in particular, and to preserving her native region's traditional culture in general. During her years in the United States, she continued the work she had started in the displaced persons' camp. She recorded traditional patterns and designs, wove clothing, and collected Hutsul folk arts. Sorochaniuk has several albums filled with fabric "pages" illustrating hundreds of reverse flat stitch patterns stitched in the traditional colors. Included among these are three rough cloths on which she recorded native patterns while in the camp, and samples collected from other displaced Ukrainians in the camp. Her "scrapbooks" are so well known within the Ukrainian American community that Ukrainians from all over the country continue to send her scraps. Each page shows a traditional design, one-half of which is stitched in the traditional colors, the other in black and white, so that both the counted-stitch pattern and the traditional colors will be visible to observers. Because many

of the samples were brought with her from the Ukraine, they are important examples of her culture's traditional arts prior to Soviet censorship.

The Hutsul style of embroidery that Sorochaniuk practices is called *nyzanka*. It is more common to Hutsul culture than the traditional Ukrainian cross-stitch. *Nyzanka* is a painstaking process that produces a rich decoration. The work begins with embroidering the reverse of the cloth with the background color, following the weft. Then the brightly colored design is stitched on the right side of the material. *Nyzanka* refers not only to the embroidery technique, but also to specific designs. Bright colors and geometric patterns are characteristic of *nyzanka*. Sorochaniuk's embroidery expertise is most vividly displayed in the costumes she creates for the Cheremosh Ensemble, a traditional Hutsul folk dance ensemble that her husband directs. She prides herself on careful finishing and the small, deft touches that make a work completely satisfying. She may make small changes that show her own craftsmanship, but she is conservative with innovation, always working within the framework of tradition. Seventy years of practice, a good eye for detail, and skilled hands make Sorochaniuk's work exquisite.

For many years the Sorochaniuk home has been the center of folk arts activity for the Ukrainian American community of the Delaware Valley, a community of more than 70,000 people. Sorochaniuk has conducted both informal and formal apprenticeships since arriving in the United States. In her role as a master artist, she teaches more than textile arts: She shares with her students the history of patterns and the traditional uses for garments, bags, and other articles. Several women who learned Hutsul textile arts from Eudokia have modified the traditions to incorporate traditional elements into modern life for everyday use. For example, one woman used a design traditionally woven into a *besaha* (woven saddlebag), an article not commonly used in the suburbs of New Jersey, for a table runner. In subtle and important ways, her formal and informal teaching stimulates an appreciation for the fragility of traditional culture, even as modified to "fit" into a modern lifestyle. Although some modifications take place, other articles are cherished in their original form, and women are committed to making them the traditional way. Dora Horbachavsky, one of the women who has spent many months learning Hutsul weaving from Sorochaniuk, vowed that she was "absolutely going to learn to make the wedding headdress, or *trisunka*."

Following the breakup of the Soviet Union, Ukrainians struggled to recapture their cultural forms that were highly regulated and censored under Soviet occupation. Sorochaniuk traveled back to Ukraine twice in the mid-1990s and discovered that the folk traditions, considered by the Communists to be a sign of Ukrainian na-

tionalism, had been obliterated. When the young women there met her and saw her work, they sought Sorochaniuk's help in learning the native weaving and embroidery arts that traditionally would have been passed along from mothers to daughters. Since that time, Hutsuls from the Ukraine have come to the Sorochaniuk home to learn their native arts as practiced prior to the cultural destruction that took place during World War II.

Through her ongoing creation of *nyzanka* and traditionally woven articles, Sorochaniuk has maintained a remarkably close tie to her heritage. Her participation in workshops, seminars, and community programs has ensured that others of Ukrainian descent in the United States and Ukraine are learning the skills and history of the Hutsul traditional culture.

Dolly Spencer

ALASKA NATIVE DOLLMAKER (INUPIAT)

Born: March 30, 1930

Dolly Spencer (Dane Penland, Courtesy Smithsonian Institution)

DOLLY SPENCER WAS BORN IN KOTZEBUE, ALASKA, on March 30, 1930, the 11th child born to Grace and York Mendenhall. During the summer and fall months of her younger years, her family lived in temporary camps, moving from one to another gathering food such as berries and greens, fishing, and hunting seals or foxes. They collected as much as they could in preparation for winter. In these temporary camps the family lived in a tent. She thought the fall camps were fun because the kids were able to ice skate. They had 45 or more dogs and puppies. Spencer remembers playing with the puppies as a child, often carrying them in her parka. The dogs were more than pets; they were vital to the family's movement. They depended on the dogs to transport them by dogsled, even in the summer, and to pull their boat from the shore.

Spencer's parents were very religious people, praying each morning and evening. She has happy memories of attending Sunday school. "The happiest day was Sunday," she recalled. She learned religious songs by memorizing the verses and studied the Bible. They never hunted on Sunday.

Spencer's father died when she was 10 years of age. At about that same time, her mother started teaching her to sew. Her first project was making Caribou mittens. Her mother examined her work, and if it was not done well, she would rip out Dolly's stitches and make her redo them until they were done to her satisfaction. This attention to detail in sewing was the first of many lessons her mother taught her. As a child, she learned how to prepare sealskin for sewing by scraping the underside of the pelt and removing the hair.

In the winter Spencer attended school. Among the first things she learned at school was English. Until she went to school she spoke and heard only the Inupiat language. She left school when she was in the seventh grade, when her mother took her to Nome. There, she worked as a dishwasher for a time before becoming a camp cook. After two years as a cook she worked in a bakery, then in a restaurant.

During this time, Spencer married and had children, for whom she made parkas and mukluks (soft boots made of reindeer hide or sealskin). Using scraps from these projects, she started work on a doll's dress at the request of a friend, and then started making dolls for herself. She used dental floss to sew, but switched to sinew at the urging of her husband.

Over the years, Spencer has refined her skills in the making of dolls, carefully carving each doll's head and then sewing custom clothing. In her dolls, she strives to reproduce traditional dress and customs, hoping that each creation will preserve her memories of Inupiat life and serve to educate the general public.

Robert Spicer

ANGLO-AMERICAN FLATFOOT DANCER

Born: January 28, 1921

Robert Spicer, 1984 (Robert Cogswell, Courtesy Tennessee Arts Commission)

ROBERT SPICER WAS BORN IN DICKSON COUNTY, Tennessee, on January 28, 1921, the youngest of nine children. He began flatfoot or buck dancing when he was seven years old and visiting the nearby town of Charlotte with his mother. "I seen a black man dancing on the bed of a two-horse wagon," he said. "I just stood there eating an ice cream cone and watched how he was doing it and listened to the rhythm he was making. I decided that I was gonna learn to do that."

The dance style that so fascinated Spicer undoubtedly originated in Africa, where ground-hugging, improvised dancing still thrives. In the United States, these relaxed, subtle movements were combined with Celtic foot-stepping to produce American flatfooting, a dance that is widespread today throughout the South among both blacks and whites. Flatfoot is an improvised solo dance, characterized by fast, percussive footwork that stays close to the floor and often duplicates the rhythm of the accompanying instruments. The feet seem to be "all of a piece," the body is erect but not stiff, and the arms move gently in response to the need for balance. Any kind of showy athleticism—jumping, leaping, high kicking—is inappropriate; the dancers strive for economy, neatness, and simplicity of movement, and always for rhythmic precision of the highest order.

Flatfoot dancing is also called rhythmic buck dancing. The origin of this name remains unknown. Older black dancers sometimes say that there were 37 named steps in a complete buck dance, steps that mimed the entire life cycle of the African American man. Spicer learned some of these named steps—Cutting the Grass, Shining Your Shoes, Rock the Cradle, The Wing, and The Old Time Double Back Step.

Accompaniment is an important part of the flatfoot dance. Lacking instruments, Spicer clapped for his dancers and played the spoons, each musical beat to be echoed by a foot sound. Essentially, he provided what some call a "juba" rhythm, an African American contribution, in which the hands clap twice on the upbeat and the foot stamps once on the downbeat. Spicer said he "tuned" his clap to correspond to musical effects produced by the dancer he was accompanying, in a manner similar to black gospel singers, who clap in parts, producing bass, baritone, and treble pitches in their clapping.

Spicer won many flatfoot contests during his lifetime, and learned to call squares from his one-time neighbor, Fiddling Arthur Smith. Over the years, he supplemented his income by working as a professional caller and dance organizer at musical clubs throughout Tennessee. But most of all, he liked to teach flatfoot dance in the "old-fashioned" way, setting up the appropriate atmosphere in public parks and community centers across Tennessee and providing sensitive accompaniment with his deceptively simple hand claps.

Clyde "Kindy" Sproat

NATIVE HAWAIIAN COWBOY SINGER AND UKULELE PLAYER

Born: November 21, 1930

Clyde "Kindy" Sproat (Courtesy Clyde Sproat)

CLYDE "KINDY" SPROAT WAS BORN NOVEMBER 21, 1930, in the district of North Kohala on the Big Island of Hawaii and raised in the rural isolation of Honokane Iki, a valley two hours away from the end of the road. Transportation to the valley was by mule pack train. His father was part Hawaiian and worked on the Kohala Ditch Trail, maintaining the waterways that fed the great sugar plantations of the early and middle twentieth century.

From an early age, Sproat remembered how his Hawaiian mother played the banjo and sang to the children every night after supper. "We sat on mats that were woven from the leaves of the *pandanus* tree and watched the reflection of the sun rising up the east wall of the valley, then dancing on the trees at the very top of the ridge before slowly fading out of sight. I sang my heart out. At that time I felt like we were singing the sun to sleep, so in the morning as he crept over the west ridge with his long, shadowy legs, he would be warm and friendly and let us have another good day of swimming and fishing in the stream and doing all the things that little boys do in a day."

Later, the family moved to Niulii, still on the Big Island, but closer to schools, churches, restaurants, and saloons, where Sproat liked to stop and listen to the master slack key guitar players of the time—John Akina, John Kama, and Kalei Kalalia. "That sound and rhythm," he said, "has haunted me all my growing years, and even until this day I listen for the old sweet rhythm of the old slack key. Slack key has changed considerably since I was a boy. Like the old-time slack key, the old-time folk songs of Hawaii have faded into the past. I love the old songs, so I hang onto them and sing them just as I heard them sung. . . . I had a special feeling for the old Hawaiian songs. The tunes haunted me. I sang, whistled, and hummed them constantly."

In school, Sproat's interest in his Hawaiian heritage was reinforced by his principal. "I went to a little grade school called Makapala School. There each morning school started with an assembly of students and teachers all standing in rows by grades on the veranda. The first half an hour was doing the pledge of allegiance, the Preamble, singing patriotic songs and all the old traditional Hawaiian songs. Edwin Lindsey, the principal of Makapala School, was a master musician, and under his direction, everyone sang old Hawaiian songs and learned the meaning of the songs. 'Uncle Edwin' was a large influence on the stories and songs I sing today. Our May Day programs were so beautifully done. We sang songs that were written and sung by Queen Emma, Queen Liliu, Lelehoku, and many other writers of that era."

Growing up, Sproat also learned to play the four-stringed ukulele and liked the straightforward accompaniment of the slack key guitar for his Hawaiian songs. He admired the songs of the Hawaiian cowboys, *paniolos,* who worked on the ranches near where he lived. The Big Island of Hawaii to this day contains some of the largest ranches in the United States under single ownership; during Sproat's boyhood there were many Mexican *vaqueros,* who were brought in during the late nineteenth century to help develop the new ranching economy. Along with their technical skills, the Mexican ranchmen also brought their musical traditions, especially that of singing with stringed instrumental accompaniment. And as they began to make their homes in Hawaii, they taught tunes, instrument construction, and harmonies to their fellow Hawaiian workers.

Over the years, Sproat developed a repertoire of more than 400 songs. He has preserved the music that originated for the most part in the early twentieth century and reflected the changes in Hawaiian musical traditions from ancient chanted forms accompanied by percussion instruments to falsetto singing and Western melodic forms accompanied by the ukulele and slack key guitar. He has performed at *luaus,* family gatherings, retirement homes, and community events, and in concerts. "Singing to me," he said, "is the feelings that I have locked up inside that have a need to come out pure and simple."

Simon St. Pierre

FRENCH AMERICAN FIDDLER

Born: February 26, 1930

Simon St. Pierre (Joe Pfeffer)

Simon St. Pierre, 1991 (Alan Govenar)

SIMON ST. PIERRE WAS BORN IN QUEBEC on February 26, 1930. As a child, he liked to listen to his father and brother play the fiddle. "My father loved music with all his heart," he said, "but he never put much time to it. My father was not a great fiddler. He play a few tunes, but my older brother was real good. And I learn a lot from him. My older brother used to play a lot for square dances, weddings, and he play at home a lot. He was the oldest one, and I was the last one in the family. And he work outside in the woods, and he come every weekend, and when he play that fiddle, it make me so happy. I love it so much. I said to myself, I can't wait to get old enough, and when I got old enough I try it."

When he was about 15 years old, he started to play the fiddle, around the time he began working in the lumber camps and living in the bunkhouses in the northern woods. Music was a favorite pastime for the lumberjacks during the long winter nights, and every bunkhouse usually had at least one fiddler with a good repertoire. In the logging camps St. Pierre traded tunes with musicians from across eastern Canada. "A lot of them [tunes] have been passed on," he said, "some I learned from different parts of the country. Like people from Ontario, they play a little different music than Quebec, and Nova Scotia. And I got it all mixed together. I'd like to be able to sing, but I can't."

St. Pierre married his wife, Liza, in 1952, and together they have worked as independent sawmill operators. He moved to Maine in 1957, "for the reason," he said, "there was no work up in Canada. I stayed in a lumber camp, and after a couple of years, I moved my family. I got a little portable sawmill. I cut some cedar fencing and stuff. I do custom sawing for a company. I make me living with that little sawmill."

In Maine, he continued to play the fiddle, performing sometimes at square dances and weddings, but also at festivals, where he was introduced to Irish music and bluegrass. He became particularly skilled in rendering old waltzes, reels, and two-step dance melodies, accompanying many of his tunes with the intricate foot clogging, *frapper du pied,* commonly practiced by French Canadian fiddlers.

St. Pierre taught himself to make violins out of necessity. "I made my fiddle last winter [1990]. I had a good fiddle. I had a good violin somebody gave me quite a while ago, and somebody took it from me. It was in my pickup truck, and somebody took it. I not see it, but my fiddle went somewhere, anyway. So, I make me one last winter. I made with curly maple—the back and the sides, spruce for the top. I like to make fiddles. That's interesting. And it come out fairly decent, not like the one I had, but good enough."

Once St. Pierre gained a reputation at festivals in northern Maine, he was invited to tour, but he soon tired of the hard pace of traveling, and for several years he refused to play much in public. "I'm a working man," he said. "I work every day and when I come home, I'm tired. I don't like playing my fiddle. Sometimes on the weekend I play a little music. It's no fun to just play by yourself. You got to have somebody to play with you. Once in a while I play my tunes on the weekend. I'm really a happy man down here in that little corner of the wilderness. I love it."

Ralph Stanley

ANGLO-AMERICAN BLUEGRASS
BANJO PLAYER AND BANDLEADER

Born: February 25, 1927

Ralph Stanley (Courtesy National Council for the Traditional Arts)

RALPH STANLEY WAS BORN FEBRUARY 25, 1927, near McClure, Virginia, in the Clinch Mountains. He and his older brother Carter learned ballad singing and banjo frailing from their mother. Her repertoire ranged from traditional narrative songs to nineteenth-century hymns sung *a cappella*. Ralph Stanley's continuation of *a cappella* singing led to its revival in contemporary bluegrass bands.

Ralph and Carter began performing with Roy Sykes and the Blue Ridge Mountain Boys in 1946. They soon left to form a band called the Stanley Brothers and the Clinch Mountain Boys. They broadcast on radio station WCYB in Bristol, Tennessee, "the five-state station," with a signal that reached portions of Virginia, Kentucky, Tennessee, West Virginia, and North Carolina. Their first recordings were made in 1947 on the small Rich-R-Tone label in Johnson City, Tennessee. The group then moved to WPTF in Raleigh, North Carolina. They also signed with Columbia Records, prompting an angry Bill Monroe to move to Decca. Nonetheless, Carter Stanley worked with Monroe for a short time in 1951. The Stanleys reunited, and in 1954 they signed with the Mercury record label and returned to WCYB. On Mercury, they fashioned a hot sound that attracted national attention.

In 1958, feeling the competition from rock 'n' roll, the Stanleys left Mercury. They worked from a Florida base, touring and performing on radio and recording for the Starday and King labels. Carter died in 1966. He had been the spokesman, joke-teller, songwriter, and personality in the act. Ralph, who played banjo and sang tenor harmony, was much more reserved, and many did not expect him to continue his musical career. But in 1967 he formed a new band. He moved back to his old homeplace and told an interviewer, "Some people have told me I ought to continue. I appreciate that. I'm going to."

Although Stanley has played primarily a traditional repertoire, he has also written his own songs. "It's something that comes to you. I might write one tonight and I might not write another one for three years. It just hits you, comes on your mind. I've got up at three or four o'clock in the morning, wrote a song or two, maybe wrote three before I went back to bed. If I didn't get up and write them down, I wouldn't have remembered them the next day. One of them was 'Prayer of a Truck Driver's Son.' They were gospel songs. One of them was 'I Want to Be Ready.' There's been so many in so many years. It's hard to remember."

By the 1970s, Stanley's band, the Clinch Mountain Boys, was in top form and recording for the Rebel label. The lead singer, Roy Lee Centers, had a voice very similar to that of Carter Stanley. The group also featured Keith Whitley on guitar and Ricky Skaggs on mandolin. De-

spite turnover, Stanley maintained good bands that played traditional material. He continues to play in concerts and festivals around the country and abroad. His music was used in the film *O Brother Where Art Thou?* (2000).

Ralph W. Stanley

ANGLO-AMERICAN BOATBUILDER

Born: February 9, 1929

Ralph W. Stanley (Craig S. Milner)

RALPH W. STANLEY WAS BORN FEBRUARY 9, 1929, in Bar Harbor, on Maine's Mt. Desert Island. His mother was a registered nurse and his father was a lobster fisherman who also skippered a yacht for well-to-do summer residents. Stanley descends from a long line of mariners who first settled on the island around 1760.

Stanley grew up in the small island community of Southwest Harbor. Commercial fishing boats and pleasure boats have always been a prominent part of the local landscape, and Stanley was attracted to them at an early age. As a youngster, he made toy boats out of wood and played with them in the harbor, and he enjoyed making drawings of boats, too. When he was old enough, he accompanied his father in his boat when he went out to haul his lobster traps. During his high school years, Stanley became interested in boat-building. World War II was in progress, and since the local boatyards were humming with activity, he was able to observe the construction of large fishing boats, called draggers, and other vessels.

After earning an associate's degree from a college in northern Maine, Stanley returned to Southwest Harbor. Not sure what occupation he wanted to pursue, he decided to try to build a boat. So he earned the money he needed to buy wood and other construction materials and, during the winter of 1951–1952, he built a 28-foot lobster boat. The boat turned out well and a local person bought it. This led to orders for other boats. "I've been building [boats] ever since," he said.

Stanley learned how to build boats not by apprenticing himself to another boatbuilder but mainly by keenly observing and using boats and by observing the activities of several professional boatbuilders who specialized in the Mt. Desert Island version of the Maine lobster boat. As Stanley explained, "I used to go and see what they were doing and talk with them. A lot of times it was better to watch what they were doing and not ask. You'd learn more [that way]. Boatbuilders didn't know how to tell you, you know. Stand back and watch and you'd find out more."

In designing his boats, Stanley uses locally available wood, including white cedar, oak, and pine. He designs his boats either by drawing scaled-down "lines plans" on paper or by carving scaled-down wooden half-hull models and then drawing out or "lofting" the boat's full-scale lines on the floor of his shop. This drawing provides a full-size pattern for the boat that is to be built.

Over the course of his career, Stanley has built a large number of traditional boats: approximately 70 vessels, from small sailboats to large offshore lobster boats, most of which are still in use. In addition to fishing boats, Stanley has also built a number of pleasure craft. These include engine-powered pleasure boats derived from

the lobster boat hull form; they are sometimes called "lobster yachts."

Other pleasure boats he has built are single-masted sailing vessels called Friendship sloops. The sloops were originally built in and around the coastal village of Friendship, Maine, in the 1880s, and were used by commercial fishermen. Eventually they were replaced by engine-powered boats that gave fishermen greater speed and range. However, during the 1960s and 1970s, there was a revival of interest in Friendship sloops by recreational sailors, and Stanley played a major role in the revival by restoring old sloops as well as building new ones in the old style.

Stanley is one of Maine's few remaining professional boatbuilders solely engaged in wooden-boat construction. "Building wooden boats is like climbing a still-growing tree where you never get to the top," he said. "I keep finding new ways of doing things and new things to do. You can always improve; you're always looking to improve."

Like many small Maine boat shops of the past, Stanley's shop is family-run. His daughter Nadine is the bookkeeper, a job previously held by her mother, Marion. A son-in-law, Timothy Goodwin, runs the boat storage and maintenance part of the business. Stanley's son Richard—a talented boatbuilder in his own right—is his right-hand man in the shop.

When he is not making boats, Stanley is a dedicated amateur historian who tries to uncover new information about the history of boat-building on his island and share it with children and adults. He also writes articles based on his research and takes part in symposia sponsored by museums in New England.

Roebuck "Pops" Staples

AFRICAN AMERICAN GOSPEL AND BLUES SINGER

Life dates: December 25, 1914–December 19, 2000

Roebuck "Pops" Staples (Courtesy Stax Records)

ROEBUCK "POPS" STAPLES WAS BORN December 25, 1914, in Winona, Mississippi. Growing up on the same plantation as bluesman Charley Patton, Staples drew from both the gospel and blues traditions to forge a sound that transcends their stylistic divide. As a child in his Mississippi Delta community, Staples listened to *a cappella* singers in church and sang religious songs at home with family and neighbors. As a teenager, he took up the guitar, inspired by blues artists such as Big Bill Broonzy, Patton, and Barbecue Bob. In later years, his style would be influenced by Muddy Waters and Howlin' Wolf, two Delta blues musicians who relocated to Chicago and amplified their sound.

Though he admired and to some extent emulated blues players, Staples developed a guitar style to accompany religious music and sang with a local gospel group, the Golden Trumpets. Staples and his wife, Oceola, moved their family to Chicago in 1936. There he worked in meatpacking, steel, and construction, but also continued his work in gospel music. He joined the Trumpet Jubilees and heard the gospel music of pioneers Thomas A. Dorsey and Sallie Martin. In 1948, he formed the Staple Singers with daughters Cleotha and Mavis and son Pervis. They sang at home and in local churches. Of those early years, Staples has said, "We just wanted to have music in the house, that's all."

The family group's first jobs on the road took them to New Orleans and to Jackson, Mississippi. The Staple Singers began recording in 1953 and had their first success with the 1957 release "Uncloudy Day." Staples kept his day job until his daughter, Mavis, graduated from high school, then began to pursue work for the group full-time. His daughter Yvonne left the group in 1955, and rejoined four years later when Pervis was called for military service. As the Staple Singers perfected a distinctive sound based on vocal harmonies and Staples's guitar, they became known as "the First Family of Gospel."

As the Civil Rights Movement gained momentum, the Staples family became good friends with Dr. Martin Luther King, Jr., and expanded their repertoire to include songs that reflected social change and their commitment to the struggle. After Dr. King's assassination, they released a memorable song, "A Long Walk to D.C." The group had its biggest commercial success in the 1970s with "Respect Yourself" (1971), "I'll Take You There" (1974), and "Let's Do It Again" (1976).

In the 1980s, rather than retiring, Pops Staples began a solo career. His second solo album, *Father Father*, won a Grammy Award in 1994. Despite the obvious blues influence in his music, Staples said, "I don't consider myself a blues singer, I try to carry a message of good news to everybody. I'm not a bluesman. I'm a message-man."

Alex Stewart

ANGLO-AMERICAN APPALACHIAN COOPER AND WOODWORKER

Life dates: January 24, 1891–April 15, 1985

Alex Stewart, 1983 (Courtesy Smithsonian Institution)

ALEX STEWART WAS BORN JANUARY 24, 1891, in Hancock County, Tennessee. He was the third generation of his family to follow the coopering trade, an essential craft in the isolated, rural mountain community in which he was raised. His grandfather, Boyd Stewart, opened a cooperage in 1860, and his father, Joseph Stewart, took over the family trade in 1880.

As a child, Alex watched his grandfather and father splitting, shaving, and bending wooden staves and bands into churns, buckets, piggins (a bucket with a stave extended for a handle), and tubs. Prior to the advent of crock churns and galvanized tubs and buckets, people in the mountains depended on the cooper's woodenware for their household containers. Farmers and merchants needed wooden barrels for storing and transporting goods—*wet* barrels for liquids, such as water, whiskey, and molasses, and *dry* barrels for flour and grain.

Stewart made his first wooden vessel in 1912, and over the years he worked hard in the coopering trade, cutting and seasoning his own cedar wood in his small sawmill and forging tools in the blacksmith shop on his farm. "I've made all my tools—matter of fact, everything I've got," he said. "My grandfather, I learned this from him. He made everything—wheels, anything that could be thought about, he made it, and I got the pattern off of his. And my daddy, he worked at it as long as he lived. I've been doing it since I was old enough to do it."

In addition to coopering, Stewart was a chair maker, blacksmith, basket maker, musical instrument maker, bowl and rolling pin maker, and whittler. "I can make anything that can be made out of wood, and I don't use nails or glue. It's better than the stuff you buy, and it makes me feel good, too. . . . Reckon what the young folks today would do if they had to do what I've done just raising my family and trying to get along? I've smithed and wove and had a fine cabinet shop and even ran logs to Chattanooga. Why, there's been time my clothes would go stiff in five minutes from the cold! We'd be lashing logs to run, and the wind would freeze the spray while it was soaking your pants and shirt."

In the early 1960s, with the increasing availability of metalware and the difficulty of finding good wood, his business began to decline. However, John Rice Irwin, owner and operator of the Museum of Appalachia in Norris, Tennessee, became interested in Stewart's work and tried to persuade him to continue his coopering. Stewart agreed on the condition that Irwin supply the timber, and the exhibition of his work at the museum in Norris brought him wider recognition.

In 1976, Stewart was invited to participate in the Festival of American Folklife in Washington, D.C., with his apprentice, Bill Henry, from Oak Ridge, Tennessee. Later, his grandson, Rick Stewart, apprenticed himself to him when he was 16. "I just thought it's a thing I should do," Rick said. "It's been in the family so long. It's going to lose out of the Stewarts."

By the early 1980s, advancing age forced Alex Stewart to retire, but he never lost interest in the coopering trade and continued to work as long as he was able. About his lifelong commitment to his craft, he said, "I just delighted in it. Anything you delight in, it ain't any trouble for you to do it."

Margaret Tafoya

NATIVE AMERICAN PUEBLO POTTER
(SANTA CLARA)

Life dates: August 13, 1904–February 25, 2001

Margaret Tafoya (Tom McCarthy)

MARGARET TAFOYA WAS BORN IN Santa Clara Pueblo, New Mexico, on August 13, 1904. As a child, she learned the art of making pottery from her mother, who was herself an heir to the pottery tradition that had been passed on from one generation to the next for centuries by the speakers of the Tewa language in the Rio Grande Valley of New Mexico. Of the six pueblos where the Tewa language is spoken, the Santa Clara has long been noted for its pottery tradition, which emerged around A.D. 500, when the pueblo people developed agriculture and adopted a more settled lifestyle than that of their hunting and gathering ancestors.

For more than 1,000 years, pottery had been an important trade commodity among the Rio Grande pueblos, and archeological evidence demonstrates its widespread use among people of the region. With the coming of the Spaniards and other Europeans in the sixteenth century, pottery commerce continued; after the opening of the Santa Fe Trail in 1821, however, utilitarian pueblo-made pottery was gradually replaced by machine-made products. By the turn of the twentieth century, pueblo pottery was beginning to be identified as an art form in its own right and to be collected by anthropologists, historians, artists, and patrons of the arts.

Tafoya's family, she said, had been potters "as far back as records exist." A 1983 exhibition at the Denver Museum of Natural History included more than 100 pots by six generations of Tafoya family potters, the earliest made by her great-grandmother around 1934. But it was her mother, Serafina Gutierrez Tafoya, who was her greatest influence. Both Serafina and Margaret were best known for their ability to make unusually large pots—30 inches or more high. These pots necessitated the digging of a special clay, months of careful drying of the unbaked body, a meticulous firing to achieve a uniform color and to prevent cracks, and many hours of polishing to achieve the desired, mirrorlike finish.

She made only hand-coiled vessels, and only used clay dug from deposits on Santa Clara land. "We get the clay where our ancestors used to take it," she said. "My girls are still doing work from the clay that my great-great-grandparents used." Furthermore, she insisted that her descendants do likewise and required them to fire their wares with natural fuels in an open fire and to finish their vessels to the characteristic luster by rubbing their surfaces with a smooth stone.

Overall, Tafoya's work reflected the transformation of the Santa Clara pottery tradition from the utilitarian to the artistic. She adapted the general vessel shape; animal forms were appended in jars and bowls, but she helped revive the use of polychromes, the making of which had been discontinued by the late 1800s. She cre-

ated polished red and black ware, decorated with impressed and carved (intaglio) designs, highlighted in matte buff, red, or black against the polished surface. Unlike some of her contemporaries, who painted designs in matte black, buff, and orange on black vessels, and red, tan, ochre, and blue-gray on red vessels, Tafoya always preferred the intaglio method. She often carved a "bear paw" design, introduced by her mother, on the neck of each large storage vessel. "It is a good luck symbol," she said. "The bear always knows where the water is."

 Tafoya also decorated her pots with water serpents, rain clouds, and buffalo horns, all symbols of survival for her people. She was a traditionalist, but also an innovator in the making of wedding, storage and water jars, plates, vases, lamps, candlesticks, and other distinctive forms. As a teacher, she imbued her students with the values she learned as a child. Her daughter, Toni Roller, and her grandchildren, Cliff Roller, Nancy Youngblood Cutler, and Nathan Youngblood, have all been recognized for their pottery, and they too utilize traditional methods and at once preserve and broaden the scope of the tradition.

Seiichi Tanaka

ASIAN AMERICAN TAIKO DRUMMER AND DOJO FOUNDER (JAPANESE)

Born: June 18, 1943

Seiichi Tanaka (Courtesy Seiichi Tanaka)

SEIICHI TANAKA WAS BORN IN TOKYO, JAPAN, in 1943. He attended local schools and enrolled at Chiba University of Commerce, though he also studied several traditional art forms. These included different styles of *taiko,* a form of ritual drumming that combines percussive sounds with physically demanding choreographic movement, in addition to martial arts, *yokubue* (bamboo flute), and *hogaku,* the traditional stage music for Kabuki dance and Noh drama.

In 1968, Tanaka attended a Cherry Blossom Festival in San Francisco, where many Japanese cultural traditions were featured, though *taiko* drumming was not represented. Recognizing a need for *taiko* drumming in the United States, Tanaka established his own *taiko dojo* (school). Over the years, he has trained hundreds of *taiko* performers, using drums of stretched cowhide that are remarkably similar to instruments built 1,400 to 2,000 years ago.

In ancient times, *taiko* drums were probably first used as a military tool, but were later incorporated into agricultural rituals to repel evil spirits, encourage bountiful crops, and bring rain. Their rhythms were eventually adopted in the imperial court and were used in Buddhist temples and at Shinto shrines. After World War II, *taiko* drumming evolved into a more musical form, employing a variety of drums in different sizes and incorporating choreographed performance.

Tanaka is recognized as a grand master or *Tanaka-sensei,* as he is known by his followers around the world. The energetic but disciplined performance style of his group—part dance, part music, part martial arts, part philosophy—reflects what he calls "the development of the inner muscle."

In 1982, Tanaka's San Francisco Dojo recorded for the sound track of George Lucas's *Return of the Jedi.* A year later, the group released its first recording, *Sound Space Soul,* and was asked to record for the movie *The Right Stuff.* In the 1990s, Tanaka performed in the first Annual Sacred Drum Concert and formed a youth group called the San Francisco Taiko Dojo Little League.

For Tanaka, the "essence of *taiko* is not only the skillful playing of percussion instruments, but the discipline of mind and body in the spirit of complete respect and unity among the drummers."

Liang-xing Tang

ASIAN AMERICAN PIPA (LUTE) PLAYER (CHINESE)

Born: 1948

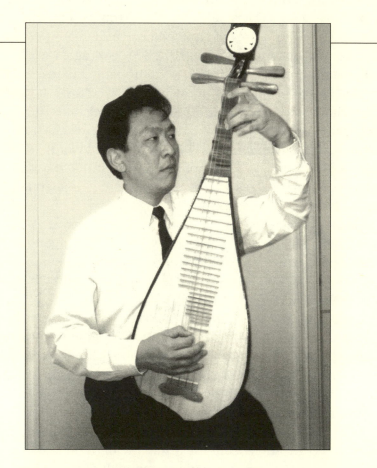

Liang-xing Tang, 1993 (Alan Govenar)

LIANG-XING TANG WAS BORN IN 1948 in Shanghai, China, and was raised in a musical family. Tang recalled that his family "loved Chinese music so much that they organized the entire family into a music group. . . . We learned music under the guidance of our father and grandfather." They were known around Shanghai in the 1950s as Tang's Musical Group, and it was in this family setting that Liang-xing began studying *erhu* (a two-stringed bowed lute) at age seven. Soon he became a member of a performing-arts group called Little Playmates of the Shanghai Municipal Children's Palace.

At 13, he was selected to join the Shanghai Chinese Music Orchestra, but when the instructors saw his large, long-fingered hands, they moved him to *pipa*, a pear-shaped, vertically held lute, popular in China since the sixteenth century. Tang had been interested in the *pipa* since he was a child, when he watched the master teacher Cheng Wujia teach the instrument to his older sister. "It was the first time I heard major *pipa* works," he said, "and I was enthralled."

Pipa is played both solo and as an ensemble instrument. It is perhaps best known and admired for its traditional repertoire of "programmatic" pieces that paint vivid sonoral pictures of events, scenes, or moods. None is more famous than "Ambush from All Sides," which originated as early as the sixteenth century and described the battle between warlords of the Chu and Han states. Two other popular pieces that Tang performs are "Night of Flowers and Moon at Spring River" and "Song of the Frontier."

The *pipa* tradition involves a relatively high degree of personal interpretation. A given piece may differ greatly from one performance to another, between performers, and among schools of playing style. Tang upholds the traditional view that each *pipa* player must cultivate a distinctive style rather than attempt to outdo his or her peers. Tang's own style is one of exuberance with a fine lyrical sense and melodic awareness. "My first teacher, Ma Linsheng, told me," he says, "it's better to strengthen your own style and unique characteristics than to surpass others. In *pipa*, there's no undisputed champion. It's more important for individuals to blossom—only that is *pipa*'s springtime."

Tang does not use his fingers to play the strings of his *pipa*. He tapes cellulose picks to his fingers to pick the metal strings. In earlier times, the strings were made of silk and players used their fingernails as picks. The front panel is made from soft French wood; the back is made from redwood. The *pipa*'s vents are made out of bamboo. The upper fronts are made of ox horn and the carved piece at the top is ivory. The *pipa* is a versatile instrument that holds an essential place in many genres of traditional Chinese music. It is an integral component of Chinese opera, folk songs, and symphonic music.

In 1964, when he was 16 years old, Tang had his solo debut, and in 1970 he was a soloist with the orchestra. For several years, Tang earned his living as a professional musician, playing and touring with Chinese orchestras. In 1986, he immigrated to the United States and settled in New York City, where he joined the group Music From China.

In a relatively short time, he was invited to perform at musical events in the Chinese community. During his first five years in the United States, he gave more than 500 recitals and major concerts at a broad range of events, from folk festivals to Chinese celebrations, to major concert halls, to regular appearances as a soloist in the Broadway play *M. Butterfly.*

Tang is widely sought as a teacher of *pipa, erhu,* and *gu qin* (a seven-string zither). Both of his twin daughters, Juehua and Jueli, have followed in his family's musical traditions and frequently perform with him on *pipa.* His importance to the American and international Chinese communities is inestimable, but he also sees the special value of his music in a multicultural society: "I believe music can forge a link between people and stimulate understanding and communication."

Dave Tarras

JEWISH AMERICAN KLEZMER MUSICIAN

Life dates: c. 1890–1989

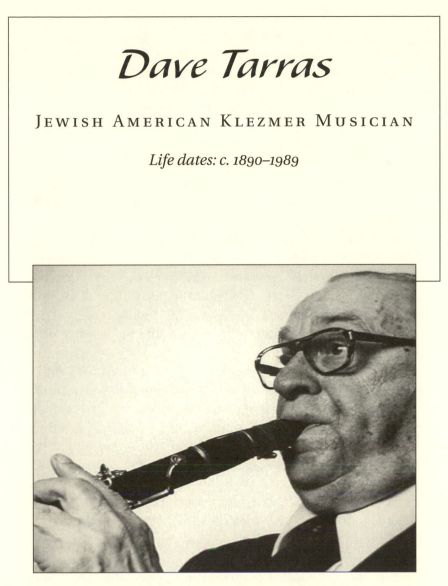

Dave Tarras (Jack Mitchell, Courtesy Ethnic Folk Arts Center)

\mathcal{D}AVE TARRAS WAS BORN AROUND 1890 in southern Ukraine. He learned to play the clarinet as a young man, and by the time he immigrated to the United States in 1921 and settled in New York City, he was an accomplished musician. His first job in New York was in the fur industry, though in a relatively short time he began to play in Yiddish theater pit bands.

Tarras made two recordings for the Columbia label in 1924 and soon became the preferred accompanist to many popular figures in Yiddish theater, including Aaron Lebedeff, Moyshe Oysher, Molly Picon, Maurice Schwartz, Sidor Belarsky, Seymour Rechzeit, and Miriam Krassen, and many of the great cantors of the era, such as Leible Waldman and Jan Peerce. He also was employed by Jewish composers and orchestra leaders to play in the concert orchestras of Rumshinsky, Ellstein, Secunda, and Olshenitsky. In addition to this work in orchestras, theaters, and recording studios, he was active in the immigrant Jewish community, performing for various Hasidic groups.

Tarras's repertoire was far-reaching, reflecting his own regional and familial background from Eastern Europe, but also building upon his unique capabilities as a musician. He was renowned for his versatility, his talent as a composer, his choice of traditional melodies, and the virtuosity of his tone and phrasing. Over the course of his career, Tarras created a new klezmer sound that fused popular American music with recognizable European roots. Klezmer improvisation techniques are similar to those of American fiddle or Greek music: Basic melodies are embellished through slurs and ornamentation. Americanized klezmer music centers on clarinet melodies.

Klezmer, like the Yiddish language itself, is a creative combination of different cultural features and styles, combining the long melismatic melodic line of cantorial phrasing with rhythms of Eastern European village dance tunes, the shepherd's clarinet with the gypsy violin, the instrumental techniques of art music with the free improvisational style of Near Eastern folk music. Once established in the United States, klezmer music has been credited with influencing the development of American popular music, especially in the swing era.

The Tarras family contained three generations of Hasidic klezmorim who settled in various towns of southeastern Ukraine. There they came into contact with gypsy musicians who played lively music on a variety of instruments. In combining these influences with the traditional Jewish repertoire, Jewish musicians further developed a new form of dance music. The hallmarks of this style are the dances named *bulgar, honga, hora, sirba,* and the melodic *diona*.

Over the course of his career, Tarras made hundreds of recordings for almost every major label. In addition to klezmer, he recorded with numerous trios and ensembles, playing the clarinet part for Greek, Polish, Ukrainian, and other styles of American popular music.

Sanders "Sonny" Terry

African American Blues Musician

Life dates: October 24, 1911–March 12, 1986

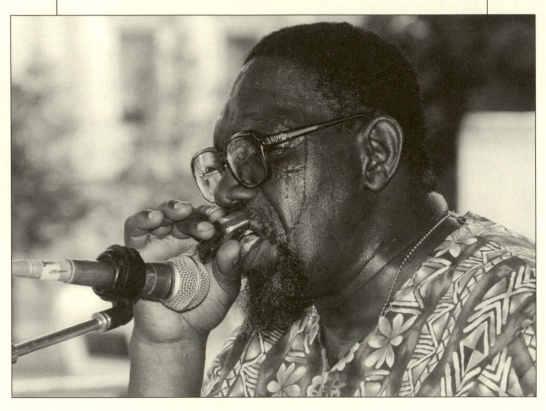

Sonny Terry, 1982 (Courtesy Smithsonian Institution)

SONNY TERRY WAS BORN SANDERS TERRELL ON October 24, 1911, in the country near Greensboro, Georgia. His father, Ruben Terrell, used to play the harmonica in the evening to relax. Each night he put the instrument away on a high shelf, well out of reach of young Sonny. But when he left for work for the day, Sonny climbed up and got the harmonica down to try it out. One day he didn't put it back just as his father had left it, and when his father noticed, he asked Sonny if he'd been playing. Sonny's mother told his father that he played a tune for her every day, and his father decided to teach him how to "really play." From his father, Sonny learned to play blues and to mimic on the harmonica the sounds of far-away trains and the baying of hounds.

When Sonny was 11 and again when he was 16 years old, he had accidents that resulted in the loss of vision in both of his eyes. After the second accident, he started playing harmonica in local churches and dance halls. When he was 19, he began to tour with traveling medicine shows, moving from town to town, supporting himself as best he could.

By the early 1930s he was living in Durham, North Carolina, where he played at tobacco warehouses, fish fries, and house parties, and on the streets with two blind guitarists, Reverend Gary Davis and "Blind Boy" Fuller. He made several 78 rpm recordings with Fuller on the Vocalion label that were popular among rural blacks across the South. In 1938, he was invited by John Hammond to play at Carnegie Hall in the legendary "Spirituals to Swing" concert.

After Fuller died in 1941, Terry teamed up with guitarist Brownie McGhee, and the two men played and toured together for the next 40 years. They joined the Great Migration to New York City and attained considerable success, recording prolifically and entertaining at private parties, on radio programs, and in stage shows. They appeared in the casts of the Broadway shows *Finian's Rainbow* (1947–1948) and *Cat on a Hot Tin Roof* (1955–1957). In the late 1950s, they became part of what is now called the folk revival, and were invited to participate in numerous European tours. For a time, Terry lived in an old loft building where Woody Guthrie, Burl Ives, and other popular singers stayed. About 1970, Terry and McGhee split up over personality conflicts and tensions related to their respective musical careers, though they did reunite on different occasions over the years. Terry began playing solo harmonica and for a brief period he led his own small band.

Terry was renowned for his virtuosity in playing the harmonica. He used a "cross-note" technique, playing in a key other than the key of the diatonic harmonica, and was especially talented in creating special effects, including train whistles, animal cries, and vocal

moans. He sometimes sang while he played, and by controlling his breath and cupping his hands over the harmonica, he was able to modulate from key to key, blending the musical pitch and slurring notes.

Jennie Thlunaut

ALASKA NATIVE BLANKET WEAVER
(TLINGIT CHILKAT)

Life dates: May 18, 1891–July 16, 1986

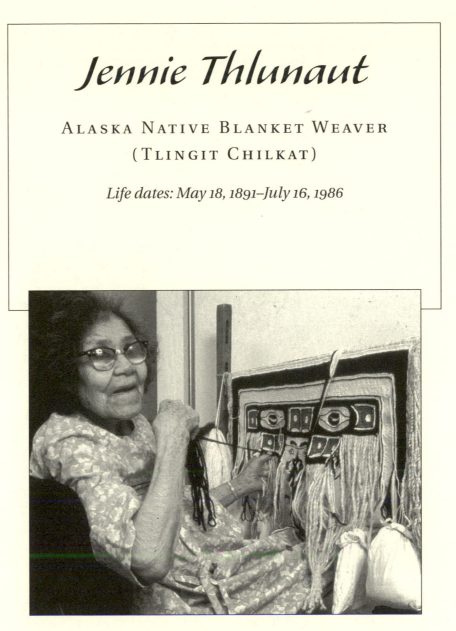

Jennie Thlunaut (Courtesy Jenny Thlunaut)

JENNIE THLUNAUT WAS BORN MAY 18, 1891, to Tlingit parents in Alaska during the spring run of the "hooligans" (smelt). Like most Tlingit children, she spent her early childhood playing on the beach, picking berries, and gathering wild celery. She accompanied her parents on their cyclical expeditions to hunt and fish and traveled with them in Tlingit war canoes to visit relatives in other communities.

When still a little girl, she received her first box of mountain goat hair—one of the essential components of Chilkat weaving. Southeastern Alaska is rich in the natural resources needed for these weavings; in Chilkat blankets, mountain goat hair and the fibers from red cedar are woven together. When Thlunaut was 10 years old, her mother began to teach her to weave.

The Chilkat blanket has mythical origins, and the art of blanket weaving was transmitted from the Tsimshian to the Tlingit Chilkat in the nineteenth century. The designs woven into the blankets—stylized animal figures similar to those found in Tlingit carving—are the crests of family or clan groups and serve as property makers and emblems.

"The Tlingit were not writers of books," Austin Hammond, a Tlingit elder, said. "They wove their history into their garments, and they wear their history on their backs."

Chilkat blankets are worn in potlatches and other ceremonies, and their long-fringed borders create a spectacular display as the dancers spin and swirl. They are made for movement.

Over the course of her life, Thlunaut became a master weaver and is credited with single-handedly keeping the tradition alive in Alaska during a period of decline in interest in native crafts. She was directly or indirectly a great inspiration for younger weavers, who, in time, have renewed the vitality of the indigenous Tlingit traditions. By the end of her life, Thlunaut's blankets were selling on the open market for $10,000–$16,000 each, but despite this success she continued to give them away in the traditional manner. She never kept a single blanket for herself. "I don't want to be stingy with this," she said. "I am giving it to you, and you will carry it on."

Ada Thomas

NATIVE AMERICAN BASKET MAKER
(CHITIMACHA)

Life dates: July 31, 1924–September 6, 1992

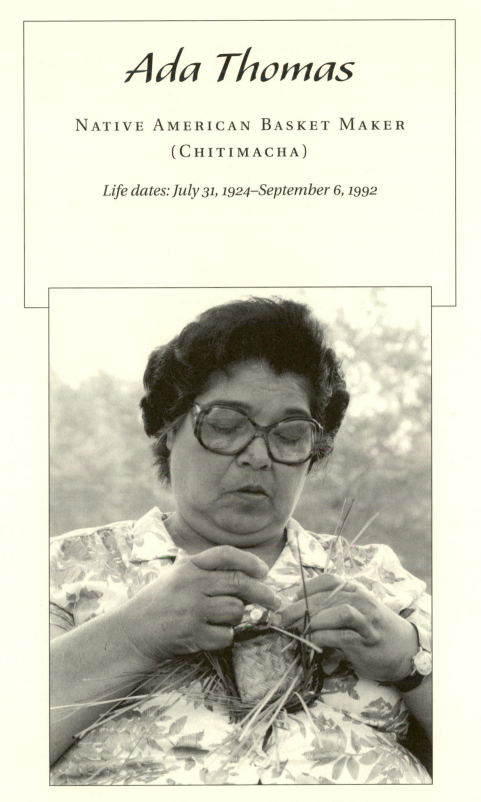

Ada Thomas, 1982 (Courtesy Smithsonian Institution)

ADA V. THOMAS WAS BORN JULY 31, 1924, on the Chitimacha Reservation, one mile west of Charenton, Louisiana, in St. Mary's Parish. Prior to European settlement of the United States, the Chitimacha Indian tribe consisted of 17 bands of hunters and fishermen scattered across Louisiana. By the turn of the twentieth century, the government had reduced Chitimacha land to about 265 acres located in the area near Charenton, Louisiana.

Thomas attended elementary school in a one-room schoolhouse on the Chitimacha Reservation, where grades one through eight were taught together. When she was about 12 years of age, she learned traditional basketweaving techniques from her grandmother, Christine Paul, who was a teacher at the school. When her grandmother retired, her aunt, Pauline Paul, took over teaching at the school, and Thomas continued her studies of basketweaving from her. This Chitimacha basketry tradition dates back to the early 1700s, when it was first noted by European writers.

In the late 1930s, after Thomas earned her eighth grade certificate, she wanted to continue her schooling, but there was no high school on the reservation and she wasn't allowed to attend either the white or the black high schools in her area. So she moved to New Orleans to go to high school, and while there she went to a museum and was surprised to see some Chitimacha baskets on display. "For the first time I felt proud of who I was," she said.

Upon graduating from high school, she moved away from Louisiana. "I traveled," she recalled, "and worked all over the United States and finally settled in Miami, Florida, where I got married and stayed for the next 21 years. When my husband got sick, we returned to the reservation." In the mid-1970s, Thomas decided to resume making traditional baskets, after nearly 30 years of inactivity.

For Thomas, the process of creating Chitimacha baskets was long and tedious. To begin, she gathered swamp cane or cane reed from the bayous near where she lived. In so doing, she selected reeds of different ages for each color she needed. She then split and peeled the reeds by hand before curing and drying them. Traditionally, the reeds were soaked in dew and sun for eight days to bleach them. Most were then dyed by soaking for seven more days in colored water. The dyes were all natural. "A root of a wild plant," Thomas explained, "is used for red coloring. The outer bark of the regular walnut [tree] is used for the black coloring, and lime is used for the yellow coloring."

To make the double-woven basket, Thomas worked simultaneously with numerous strands of red, dark brown, and other naturally colored cane. She interlaced the cane in one continuous weave, creating the inside basket first. When it was completed, she doubled

back, weaving the outside basket, carefully selecting strands of cane at each point throughout the weaving process to construct a design. As she neared completion of a basket, the design became readily apparent. Traditional designs included Alligator Entrails, Bull's Eye, Rabbit Teeth, Snake Design, Bear's Earrings, Fish, and Muscadine Peel. Most of these designs reflected the tribe's close association with nature and aspects of its life in the Louisiana bayous.

Throughout the last years of her life, Thomas worked to revive interest in Chitimacha basketry traditions. "I would like to see our Indian people start over and learn basketweaving. The interest is there, but finding and processing the materials is hard to do. To me, it would be an interesting pastime or hobby, but none of the young girls weave baskets to keep the Chitimacha tradition alive."

Dorothy Thompson

CZECH AMERICAN APPALACHIAN WEAVER

Born: August 20, 1920

Dorothy Thompson (Gerald Milnes, Courtesy Augusta Heritage Center)

DOROTHY THOMPSON WAS BORN IN rural Pennsylvania on August 20, 1920. Her parents were Czech immigrants and moved the family to West Virginia when she was an infant. Her father, a coal miner, was a wood carver on the side. He made a "rigid hettle" loom that was Dorothy's introduction to the weaving tradition that had begun in Europe on her mother's side; an aunt was the most active weaver in the family. In the backyard of their home in West Virginia, the family strung a long warp to weave carpet for themselves and others. Starting when she was 10, Dorothy helped with these family rug-weaving projects.

During the Great Depression, Dorothy's father worked at woodworking shops at Scott's Run and Arthurdale, Quaker-run community projects in northern West Virginia. Her mother wove at a community weaving center set up as a cottage industry for area women. Dorothy liked to assist her mother in the community projects and took a vocational weaving class through the county school system.

Later, Dorothy was selected for a weaving apprenticeship set up by Eleanor Roosevelt. She was apprenticed to Lou Tate, a weaver in Louisville, Kentucky. She lived and worked with Tate for a year and a half, then returned home. By then, her father had become self-employed as a furniture and loom maker and had made more than 50 looms that were sold to area weavers. She still has five of his looms and uses them for instruction.

Ben Thompson, Dorothy's husband, also came from a family with a weaving tradition. He gave her his great-grandmother's loom, a large, barn-frame, four-harness loom in good condition.

During the 1960s, Dorothy accepted an invitation from the Tucker County schools to teach hand weaving to students, though she also taught area residents at her home. In the late 1970s, she conducted hand-weaving workshops at the Augusta Heritage Center. In 1990, she accepted an apprentice, Virginia Mayor, through the West Virginia Folk Arts Apprenticeship Program. Mayor still weaves with the six women who meet at Thompson's home to weave on Tuesday and Thursday nights. Over the years, Thompson estimates that she has taught more than 150 people to weave.

She has woven commissioned pieces, such as tablecloths, coverlets, and rugs, and produced work for sale, but always saves the proceeds to buy materials for new projects. She commissions tablecloths, coverlets, rugs, and an assortment of smaller items.

After her husband's death in 1994, Thompson devoted most of her time to weaving and working with her students. She is a longtime member of the Mountain Weaver's Guild and assists in demonstrations at the organization's annual exhibit at the Mountain State Forest Festival. Marion Harless, president of the guild, says of Dorothy,

"Her students love her, although she is an exceedingly tough taskmaster."

To be a master weaver, Thompson says, "you have to weave all your life."

Paul Tiulana

Alaska Native Mask Maker, Dancer, and Singer (Inupiaq)

Life dates: 1921–June 17, 1994

Paul Tiulana (Kathy James, Courtesy National Council for the Traditional Arts)

PAUL TIULANA WAS BORN IN 1921 ON King Island in the Bering Strait, just off the Alaskan Seward Peninsula. He was an Inupiaq Native, and was taught at an early age how to survive in nature, how to hunt, and where to go on the ice floes to look for seals. In addition, he learned how to mark moving ice, shore ice, and mainland ice to help understand drifting patterns and other necessities of living on a remote Alaskan island.

Tiulana started going to school on King Island when he was nine years of age. That same year his father died, and his uncle, John Olarrana, became his mentor. Under his tutelage, Tiulana grew up to become a leader in the preservation of Inupiaq traditions. He was an accomplished ivory carver, mask maker, singer, and drummer. He made the perpetuation of the culture and heritage of the King Islanders a major concern, and he devoted much of his life to this work.

The King Island Eskimos were forced to leave their island in the 1950s and were resettled in Nome, Anchorage, and other locations in Alaska. Tiulana taught carving classes and workshops for the native organizations that serve Anchorage, and he was a member of the King Island dancers for more than 40 years, and their leader since 1956. He toured extensively with this group throughout Alaska and in the lower United States. He spearheaded a project to build a traditional skin boat, or *umiak*, in 1982, and he played a key role in the revival of the ceremonial Wolf Dance, which was finally performed in 1982 for the first time in more than 50 years.

In 1983, Tiulana was named Citizen of the Year by the statewide Alaska Federation of Natives for his work promoting cultural heritage. Rarely had a civic award of this nature been presented to a practicing artist. He was an exemplary craftsman, a vigorous and subtle dancer, and an expressive singer. He knew and could teach the survival crafts that were once so essential to the quality of human life in the Arctic, skills still vital to the maintenance and dignity among native populations. On completing his skin boat, a labor of many years, he wrote, "I have been taking a walk in the past." But throughout his life, he was firmly situated in the present, sustaining for his contemporaries and descendants the traditional values and complex aesthetics of the Inupiaq Eskimo people.

Lucinda Toomer

AFRICAN AMERICAN QUILTER

Life dates: February 5, 1888–September, 1983

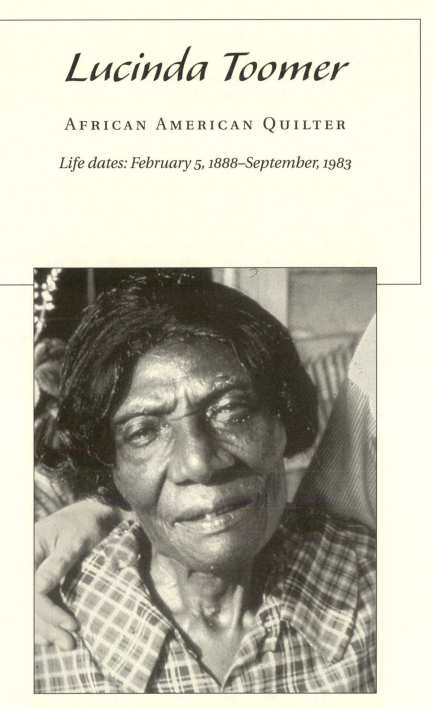

Lucinda Toomer (Maude Wahlman)

*L*UCINDA HODRICK TOOMER WAS BORN FEBRUARY 5, 1888, on a cotton and peanut farm in Stewart County, Georgia. The oldest of seven children, she learned to quilt from her mother, Sophie Hodrick. "When I was a little girl," she said, "we'd set that lamp down on the floor. There was no electric lights nowhere, and she had a big lamp with a chimney, and she'd set that lamp down between me and her on the floor. All the rest were on the bed. It's funny to tell it. I would play sleep so I could go to sleep. She would take her thimble and thump me in the head and wake me up and learn me how. And I'm so glad she done it. I sure thank her for it. . . . We just had a better time than we do now. Everything people had, they made."

Lucinda and her mother sewed and quilted out of necessity, making a variety of "strip quilts" by using an array of fabrics and stitches. In sharp contrast to Anglo-European quilts, in which the primary design principles are order, symmetry, and the repetition of motifs and patterns, African American quilts are characterized by innovation and improvisation.

When Lucinda was 18, she married Jim Toomer, and together they worked and farmed near Dawson, Georgia. Their two children died in infancy, but they raised one of her sister's children. Throughout her life, Toomer was active in the Piney Grove Baptist Church and always liked to quilt, making about 20 quilts a year.

For her quilts, she used whatever fabrics were readily available. She often bought materials, priced at nine dollars a bag, from local pajama and shirt factories. Usually, she spent four days to complete a quilt top, by piecing four to five blocks a day, and then about a day and a half to quilt out the tops. Most of her quilt patterns were her own creations; she liked to adapt unnamed designs she had seen in books and magazines. She frequently ordered her quilt top designs with strips because, she said, "a strip divides so you see plainer."

In organizing the strips into a quilt top, she was very careful to juxtapose the colors in ways that intensified the hues. "I get any color . . . and I try to match with a different color . . . to make them work . . . see that makes it show up." Red was her favorite color because of its vividness. "I put it where it will show up the pieces . . . red shows up in a quilt better than anything else . . . you can see red a long while."

Other quilts that Toomer made were called Star of Bethlehem, Cotton Leaf, and Fish Shell, all of which demonstrated a knowledge of traditional patterns, but were nonetheless sewn with an improvisatory quality. Each piece in her quilts was individually distinctive, but simultaneously integral to the overall design. "I like to make them and put different pieces in there to make it show up what it is

. . . if you just make what you can of it and make a change of it, there's something good in it."

Toomer's husband died in 1977, and she lived the rest of her life in relative isolation, but continued making quilts, even though her production far surpassed her needs. "I just do it. I get joy out of it. I just feel they're worth something. . . . I just sit down here and sew. There ain't nobody there but me. Ain't got nobody to talk to if I got something like that on my mind. . . . This is company to me. . . . I say, well, Lord, I ain't got nothing to do and that's my company sitting down here that I'd be doing it."

Henry Townsend

AFRICAN AMERICAN BLUES MUSICIAN AND SONGWRITER

Born: October 27, 1909

Vernell and Henry Townsend, 1991 (Alan Govenar)

HENRY TOWNSEND WAS BORN OCTOBER 27, 1909, in Shelby, Mississippi, the third son of Allen and Omelia Townsend. Allen played guitar and accordion and sang blues. When Henry was young, his family moved to Future City, Illinois, a notorious shantytown near the rail and river town of Cairo. After a series of confrontations with his father, who had a violent temper, Henry left home at nine, walking north along Highway 3, stopping in small towns along the way to hustle jobs and food. "I came to be a man about age nine," he said. "I had to . . . I decided I'd move from where the whipping was gonna come and so I did. . . . Well, I rode a train, I caught the train with nobody knowing it—we call that hoboing—I didn't care where I was going. . . . This was the first big city I came to, so I got off."

In St. Louis, Townsend made friends with two guitar players, who taught him the basics of playing the guitar and helped him to find regular jobs. At different times, he worked as an auto mechanic, a shoe shiner, a hotel manager, and a salesman, but these were all second to his aspiration to become a musician. "I didn't like the hard part of work, the really going in there like a man part. After I decided I didn't want to work like that, I had to try to find another way out, without going into the wrong things, you know, and I started to work very diligently on the guitar."

During the 1920s, the city had an active blues scene that featured figures such as Roosevelt Sykes, Big Joe Williams, John Lee "Sonny Boy" Williamson, and Lonnie Johnson. They were forging a sound identified with St. Louis, a music that combined the acoustic string playing of the Delta country blues with a driving piano–guitar interplay that foreshadowed the later Chicago electric blues bands. Townsend first took up guitar, then piano. He accompanied most of the stars of the era in performance and on recordings. In 1935 alone, he appeared on 35 recordings. He also became a fine singer and songwriter.

By the mid-1950s, the heyday of St. Louis blues had passed, and Townsend was forced to seek other work. He found himself more appreciated in Europe than in his own country. In the early 1960s, he was interviewed and recorded by the British blues authority Paul Oliver and was featured in several British films, including *Blues Like Showers of Rain* and *The Devil's Music—A History of the Blues.* His concerts in Europe drew large audiences, and he appeared at a number of American festivals. As Townsend dryly notes, he has been "rediscovered three or four times."

Townsend continued to live in St. Louis with his wife, Vernell, a fine blues singer herself. He became an articulate spokesman for the blues, often speaking in classes and seminars. In addition, he was generous with his time in mentoring young musicians, often taking them into his home for months at a time.

Dorothy Trumpold

GERMAN AMERICAN RUG WEAVER

Born: September 22, 1912

Dorothy Trumpold (Courtesy Dorothy Trumpold)

DOROTHY TRUMPOLD WAS BORN SEPTEMBER 22, 1912, in her family home in East Amana, Iowa. She has lived her entire life in the Amana Colonies, which have a unique social and religious history. Settlers of these communities, often confused with the Amish, came from Germany and were members of the Community of True Inspiration, a Lutheran sect founded in 1714 and based on the belief that God may communicate through an inspired individual. The group first moved to Ebenezer, New York, and then to Iowa in 1855. There, they established a communal lifestyle in seven villages on 26,000 acres of farmland. The communal way of life endured until 1932.

Dorothy's mother, Catherine Hess, was a seamstress and kitchen worker. Her father, Benjamin Schuerer, was a cooper and farm boss. As a girl, Dorothy learned knitting, crocheting, and embroidery. She spent time with her grandfather, Louis Hess, observing him at his loom and helping him prepare shuttles for carpet weaving. By the time she was 12, she had learned to make her own clothes.

At 14, Dorothy graduated from school and began working in the community kitchens of the Amana Colonies. She learned to make crocheted, braided, and hooked rugs. In 1932, she went to work in the spinning and weaving departments of one of the woolen mills that served all seven villages. The following year she married Carl Trumpold.

In 1940 she took over carpet weaving from her ailing grandfather. She worked in a one-room building heated by a wood-burning stove. In the late 1940s, the loom was moved to her present residence. She began making throw rugs and then for years made full-sized room carpets. Later she returned to making throw rugs and was still turning out beautiful work in her late eighties, using the cast iron loom her family brought from Europe in the 1840s. She was one of the few practicing artists who lived through the dissolution of the Amana communal life, known as "the Great Change."

Trumpold has long been recognized for her work in Iowa. In 1985, she served as a master artist in the Iowa Folk Arts Apprenticeship Program, and for the last few years she has been teaching a young local girl to weave rugs. She was a featured artist in the Iowa portion of the 1996 Festival of American Folklife and in the Sesquicentennial of Iowa Folklife. In 2001, her work was being shown in an Iowa artists exhibit at the Des Moines Art Center. She and her work are highlighted in Steve Ohrn's books *Passing Time and Traditions* (1983) and *Remaining Faithful* (1988).

Nikitas Tsimouris

GREEK AMERICAN BAGPIPE PLAYER

Born: 1927

Nikitas Tsimouris (Blanton Owen)

NIKITAS TSIMOURIS WAS BORN IN 1927 on Kalymnos, in the Dodecanese, a group of Mediterranean islands belonging to Greece but lying off the Turkish mainland. Like others in the Dodecanese, the Tsimouris family derived its livelihood from both sea and land by fishing, sponge diving, raising small herds of goats and sheep, and farming, cultivating olives, grapes, and other fruits.

As a young man, Tsimouris learned to play the Greek bagpipe, *tsabóuna,* from his father and other male relatives, who often played the instrument to pass the hours while tending their animals. The *tsabóuna* is usually made from a goatskin *(tragéois),* wood, and string. These components are held in place with beeswax and onionskin. The air bag of the instrument *(touloumi)* is a goatskin turned inside out, with the neck, tail, and two leg openings tied shut. The mouthpiece and chanter (finger pipe) are tightly affixed with string to the remaining two leg openings of the bag. When the bag is filled with air and the air pressure inside is increased by squeezing the bag with the arms, the air forced through the chanter produces sound. Any air leaks are stopped with bits of beeswax, and air is kept from escaping out the mouthpiece by an onionskin flap affixed on the inside with beeswax.

The chanter is traditionally passed from father to son and is inserted in the skin when a new bagpipe is made. Tsimouris's chanter, made of olive wood by his father, has two bamboo reeds. One reed has five finger holes; the other has three. To tune the chanter, he adjusts the reed lengths with a piece of string and reduces the size of certain holes with blobs of beeswax. He plays standing up, wraps his arms around the bag, and keeps pace by tapping his feet. By varying the air pressure in the bag, he is able to "bend" notes or ornament the basic melody with flurries of grace notes. Occasionally, Tsimouris will hold the air pressure with his arms while singing a line or two of a song. The music is essentially designed for dancing and Tsimouris sometimes paces along with the dancers as he sets the complex 7- and 13-beat rhythms.

In 1968, Tsimouris moved with his family to the tightly knit Greek community of Tarpon Springs, Florida, where he operates a stuccoing business in partnership with his son, Anonios. In Florida, the *tsabóuna* music he plays is considered antiquated by many, but it continues to serve as a focal point for the needs of cultural preservation. Tsimouris is often invited to perform for weddings and other community events.

Fred Tsoodle

NATIVE AMERICAN SACRED SONG LEADER
(KIOWA)

Born: November 14, 1919

Fred Tsoodle (Courtesy Fred Tsoodle)

FRED TSOODLE WAS BORN NOVEMBER 14, 1919, west of Carnegie, Oklahoma. He had nine brothers and sisters. His mother, Mable Hummingbird Tsoodle, died when he was 13. He and his four brothers were raised by their grandmother. He graduated from the Chilocco Indian School. During World War II, Tsoodle served in the Air Force in North Africa and Europe. In 1942, he married Peggy Quetone. They have three children. He retired in 1981 from a job as an operations officer at Tinker Air Force Base in Midwest City, Oklahoma.

The Kiowa of southwestern Oklahoma have long been known as great singers and composers of songs ranging from traditional healing and gourd dance songs to more modern intertribal powwow songs. Tsoodle, who is active in the Kiowa Gourd Clan, is conversant with many of these forms. But he specializes as a song leader of a unique repertoire of Kiowa sacred Christian music, a tradition that dates to 1893. He began learning these songs in the 1930s, when he joined a church baseball team and began attending Rainy Mountain Kiowa Indian Baptist Church.

The Kiowa say that there is a song for every occasion in the church setting, from holiday hymns to songs to celebrate the significant stages of life, including birth, baptism, and death. There are now more than 200 of these hymns, each with a unique tune and lyrics in the Kiowa language. These songs are preserved primarily through human memory. As the recognized song leader in the Rainy Mountain church, Tsoodle became the performer and keeper of this valuable cultural repertoire.

Of his background, Tsoodle said: "We had our Indian religion and peyote religion; Grandfather was a medicine man, so we know all that. We were powwow people; we went to powwow. They had gourd dances down at Daddy's place; we had an arbor there, medicine bundles. They're still around.

"I love my Indian ways. I grew up around them, singing. I respect our Indian ways. But you know that we're losing that, you know that they copy other tribes' ways. I remember when I was young, gourd dancing was important to our people; that was in the 1930s. We used to have an annual dance with the Otoe Tribe. Every other year, we would host the dance at my grandfather's place. When it was their turn to host the dance, I would drive my grandfather up to their territory. . . . The last exchange like that was in 1941. My grandfather passed away that winter, and the gourd dance kind of faded out.

"In 1953 and '54, I was the director of the Kiowa contingent of the American Fair; each tribe was supposed to do a presentation of some kind. We did the gourd dance. It hadn't been done since 1941. I asked some of the old men that were active in the 1930s to help us.

Six dancers and two singers came out to help us. We wanted them to dress in traditional clothes from head to toe; we had to go around and borrow leggings and other old gourd dance regalia.

"We went into hock shops and found all the items that were needed; everything was authentic. . . . When we brought the dancers into the dance arena, there was no noise; everything was quiet. You could even hear the people crying, remembering the old days. We try to do things the way the old folks did them. . . . From that day, the Kiowa Gourd Clan and other groups have grown and become a regular part of our community life."

Tsoodle is passing the sacred songs along to his nephew Milton Noel and grandson Freddie Cozad. The Chilocco Indian School Alumni Association is recognizing Tsoodle as the honored elder in 2001.

Othar Turner

AFRICAN AMERICAN FIFE PLAYER

Born: June 2, 1908

Othar Turner, 1993 (Nicholas R. Spitzer)

OTHAR TURNER WAS BORN ON JUNE 2, 1908, in Canton, Mississippi, east of Jackson. Except for a nine-month period laying and repairing railroad track as far north as Indiana, he has lived his entire life in and around Gravel Springs, which straddles the Tate–Panola county line. "I been out on the farm a good while and raised six kids, and I don't know how many other people," he said of his life as a small farmer.

Turner made his first cane fife when he was 13. He had already learned a good deal about drumming from players in the area and wanted to move on to the fife. He picked his cane from a ditch bank and cut it to the right size: a little over a foot long, with several joints in the right places. He bored six holes in it with a red-hot rod, five finger holes and one for the mouthpiece. He experimented until he got the right intonation. Since then, he has made countless fifes for others.

His band, the Rising Star Fife and Drum Band, consists of the fife and three drums: two kettles (snare drums) and a bass. The high-pitched kettle drum is the lead instrument. All the musicians play standing up, often while walking, with the fife leading the way. The repertoire is a mix of blues, old popular tunes, spirituals, and instrumental pieces collectively known as "Shimmy She Wobble," for the liberating effect the music has on dancers.

Some scholars consider the fife and drum music of northern Mississippi the most deeply rooted African style of music still being played in the United States. It certainly is among the rarest. Fife and drum ensembles are found in many parts of Africa and in the English-speaking Caribbean. Ethnomusicologist David Evans has traced the music to a combination of African styles and European-derived militia music of Colonial times, during which there were many accounts of black fife players and drummers. As late as the mid-twentieth century, it could be found in Harris County, Georgia, and in western Tennessee, as well as in Mississippi.

The most common performance settings are picnics, large community gatherings at which there is plenty of food, camaraderie, and dancing to the music of the fife and drums. These picnics have been going on in the communities as long as anyone can remember. They are family affairs that attract both local people and those who drive down for the weekend from St. Louis, Memphis, and Chicago. Turner organizes picnics around the Fourth of July and Labor Day, starting them off at first light on Saturday and playing no later than midnight, out of respect for the Sabbath. "Way I introduce . . . [a picnic]," he said, "I walk right out on the hill out there and play them drums . . . and man, folks be coming from up yonder all the way on

down to where my truck was, just laughing and talking, man, and them drums be playing music, they just enjoy."

Since the mid-1970s, however, Turner's music has been more in demand outside the region. He has made numerous recordings and appeared at the Mid-South Folklife Festival in Memphis and in concerts and festivals around the country.

Cleofes Vigil

HISPANIC AMERICAN STORYTELLER AND MUSICIAN

Life dates: April 9, 1917–June 15, 1992

Cleofes Vigil, 1990 (Alan Govenar)

*C*LEOFES VIGIL WAS BORN APRIL 9, 1917, in a small village in the San Cristobal Valley of northern New Mexico. His family has lived in this region for centuries, and he was a descendant of the early Spanish settlers in the area. His native language was Castilian Spanish, although he did eventually learn to speak English. As a child, he helped his family in growing fruits and vegetables and raising livestock in the high mountains of the Sangre de Cristo range.

He said of himself, "I play the mandolin and sing old songs and religious chants (*alabados*). My religious chants came from Spain with the first settlers and are very old, and I am sorry to say that I am one of the few that sings them exactly the way Juan de Oñate and his settlers sang them when they came to the New World. I have kept them, and know many for different occasions, and of course I would like to share this history of the mountains of the Sangre de Cristo with my people and others. . . . I talk Spanish and some English, and some of my music is a mixture of Indian and Spanish."

When he was 13, Vigil joined the fraternal order commonly known as *Los Penitentes*. This group, formally called The Brothers of Our Father Jesus, is now recognized as a lay religious society of the Roman Catholic Church, sponsoring "pious observances, especially during Holy Week" and providing "year-round mutual aid for members and unobtrusive charitable acts for neighbors."

Vigil participated in *Los Penitentes* rituals and eventually became a *cantante,* or singer. Many of his *alabados* came from the *Penitente* repertoire and had been kept private. Vigil was a self-taught musician who played the mandolin, violin, saxophone, clarinet, and harmonica.

In addition to his talents as a religious singer and musician, he was also a master teller of traditional stories. He prided himself in telling traditional tales, which he said were both "educational and humorous." Many of these he learned from his grandparents and community elders as he was growing up.

Vigil was among the few *cantantes* willing to sing widely in public. He performed on many university campuses and in festivals across the country. Through the years, Vigil committed himself to living an exemplary Christian life and was devoted to the preservation of the traditional culture of *Los Penitentes* and his community in northern New Mexico.

"All of this history has been passed to me by my ancestors," he said, "and I have preserved it, because to me, it is beautiful and penetrates the heart."

Felipe García Villamil

AFRO-CUBAN AMERICAN DRUMMER

Born: September 5, 1931

Felipe García Villamil (Guadalupe Vasquez Garcia)

FELIPE GARCÍA VILLAMIL WAS BORN SEPTEMBER 5, 1931, in Matanzas, Cuba, into a family rich in Afro-Cuban musical tradition. His mother, Tomasa Villamil, came from a line of prominent singers, musicians, and dancers of the Yoruba-derived *Santeria* religion. Her family also includes performers of Matanzas province's signature folk music, the *rumba*. Many of these relatives performed with Cuba's leading folklore groups, such as Los Munequitos de Matanzas, Grupo Afro Cuba de Matanzas, and Conjunto Folklorico Nacional.

García Villamil's father, Benigno García García, was an adept in the Kongo-derived *Palo Monte* spiritual tradition and in the Abakua men's society brought to Cuba from West Africa. From his Yoruba great-grandfathers, García Villamil inherited a set of *bata* drums.

"My drums are called *Anya Biollo*," he said. "They were born of Noblas Cárdenas, and came to my hands in this way. The founders of these drums were four men born in Africa, in the city-state of Oyo, in the land known presently as Nigeria: Noblas Cárdenas, grandfather of Tomasa Villamil on her mother's side; Mauricio Piloto, grandfather of Tomasa Villamil on her father's side; Oba Enkole; and Ablawo Ochablowo."

With deep grounding in the three most prominent Afro-Cuban rituals, García Villamil became one of the most talented Cuban drummers. He also learned to make the instruments to accompany each ritual tradition: the three sizes of *bata* drums, the *yesa* drums, and the set of gourd rattles called *guiros* or *chequeres*. He has been described as a *completo*—a complete percussionist. In addition, he crafts exquisitely beaded *Santeria* ceremonial objects and is deeply knowledgeable about the healing properties of plants.

In Cuba, García Villamil directed the highly respected folkloric performing group Emikeke. After coming to the United States in the 1980 Mariel boatlift, he settled in New York City, where he formed the group Tradicion Mantacera and later reformed Emikeke with his advanced students. Emikeke performed widely in the region.

In recent years, García Villamil has moved to Los Angeles, where he continues to perform and teach. His skill as a ritual craftsman also has brought invitations to exhibit and demonstrate his work. His symbol-filled, consecrated "Altar for the Spirit Sarabanda Rompe Monte" was a featured component of the exhibition "Face of the Gods: Art and Altars of Africa and the African Americas," organized by Yale professor Robert Farris Thompson. This altar was built in a closet in a third-floor apartment and was described as an "urban *munansó*" (altar enclosure). At the top was a straw hat for Sarabanda Rompe Monte to wear as a sign of his presence. The *munansó* also

contained *nkisi* of Cantella (a lightning charm), Madre de Agua (mother of the waters), and Kobayende (with red cloth and feathers).

García Villamil has participated in the National Black Arts Festival in Atlanta and conducted seminars and workshops at the American Museum of Natural History and the Caribbean Cultural Center in New York and at the California African American Museum in Los Angeles. He is committed to the preservation of Afro-Cuban performance traditions that synthesize song, drumming, and dance and that are incorporated into systems of moral and philosophical guidance and healing.

T. Viswanathan

ASIAN AMERICAN FLUTE PLAYER
(SOUTH INDIAN)

Born: 1927

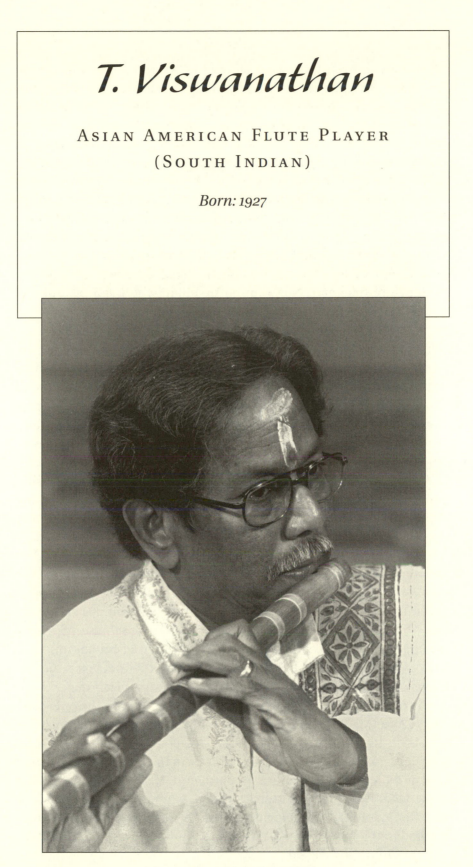

Tanjore Viswanathan (Nancy Walz)

T. Viswanathan was born in 1927 in Madras, a city in southern India. He comes from a family of illustrious Karnatic musicians and dancers. His grandmother, Veena Dhanammal, was considered one of the finest *vina* (plucked zither) players of this century, and his sister, T. Balasarasawati, was regarded as the greatest exponent of Bharata Natyam (South Indian classical dance). Although South Indian, or Karnatic, music is based on the same basic concepts, such as *raga* (melodic mode) and *tala* (rhythmic meter), as found in its North Indian or Hindustani counterparts, its style of ornamentation, musical forms, favored modes, and performance traits are different.

Viswanathan learned his family's musical repertoire as a child, and when he was eight years of age he decided he wanted to study under flute master T. N. Swaminatha Pillai, who lived in Tanjoor, about 200 miles from Madras. Viswanathan left his parents and went to live with his teacher, dedicating himself to studying the flute. Under Pillai's tutelage, he practiced the flute each morning for two hours before going to school, and then again for another two hours in the evening before going to bed. He says that such a commitment was expected of him because he was training to become a professional musician. After about a year, Master Pillai relocated from Tanjoor to Madras. Viswanathan returned to his family and continued to study with Pillai for almost 20 years.

Viswanathan's instrument, the *kuzhal,* is a bamboo flute with seven or eight holes. The basic pitch of the instrument depends on its length. The *kuzhal* has no metal keys; its subtle ornamentation is produced by the position of the fingers over the holes and by movement of the head. Classical Indian music is based on scales of five, six, or seven primary tones or *swaras* represented by the abbreviations sa, ri, ga, ma, pa, dha, and ni. Microtonal variations of these seven tones are called *srutis* and occur in melodic modes called *ragas.* The *raga* is a particular scale. There are several hundred South Indian *ragas.* The second important component of Indian music is *tala,* a rhythmic cycle of a number of beats that acts as a metric framework for all musical compositions and improvisations.

For over 40 years Viswanathan has toured India, Europe, and North America both as a solo performer and as an accompanist for his sister. In 1958, he enrolled at the University of California at Los Angeles (UCLA) with financial support from the Rockefeller Foundation and the Fulbright scholarship program. He studied at UCLA for three years, and then returned to India, where he became head of the Department of Music at Madras University. In 1961 he performed in the milestone East–West Encounter in Tokyo, and in 1963 at the Edinburgh Festival.

He settled in the United States in 1966 and has worked steadily as a performer and professor at UCLA, the California Institute of Arts, and Wesleyan University. In 1976 he and his brother T. Ranganathan recorded the musical accompaniment for *Bala,* Satyajit Ray's film on the life of their sister. His other recordings include *South Indian Flute* (World Pacific) and *Pallavi* (Nonesuch Explorer Series). In 1978 the government of Madras selected him as Instrumental Musician of the Year. He was awarded an American Institute of Indian Studies research fellowship in 1992 to do research on *raga alapana* and has since also engaged in research on *javalis* (dance compositions).

Lily Vorperian

Armenian American Marash Embroiderer

Born: 1919

Lily Vorperian (Courtesy Lily Vorperian)

LILY KAMBOURIAN WAS BORN IN 1919 in Aleppo, Syria, three years after her parents had fled the Armenian city of Marash. Raised in the refugee community of Aleppo, she married Haroutioun Vorperian, a prominent community leader and businessman, in 1937. Over the next six years she had four children. After her husband's death in 1953, she was forced to sell many of her personal possessions to support her children. She moved to Beirut in 1964, and immigrated to the United States in 1978, settling in southern California, where more than 300,000 Armenians live today.

She began embroidering at the age of 12, learning from the elderly Marash women who gathered at her house daily and waited for the refugee aid that her father distributed for the missionary organizations he represented. Though she is familiar with 18 other regional Armenian embroidery styles, Vorperian said that she preferred the Marash embroidery "because it was the hardest." With the exception of her high school years and the time she spent raising her young children alone, she dedicated herself to her embroidery.

Marash embroidery is known for its color combinations, intricate designs, and complex, demanding stitchery. Vorperian is especially proud of the neatness of her work: "Look how clean it is on the back." Her Marash technique barely pricks the surface of the reverse side of the fabric; the basis of each design is interconnected herringbone stitches, over and under which the thread may be woven four or even eight times. Clusters of squares or crosses then become the building blocks for bold patterns. The effect is slightly raised and intricate, reminiscent of traditional Armenian wood carving, stonework, or jewelry engraving.

In Marash embroideries, there are three fundamental stitches. The first and oldest, the *hartagar* or *suntousi gar*, resembles a satin stitch. The second, *godtgar*, is similar to the stem or outline stitch. The patterns of these two stitch types are generally stylized birds, flowers, trees, leaves, or fruits, and are worked in rich multicolored silk, highly twisted mercerized cotton, or gold thread. The third stitch, *heusvadz gar*, is woven or interlaced embroidery worked over two rows of stitches in the form of fishbone or herringbone stitches. The first row of the fishbone stitch has the second row superimposed upon it. The third row is worked by filling in the upper (or lower) outline by a darning-type stitch. The fourth row completes the process by weaving in and out of each stitch until the work is completed. The patterns of *heusvadz gar* are geometric, the fundamental design being a group of linear crosses, clusters of crosses, circles, and squares. These three stitches are worked on linen, wool, heavy cotton, velvet, or silk satin. The designs are printed on the fabric with carved wooden stamps or by painting on the fabric with a

brush or steel pen dipped in a special paste. Traditionally Marash embroidery is done on dark velvet so that the colors stand out. Pieces are finished off with simple X-shaped stitches around the border or with handmade black trim.

Vorperian's home is decorated with Marash embroidery pieces alongside memorabilia from exhibits of her work and family photographs. Doing embroidery is part of her daily life. Because each stitch must be drawn onto the fabric before it is stitched, preparing the fabric for a large piece can take several days. Vorperian incorporates traditional designs she recalls from her childhood, when she watched and imitated the older refugee women. Additionally, she has adapted the Marash stitch to create letters and words, and has made banners for two Armenian American organizations. In these, she has embroidered unique images to express Armenian cultural and historical pride; they include two large tableaux that incorporate lines from Armenian poetry about the genocide and dislocation of Armenians in 1915.

Vorperian signs each piece of her embroidery with a hand-stitched signature in Armenian and English letters. In the 1990s she began to embroider slogans and names in the Armenian alphabet that speak her sentiment concerning the tragedy and survival of her people, such as "Oh, Armenian people, your only salvation is in your collective strength."

Doug Wallin

ANGLO-AMERICAN APPALACHIAN BALLAD SINGER

Born: 1919

Doug Wallin (Jeffrey Smith, Courtesy National Council for the Traditional Arts)

DOUG WALLIN WAS BORN IN 1919 and grew up in the Sodom-Laurel section of Madison County, in the Blue Ridge Mountains of North Carolina. His parents, Lee and Berzilla Wallin, were farmers who earned their only income from a small annual crop of tobacco and raised all the food for their family of 12 children. In his spare time, Lee Wallin sang and played music. He was a banjo player, and was a favorite at local "frolics" and box suppers, and his wife was similarly inclined. She also played banjo and liked to sing and tell stories that she learned growing up in the mountains. Doug's uncle, Cas Wallin, led the hymns in the local Church of God, and "when the preacher was out of earshot, he would sing ballads or blow a tune on his mouth harp."

Berzilla Wallin used to speak of the visit of the renowned English ballad collector Cecil Sharp to Madison County around the time Doug was born. Sharp described the Sodom-Laurel as a "community in which singing was as common and almost as universal a practice as speaking." Many of the local residents, in addition to Wallin's family, sang ballads, and it was among them that Doug became part of this vital tradition.

While growing up, Doug learned ballads and songs from his mother and father, and in a relatively short time he was recognized in the community as one of the best-known unaccompanied singers of Southern Appalachian tunes. The ballads he sang were among the most direct reflections of the cultural heritage brought by early white settlers to the Appalachian region. They are reminiscent of those sung by settlers who came directly from England, as well as those who came from lowland Scotland and northern England via a long tenure in the north of Ireland.

Traditional ballads usually consist of four-line rhyming stanzas with an occasional brief refrain and a relatively short melody that repeats with each verse. Ballads often recount powerful and evocative tales that touch the main themes of love, death, betrayal, and loss. Individual singers sometimes embellish ballad verses in performance, though the traditional themes have a remarkable continuity that has been passed on from one generation to the next for centuries.

Through the years, Wallin has learned to play the fiddle and sometimes accompanies himself when he sings, although he still prefers the traditional unaccompanied ballad form. He has studied the historical origins of the ballads he performs and prides himself on the completeness and complexity of his repertoire.

Wallin has performed at festivals such as the British American Festival, the Mountain Heritage Festival at Cullowhee, North Carolina, the Bascom Lamar Lunsford Festival at Mars Hill, and the Celebra-

tion of Traditional Music at Berea, Kentucky. He stands as a representative of his entire community, a role that he believes is appropriately fitting for the repertoire itself, since the surviving British ballads in this country have been traditionally sung as solo accounts of long ago.

Don Walser

ANGLO-AMERICAN WESTERN SINGER AND GUITARIST

Born: September 14, 1934

Don Walser (Courtesy Don Walser)

DON WALSER WAS BORN SEPTEMBER 14, 1934, in the small Texas Panhandle town of Brownfield and grew up in nearby Lamesa. His mother died when he was 11, and his father worked nights as a cotton mill superintendent. To fill the solitude of the daylight hours, Don listened to the music of the West Texas plains on the radio and watched the early cowboy crooners at the movie theater. "I had the old radio to keep me company—I listened to all the good old music they had back then," he said. "And there were three movie theaters. I'd see them old shoot-'em-ups, all the white-hat guys." Walser also passed the time by singing and teaching himself to play the guitar.

"Even when I was a little bitty boy, I started to sing," Walser recalled. "When I was just a kid, I could hear a song one time and know it. It would be just like a record playing in my head. I don't know how to explain it, exactly. It's like someone with a photographic memory. One of my teachers once said that if she could make everything rhyme, I'd be the smartest kid in the class."

Walser lied about his age so he could join the National Guard at age 15, and he married at 17. He and his wife, Pat, raised four children. He remained in West Texas, working for the National Guard as a mechanic, superintendent, and auditor and playing clubs, VFW halls, and honky-tonks at night and on weekends.

He transferred to Austin in 1984. After he retired 10 years later, he put together his Pure Texas Band and poured himself into his music full-time. Soon he received long-overdue recognition. Country music expert Bill Malone says of Walser, "He preserves a singing style reminiscent of earlier cowboy singers, but nevertheless sounds fresh and engaging. He is a yodeler almost without current parallel . . . and his powerful tenor voice is virtually without equal in the field of country music." Of his own compositions, Walser says, "I heard Jimmie Rodgers, Elton Britt, and Slim Whitman and learned those songs pretty easily. Then I couldn't find any more, so I wrote 'Rolling Stone from Texas' and a few other yodeling songs."

After the release of his album *Rolling Stone from Texas*, the press labeled him the "Pavarotti of the Plains." Two other albums followed, *Top Texas Hand* and *Down at the Sky-Vue Drive-In*. He has been featured on ABC's *PrimeTime Live*, PBS's *Austin City Limits*, and National Public Radio's *Fresh Air* and *All Things Considered*. He contributed music to Robert Redford's film *The Horse Whisperer* and appeared in *The Hi-Lo Country*, starring Woody Harrelson. Walser has also been inducted into the Texas Music Hall of Fame. He has even appeared and recorded with the avant-garde Kronos Quartet.

Walser has won a wide range of fans, from traditional country aficionados to young people. Of his late-life success, he says, "I'd like to get some money, don't get me wrong. But my motivation for this is to

spread that old music. I'm just trying to do my part to keep it alive. . . . When you pass from this good earth, your kids and grandkids will remember you for a long time, but further than that nobody's gonna remember who you are unless you've been an astronaut or written some good books. I feel real privileged to be able to leave a little music."

Lem Ward

ANGLO-AMERICAN DUCK DECOY CARVER

Life dates: September 19, 1896–August 29, 1984

Lem Ward (Courtesy Historical Society of Talbot County, Maryland)

LEM WARD WAS BORN SEPTEMBER 19, 1896, in the Crisfield, Maryland, region of Chesapeake Bay. Lem and his brother, Steve, learned to carve working duck decoys from their father, who also trained them as barbers. In 1918, their father drowned in a boating accident, and with the loss of his income, their family was almost destitute. Lem and Steve began carving decoys as a part-time occupation, supplemented by barbering and hunting wild game.

Although "duck coys" and "duck cages and traps" are known to have been employed in bird hunting in Europe and England, it was in North America that artificial lures resembling birds in various natural poses first came into common use. Decoy making became a regional tradition in several areas of the United States and Canada that lie along the flyways used by waterfowl in their seasonal migrations. Carving decoys flourished as a folk art form during the last half of the nineteenth century, when "market gunning" (unrestricted hunting) created a demand for large numbers of these lures.

By the 1930s, the Ward brothers had brought the distinctive Crisfield decoy type—flat bottom, exaggerated head shape, and simple painted patterns—to a new level of perfection. With Steve doing practically all the carving by hand and Lem most of the painting, the brothers experimented with varying poses, positions, and shapes, developed the technique of "strippling" the painted surface, and employed an impressionistic painting style in order to create decoys far more lifelike than those typical of the period.

The pursuit of realism in their decoys also led the Ward brothers in the direction of decorative bird carving, which brought them their greatest recognition. Although Lem's earliest decoratives were essentially decoys with legs placed on them, his experimentation with techniques such as feather insertion became the basis for much of the decorative bird carving that followed, and ultimately prompted the development of independent categories in carving contests for decoys and decoratives.

In the late 1950s, the Ward brothers stopped cutting hair and became full-time wood carvers. Lem lost interest in making functional decoys and devoted himself to decorative birds. "We didn't claim to know it all then," Steve said. "We were not satisfied then and we are still not, for we have sense enough to know there is still room for improvement."

In 1968, the Ward Foundation was formed to promote the art form of bird carving that Lem and Steve had played such an important role in developing. In 1972, Lem suffered a major stroke, leaving his left side paralyzed, and a year later he developed cataracts, but nonetheless continued to work. Steve died in 1976, and two years

later Lem was forced to stop carving when his eyesight became too poor for him to work with his tools.

Lem was a teacher and inspiration to Arnold Melby, Homer Haertel, Bruce Burk, Don Briddell, and a lengthy list of other wildfowl artists. He was often self-effacing, referring to himself as "a dumb old country boy," and when he wasn't able to carve, he wrote poems. "I am glad that I live, that I struggle and strive," he said in verse, "For the place that I know I must fill. I'm thankful for sorrow I'll meet with a grin, What fortune may send good or ill. I may not have wealth, I may not be great, But I know I will always be true. For I have in my life that courage you gave, When I first rubbed shoulders with you."

Newton Washburn

ANGLO-AMERICAN BASKET MAKER

Born: April 4, 1915

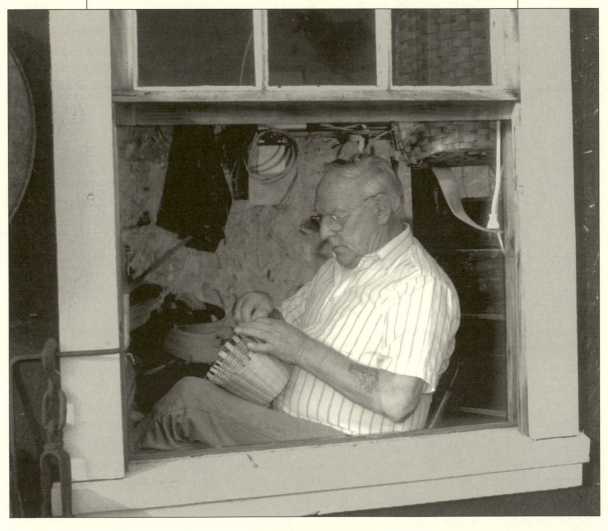

Newton Washburn (Tom Pich)

Newton Washburn was born April 4, 1915, in Stowe, Vermont, the grandson of Gilman Sweetser. The Sweetsers have been known for their brown ash split baskets since at least 1850. Reportedly, the original Sweetser came to Vermont from Switzerland in the late eighteenth century, and his son married Lydia Hill, of the Abenaki Indian tribe.

When Washburn was about eight years old, he began to learn to make baskets. "Dad showed us how to get it off the log. . . . Then it was up to Mother. . . . Mother started me out with a flat-bottom [basket]. Then we went to round baskets. Each one, you had to do till it was right. The first one you did was right because if it wasn't, you took it apart and started over again. There was never nothing said about how many you made. . . . It was quality, not quantity. She'd tell me, 'Make it right, or make it over.'"

The brown ash tree is usually found in swampy areas. The tree is felled and cut into logs; these are then pounded to loosen the different layers—each layer representing a year's growth. Cutting down the tree and removing the strips was usually the man's job. This was followed by the process of preparing the basket materials—shaving and shaping the ash, setting up the bottom, putting in the hooping, and then making the handle.

By the age of nine, Washburn was able to make a good basket, as were his cousins. At one time, there were 17 different branches of the family making baskets, and they often assembled for a basketmaking party. However, basketmaking was never taught to anyone outside of the family. The basketmaking season started around the first of November and continued through the winter months, although they often came together for at least a week in the summer. "A typical day would be a circus," Washburn said. "When we had a big gathering, the kids didn't make baskets. That was for grownups. That was their entertainment." Sometimes family members played banjo or fiddle, and the children danced, while others played cards.

Until the 1930s, Sweetser baskets were used by working farmers, but with the advent of readily available galvanized containers, the demand for baskets declined. Prices dropped and the older generation eventually stopped making baskets for such little pay.

During World War II, many Sweetsers served in the armed forces, and after the war some family members moved away from Vermont. When Washburn returned from the war, he got a job at an auto body shop, where he worked for the next 20 years. He set aside his basketmaking until two heart attacks forced him to slow down. During his recovery, he decided to make his wife a laundry basket, and then two sewing baskets.

Before long, his friends and family were asking for more. He wanted to make the traditional peck basket he had learned when he was growing up, but he realized he had forgotten the dimensions. "Then," he recalled, "[that night], about three o'clock in the morning I woke and I said, 'I know what the length of those peck basket uprights are, and the width.' And I got right up then. I come right down and made one. I let it set a couple of days, and I tightened it down and put the hooping handle on. And said, 'Whether it's a peck or not, it's a pretty basket.' So my wife had a bag of potatoes, and we set it on the bathroom scale and filled just level full, just 15 pounds. It was perfect. So then I knew what the half-bushel and the bushel was. And so I made one of each, and they were perfect."

As the last Sweetser basket maker, Washburn was in a unique position. Many of the people who bought his baskets were eager to learn to make them, but at first he didn't want to violate the tradition of never teaching basketmaking outside of the family. Not sure how to proceed, he went to his aunt and asked her for advice. "Am I going to let it drop or teach it?" "Well," she said, "we never did." "I know it. If someone doesn't, the art going to go." "Well," she said, "use your own judgment." Gradually, Washburn accepted young people who wanted to work with them, and over the years he taught more than 80 apprentices.

Arthel "Doc" Watson

Anglo-American Appalachian Guitarist and Singer

Born: March 3, 1923

Arthel "Doc" Watson (Peter Figen)

ARTHEL "DOC" W$ATSON WAS BORN$ M$ARCH$ 3, 1923, in Stoney Fork in western North Carolina, the sixth of nine children born to Annie and General (his given name) Dixon Watson. Watson contracted glaucoma when he was an infant, causing him to lose his sight by the age of two.

He entered the Raleigh School for the Blind at the age of 10 and stayed for four years. His musical education began at home with a new harmonica in his stocking every Christmas and, one day, a homemade banjo. "My dad picked that banjo up and said, 'Here, son, I want you to learn to play it real well. . . . You get where you can play that thing pretty, it might help you get through the world.'"

Watson's musical education continued in the home through a battery-powered radio and a small windup record player with a stack of 78 rpm records his father had purchased from a neighbor. These included recordings of Gid Tanner and the Skillet Lickers, the Carolina Tar Heels, and the Carter Family. While at the Raleigh School for the Blind, he heard a classmate playing a guitar and learned a few chords himself. When he returned home that summer, he was eager to play the guitar. His brother, Linny, had borrowed a cousin's guitar on which Watson practiced.

"Daddy heard me messing with it one morning," Watson remembered, "and said, 'Son, if you can learn a tune on that by the time I get back from work this evening, we'll go find you a guitar of some kind.'" By the time his father returned home, he was picking the chords to "When the Roses Bloom in Dixieland," and, as promised, they went and got his first guitar, a $12 Stella. In time, Watson was able to get a Sears Silvertone guitar with money he earned cutting wood. Around 1940, he bought a Martin D-28 from Richard Green, who owned a little music store in Boone, North Carolina, and let him have a year to pay it off. Pressure to make payments on his new Martin prompted Watson to sing on the streets for tips. "I played on the street nearly every Saturday, when the weather was warm, at a cab stand in Lenoir, South Carolina. Sometimes I'd make as much as $50, and I paid that guitar off in four or five months."

People who heard him on the street invited him to play amateur contests and fiddler's conventions, and he did. He won some of the contests but, as he said, "I found that people didn't want me in their shows no matter how good I was because I was a little trouble to them and I didn't have a flashy stage show."

When Watson was 18, he joined a group that sometimes played on local radio stations. Before a remote radio broadcast at a furniture store, the announcer decided that "Arthel" was too cumbersome to use on the air. A woman in the crowd suggested, "Call him 'Doc,'" and the name stuck.

In 1947 Watson married Rosa Lee Carlton, the daughter of old-time mountain fiddler Gaither Carlton. They had two children, a son, Merle, and a daughter, Nancy. To earn a living, Watson tuned pianos and played music wherever he could, for local dances and over the radio. Finally, in 1953, Jack Williams, a piano player from Tennessee, invited Watson to play lead guitar in his country swing and rockabilly band. Not long after joining Williams, he traded in his Martin for a 1953 Les Paul Standard and became an electric guitarist. Watson doubled as lead fiddler and vocalist when the band played for square dances, and traveled around playing for VFW clubs and other social organizations in eastern Tennessee and western North Carolina. He remained with Williams for eight years. During those years he continued to pick and sing old-time music on acoustic guitar with his family, and sometimes performed with Clarence "Tom" Ashley, a neighbor who had been an original member of the Carolina Tar Heels.

In 1960 Ashley told folklorist Ralph Rinzler about Watson, and asked Rinzler if Watson could join him on the recording session he was planning. Rinzler, quickly recognizing Watson's musical talents, agreed, but urged him to play acoustic guitar. The two resulting LPs, *Old Time Music at Clarence Ashley's, Volumes 1 & 2*, were highly acclaimed and helped to launch Watson's professional career.

In 1961 Watson made his urban debut at the Friends of Old-Time Music concert in New York, playing with Ashley, Clint Howard, and Fred Price. For the next several years, he performed at concerts and festivals. Watson's son, Merle, began playing backup guitar and in 1965 became his father's road manager and driver. Together, they toured nationally for more than 20 years. Watson retired from active touring in 1987.

Gussie Wells and Arbie Williams

AFRICAN AMERICAN QUILTERS

Life dates: Wells, 1901–?; Williams, born 1916

Arbie Williams, 1991
(Chris Arend, Courtesy National Endowment for the Arts)

Gussie Wells, 1991
(Chris Arend, Courtesy National Endowment for the Arts)

Gussie Wells was born in 1901 in the country near Shreveport, Louisiana, and Arbie Williams was born in 1916 in a small rural community near Carthage, Texas. They did not meet until they were both retired, though their backgrounds were remarkably similar. As children, both helped their mothers and grandmothers with piecing and quilting by the age of 10.

"My mother said, 'Here, if you lose this needle, don't come back to me,'" Williams recalled. "Times were hard then. You didn't throw stuff down. So, by us being kids, two girls, we would lose them needles. So, she finally said, 'Your uncle give you a quarter. You better send it off, get some thread and some needles, because you're not using mine anymore.' Been on my own ever since. She'd give me little pieces of scrap. And we'd sew them together."

Both Williams and Wells married and raised their families early, and both labored hard all their lives, doing a variety of jobs. Wells began working in a sawmill when she was 16 years old; later she did housework and hotel work in Texas, ran a candy store, and worked on power sewing machines in New York City. Williams, like Wells, took whatever jobs she was able to find, and at different times in her life she was a farmer, maid, cook, cocktail waitress, nurse, seamstress, and beautician. For both women, quilting was undertaken when they were young primarily for its functional purpose. Wells, however, stopped quilting during her most difficult working years, and though Williams continued quilting, she did so infrequently, though she did organize a local quilting club in a little railroad town in East Texas during World War II.

In the 1940s, Wells and Williams moved with their families to California, looking for a better life in the San Francisco Bay area, where massive numbers of African Americans from Texas and Louisiana had relocated to work in the wartime industries. The two women met during the 1980s, when Williams came to help Wells care for her elderly mother. In a short time they became friends, and both renewed their interest in quilting and discovered that they shared a common aesthetic sensibility.

Like other quilters in the western Louisiana/eastern Texas/southern Arkansas region, Wells and Williams tended to emphasize design, bright colors, and vivid contrasts in their quilts. They played endlessly with the form of the square and the straightforward strip, disguising and exploding these essential design elements in myriad ways. They liked the stark, plain geometric side of quilt construction, and enjoyed turning to positive use the inevitable "accidents" that occur during the process of sewing.

Williams's grandmother believed that one should never make all the quilt blocks "tally"—in other words, that all the repeated blocks

in a quilt should not be exactly alike, meaning that if an irregularity did not simply occur, it should be created purposefully. Some have compared this aesthetic to that of African American blues, jazz, and gospel musicians, who also improvise creatively around certain basic themes.

Francis Whitaker

ANGLO-AMERICAN BLACKSMITH AND ORNAMENTAL IRONWORKER

Life dates: November 29, 1906–October 23, 1999

Francis Whitaker, 1998 (Alan Govenar)

FRANCIS WHITAKER WAS BORN NOVEMBER 29, 1906, in Woburn, Massachusetts. He left high school at the age of 16 to apprentice with the premier ornamental blacksmith of the day, Samuel Yellen, in Philadelphia. "The first time I took a piece of hot iron out of the fire and started to beat it with a hammer, I was hooked," he said.

But learning to become a master blacksmith, Whitaker found, was hard work and meant starting at the bottom at Yellen's shop, for he had 200 men laboring at his forge. "I had to clean out the forges in the morning," Whitaker said. "I was told to get there early, a half an hour early. I wasn't paid for it. A little bit later on, I also had the job of starting the fires so that the fire was ready when the smith came to work at 8:00."

After a year with Yellen, Whitaker volunteered for a three-year apprenticeship in Berlin with the German master Julius Schramm. He recalled, "I got to be the blacksmith's helper for the top smith. There were only two smiths there, but the top smith, that was the coveted job, and I worked like hell to hold that position."

In 1927, he returned to the United States and settled in Carmel, California, where work was plentiful. "Those were very productive years. California was building up with the Spanish tradition. There was a great deal of ironwork: door hardware, railings, gates, curtain rods. Houses were filled with ironwork then. This was in an area where there was a good deal of money and a lot of good taste in design."

Whitaker spent seven years as the head smith for a large contracting firm with major commissions in the Pebble Beach and Carmel area. He then secured a job with another contractor who had his own blacksmith shop with two forges, two smiths, and a couple of helpers. In 1933, Whitaker opened his own forge, The Forge in the Forest, and despite the depths of the Great Depression he managed to build his own business. "The Depression," he said, "taught me that if you're dedicated to your work and do good work and are uncompromising about it, there will always be a place for you in society. The others can fall by the wayside, the second-raters."

In addition to ornamental ironwork, Whitaker sharpened tools, welded fenders, built truck bodies and stair railings, and made fireplace tools and andirons. He maintained high standards for his work, and his reputation grew. During World War II, he did production work and was the head instructor in welding at the Richmond Shipyards. As soon as war production work ended in 1945, he returned to his forge.

In Carmel, Whitaker was active in local politics and was a pioneer conservationist. He was instrumental in ensuring that Point Lobos, a spectacularly scenic and biologically rich stretch of seacoast near

Monterey, was designated a state reserve. In 1963, his efforts to protect Carmel's sand dunes failed; disappointed, Whitaker closed his Forge in the Forest and moved his shop to Aspen, Colorado. There he received numerous private commissions, and in 1968 he began teaching at Colorado Rocky Mountain School, a private school in Carbondale, where he worked until his death on October 23, 1999.

Because of Whitaker's dedication to teaching smithing to younger generations, the school named a building for him. The Whitaker Building is a 3,600-square-foot structure that houses a 2,000-square-foot blacksmith shop with six forges. The walls and roof of the building were put up over two weekends, barn-raising style, by 40 of Whitaker's friends. Whitaker and his wife, Portia, who died in 1989, had donated much of the funding for the facility, and were aided by their friends, admirers, and supporters. The building also houses The Portia Room, which is used as a resource area for aspiring blacksmiths and contains many of Whitaker's memorabilia.

When asked about his lifelong commitment to ironwork, Whitaker often replied, "There's a fascination to it that I have never lost. There's a magic to it, taking something, a stubborn material, and doing what you want with it."

Claude Williams

AFRICAN AMERICAN JAZZ/SWING FIDDLER

Born: February 22, 1908

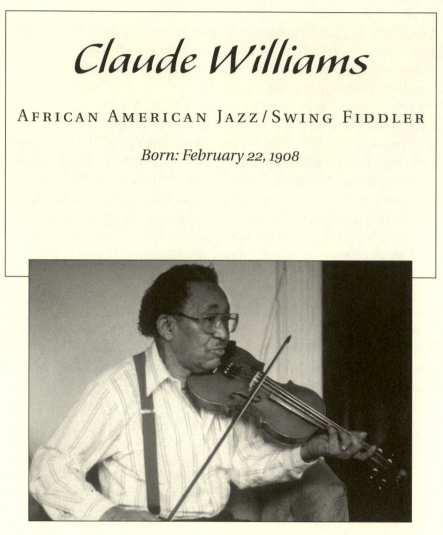

Claude Williams
(Russ Dantzler, Courtesy National Council for the Traditional Arts)

CLAUDE "FIDDLER" WILLIAMS WAS BORN FEBRUARY 22, 1908, in Muskogee, Oklahoma. By age 10 he was playing guitar, banjo, mandolin, and cello in his brother-in-law's string band. The young musicians played outdoors and in barbershops and hotels. Williams remembered making "six to seven dollars apiece" in an evening, at a time when "folks were working all week for five or six dollars." He was inspired to take up jazz violin when he heard Joe Venuti at an outdoor concert in Muskogee.

In the late 1920s, young Claude traveled the black vaudeville circuits of the South and Midwest, "sleeping in the car, and under it at times." After moving to Kansas City, he played and toured with a number of bands, including the Clouds of Joy and the Cole Brothers, featuring Nat "King" Cole, then a brilliant pianist.

Williams joined Count Basie's band in 1936. He toured extensively with Basie and played guitar on the band's first commercial recordings. He was named best guitarist of the year in *Downbeat* magazine's reader's poll. But he wasn't doing what he wanted to. As he said, "If I had stayed with Count, I would have just been playing that ching-ching rhythm guitar for 40 years."

In 1937, Williams returned to the violin and formed his own group. For the next 40 years he played and toured with a variety of bands. His career included a long collaboration with Kansas City pianist, singer, and bandleader Jay McShann. As the violin receded as a lead voice in jazz, Williams remained true to the instrument, though he sometimes had to take other work, such as playing guitar in rhythm-and-blues bands. He also has taught a number of young musicians.

Williams worked for years in relative obscurity, though he has played with any number of stellar musicians, including Charlie Christian, Charlie Parker, and Art Tatum. More recently, his talent and contributions have been recognized. He has appeared at the Monterey and Nice jazz festivals and at the Smithsonian Festival of American Folklife. In 1989 he was inducted into the Oklahoma Jazz Hall of Fame. That same year, he performed in the popular Broadway show *Black and Blue* and in a tour called "Masters of the Folk Violin." The show-stopping finale included a duet between Williams and Alison Krauss, then an aspiring 16-year-old country fiddler and singer. Tour organizer Joe Wilson called Williams "the oldest and the newest" of its performers.

In 1998, a few days after his ninetieth birthday, Williams performed at the White House with guitarist Bucky Pizzarelli and bassist Keter Betts, providing music for tap-dancing master "Jimmy Slyde" Godbolt, with whom Williams performed in *Black and Blue*. Williams summed up his fluency on his favored instrument in this way: "Whatever runs through my mind, I can play on the violin."

Dewey Williams

AFRICAN AMERICAN
SHAPE-NOTE SINGER

Life dates: March 6, 1898–November 11, 1995

Dewey Williams, 1991 (Alan Govenar)

*D*EWEY PRESIDENT WILLIAMS WAS BORN MARCH 6, 1898, in the Haw Ridge community, seven miles west of Ozark, in Dale County, Alabama. His parents, June and Anna (Bruner) Williams, were share-croppers in Haw Ridge. His grandparents had been slaves in Barbour County, Alabama, before the Civil War.

As a child, Williams was instructed in the singing of Sacred Harp or shape-note hymns by his grandmother in the kitchen of her house. "I started when I was about seven years old," Williams said. "When I first started off, I'd hear my old folks singing at night, and I'd get up the next morning; me and my brother would set in the kitchen and take the book and look at it and sing the same songs they sung. We didn't know what we was doing, but we knew it was singing."

Williams attended public schools in Dale County through the third grade, but was forced to leave to join his father as a sharecrop-per. As he grew up, he learned more about the Sacred Harp and Seven Shaped Music from local music leaders, notably Webster Woods and Judge Jackson, two black singing school masters. Judge Jackson was the author and editor of *The Colored Sacred Harp* (1931), the only black Sacred Harp hymnal ever published.

The term "shape-note" refers to the four shapes (triangle, square, oval, diamond) used to designate the four tones of the scale (bass, alto, tenor, and treble) used in Sacred Harp arrangements. Sacred Harp is performed in unaccompanied four-part harmony with the singing of the notes preceding the lyrics. Sacred Harp takes its name from the songbook *The Sacred Harp,* first published in 1844. Thirty-eight different shape-note tune books were published between 1798 and 1855, but *The Sacred Harp* is the only one that remains in com-mon use. The songbooks were originally used in singing schools and were eventually used at singing conventions. They were never used historically as part of the liturgy of an established church. First de-veloped in New England, Sacred Harp or shape-note singing is im-mensely popular in the Deep South. Southeast Alabama is the only area in the country where there is a vibrant black Sacred Harp tradi-tion. Documentation dates the earliest black convention to 1880, and there is evidence that Sacred Harp was sung by African Ameri-cans before the Civil War.

During a typical sing, participants arrange themselves in a square according to voice part, the basses facing the trebles and the tenors facing the altos. A song leader stands in the middle of the square leading the singers, first through the notes to the songs and then through the lyrics, a practice emanating from the traditional singing school classes, where singers are taught the notes (musical syllables) and then the words.

Although African Americans sing essentially the same hymns as their Anglo counterparts, they perform in a somewhat different

style. About these differences, Williams said, "White folks sing it faster than we do, as a rule. Singing is the understanding, but really and truly, we sing the way it was sung back . . . years ago."

In 1921, Williams married Alice Nancy Casey in Ozark, Alabama; the couple had eight children. Williams continued to labor as a sharecropper and maintained a strong Christian faith. He was a member and deacon of the Church of God by Faith in Ozark. At age 40, Williams began to teach singing school himself, and over the next 25 years he traveled throughout southeast Alabama to instruct people in African American communities.

In 1956, he developed a Sunday morning singing program that aired weekly over radio station WOZK. In 1964, he began producing and directing a monthly television program dedicated to the celebration of Sacred Harp singing for television station WTVY, in nearby Dothan, Alabama.

After he retired from farming, Williams devoted himself full-time to teaching and performing Sacred Harp music. He organized the Wiregrass Sacred Harp Singers in 1971, and directed the group in performances and workshops throughout Alabama, as well as in touring programs in Washington, D.C.; Montreal, Canada; and Berea, Kentucky. In 1973, he worked with the Alabama State Council on the Arts and Humanities to reprint *The Colored Sacred Harp.* Williams was able to key and sing every part of every one of the more than 500 songs in *The Sacred Harp,* in addition to the 77 songs in *The Colored Sacred Harp.*

Horace "Spoons" Williams

AFRICAN AMERICAN SPOONS AND BONES PLAYER AND POET

Life dates: May 9, 1910–1985

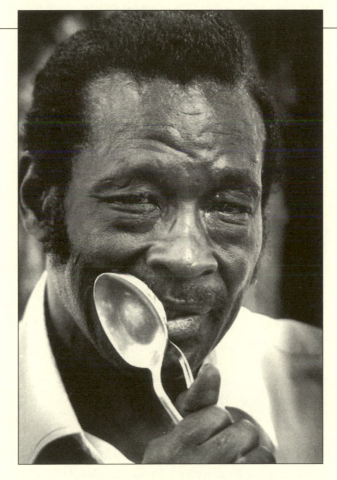

Horace "Spoons" Williams, 1985
(Courtesy National Endowment for the Arts)

*H*ORACE WILLIAMS WAS BORN MAY 9, 1910, in Newberry County, South Carolina, into an impoverished sharecropping family. He began making music at an early age, coaxing sounds from homemade instruments such as jugs and tin pans. "Music was all I had growing up," he said. "Music and animals. I had to do something to amuse myself. I'd play my spoons, make up some stories, and it was like cutting a hole in the clouds to let the sun shine through."

Early on, Williams aspired to be a dancer. Having watched his elders "cutting steps" at house parties and corn shuckings, he thought that dancing might be a means to escape the oppressiveness of sharecropping and the Carolina plantation on which he was raised. But, he said, too many others had the same idea, and openings were rare in the few carnivals and tent shows that passed through the rural area where he lived.

At age 13, he left home and traveled across the Eastern Seaboard, looking for work and moving north. He laid railroad track and built roads, mined coal for a short period, and pulled menhaden nets off the Virginia coast. All the while he continued his music, adding bones to the spoons already in his instrumental repertoire, exploring ever greater tonal variations and rhythmic complexities. He accompanied blues guitarists, brass bands, and even gospel quartets.

A traveling carnival hired Williams as a spoons player and comic, and he finally made his way to Philadelphia, where he decided to settle down. To earn a living, he shined shoes, picked vegetables, laid brick, dug ditches, and chauffeured. In a relatively short time, he attained a citywide reputation in the African American community as a master of street rhythms and was given the nickname "Spoons," which he kept for the rest of his life.

During this time, he also mastered the art of monologue recitation, performing not only traditional African American toasts, but long narrative poems of his own composition, pieces addressing in rhyme his experience as a black man in a white man's world. Williams recalled hearing both men and women reciting poems when he was growing up, and he composed his first verse when he was only eight years old, a short lyric entitled "Thankful":

> *I'm thankful to God, for the knowledge and wisdom*
> * that he gave to me at birth*
> *To never sell or trade my soul for the riches of the earth.*

As an adult, Williams composed far more complex oral verses. Some poems took 15 minutes to recite. In "A Black Talks to God," composed in the 1930s, he described fleeing the racist South, and his words were hard and angry:

Oh Father God . . . they tie us to stakes down here, and they tear
our flesh with their whips. . . . And we're flayed like hogs, and
shot down like dogs . . . And we work in their fields every day for
pennies from dawn to dusk. . . . But when the days are over, not
even thanks are given us. . . .

In his poem "My Saddest Experience," Williams recounted his experiences during his overseas service in the Army during World War II.

Closely related to his spoons playing and oral poetry was his artistry on the jug. As a child, he joined his friends in beating out rhythms on whatever was available—washboard, a set of spoons, a tin tub, or a hollow log. Particularly valued was the stoneware jug, whose mouth he was able to partially cover to create a resonant instrument. Slight movements of his palm effectively altered the jug's sound, creating expressive intonations not possible with his other homemade instruments. Throughout his life, Williams was incredibly resourceful, sustaining an indefatigable spirit against all adversity.

Chesley Goseyun Wilson

NATIVE AMERICAN FIDDLE MAKER
(APACHE)

Born: July 31, 1932

Chesley Goseyun Wilson, 1991 (Alan Govenar)

CHESLEY GOSEYUN WILSON WAS BORN JULY 31, 1932, in the village of Bylas on the San Carlos Apache Reservation in the White Mountain area of southeastern Arizona. He is a Western Apache of the Eagle Clan and is the great-grandson of Aravaipa Chief Hashke-bansiziin (Eskiminzin) and the great-great-grandson of White Mountain Apache Chief Hashkedasila, who invited the United States government to establish a military facility on his land.

Wilson is a medicine man, qualified to conduct important tribal ceremonies, a singer, a dancer, and the last active member of a family of Apache violin makers descended from Amos Gustina, a seminal musician of the Western Apache people. The Apache have a long tradition of wood carving in general, but are especially notable for their tradition of stringed instrument making, a musical tradition shared only, as far as is now known, with the Seri Indians of northwestern Mexico. The origin of the Apache violin is difficult to establish, though it seems likely the tradition existed prior to the coming of the Spanish.

The Apache name for the one- or two-stringed violin is *Tsii' edo'a'tl,* which translates to "wood singing" or "wood that sings." The instrument is also known by its colloquial name, *Ki'zh ki'zh di'hi,* which translates to "buzz buzz sound." Wilson describes the sound produced as a cross between a soft flute and a dulcimer.

The present-day Apache violin is most typically made of the dried flower stalk of the agave *(Agave desertii)* or century plant, cut to lengths of about 40 centimeters, although some are nearly 70 centimeters long. The soft interior pith is hollowed out and the stalk is shaped into the body of the violin, leaving a few inches of stalk intact at both ends to support the string peg and the tuning peg. The instrument is strung with black horsehair, as is the bow, which is made of any flexible wood that can be bent into shape. Only one string is used, and the violin is played by placing the lower end against the chest, stopping the strings with one or more fingers of the left hand and moving the bow with the right hand. As in the playing of most similar unfretted instruments, there is frequent use of microtones, which are often not noticeable to the untrained ear. This also is a characteristic of Apache melodies. Because the instrument is intended for solo performance, its tone is delicate and soft. Songs played on the Apache violin include love songs, ceremonial songs, social dance songs, and improvisation for the performer's own enjoyment.

Wilson finishes the violin with ornamentation that includes painting and light carving of the body and tuning peg. In addition to the usual two or three soundholes near the base, he usually drills patterns in the body. Early violins, those made prior to 1920, were most

often painted with simple geometric designs using black or red paint, or both colors together. After 1920, the decoration became more ornate, intricate, and colorful. Geometric designs and traditional symbols employed for decoration might represent the four directions, clouds, mountains, the sun, serpents, wind spirits, and the Ga'an (Mountain Spirit or Crown Dancer).

Over the years, Wilson has had various jobs to earn a living. He worked for Comstock Silversmiths, Inc., of Nevada for 25 years, and has been employed as a security guard. In his free time, he has made violins and strived to keep other Apache crafts, customs, and ceremonies alive. He sings traditional Apache songs that he learned from his uncles and his father, both of whom were prominent medicine singers. He also carves and paints figurines of *Ga'an* dancers and participates as a singer in traditional *Ga'an* dancing ceremonies. As an authority, he has instructed younger Apache students on the discipline of *Ga'an*.

Wilson has also spoken and demonstrated before wider audiences at the Heard Museum in Phoenix, at the Southwest Museum in Santa Fe, and at the Tucson Meet Yourself Festival, among others. Wherever he goes, he embodies the Apache qualities of independence and cultural commitment. He says, "My fiddle only plays Apache songs."

Elder Roma Wilson

AFRICAN AMERICAN HARMONICA PLAYER

Born: December 22, 1910

Elder Roma Wilson, 1994 (Alan Govenar)

ELDER ROMA WILSON WAS BORN DECEMBER 22, 1910, in Tupelo, Mississippi, one of 10 children raised on his parents' cotton farm. As a child, he attended school and worked alongside his siblings in the cotton fields. At night, his father often told stories and played the harmonica. When Wilson was 15, he taught himself to play the harmonica, using an instrument that his older brothers had discarded. That same year his parents split up. "My mother left home, " Wilson says, "when I was 15 years of age, separated from my father. And when he broke housekeeping, I had to get out."

To support himself, Wilson began working for the railroad and at sawmills. Later that year, he says, he "got converted," and within two years he was called to the ministry of the Holiness Church. He was ordained when he was only 17 years old and became an evangelist, preaching at different churches until he was appointed pastor of his own congregation. In his ministry, Wilson believed in the harmonica as an instrument of faith and focused his repertoire exclusively on spiritual songs.

In 1935, Wilson left Mississippi with his wife and children, fleeing the throes of the Great Depression and the terrors of racism. He worked for the Missouri Pacific Railroad and labored as a farmer in Arkansas before finally settling near Detroit, Michigan, where he was employed by a foundry. After a couple of years, he joined the contracting company started by his son. All the while, Wilson remained active in the Holiness Church and continued to play the harmonica.

When his children were still young, he and three of his sons, whom he had taught to play harmonica, often performed their unique style of religious music on the streets of Detroit. Joe Van Battle, owner of Joe's Record Shop, covertly recorded their street playing in 1948 and sold his recordings of "Lily of the Valley" and "Better Get Ready" to the Gotham label. These now legendary 78 rpm releases introduced the music of Wilson to audiences in Europe and the United States. It wasn't until the 1980s that Wilson learned of these records, and eager gospel music listeners learned the life story of the "unknown" musician identified on the recordings as "this charismatic preacher who blew harp."

As a young man, Elder Wilson learned from masters of both traditional secular and sacred harp. He learned to "choke" the harps in order to get traditional sounds from them. He became known throughout Mississippi for his arrangement of the song "This Train." Recalling the Scripture about the Lord's train, he decided to build the lyrics around the idea of God's train and mimicked the sounds of the railroad yards where he used to work. In the song, Wilson added the shuffling locomotive sound of a train, alternating his singing with "letting the train run" on the harmonica.

He went home to Mississippi after his wife died in 1976, and returned to his original church, The Church of the Living God. Among the people Wilson met when he returned to Mississippi was Ruth, a woman who had attended a revival run by Wilson in 1935. Although they didn't know each other back then, they became friends in 1977 and were later married.

Back in Mississippi, Wilson also reunited with Reverend Leon Pinson, a blind guitar player with whom he had traveled the "brush arbor circuit" of rural churches decades earlier, preaching and playing religious-inspired music. The men resumed traveling and have performed together all over the country. Since the early 1990s, Elder Wilson has worked as the presiding elder for a group of Holiness churches in eastern Mississippi. When he is not visiting his churches, he participates in services at other churches, where he sometimes plays harmonica or preaches sermons.

Melvin Wine

ANGLO-AMERICAN APPALACHIAN FIDDLER

Born: April 20, 1909

Melvin Wine, 1991 (Alan Govenar)

MELVIN WINE WAS BORN APRIL 20, 1909, in Burnsville, West Virginia. His father, Bob Wine, played the fiddle and his mother, Elizabeth Sandy, sang ballads and hymns. Some of Melvin's earliest memories were of lying in bed at night, listening to his father's fiddling. "Some of those tunes he'd play at night would just touch me," he said. "I don't know why. One of them, 'Lady's Waist Ribbon,' used to make me cry. There was just something about it that bothered and overjoyed me."

Melvin had little formal schooling. When he was nine, he started playing the fiddle while his father was out hunting, cutting timber, or working as a farmhand for neighbors. He taught himself "Bonaparte's Retreat," and after many days of practicing, he played the tune for his father, who in turn taught him some of the tunes that he had learned from his own father, Nelson Wine, and his grandfather, "Smithy" Wine. These included "Cold Frosty Morning" and "Hannah at the Spring House," among others.

"My dad, if I didn't play it right," Wine said, "why, he'd get behind me and grab ahold of my arm and show me how to do it. We played so near alike that he could note the fiddle and hold it and I could use the bow or vice versa."

Besides his father, Wine credited other area fiddlers as the sources of many of his tunes—jigs, ballads, and waltzes that he heard played by Sam Hacker, Jack Blake, John Cogar, Milt Perkins, Jilly Grace, and others. Wine said he once made a "pilgrimage" to "Uncle Jack" McElwain's home in Webster County, West Virginia, to learn the songs that he knew, including one of his favorites, "Old Sledge." While there, he also visited Tom Dillon, who, he said, "played with two bows strapped together and sometimes he danced as he played. Stood up and back-stepped!"

During the Great Depression, Melvin went "on the road" with his brother, Clarence, playing in restaurants and bars and over local radio. After three months of work at a radio station in Fairmont, West Virginia, they gave it up and came home. Melvin took any kind of job he was able to find, including several years in the coal mines, and then he became a farmer. In 1930, he met and married his wife, Etta Singleton, who called square dances and played banjo and guitar.

Over the years, Wine kept on fiddling, and his reputation continued to grow. For more than two decades he was the most frequent winner of the West Virginia State Folk Festival Fiddling Contest in Glenville, West Virginia. In the 1980s and 1990s, Wine was invited to perform at the Vandalia Gathering in Charleston, West Virginia; at the Berea Celebration of Traditional Music in Kentucky; and in concerts and festivals across the country. He also volunteered to play

weekly for the residents of a Braxton County nursing home, and donated his time at homecomings, cakewalks, and fund-raisers.

Acclaimed as one of the most versatile of fiddlers, Wine is also renowned for his deft bow work and the immensity of his repertoire, including the varied melodies and tunes of his youth, many of which date back more than 200 years to the earliest Appalachian settlers.

Nimrod Workman

ANGLO-AMERICAN APPALACHIAN BALLAD SINGER

Life dates: 1895–November 26, 1994

Nimrod Workman (Courtesy Nimrod Workman)

NIMROD WORKMAN WAS BORN IN MARTIN COUNTY, Kentucky, in 1895 to a farming family that eked out a living in the remote Tug River country. He was named after his grandfather, a full-blooded Cherokee Indian who fought in the Civil War and who taught his namesake the old ballads from Britain about lords and ladies and the ancient Scottish wars. Nimrod's mother was also a singer, and his sister, Laura, played the banjo and the guitar. "My race of people," Workman said, "seem like they pick up music, they can learn it, seem like it's in 'em."

When Workman was 14, his parents signed a minor's release so that he was able to work in the coal mines, where he labored until 1952, when he retired with back and lung problems. On his last day in the mine, he fainted and his fellow workers carried him home to his wife, Mollie, whom he had married in 1929. Workman received no compensation for his illness and injuries, but in 1969 a public program was introduced to help miners with black lung disease. Still, Workman did not qualify for this support until 1971.

Over the years, Workman was active in the bitter struggles for unionization, and he memorialized the hard-fought legacy of his generation in songs that he wrote and sang for his family and community. "I've wrote a lot of coal-mining songs," he said. "I've done a lot of old-timey Christian songs. I've made quite a few of 'em. I worked in the coal mines about 44 years, maybe a little longer. I've worked many and many 10 hours for 50 cents."

Workman and his wife had 13 children, two of whom died at an early age. "I raised my children by the hardest in the mines," Workman said, "from the old punchers, all the way to the 'Double-B,' to the conveyors, all the way to the 'Joy,' shooting from the solid with an old breast auger. I'm a man who knows mining. I done it. No other way to raise my children but that way. And I thank God that I've raised 'em."

Workman's song "Coal Black Mining Blues" exemplified the hardships he endured and the plight of his fellow miners.

Went to my place and I looked in,
Slate and the water up to my chin.
I've got the blues, I've got the blues,
I've got the blues, Lord, Lord.
Coal black mining blues.
I looked at my boss, and he looked sad,
The worst dang place I've ever had.
I've got the blues, I've got the blues,
I've got the blues, Lord, Lord.
Coal black mining blues.

Well, they sent me to the office,
Looked at the roll
Counted up nine dollars in the hole.
I've got the blues, I've got the blues,
I've got the blues, Lord, Lord.
Coal black mining blues.

Workman continued to perform into his nineties at community events and festivals around the country, singing to children and adults alike about the deep history of Appalachia. He was the subject of the Appalshop film *Nimrod Workman: To Fit My Own Category* and of the recording *Passing Through the Garden* produced by his daughter, Phyllis Workman Boyens, who is herself a fine singer.

Emily Zuttermeister

NATIVE HAWAIIAN HULA MASTER

Life dates: March 8, 1909–March 3, 1994

Emily Kau'i Zuttermeister, 1984
(Courtesy National Endowment for the Arts)

EMILY KAUIOMAKAWELINALANIOKAMANOOKALANIPO was born on the Island of Oahu on March 8, 1909, to Hawaiian parents. They followed the traditional practice of the time and gave Emily to her *kahu hanai* (maternal grandparents), William Kamahumahu and Virginia A'ahulole, to raise. As a child, she learned about the mountain taro patches of Heeia on Oahu's windward side. Her grandfather taught her how to cultivate plants for food, and her grandmother showed her the uses of medicinal plants and how to quilt or weave *lauhala* when it rained. "One of my earliest memories," she said, "was my grandfather reading the Bible to us every night and teaching us children the correct pronunciation of the Hawaiian words." Later, he explained to her the meanings of native Hawaiian chants and the legends that accompanied them. She grew up immersed in old Hawaiian customs.

Her uncle Sam Pua Ha'aheo was a policeman and elder in the church, but his traditional duty in the community was that of the *lawai'a kilo*, the spotter who stood on a high perch in the fishing boat and directed the fishermen. In addition, he knew the *hula* traditions and the ancient chants, which he kept secret until he was an old man.

In 1933, Ha'aheo decided it was time to pass on his knowledge of these vital Hawaiian traditions, and he opened a *hula halau* (*hula* house) on the shore of Kahana Bay beside his fishing shack. By then, his niece Emily had married Karl Zuttermeister, a U.S. serviceman stationed in Hawaii. Zuttermeister loved Hawaiiana and urged his wife to learn the old *hula* traditions. She reluctantly agreed and began studying with her uncle, practicing with him six nights a week for three years. She was forced to memorize each of the dances and the chants associated with them. There were many rules she had to follow: some *hula* could not be danced with the *pahu* drum, the *lei* must be short, not hanging, and only certain greenery was appropriate for the altar. For the chanting, Ha'aheo instructed her to sit in front of him and repeat every part of the chant until her pronunciation and tone were identical to his. Ultimately, he designated her to be one of the principal heirs to his *hula* repertoire.

In 1936, Zuttermeister, who was nicknamed Aunty Kau'i, opened her own school for *hula*, called the Ilima Hula Hale, and a year later she graduated her first class of students. She continued teaching *hula*, traditional chants, and *pahu* drumming in the Pua Ha'aheo style for more than 50 years, mentoring several generations of young dancers, including her daughters, Noenoe and Kuuipo, and her granddaughter, Hauoli.

She was a judge of numerous *hula* competitions, including the Merrie Monarch Festival in Hilo, the King Kamehameha Traditional

Hula and Chant Competition, and the Queen Lili'uokalani Trust's Hula Kahiko Amateur Contest. She was recognized as a Living Treasure of Hawaii by the Honpa Hongwanji Mission and was honored by the Hawaiian Civic Clubs for her distinguished service to the Hawaiian community at their annual Holoku Ball.

In 1982, Zuttermeister summarized her lifelong philosophy in an address about Nana E Na Hula Loea, a project of the Kalihi-Palama Culture and Arts Society: "I have never intentionally changed any aspect of the Pua Ha'aheo style. The minute you change or modify what you have been taught, then the *hula* becomes a classical dance that is less pure. That's why I don't change the dances and have kept them intact for 50 years. My uncle told me the only way the culture is going to live is if the dance is kept pure."

Appendix

The Bess Lomax Hawes Award

The Bess Lomax Hawes award was introduced in 2000. One award may be given annually to recognize artists whose contributions, primarily through teaching, advocacy, organizing and preserving important repertoires, have greatly benefited their artistic tradition. It also recognizes individuals, such as producers and activists, who have comprehensively increased opportunities for and public visibility of traditional artists.

Chris Strachwitz

RECORD PRODUCER AND LABEL FOUNDER

Born: July 1, 1931

Chris Strachwitz (Philip Gould, Courtesy Arhoolie Records)

CHRISTIAN "CHRIS" ALEXANDER STRACHWITZ was born July 1, 1931, in Gross Reichenau, a little village in lower Silesia. His father, Count Alexander Graf von Strachwitz, was a landowner and managed a farming and dairy business. When Chris was a child, his mother, Friederike von Bredow Strachwitz, who was part American, traveled to the United States and brought back several 78 rpm records of the popular music of the 1930s. Chris loved to listen to these on his family's old wind-up Victrola.

In 1945, at the end of World War II, Strachwitz and his family fled Silesia in the wake of the Russian invasion. The family moved to the province of Brunswick, a small farming community south of Hamburg, Germany. They stayed there until 1947, when an American great-aunt helped them to immigrate to the United States and to settle in Reno, Nevada.

Strachwitz was sent to the Cate School near Santa Barbara, California, and while he was a student, his interests in music expanded. He listened to radio stations XERB and KFVD. "I've always loved radio," Strachwitz said. "In Germany, I listened to American and British Armed Forces Radio, and in California, XERB played hillbilly music all day long. I got inundated in the sounds the Maddox Brothers and Rose, the Armstrong Twins, 'T' Texas Tyler. And on KFVD, I heard Hunter Hancock and his *Harlem Matinee* that introduced me to R & B. That same year I saw the movie called 'New Orleans' and was absolutely knocked out by that music featuring Louis Armstrong, Kid Ory, Meade Lux Lewis, and Billie Holiday, among others. I became a total New Orleans jazz nut. And I bought all the records I could afford."

In 1951, Strachwitz enrolled at Pomona College, and after two years he transferred to the University of California at Berkeley. He served in the U.S. Army from 1954 to 1956; after his discharge, he graduated from the University of California at Berkeley and got secondary school teaching credentials. He taught German and social studies at Los Gatos High School and at Saratoga High School near San Jose, and in his free time he went to R & B concerts, met with R & B record producer Bob Geddins and musicologist Sam Charters, and collected and sold 78 rpm records, which he often advertised in *VJM* magazine in England. Through his interest in records, he began to correspond with British blues aficionado Paul Oliver.

In 1959, Charters sent Strachwitz a postcard saying that the legendary Sam Lightnin' Hopkins was living in Houston, and Strachwitz traveled to Texas to meet him. A year later, he returned to Houston, and with Mack McCormick, a self-styled folklorist, playwright, and taxi driver (who was trying to manage Hopkins), Strachwitz ended up meeting the blues songster Mance Lipscomb in Navasota. Strachwitz recorded Lipscomb and decided to start his own record label, called Arhoolie (after the name of a kind of field holler or work song).

Over the years since then, Strachwitz has sought out and recorded hundreds of musicians across America, spanning virtually every culturally defined traditional style, including blues, jazz, gospel, old-time country, Cajun, *zydeco*, and *conjunto norteño*. Strachwitz has been equally committed to reissuing vintage folk recordings from the early twentieth century. His reissues of early recorded Mexican American border music, the earliest recordings of Mexican *mariachi* music, historic Greek, Polish, and

Ukrainian music, and Cajun classics are major contributions to the preservation of the musical heritage of the United States.

In addition to his recording activities, Strachwitz produced concerts that brought important folk musicians to large audiences. He toured with Lightnin' Hopkins, Mance Lipscomb, and Fred McDowell. He conceived of and wrote the groundbreaking film *Chulas Fronteras* about Texas–Mexican music, produced it with Les Blank, and coproduced a comprehensive film about Cajun and *zydeco* music, *J'tai Eté Au Bal*. With James Nicolopulos, he compiled and edited the book *Lydia Mendoza: A Family Autobiography*.

In 1995, Strachwitz founded the not-for-profit Arhoolie Foundation to ensure that the music he has collected will be available for future generations. Among its holdings is the Frontera Collection, one of the nation's largest archives of Spanish-language vintage recordings.

Joseph T. Wilson

FOLKLORIST, FOLK ARTS ADVOCATE, AND PRESENTER

Born: March 16, 1938

Joseph T. Wilson
(Courtesy National Council for the Traditional Arts)

JOSEPH T. WILSON WAS BORN MARCH 16, 1938, in Trade, Tennessee, in the Blue Ridge Mountains. He has worked as a Nashville country music producer, a door-to-door salesman, a civil rights reporter, and a Madison Avenue consultant. But his life's work is folklore, and he has served since 1976 as executive director of the National Council for the Traditional Arts in Silver Spring, Maryland. Founded in 1933, it is the oldest organization in the nation devoted to the presentation and documentation of folk arts.

Wilson's work has brought him full circle, back to the culture of the area where he grew up, on the North Carolina border. There were traditional musicians in his family, and, as he recalls, "I went to a Baptist church where they had singing schools every fall, and I learned to sing shape-notes. People sang ballads there and told stories for entertainment."

To his surprise, he learned that the music he loved was not always held in high esteem, that it was sometimes derided as "hillbilly." As his experience broadened, he recalled, "I learned that this level of great folk culture existed everywhere. I heard Mexican music over the border radio stations in the early 1950s and loved it. Later on, hearing Harry Choates, the Cajun violinist, I realized he, too, was making great music—music that was kin to the French Canadian sounds I also liked."

Wilson's interest in folk material grew as he worked in other jobs, and he discovered that others around the country shared this fascination and were recording folk musicians. He began producing records by musicians in his hometown. Joining NCTA, then called the National Folk Festival Association, gave him the opportunity to make a living at his avocation.

NCTA is a nonprofit educational organization that has conducted research in folklore, ethnography, and related areas. It assists the National Park Service with planning and interpretation. Other efforts include the production of tours by American folk artists, the National Folk Festival, films, videotapes, recordings, concert series, museum exhibits, occasional publications, and the coproduction of regional festivals.

Wilson has directed or assisted in directing national, regional, and local folk festivals; produced, coproduced, recorded, or annotated sound recordings; been involved in the production of films and videotapes; organized or directed 22 national and international performing-arts tours; and written books and numerous articles in professional and general interest publications. He is a founding member and board chairman of the Fund for Folk Culture, a private foundation in Santa Fe, New Mexico, and has served as a panelist for the National Endowment for the Arts and on the grants panels of four state agencies.

Despite all of his achievements and honors, Wilson wryly closes his resume with this statement: "Joe Wilson was reared in the Blue Ridge Mountains at Trade, Tennessee's easternmost and oldest community. He has no graduate degrees and is not listed in Who's Who of anywhere."

Selected Bibliography, Discography, Filmography

The following selected bibliography, discography, and filmography focuses on available recordings, publications, films, and videos. This documentation was compiled from materials at the National Endowment for the Arts, Library of Congress, and Smithsonian Institution, and identified in the *Centennial Index: 100 Years of the Journal of American Folklore* (1888–1987), the *Readers' Guide to Periodical Literature* and EBSCO host periodical index. The National Heritage Fellows and cultural specialists provided additional published and unpublished materials.

For additional discographical information, see Richard K. Spottswood, *Ethnic Music on Records: A Discography of Ethnic Recordings Produced in the United States, 1893–1942*, 7 Volumes (Urbana: University of Illinois Press,1990); John Godrich, Robert M. W. Dixon, and Howard Rye, *Blues and Gospel Records, 1890–1943* (Oxford: Clarendon Press, 1997); Mike Ledbitter, Leslie Fancourt, and Paul Pellettier, *Blues Records, 1943–1970*, 2 Volumes (London: Record Information Services, 1994); Brian Rust, *Jazz Records, 1897–1942* (Chigwell, Essex: Storyville Publications, 1982); Cary Ginell, *The Decca Hillbilly Discography* (Westport, Connecticut: Greenwood Publishing, 1989); and Joe Nicholas, *Country Directory* (Cheswold, Delaware: International Hillbilly Record Collector Exchange, 1962).

OBO ADDY

Discography
Addy, Obo. *Born in the Tradition.* EarthBeat! 2602.
_____. *Ikropong.* Earthbeat! 42508–2.
_____. *The Rhythm of Which a Chief Walks Gracefully.* Earthbeat! 42561–2.
_____. *Safarini in Transit: Music of African Immigrants.* Smithsonian Folkways 40457.
Addy, Obo, and Kronos Quartet. *Pieces of Africa.* Elektra/Nonesuch 79275–2.
Addy, Obo, and Kukrude. *Obo.* Avocet 102.
_____. *Let Me Play My Drums.* Burnside BCA–0010–2.
Addy, Obo, and Oboade. *Kpanlogo Party.* Lyrichord 7251.
Addy, Obo, and Randy Weston. *Volcano Blues.* Verve/Polygram.

FRANCISCO AGUABELLA

Bibliography
Love, Jacqueline. "Ghanaian Event Celebrates End of Famine." *Oregonian* (August 23, 1999).
"Out of Africa." *Time* (April 6, 1992).
Vega, Marta Moreno. "The Yorum Orisha Tradition Comes to New York City." *African American Review* (summer 1995) 29, 2: 201.

Filmography
Sworn to the Drum: A Tribute to Francisco Aguabella. 16mm, videotape, color, 54 minutes. Directed by Les Blank, with Maureen Gosling. El Cerrito, California: Flower Films, 1995.

JUAN ALINDATO

Bibliography
Hunt, Marjorie, and Boris Weintraub. "Masters of Traditional Arts." *National Geographic* (January 1991) 179: 1.
"Un Vida Dedicada a la Tradición." *La Perla del Sur* (February 25–March 3, 1998).
Vidal, Teodoro. *Las Caretas de Cartón del Carnaval de Ponce.* San Juan, Puerto Rico: Ediciones Alba, 1983.

SANTIAGO ALMEIDA

Bibliography
Hernandez, Ramón. "Tonantzin." *Chicano Arts Magazine* (May 1987) 4, 2.
Peña, Manuel. *The Texas–Mexican Conjunto: History of a Working Class Music.* Austin: University of Texas Press, 1985.

APSARA ENSEMBLE

Discography
Sam, Sam-Ang. *Echoes from the Palace.* Music of the World CDT–140.

EPPIE ARCHULETA

Bibliography
Everts, Dana. "Folklife Festival to Showcase the Authentic Folklore of the San Luis Valley." *State of the Arts* (April 1984) 2: 4.
_____. *Tradiciones del Valle: Folklore Collected in the San Luis Valley.* Alamosa, Colorado: Rio Grande Arts Center, 1986.
Hunt, Marjorie, and Boris Weintraub. "Masters of Traditional Arts." *National Geographic* (January 1991) 179, 1.
Pardue, Diana. "Chispas! Cultural Warriors of New Mexico: Eppie Archuleta, Teresa Archuleta-Sagel, Charles Carrillo, Marie Romero Cash, Juanita Jaramillo-Lavadie, Felix Lopez et al." Phoenix: Heard Museum, January 1992.

ALPHONSE "BOIS SEC" ARDOIN

Bibliography
Ancelet, Barry Jean, and Elemore Morgan, Jr. *The Makers of Cajun Music: Musiciens Cadiens et Créoles.* Austin: University of Texas Press, 1984.
Jennings, Dana. "In Bayou Country, Music Is Never Second Fiddle." *New York Times* (November 22, 1998), 2: 37.
Savoy, Ann Allen. *Cajun Music: A Reflection of the People, Vol. 1.* Eunice, Louisiana: Bluebird Press, 1985.

Discography
Ardoin, Alphonse, Canray Fontenot, et al. *"Boisec" Ardoin: La Musique Créole.* Arhoolie 445.
Ardoin, Alphonse, Adam and Cyprien Landreneau, et al. *Louisiana Cajun French Music from the Southwest Prairies, Vol. 2.* Rounder 6002.
Ardoin, Alphonse, et al. *Voices of the Americas Series: Cajun and Creole Music.* World Music Institute T110.
Ardoin Family, et al. *Zodico: Louisiana Creole Music.* Rounder 6009.

Filmography
Dry Wood. 16mm, videotape, color, 37 minutes. Directed by Les Blank, with Maureen Gosling. El Cerrito, California: Flower Films, 1973.
Hot Pepper. 16mm, videotape, color, 54 minutes. Di-

rected by Les Blank, with Maureen Gosling. El Cerrito, California: Flower Films, 1973.

J'ai Eté au Bal. 16mm, videotape, color, 84 minutes. Directed by Les Blank, with Chris Strachwitz and Maureen Gosling. El Cerrito, California: Flower Films, 1989.

Zydeco: Creole Music and Culture in Rural Louisiana. Videotape, color, 56 minutes. Directed by Nicholas R. Spitzer. New Orleans: Center for Gulf South History and Culture, 1984.

HOWARD ARMSTRONG

Discography

Armstrong, Howard, et al. *Barnyard Dance.* Rounder 2003.

_____. *Let's Have a Party.* Flying Fish Records 27003.

_____. *Louie Bluie.* Arhoolie 470.

_____. *That Old Gang of Mine.* Flying Fish Records 27056.

Filmography

Louie Bluie. 16mm, videotape, color, 60 minutes. Produced by Terry Zwigoff. San Francisco: Superior Pictures, 1985.

FRISNER AUGUSTIN

Bibliography

Jacobson, Mark. "Hear My Ear." *Esquire* (January 1996): 21.

Ridgeway, James, and Jean Jean-Pierre. "Heartbeats of Voudou: Haitian Drums Call from Port-au-Prince to Brooklyn." *Natural History* (December 1998/January 1999), 107, 10: 30.

Wadler, Joyce. "An Urban Hero, Captive to the Drums." *New York Times* (November 17, 1998): B2.

Wilcken, Lois. *The Drums of Vodou.* Tempe, Arizona: White Cliffs Media Company, 1992.

Discography

Augustin, Frisner. *Rhythms of Rapture: Sacred Musics of Haitian Vodou.* Smithsonian Folkways 40464.

Augustin, Frisner, and La Troupe Makandal. *Erzili.* World Music Institute WMI–109.

CELESTINO AVILÈS

Bibliography

"Imagineria." *Boletin Artes Populares,* No. 12. San Juan: Instituto de Cultura Puertorriqueña, 1996.

"La Familia Avilès de Orocovis." San Juan: Instituto de Cultura Puertorriqueña, Programma de Artes Populares, 1996.

PEDRO AYALA

Bibliography

Morthland, John. "Wasted Days." *Texas Monthly* (October 1995) 23, 10: 64.

Peña, Manuel H. *The Texas–Mexican Conjunto: History of a Working-Class Music.* Austin: University of Texas Press, 1985.

Discography

Ayala, Pedro, et al. *South Texas Polka Party.* Arhoolie 9005.

EDWARD BABB

Bibliography

Conovor, Kirsten A. "National Endowment for the Arts Honors American Folk Artists." *Christian Science Monitor* (June 30, 1997) 89, 150: 15.

Discography

Babb, Edward, and McCollough Sons of Thunder, et al. *Saint's Paradise.* Smithsonian Folkways SFW 40117.

ETTA BAKER

Bibliography

Henderson, Bruce. "Blues Not Doleful in Etta Baker's Hands." *Charlotte Observer* (December 27, 1988).

Menconi, David. "She Picks Up a Guitar, and Nothing Gets in the Way." *News and Observer (Raleigh)* (June 23, 1991).

Olson, Ted. "Etta Baker: What My Daddy Gave Me." *Living Blues* (January/February 1993): 28–30.

Traum, Happy. *Finger-Picking Styles for the Guitar.* New York: Music Sales Corporation, 1969.

Wald, Elijah. "Rural Routes." *Acoustic Guitar* (July/August 1993): 62–67.

Discography

Baker, Etta. *One-Dime Blues (Finger-Picked Blues and Traditional Tunes).* Rounder CD 2112.

Baker, Etta, et al. *Instrumental Music of the Southern Appalachians.* Tradition T1007.

_____. *Music from the Hills of Caldwell County.* Physical PR 12–001.

Filmography

The Fingerpicking Blues of Etta Baker, Taught by Etta Baker and Hosted by Wayne Martin. Videotape. Happy

Traum, producer. Woodstock, New York: Homespun Video HL00641334, 1996.

KENNY BAKER

Bibliography

Watson, Bruce, and Catherine Karnow. "This Here's All for Foot Tappin' and Grin Winnin'." *Smithsonian* (March 1993) 23, 12: 68.

Discography

Baker, Kenny. *Kenny Baker Plays Bill Monroe*. County 2708.

_____. *Master Fiddler*. County 2705.

Baker, Kenny, and Blaine Sprouse. *Indian Springs*. Rounder 259.

Baker, Kenny, et al. *Let's Put the Axe to the Axis—Songs of World War II, Vol. I*. Smithsonian Folkways RF610.

DEWEY BALFA

Bibliography

Ancelet, Barry Jean, and Elemore Morgan, Jr. "Dewey Balfa: Cajun Music Ambassador." *Louisiana Life* (September/October 1981).

_____. *The Makers of Cajun Music: Musiciens Cadiens et Créoles*. Austin: University of Texas Press, 1984.

Gates, D. "The Voices of America." *Newsweek* (July 16, 1990) 116, 3: 60.

Horne, Jed, and Bob Sacha. "Cajun Country." *Travel Holiday* (November 1994) 177, 9: 56.

Humphreys, Brian. "Cajun Festival Boosts Visibility of Unique Kind of Folk." *Christian Science Monitor* (September 23, 1996) 88, 209: 15.

Pareles, Jon. "Dewey Balfa, Folk Fiddler, Is Dead at 65." *New York Times* (June 18, 1992): D22.

Sancton, T. "Why the Good Times Still Roll." *Time* (November 4, 1991) 138: 18, 36.

Savoy, Ann Allen. *Cajun Music: A Reflection of a People, Vol. 1*. Eunice, Louisiana: Bluebird Press, 1985.

Wilson, Charles Reagan, and William Ferris, eds. *Encyclopedia of Southern Culture*. Chapel Hill and London: University of North Carolina Press, 1989.

Discography

Balfa, Dewey. *The Balfa Brothers Play Traditional Cajun Music*. Swallow 6011.

_____. *The Balfa Brothers Play More Traditional Cajun Music*. Swallow 6019.

_____. *Cajun Days*. Sonet 813.

_____. *Handmade*. Swallow 6063.

_____. *The New York Concerts*. Swallow 6037.

_____. *Souvenirs*. Swallow 6056.

Balfa, Dewey, and Tracy Schwartz. *Traditional Cajun Fiddle: Cajun Fiddle Old and New*. Smithsonian Folkways 8361, 8362.

Balfa, Dewey, et al. *Cajun Fais Do-Do*. Arhoolie 416.

Filmography

Les Blues de Balfa. 16mm, videotape, color, 28 minutes. Produced by Yasha Aginsky. El Cerrito, California: Flower Films, 1983.

J'ai Eté au Bal. 16mm, videotape, color, 84 minutes. Directed by Les Blank, with Chris Strachwitz and Maureen Gosling. El Cerrito, California: Flower Films, 1989.

Spend It All. 16mm, videotape, color, 41 minutes. Directed by Les Blank, with Skip Gerson. El Cerrito, California: Flower Films, 1971.

BAO MO-LI

Bibliography

Alley, Rewi. *Peking Opera*. Beijing: New World Press, 1984.

Dong, Zhensheng. *Paintings of Beijing Opera Characters*. Beijing: Zhaohua Publishing House, 1981.

Gong, Li, Robin Magowan, and Jessica Tan Gudnason. *Chinese Opera*. New York: Abbeville Press, 2001.

Kuo, Alex. *Chinese Opera*. Hong Kong: Asia Two Thousand, Limited, 1999.

Lovrick, Peter, and Siu Wang-Ngai. *Chinese Opera Images & Stories*. Seattle: University of Washington Press, 1997.

Tsíao, Guo-Lin. *The Face of Chinese Opera*. Grawn, Michigan: Access Publishers Network, 1995.

Wu, Zuguang, Huang Zuolin, and Mei Shaowu. *Peking Opera & Mei Lanfang*. Beijing: New World Press, 1981.

SISTER R. MILDRED BARKER

Bibliography

Barker, Sister R. Mildred. *Poems and Prayers*. Sabbathday Lake, Maine: The Shaker Press, 1985.

Patterson, Daniel. *The Shaker Spiritual*. Princeton: Princeton University Press, 1979.

"Shaker Ranks Dwindle as Two Leaders Die." *National Geographic* (March 1991) 3: 1.

Wolkomir, Richard, and Joyce Wolkomir. "Living a Tradition." *Smithsonian* (April 2001) 32, 1: 98.

Discography

Barker, Mildred. *Early Shaker Spirituals*. Rounder 0078. Sung by Mildred Barker and other members of the United Society of Shakers.

Filmography
The Shakers. 16mm, videotape, color, 30 minutes. Directed by Tom Davenport. Delaplane, Virginia: Davenport Films.

LOUIS BASHELL

Bibliography
Leary, James P., and Richard March. *Down Home Dairyland.* Madison: University of Wisconsin Extension, 1996.

Discography
Bashell, Louis, and His Silk Umbrella Orchestra. *Polka Special, Silk Umbrella Polkas.* Greenfield, Wisconsin: Louis Bashell.

KEPKA BELTON

Bibliography
Burkhead, Jeff. "Egg Lady." In *Czech Festival '83.* Wilson, Kansas: *The Wilson World.*
Szermet, Mike. "Mrs. Belton to Display Art." *The Wilson World* (July 29, 1976).

EARNEST BENNETT

Bibliography
Bronner, Simon. *Chain Carvers: Old Men Crafting Meaning.* Lexington: University Press of Kentucky, 1985.
Hufford, Mary, Marjorie Hunt, and Steve Zeitlin. *The Grand Generation: Memory, Mastery, Legacy.* Seattle: University of Washington Press, 1987.

MOZELL BENSON

Bibliography
Harper, Samuel T. "Quiltmaker Helps Weave Some History." *Opelika Auburn (Ala.) News* (March 22, 1994).
Moe, Andrew. "Piece by Pieces: Quilts Reflect African-American Heritage." *Montgomery (Ala.) Advertiser* (January 30, 1994).
Patterson, Andrea. "Warmth, Beauty Sewn into Quilts." *York (Pa.) Observer* (February 10, 1989).
Wahlman, Maude. "Mozell Benson." In *Ten Afro-American Quilters.* Oxford, Mississippi: Center for the Study of Southern Culture, 1983.
_____. *Signs and Symbols: African Images in African American Quilts.* New York: Penguin, 1994.

MARY HOLIDAY BLACK

Bibliography
Baierschmidt, Chris. "Weaving the Bond." *Catalyst* (April 1994).

Castro, Peter, and Cathy Free. "Stitches in Time." *People* (January 22, 1996): 63–64.
Edison, Carol A., ed. *Willow Stories: Utah Navajo Baskets.* Salt Lake City: Utah Arts Council, 1996.
Jacka, Lois Essary, and Jerry Jacka. "Weaves of Grass." *Arizona Highways* (November 1997) 73, 11: 18.
McEntire, Frank. "Navajos Keeping the Tradition of Basket Weaving Alive." *Salt Lake (Utah) Tribune* (September 25, 1994).
McGreevy, Susan Brown. "What Makes Sally Weave: Survival and Innovation in Navajo Basketry Trays." *American Indian Art* (summer 1989): 38.
Miller, Layne. "Clan Keeps Traditional Navajo Basket Weaving Alive." *Salt Lake (Utah) Tribune* (February 19, 1994).
Ortiz, Alfonso, ed. *Smithsonian Handbook of North American Indians, Vol. 10.* Washington, D.C.: Smithsonian Institution Press, 1983.
Whiteford, Andrew Hunter. *Southwestern Indian Baskets: Their History and Their Makers.* Santa Fe: SAR Press, 1988.

LILA GREENGRASS BLACKDEER

Bibliography
Hocak Wazijaci Artistic Traditions (A Companion to the Hocak Wazijaci Photo Text Exhibit). Mount Horeb, Wisconsin: Hocak Language & Culture Preservation Committee (in cooperation with the Wisconsin Folk Museum), 1994.

GEORGE BLAKE

Bibliography
Ortiz, Bev. "A Rich Red Hue: Yurok Dugout Canoes." *News from Native California* (November/January 1991): 12–34.

EDDIE BLAZONCZYK

Bibliography
Greene, Victor. *A Passion for Polka: Old Time Ethnic Music in America.* Berkeley: University of California Press, 1992.

Discography
Eddie Blazonczyk's Versatones. *Another Day at the Office.* Bel-Aire Records BACD 8392.
_____. *Greatest Hits, Vol. II.* Cleveland International CIR1018–2.
_____. *Shakin' Not Stirred.* Bel-Aire Records BACD 3051.

ALICE NEW HOLY BLUE LEGS

Filmography

Lakota Quillwork—Art & Legend. 16mm, videotape, color, 27 minutes. Produced and directed by H. Jane Nauman. Custer, South Dakota: Nauman Films, 1990.

CHARLES BROWN

Bibliography

Govenar, Alan. *African American Frontiers: Slave Narratives and Oral Histories.* Santa Barbara, California: ABC-CLIO, 2000.

_____. *Meeting the Blues,* pp. 179–183. New York: Da Capo Press, 1995.

Oullette, Dan. "Charles Brown Dies 10 Days After Tribute." *Down Beat* (April 1999) 66, 4: 15.

"Staple Singers, Curtis Mayfield, Charles Brown Inducted into Rock and Roll Hall of Fame." *Jet* (April 4, 1999) 95, 18: 26.

Watrous, Peter. "Charles Brown, 76, Blues Pianist and Singer." *New York Times* (January 25, 1999) 148, 51413: A21.

Discography

Brown, Charles. *One More for the Road.* Blue Side 60007–1.

JERRY BROWN

Filmography

Unbroken Tradition: Jerry Brown Pottery. 16mm, videotape, color, 28 minutes. Directed by Herb E. Smith. Whitesburg, Kentucky: Appalshop Films, 1989.

EM BUN

Bibliography

Krebs, Jeanette. "Woman Weaves Anew." *Patriot News (Harrisburg, Pa.)* (June 19, 1990) 149: 146.

Rosenthal, Janice G. "Cambodian Silk Weaver." *Threads Magazine* (December 1990/January 1991) 32: 22.

Tennesen, Michael. "Silk and Ceremony." *Modern Maturity* (October/November 1991): 17.

BRUCE CAESAR

Bibliography

Contemporary Southern Plains Indian Metalwork. Exhibition catalogue organized by the Indian Arts and Crafts Board of the U.S. Department of the Interior in cooperation with the Oklahoma Indian Arts and Crafts Cooperative. Introduction by Rosemary Ellison. Anadarko, Oklahoma, 1976.

Native Peoples (summer 1996) 9, 4.

Oklahoma Today (November/December 1990) 40: 6.

SHIRLEY CAESAR

Bibliography

"Blacks Showcase Talent and Style at 42nd Grammy Awards." *Jet* (March 13, 2000) 97, 14: 56.

Boland, Michaela. "25th Sydney Fest on Target." *Variety* (January 29, 2001) 381, 10: 65.

Caesar, Shirley. *The Lady, the Melody & the Word: The Inspirational Story of the First Lady of Gospel.* Nashville: Thomas Nelson Publishers, 1998.

Dodge, Timothy. "From Spirituals to Gospel Rap: Gospel Music Periodicals." *Serials Review* (winter 1994) 20, 4: 67.

Gliatto, Tom. "Great Performances: The Story of Gospel Music." *People* (February 3, 1997) 47, 4: 16.

"Gospel Divas." *Ebony* (April 1994) 49: 76.

"Gospel Music Hall of Fame Inducts Three New Black Members." *Jet* (November 20, 2000) 98, 24: 22.

Haynes, K. A. "Are the New Songs Too Jazzy and Too Worldly?" *Ebony* (March 1992) 47, 5: 76.

Innaurato, Albert, and Joshua Levine. "Revival Movement." *Forbes* (May 18, 1998) 161, 10: 334.

Johnson, Pamela. "Ya Done Good, Girl." *Essence* (May 2000) 31, 1: 130.

Moore, Trudy. "Has Gospel Music Become Too Contemporary?" *Jet* (August 21, 1995) 88, 15: 14.

Rhea, Shawn E. "Gospel Rises Again." *Black Enterprise* (July 1998) 28, 12: 94.

"The 25 Most Important Events in Black Music History." *Ebony* (June 2000) 55, 8: 140.

"Why Gospel Remains So Popular." *Jet* (November 16, 1998) 94, 25: 14.

Discography

Caesar, Shirley. *He's Working It Out for You.* Epic EK48785.

_____. *I Remember Mama.* Epic EK47755.

_____. *Jesus, I Love Calling Your Name.* Epic EK47811.

_____. *Sailin.* Epic EK48800.

DALE CALHOUN

Bibliography

Andrews, James G. "The Reelfoot Boat-Builders." *Commercial Appeal (Memphis)* (December 30, 1973): 4–6.

Clemons, Alan. "Hands of Time." *Huntsville (Ala.) Times* (February 1, 1998).

Cogswell, Robert. "Dale Calhoun & the Reelfoot Lake Boat." *Tennessee Folklore Society Bulletin* (1999) 59, 2: 48–54.

Parker, Lin C. "Reeling in the Crowds." *Chattanooga News–Free Press* (May 27, 1992).

Pomeroy, Maurice. "The Stump Jumper of Reelfoot Lake." *Tennessee Conservationist* (September 1974) 40, 9: 18–20.

Price, Steve. "The Stump-Jumpers of Reelfoot Lake." *Rod & Reel* (July/August 1981): 42–45.

Sanford, Vern. "Reelfoot's Unique Boat: 'The Stump Jumper.'" *Fisherman and Hunter's Guide* (March 1976): 50–53.

Tuberville, Jack. "A Well-Used Boat: The Reelfoot Lake Stumpjumper." *Wooden Boat* (May/June 1988) 82: 19–20, 23.

WALKER CALHOUN

Bibliography

Moose, Debbie. "Telling the Tales of Time." *News and Observer (Raleigh)* (June 28, 1992).

_____. "Folklorist Maintains Tradition of the Cherokee Nation." *Wilson (N.C.) Times* (August 4, 1992): A10.

_____. "Cherokee Passes on Traditions He Was Almost Forced to Abandon." *Morning Star (Wilmington, N.C.)* (August 17, 1992): B3.

Scott, Bob. "Cherokee Medicine Regaining Interest." *Asheville (N.C.) Citizen* (May 1, 1989): B1.

Discography

Calhoun, Walker. *Where Ravens Roost.* Cullowee, North Carolina: Mountain Heritage Center.

ALFREDO CAMPOS

Bibliography

Robert L. Woolery. "The Horsehair Hitching of Alfredo Campos." *Western Horseman* (October 1984).

NATIVIDAD CANO

Discography

Mariachi Los Camperos. *Canciones de Siempre.* Polygram Latino.

_____. *El Super Mariachi, Los Camperos.* Discos Latin International.

_____.*El Super Mariachi: Los Camperos en La Fonda.* Discos Latin International DLIS 2003.

_____. *North of the Border.* RCA/Cariño Records.

_____. *Puro Mariachi.* Indigo Records.

_____. *Valses de Amor.* La Fonda Records.

Filmography

Great Performances: The Story of Gospel Music. 90-minute documentary aired on February 5, 1997, on PBS-TV.

LIZ CARROLL

Discography

Carroll, Liz. *Liz Carroll.* Green Linnet 1092.

Carroll, Liz, et al. *A House Made of Glass.* Green Linnet 1123.

_____. *Playing with Fire: The Celtic Fiddle Collection.* Green Linnet 1101.

_____. *There Were Roses.* Green Linnet 1057.

GENOVEVA CASTELLANOZ

Bibliography

Siporin, Steve, ed. *We Came to Where We Were Supposed To Be: Folk Art of Idaho.* Boise: Idaho Commission on the Arts, 1984.

Filmography

Eva Castellanoz, Corona Maker: Mexican-American Ceremonial Traditions. Slide-tape program, videotape, 15 minutes. Produced by Alicia González, Steve Siporin, and Robert McCarl. Boise: Idaho Commission on the Arts, 1987.

INEZ CATALON

Discography

Catalon, Inez, et al. *Zodico: Louisiana Creole Music.* Rounder 6009.

RAFAEL CEPEDA

Bibliography

Torres, Jaime Torres. "En Familia con la Bomba y la Plena." *El Nuevo Dia-Domingo (San Juan)* (October 6, 1991).

Discography

Cepeda, Rafael. *Don Rafael Cepeda: "Patriarca de la Bomba."* Discos Cangejo #1.

JOHN CEPHAS

Bibliography

Bourne, Joel. "A Festival of Life." *Mother Earth News* (February/March 1995) 148: 60.

Cheakalos, Christina, and Macon Morehouse. "Strum Major." *People* (April 23, 2001) 55, 16: 83.

Hadley, Frank-John. "Feelin' Bad, Feelin' OK." *Down Beat* (October 1998) 65, 10: 57.

_____. "Plenty Good Medicine." *Down Beat* (September 1996) 63, 9: 42.

Pearson, Barry Lee. *Virginia Piedmont Blues: The Lives and Art of Two Virginia Bluesmen.* Philadelphia: University of Pennsylvania Press, 1990.

Discography

Cephas John. *Tidewater Blues.* BRI1006.

_____. *Voices of the Americas Series: The Blues.* World Music Institute WM1001.

Cephas, John, and Phil Wiggins. *Bowling Green John Cephas and Harmonica Phil Wiggins: Dog Days of August.* Flying Fish Records FF90394.

_____. *Dog Days of August.* Flying Fish Records FLY 394.

_____. *Flip, Flop & Fly.* Flying Fish Records FLY 580.

_____. *From Richmond to Atlanta.* Bullseye Blues BEYE 9633.

_____. *Guitar Man.* Flying Fish Records FLY 470.

BOUNXOU CHANTHRAPHONE

Bibliography

Circles of Tradition: Folk Arts in Minnesota. St. Paul: Minnesota History Press for the University of Minnesota, 1989.

NICHOLAS AND ELENA CHARLES

Bibliography

Fienup-Riordan, Ann. "Nick Charles, Sr." In *The Artists Behind the Work: Life Histories of Nick Charles, Sr., Frances Demientieff, Lena Sours, & Jennie Thlunaut,* pp. 25–57. Suzi Jones et al., eds. Fairbanks: University of Alaska Museum, 1986.

"Yupik Elders Among Artists Honored with NEA Awards." *Anchorage Daily News* (September 23, 1993).

WILSON "BOOZOO" CHAVIS

Bibliography

Pareles, Jon. "Boozoo Chavis, 70, Accordionist Who Spread the Zydeco Sound." *New York Times* (May 7, 2001) 150, 51746: B6.

Sandmel, Ben. *Zydeco!* Jackson: University Press of Mississippi, 1999.

Discography

Boozoo Chavis. *Johnnie Billy Goat.* Rounder 1594.

_____. *The Lake Charles Atomic Bomb (Original Goldband Recordings).* Rounder 2097.

Boozoo Chavis & the Magic Sounds. *Boozoo, That's Who.* Rounder 2126.

_____. *Live! At the Habibi Temple, Lake Charles, Louisiana.* Rounder 2130.

_____. *Who Stole My Monkey.* Rounder 2156.

Filmography

The Kingdom of Zydeco. 16mm, videotape, color, 71 minutes. Directed by Robert Mugge. Mug-Shot Productions, 1994.

CLIFTON CHENIER

Bibliography

Ancelet, Barry Jean, and Elemore Morgan, Jr. *The Makers of Cajun Music: Musiciens Cadiens el Créoles.* Austin: University of Texas Press, 1984.

Bogey, Dan, Barbara Hoffert, et al. "Book Reviews: Arts & Humanities." *Library Journal* (October 1, 1998) 123, 16: 92.

Colby, Michael, Barbara Hoffert, et al. "Book Reviews: Arts & Humanities." *Library Journal* (May 1999) 124, 8: 82.

Draper, Dan. "Clifford's Blues." *Texas Monthly* (October 1997) 25, 10: 140.

Hannusch, J. "Zydeco Great Clifton Chenier Dead at 62." *Rolling Stone* (January 1, 1988): 14.

Holston, Mark. "Cutting Edges of Yesterday and Today." *Americas* (July/August 2000) 52, 4: 54.

Horne, Jed, and Bob Sacha. "Cajun Country." *Travel Holiday* (November 1994) 177, 9: 56.

Morthland, John. "Blues Brothers." *Texas Monthly* (July 1999) 27, 7: 68.

_____. "Wills Power." *Texas Monthly* (May 2000) 28, 5: 122.

_____ "Unsung." *Texas Monthly* (October 2000) 28, 10: 112.

Patoski, Joe Nick. "The Big Twang." *Texas Monthly* (July 1994) 22, 7.

_____. "What a Disc." *Texas Monthly* (October 1992) 20, 10: 128.

Sandmel, Ben. "Allons au Zydeco." *World & I* (August 1999) 14, 8.

Savoy, Ann Allen. *Cajun Music: A Reflection of a People, Vol. 1.* Eunice, Louisiana: Bluebird Press, 1985.

Tisserand, Michael. *The Kingdom of Zydeco.* New York: Arcade, distributed by Little, Brown, 1998.

Walsh, Michael, and David E. Thigpen. "Hot off the Bayou." *Time* (May 8, 1995) 145, 19: 88.

Discography

Chenier, Clifton. *Bogalusa Boogie.* Arhoolie 347.

_____. *Bon Ton Roulet!* Arhoolie 345.

_____. *King of the Bayous, I'm Coming Home.* Arhoolie 339.

_____. *The King of Zydeco Live at Montreux.* Arhoolie 355.

_____. *Live! At the Longbeach & San Francisco Blues Festivals.* Arhoolie 404.

_____. *Out West.* Arhoolie 350.

_____. *Sings the Blues.* Arhoolie 351.

_____. *Zydeco Sont Pas Salé.* Arhoolie 9001.

Filmography

Clifton Chenier and His Red Hot Louisiana Band. Videotape, 3/4-inch and 1/2-inch, color, 58 minutes. Directed by Carl Colby. New York: Phoenix Films, 1977.

Clifton Chenier: The King of Zydeco. 16mm, videotape, color, 55 minutes. Produced by Chris Strachwitz. El Cerrito, California: Flower Films, 1987.

Dry Wood. 16mm, videotape, color, 37 minutes. Directed by Les Blank, with Maureen Gosling. El Cerrito, California: Flower Films, 1973.

Hot Pepper. 16mm, videotape, color, 54 minutes. Directed by Les Blank, with Maureen Gosling. El Cerrito, California: Flower Films, 1973.

J'ai Eté au Bal. 16mm, videotape, color, 84 minutes. Directed by Les Blank, with Chris Strachwitz and Maureen Gosling. El Cerrito, California: Flower Films, 1989.

BETTY PISIO CHRISTENSON

Bibliography

Bolz, Diane M. "Celebrating Folklife Traditions." *Smithsonian* (June 1998) 29, 3: 26.

Nelson, Sally. "Pysanky Can't Be Beat. Local Eggs Make White House Roll." *Post-Crescent (Appleton, Wisc.)* (March 7, 1988).

Sommerfeld, Jan. "Ancient Art Revives Heritage." *Shawano (Wisc.) Evening Ledger* (April 13, 1990).

Teskie, Robert. *Passed to the Present: Folk Arts Along Wisconsin's Ethnic Settlement Trail,* pp. 52–53. Cedarburg, Wisconsin: Cedarburg Cultural Center, 1994.

GLADYS LEBLANC CLARK

Bibliography

Conover, Kirsten A. "National Endowment for the Arts Honors American Folk Artists." *Christian Science Monitor* (June 30, 1997) 89, 150: 15.

JACK COEN

Bibliography

Kaplain, Lori Jane. *The Lark on the Strand: A Study of a Traditional Irish Flute Player and His Music.* Master's thesis presented to the faculty of the Center for Intercultural and Folk Studies, Western Kentucky University, Bowling Green, Kentucky, 1979.

Discography

Coen, Jack, et al. *The Branch Line.* Green Linnet 3067.

_____. *Jigs and Reels.* Green Linnet 9001.

BERTHA COOK

Bibliography

Abrams, W. Amos. "Bertha Hodges Cook." *North Carolina Folklore Journal* (May 1974) 22, 2.

McGowan, Thomas A. "Bertha Cook, Maker of Knotted Bedspreads." *Appalachian Arts* (fall 1980) 3, 1.

Filmography

Bertha Cook, Maker of Knotted Bedspreads. Videotape. Directed by Thomas A. McGowan. Boone, North Carolina: Appalachian State University, 1979.

HELEN CORDERO

Bibliography

Babcock, Barbara A. *The Pueblo Storyteller: Development of a Figurative Ceramic Tradition.* Tucson: University of Arizona Press, 1986.

_____. "Clay Voices: Invoking, Mocking, Celebrating." In *Celebration: Studies in Festivity and Ritual,* Victor Turner, ed., pp. 58–76. Washington, D.C.: Smithsonian Institution Press, 1982.

Glassie, Henry. *The Spirit of Folk Art: The Girard Collection at the Museum of International Folk Art.* New York: Harry N. Abrams, 1989.

Howard, Nancy S. *Helen Cordero & the Storytellers of Cochiti Pueblo.* Worcester, Massachusetts: Davis Publications, 1995.

Hufford, Mary, Marjorie Hunt, and Steven Zeitlin. *The Grand Generation: Memory, Mastery, Legacy.* Seattle: University of Washington Press, 1987.

JOSEPH CORMIER

Discography

Cormier, Joseph. *Dances from Down Home.* Rounder 7004.

_____. *Scottish Violin Music from Cape Breton Island.* Rounder 7001.

Filmography

New England Fiddles. 16mm, color, 30 minutes. Di-

rected by John Melville Bishop. Watertown, Maine: Documentary Educational Resources, 1983.

Masters of Traditional Music. Videotape, color, 58 minutes. Directed by Alan Govenar and Robert Tullier. Dallas: Documentary Arts, 1991.

ELIZABETH COTTEN

Bibliography

Carley, Marika. "Libba Cotten's Guitar." *Smithsonian* (October 2000) 31, 7: 32.

Hochman, Steve, and David Sinclair. "Performance." *Rolling Stone* (April 30, 1998) 785: 33.

"Popular Music." *Stereo Review* (June 1998), 63: 93.

Ricke, David. "Guitar Gods." *Rolling Stone* (April 1, 1999) 809: 67.

Schoemer, Karen, and Allison Samuels, et al. *Newsweek* (March 9, 1998) 131, 10: 59.

Seeger, Mike. "A 'Freight Train' Picker." In *Festival of American Folklife Program*. Washington, D.C.: Smithsonian Institution, 1970.

"Sight & Sound." *American History Illustrated* (January/February 1994) 28, 6: 29.

Discography

Cotten, Elizabeth. *Freight Train and Other North Carolina Folk Songs and Tunes*. Smithsonian Folkways 40009.

_____. *Live*. Arhoolie 477.

_____. *Shake Sugaree, Vol. 2*. Smithsonian Folkways 31003.

_____. *When I'm Gone, Vol. 3*. Smithsonian Folkways 03537.

Cotten, Elizabeth, et al. *Close to Home: Old Time Music from Mike Seeger's Collection, 1952–1967*. Smithsonian Folkways 40097.

_____. *Newport Folk Festival Recordings: 1964 Blues II*. Vanguard 79181.

Filmography

Legends of Country Blues. Videotape. Vestapol Productions 13003. Distributed by Rounder Records, 1994.*Me and Stella*. 16mm, videotape, color, 24 minutes. Directed by Geri Ashur. New York: Phoenix Films, 1977.

BURLON CRAIG

Bibliography

Bridges, Daisy Wade. "Burlon B. Craig." In *Potters of the Catawba Valley, North Carolina*, Daisy Wade Bridges, ed. *Journal of Studies, Ceramic Circle of Charlotte* (1980) 4: 39–47.

Burrison, John A. *Brothers in Clay: The Story of Georgia Folk Pottery*. Athens: University of Georgia Press, 1983.

Glassie, Henry. *The Spirit of Folk Art: The Girard Collection at the Museum of International Folk Art*. New York: Harry N. Abrams, 1989.

Morrison, Jim, and Kelly Culpepper. "Fired with Finesse." *Smithsonian* (October 1998) 29, 7: 109.

Zug, Charles G., III. *Turners and Burners: The Folk Potters of North Carolina*. Chapel Hill and London: University of North Carolina Press, 1986.

PAUL DAHLIN

Discography

Dahlin, Paul, et al. *Still Siljan After All These Years*. American Swedish Institute Spelmanslag, distributed by Artiega, 2000.

CLYDE DAVENPORT

Bibliography

Fulcher, Bobby. *The Cumberland Music Tour*. Program notes. Nashville: Tennessee Arts Commission, 1988.

Discography

Davenport, Clyde. *Clydeoscope*. County 788.

_____. *Getting Up the Stairs*. County 786.

_____. *Homemade Stuff*. Davis Unlimited DU 33028.

Davenport, Clyde, and W. L. Gregory. *Monticello*. Davis Unlimited DU 33014.

BELLE DEACON

Bibliography

Contemporary Native Art of Alaska. Exhibition catalogue. Anchorage: Anchorage Historical & Fine Arts Museum, 1979.

"Elder Remembered." *Iana Journal* (spring 1996).

Jones, Suzi, ed. *Pacific Basketmakers: A Living Tradition*. Catalogue of the 1981 Pacific Basketmaker's Symposium and Exhibition. Honolulu: Consortium for Pacific Arts and Cultures/Fairbanks: University of Alaska Museum.

The Native Art of Alaska. Anchorage: Anchorage Historical and Fine Arts Museum, 1972.

MARY LOUISE DEFENDER-WILSON

Bibliography

Rosencrans, Kendra. "Native Indian People's Culture

Therapeutic Aid." *Jamestown (N. Dak.) Sun* (July 17, 1991) 67: 14.

Voskuil, Vicki. "Gourd Woman." *Bismarck (N. Dak.) Tribune* (May 3, 1987), Section E.

GIUSEPPE AND RAFFAELA DEFRANCO

Discography

DeFranco, Giuseppe, and Raffaela DeFranco. *The De-Franco Family—and Franco Cofone.* DeFranco cassette.

DeFranco, Giuseppe, and Raffaela DeFranco, et al. *Calabria Bella—Italian Music in New York, New Jersey and Rhode Island, Vol. 2.* Smithsonian Folkways 34042.

ANTONIO DE LA ROSA

Bibliography

Peña, Manuel. *The Texas–Mexican Conjunto: History of a Working Class Music.* Austin: University of Texas Press, 1985.

Discography

De La Rosa, Antonio. *Atotonilco.* Arhoolie 362.

_____. *Mejor Solo.* Hacienda 0401.

De La Rosa, Antonio, et al. *15 Early Tejano Classics.* Arhoolie 109.

_____. *San Antonio's Conjuntos in the 1950s.* Arhoolie 376.

_____. *South Texas Polka Party.* Arhoolie 9005.

AMBER DENSMORE

Bibliography

Clark, Eddie. "A Quilter for All Seasons." *Yankee Magazine* (January 1992): 104–107.

"Amber Densmore." In *Stories to Tell: The Narrative Impulse in Contemporary New England* (1988) 33: 64–65. Lincoln, Massachusetts: Decordova and Dana Museum and Park.

HAZEL DICKENS

Bibliography

Arnold, Edwin T., and Jerry Wayne Williamson, eds. *Interviewing Appalachia: The Appalachian Journal Interviews,* pp. 197–214. Knoxville: University of Tennessee Press, 1994.

Carawan, Guy, and Candie Carawan. *Voices from the Mountains.* Urbana: University of Illinois Press, 1982.

Laur, Katie. "Voices from the Mountains." *Blair & Ketchum's Journal* (May 1985) 12: 84–87.

Discography

Dickens, Hazel. *By the Sweat of My Brow.* Rounder 0200.

_____. *A Few Old Memories.* Rounder 11529.

_____. *Hard Hitting Songs for Hard Hit People.* Rounder 0126.

_____. *It's Hard to Tell the Singer from the Song.* Rounder 0226.

Dickens, Hazel, and Alice Gerrard. *Hazel & Alice.* Rounder 0054.

Filmography

Gather at the River. Videotape, color, 101 minutes. Directed by Robert Mugge. Mug-Shot Productions, 1994.

DIXIE HUMMINGBIRDS

Bibliography

Boyer, Horace Clarence. *How Sweet the Sound: The Golden Age of Gospel.* Washington, D.C.: Elliott & Clark, 1995.

Broughton, Viv. *Black Gospel: An Illustrated History of the Gospel Sound.* Dorset, U.K.: Blandford Press, 1985.

"Classic Songs by Blacks Among Those Newly Added to Recording Academy's Hall of Fame." *Jet* (April 17, 2000) 97, 19: 61.

DeCurtis, Anthony, and James Henke. *The Rolling Stone Illustrated History of Rock & Roll.* New York: Random House, 1992.

Fox, Ted. *Showtime at the Apollo.* New York: Holt, Rinehart, and Winston, 1983.

Gart, Galen, and Roy C. Ames. *Duke/Peacock Records: An Illustrated History with Discography.* Milford, New Hampshire: Big Nickel Publications, 1990.

Gillett, Charlie. *The Sound of the City.* New York: Pantheon, 1983.

Groia, Phillip. *They All Sang on the Corner.* West Hempstead, New York: Philly Dee Enterprises, 1983.

Hayes, Cedric, and Robert Laughton. *Gospel Records 1943–1969: A Black Music Discography.* Record Information Services, 1992.

Heilbut, Tony. *The Gospel Sound: Good News and Bad Times.* New York: Limelight Editions, 1985.

Jackson, Joyce Marie. "The Changing Nature of Gospel Music: A Southern Case Study." *African American Review* (summer 1995) 29, 2: 185.

Jones, Quincy. "50 Years of Black Music." *Ebony* (November 1995) 51, 1: 178.

Morthland, John. "Record Label of the Century." *Texas Monthly* (December 1999) 27, 12: 182.

Oliver, Paul, Max Harris, and Harris Bolcom, eds. *The New Grove Gospel, Blues and Jazz.* New York: W.W. Norton, 1986.

Santoro, G. "Gospel Music." *The Nation* (July 8, 1991) 253, 2: 66.

Strauss, Neil. "Gospel Roots Reaching the Heart and the Soul." *New York Times* (October 3, 1995): C17.

"TLC Gets Six Grammy Nominations; Whitney and Lauryn Hill Also up for Awards." *Jet* (January 24, 2000) 97, 7.

Discography

Dixie Hummingbirds. *Best of the Dixie Hummingbirds.* MCA SP 22043.

_____. *Dixie Hummingbirds—In Good Faith.* A.I.R. 10184.

_____. *Dixie Hummingbirds—Live.* Mobile Fidelity 771.

Filmography

We Love You Like a Rock. Video-to–16mm, 77 minutes. Directed by Horace Clarence Boyer. City Lore/Film Arts Foundation presentation of a Searchlight Films production, 1994.

SONIA DOMSCH

Bibliography

"A Link with Lace." *Salina (Kans.) Journal* (June 24, 1984): 31.

"A Link with Lace." *Old Lacers Inc., Bulletin* (May/June 1985) 5, 5: 86–87.

"Domsch Teaches Folk Art." *Citizen Patriot (Jackson, Mich.)* (June 13, 1985).

Hooker, Lisa. "Demonstrators Show How They Do What They Do." *Salina (Kans.) Journal* (June 7, 1984).

"Lace Lady One of 19 Masters." *Citizen Patriot (Jackson, Mich.)* (September 13, 1984).

LYMAN ENLOE

Discography

Enloe, Lyman. *Fiddle Tunes I Recall.* County 762.

_____. *Strings Today.* Cavern Custom Recordings V42419.

Enloe, Lyman, and the Bluegrass Association. *One Tin Soldier.* Cavern Custom Recordings 4122.

EPSTEIN BROTHERS

Bibliography

Biro, Illona. "Ashkenazi Is Jazzy." *Maclean's* (September 1, 1997) 110, 35: 79.

Discography

Epstein Brothers. *Judaic International: Over 200 Years of Music Collectively.* Epstein Brothers Vols. III and IV.

Filmography

A Tickle in the Heart. Videotape, black and white. Directed by Stefan Schwietert. New York: Kino Video, 1996.

NORA EZELL

Bibliography

Cotter, Holland. "Quilts That Cover a Span of Cultural History, Not Just Beds." *New York Times* (August 16, 1996) 145: C32.

"For Art's Sake." *The Nation* (February 6, 1995) 260, 5: 151.

Freeman, Ronald L. *Communion of the Spirits: African American Quilters, Preservers, and Their Stories.* Nashville: Rutledge Hill Press, 1996.

ALBERT FAHLBUSCH

Discography

Fahlbusch, Albert, et al. *Dutch Hop Polka Music and Old German Songs, Vols. 1–5.* Fahlbusch Cassettes.

FAIRFIELD FOUR

Bibliography

DiMartino, Dave. "Swamp Thing." *Rolling Stone* (June 26, 1997) 763: 23.

Frase-Blunt, Martha. "Gospel Stars' Second Coming." *Modern Maturity* (April/May 1993), 36, 2: 24.

Gospel Arts Day, Nashville. Program. Nashville: Nashville Gospel Ministries, June 19, 1988.

"The Grammys Turn 40 with Black Winners and Surprises." *Jet* (March 16, 1998) 93, 16: 60.

Pareles, Jon. "James Hill, the Baritone in a Venerable Gospel Group." *New York Times* (July 14, 2000): B10.

Santoro, G. "Gospel Music." *The Nation* (July 8, 1991) 253, 12: 66.

Seroff, Doug. *Gospel Arts Day in Nashville. A Special Commemoration Program Book.* Nashville: Fisk University, June 19, 1988.

Discography

Fairfield Four et al. *Voices of the Americas Series: Gospel.* World Music Institute WM 1002.

Michael Flatley

Bibliography

Aloff, Mindy. "Hot Eire." *New Republic* (June 16, 1997) 216, 24,: 29.

Barnes, Clive. "Did Your Mother Come from Ireland?" *Dance Magazine* (June 2000) 74, 6: 98.

Bellafante, Ginia, and Julie K. L. Dam. "Mr. Big of the New Jig." *Time* (March 31, 1997) 149, 13: 76.

Duffy, Martha. "Not Your Father's Jig." *Time* (March 18, 1996) 147, 12: 88.

Fanger, Iris. "Lord of Irish Dance, Michael Flatley." *Christian Science Monitor* (March 26, 1997) 89, 183: 13.

Gladstone, Valerie. "The Man Behind the Duel Between Irish Blockbusters." *New York Times* (March 2, 1997): H8.

Hitchner, Earle. "Michael Flatley. Lord of Irish Stepdancing." *Wall Street Journal* (March 13, 1997) 229, 50: A12, eastern edition.

Lampert-Greaux, Ellen. "Celtic Pride." *TCI: Theatre Crafts International* (March 1997) 31, 3: 6.

McCourt, Frank. "Gotta Dance." *The New Yorker* (March 10, 1997): 37.

McNamara, Devon. "Riverdance Shifts Irish Dancing into High Gear." *Christian Science Monitor* (December 9, 1996): 13.

Parry, Jann. "Celtic Crossover." *Dance Magazine* (October 1997) 71, 10: 70.

Tresniowski, Alex, and Vicki Sheff-Cahan. "Gael Force." *People* (April 14, 1997): 135.

CANRAY FONTENOT

Bibliography

Ancelet, Barry Jean, and Elemore Morgan, Jr. *The Makers of Cajun Music: Musiciens Cadiens et Créoles.* Austin: University of Texas Press, 1984.

Sandmel, Ben, and Anita Leclerc. "Ragin' with the Cajuns." *Esquire* (April 1994) 121, 4: 40.

Santoro, Gene. "Listening in the Streets." *The Nation* (July 8, 1996) 263, 2: 32.

Savoy, Ann Allen. *Cajun Music: A Reflection of a People, Vol. 1.* Eunice, Louisiana: Bluebird Press, 1985.

Waltrous, Peter. "Canray Fontenot, 72, a Singer and Violinist in Creole Style." *New York Times* (August 2, 1995): D20.

Discography

Fontenot, Canray, and Alphonse Ardoin. *Les Blues du Bayou.* Melodeon 7330.

Fontenot, Canray, Alphonse Ardoin, et al. *"Boisec" Ardoin: La Musique Créole.* Arhoolie 445.

Fontenot, Canray, et al. *Voices of the Americas Series: Cajun and Creole Music.* World Music Institute T110.

Filmography

Dry Wood. 16mm, videotape, color, 37 minutes. Directed by Les Blank, with Maureen Gosling. El Cerrito, California: Flower Films, 1975.

Hot Pepper. 16mm, videotape, color, 54 minutes. Directed by Les Blank, with Maureen Gosling. El Cerrito, California: Flower Films, 1973.

J'ai Eté au Bal. 16mm, videotape, color, 84 minutes. Directed by Les Blank, with Chris Strachwitz and Maureen Gosling. El Cerrito, California: Flower Films, 1989.

THOMAS EDISON "BROWNIE" FORD

Bibliography

Berger, A., and J. Cruz. "For the Moment Your Girl." *Rolling Stone* (June 27, 1991), 607: 67.

Deriso, Nicholas R. "Rodeo Star Reaches Last Round-Up." *News-Star (Monroe, La.)* (August 29, 1996): 11A–12A.

Hiltbrand, D. "Picks & Pans: Song." *People* (May 20, 1991) 35, 19: 22.

Sandmel, Ben, and Anita Leclerc. "Ragin' with the Cajuns." *Esquire* (April 1994) 121, 4: 40.

Discography

Ford, Thomas Edison "Brownie," et al. *The Cowboy Tour.* Rounder 82161–0473–2.

CLARENCE FOUNTAIN AND THE BLIND BOYS

Bibliography

Brustein, R. "The Use and Abuse of Multiculturalism." *New Republic* (September 16–23, 1991) 205, 12/13: 31.

Santoro, G. "Music." *The Nation* (July 8, 1991) 253, 2: 66.

Whiteis, David. "Exhumation & Expoopidence." *Down Beat* (March 1993) 60, 3: 40.

Discography

Fountain, Clarence, and the Blind Boys of Alabama. *Golden Moments in Gospel.* Jewel 0143.

_____. *Oh Lord—Stand by Me Marching.* Specialty 7203.

_____. *Sermon.* Specialty 7041.

ROSE FRANK

Bibliography

Gogol, J. M. "Rose Frank Shows How to Make a Nez Perce Cornhusk Bag." *American Indian Basketry* (1979) 1, 2: 22–31.

Haberman, Michael. "Corn Husk Weaver." *Lewiston (Idaho) Tribune* (August 17, 1986).

"Has Their Craft Been Lost?" *Lewiston (Idaho) Tribune* (January 17, 1988).

Loeffelbein, Bob. "Sapatqíayn: Art of the Nez Perce Nation." *World & I* (August 1999) 14, 8: 128.

KANSUMA FUJIMA

Bibliography

"Fujima Kansuma in Urashima." Program notes. Los Angeles City College, July 21–22, 1955.

Gibson, Gwen. "Folk Artists Are Honored with Fellowships." *Tampa Tribune* (October 13, 1987).

"Japanese Troupe Will Bring Imperial Court and Folk Traditions to Torrance." *Los Angeles Times* (January 10, 1992).

MARY MITCHELL GABRIEL

Bibliography

Graettinger, Diana. "Passamaquoddy Women's Baskets Foster Artistic Tradition." *Bangor (Maine) Daily News* (July 23, 1990): 7.

SOPHIA GEORGE

Bibliography

Meyers, Michelle. "Indian Artists' Work on Display." *Gresham (Ore.) Outlook* (March 8, 1997).

"Portland Collects." *Sunday Oregonian* (March 14, 1993).

JOHNNY GIMBLE

Bibliography

Friedman, Kinky. "My Willie." *Texas Monthly* (September 1997) 25, 9: 56.

Discography

Gimble, Johnny. *Johnny Gimble's Texas Dance Party.* Columbia KC 34284.

_____. *Under the "X" in Texas.* Tejas Records 002.

Filmography

Appearances in *Nashville, Honeysuckle Rose,* and *Honky Tonk Man.*

JAMES "JIMMY SLYDE" GODBOLT

Bibliography

Kaufman, Sarah. "Savion Glover: Rhythm of the Feet." *Washington Post* (March 28, 2000).

Sawyer, Nora. "Tiptop Tap Room." *New York Daily News* (March 3, 1993).

Filmography

About Tap. Videotape, 28 minutes. Narrated by Gregory Hines and directed by George T. Nierenberg. Los Angeles: Direct Cinema, Ltd., 1984.

DONNY GOLDEN

Bibliography

Aloff, Mindy. "Hot Eire." *New Republic* (June 16, 1997) 216, 24: 29.

Carr, Darrah. "Irish Dance Picks Up the Pace." *Dance Magazine* (April 2001) 75, 4: 58.

Hitchner, Earle. "When His Irish Feet Are Dancing, NEA Pays the Tune." *Wall Street Journal* (July 20, 1995) 226, 13: A10, eastern edition.

Sommer, Sally. "An American Approach to the Steps of Old Ireland." *New York Times* (April 14, 1996) 145: 28.

Discography

Golden, Donny, with The Green Fields of America. *The Green Fields of America: Live in Concert.* Green Linnet 1096.

JOSÉ GONZÁLEZ

Bibliography

"Doctor José González." *El Progreso* (August 9, 1996).

Torres, Maria. "How to Weave a Hammock." Program book of the 17th Hammock Festival.

Filmography

Featured in *Desde Mi Pueblo (From My Town)*, a TV series broadcast by Channel 6, Puerto Rico's cultural channel, 1997.

ULYSSES "ULY" GOODE

Bibliography

Bibbey, Brian, ed. *The Fine Art of California Indian Basketry.* Exhibition catalogue. Sacramento: Crocker Art Museum/Heyday Books, 1996.

FRANCES VAROS GRAVES

Bibliography

Macaulay, Susan P. *Stitching Rites.* Tempe: Arizona State University Press, 2000.

Romancito, Rick. "Frances Graves Honored for Helping Keep *Colchas* Alive." *Taos (N. Mex.) News* (December 10, 1992): C6.

EDUARDO "LALO" GUERRERO

Bibliography

Paredes, Americo. *A Texas–Mexican Cancionero.* Urbana: University of Illinois Press, 1976.

Reyes, David, and Tom Waldman. *Land of a Thousand Dances: Chicano Rock 'n' Roll from Southern California.* Albuquerque: University of New Mexico Press, 1998.

Discography

Guerrero, Eduardo "Lalo," with Los Lobos. *Papa's Dream.* Music for Little People, 558CD.

JOSÉ GUTIÉRREZ

Discography

Gutiérrez, José. *Music of Veracruz: The Sones Jarochos of Los Pregoneros del Puerto.* Rounder 5048.

JUAN GUTIÉRREZ

Discography

Gutiérrez, Juan, Los Pleneros de la 21, et al. *Melodia Tropical: Mi Tierra.* Matal Shanachie 65001.

_____. *Puerto Rico Tropical.* World Music Institute Latitudes LAT 50608.

SISTER ROSALIA HABERL

Bibliography

Lind, Bob. "Bobbins Jump, Fingers Fly, as Lace Forms." *Fargo (N. Dak.) Forum* (March 1, 1987): B3.

Martin, Christopher. *Sister Rosalia's Lace.* Exhibition catalogue. Fargo: North Dakota Council on the Arts, 1988.

Voskuil, Vicki. "Upholding the Tradition: Folk Arts Program Helps Keeps the Old Skills Alive." *Bismarck (N. Dak.) Tribune* (February 15, 1987).

RICHARD HAGOPIAN

Discography

Hagopian, Richard. *Armenian Music Through the Ages.* Smithsonian Folkways 40414.

Hagopian, Richard, and ensemble. *Kef Time Detroit.* SaHa Recording SH1004.

_____. *Kef Time Fresno.* SaHa Recording SH1002.

_____. *Kef Time Hartford.* SaHa Recording SH10054.

_____. *Kef Time Las Vegas.* SaHa Recording SH100.

PERIKLIS HALKIAS

Bibliography

"Dancing to the Ethnic Beat." *New York Times* (June 9, 1978).

Discography

Halkias, Periklis. *Epirotika with Periklis Halkias: Greek Folk Music and Dance from Northern Epirus, Vol. 1.* Smithsonian Folkways 34024.

_____. *Epirotika with Periklis Halkias: Greek Folk Music and Dance, Vol. 2.* Smithsonian Folkways 34025.

CHARLES E. HANKINS

Bibliography

Clark, Wendy Mitman. "Folk Art Quality of His Skiffs Wins Builder an NEA Award." *Soundings* (December 1993), mid-Atlantic edition.

Deitch, Joseph. "Old Hand at an Older Craft." *New York Times* (September 1, 1974).

GEORGIA HARRIS

Bibliography

Blumer, Thomas J. "Catawba Influences on the Modern Cherokee Pottery Tradition." *Appalachian Journal: A Regional Studies Review* (winter 1987) 14, 2: 153–173.

Harrington, M. R. "Catawba Potters and Their Work." *American Anthropologist* (1980), 10: 399–407.

GERALD R. HAWPETOSS

Bibliography

Teske, Robert T., James P. Leary, and Janet C. Gilmore, eds. *From Hardanger to Harleys: A Survey of Wisconsin Folk Art,* p. 95. Sheboygan, Wisconsin: John Michael Kohler Arts Center, 1987.

JOE HEANEY

Bibliography

Moloney, Michael. "Joe Heaney: Cultural Ambassador." *New York Folklore Newsletter* (July 1984) 5: 2.

Discography

Heaney, Joe. *Come All Ye Gallant Irishmen.* Philo PH–2004.

_____. *Irish Traditional Songs in Gaelic and English.* Topic 12T 91.

_____. *O Mo Dhuchas*. Gael-linn CEF 051. In Gaelic.

_____. *Seosamh OhEanai*. Gael-linn CEF 028. In Gaelic.

Heaney, Joe, and Gabe O'Sullivan. *Joe and Gabe*. Green Linnet 1018. Mostly in English, some Gaelic.

WAYNE HENDERSON

Bibliography

Cheakalos, Christina, and Macon Morehouse. "Strum Major." *People* (April 23, 2001), 55, 16: 83.

Hauslohner, Amy Worthington. "Henderson Hand-Crafted Guitars: Putting Rugby on the Map." *Bluegrass Unlimited* (June 1989).

Smith, Roff. "New River's Deep Soul." *National Geographic* (June 1999) 195, 6: 120.

Discography

Henderson, Wayne. *Rugby Guitar*. Flying Fish Records FLY 542.

CHRISTY HENGEL

Bibliography

Hunt, Marjorie, and Boris Weintraub. "Masters of Traditional Arts." *National Geographic* (January 1991) 179, 1.

Discography

Hengel, Christy. *Six Fat Dutchmen*. Reissue of 1951–1952 recordings. Hengel cassette.

EVALENA HENRY

Bibliography

Lindford, Laurence D. *A Measure of Excellence*. Gallup, New Mexico: Inter-Tribal Indian Ceremonial Association, 1991.

BEA ELLIS HENSLEY

Bibliography

"Eight Get Folk Heritage Awards." *Herald-Sun (Durham, N.C.)*: E7.

Moose, Debbie. "Bea Hensley and Son Mike Hensley Win First Prize in Wrought Iron at State Fair." *Tri-County News (Spruce Pine, Newland and Burnsville, N.C.)* (November 7, 1963).

Stinson, Craig. "'Anvil Chorus': The Aesthetics of a North Carolina Blacksmith." *Southern Folklore* (1994) 51, 2: 167–179.

RAY HICKS

Bibliography

DeParle, Jason. "Mountain Voice Shares Ageless, Magic Tales." *New York Times* (June 22, 1992): A1.

Horn, M. "Have We Got a Great Tale for You." *U.S. News & World Report* (November 2, 1987): 65.

Isbell, Robert. *Ray Hicks, Master Storyteller of the Blue Ridge*. Chapel Hill: University of North Carolina Press, 2001.

Jacobson, Mark, and Anita Leclerc. "Fun, Fun, Fun, Despair, Despair, Despair." *Esquire* (November 1993) 120, 5: 37.

Kinkead, Gwen. "An Overgrown Jock." *The New Yorker* (July 18, 1988): 33.

Lowe, Judy. "Captivating Crowds with a Rollicking Tall Tale." *Christian Science Monitor* (October 14, 1997) 89, 223: 12.

Peters, John. "Starred Reviews: Books for Youth." *Booklist* (November 15, 2000) 97, 6: 638.

Renner, Craig J. "America's Jack." *World & I* (September 1998) 13, 9: 224.

Watson, Bruce, and Tom Raymond. "The Storyteller Is the Soybean . . . The Audience Is the Sun." *Smithsonian* (March 1997) 27, 12: 60.

Wolmuth, Roger. "Weaving a Spell." *People* (November 17, 1997) 48, 20: 206.

Discography

Hicks, Ray. *Jack Alive*. June Appal Recordings JA0052.

Filmography

Fixin' to Tell About Jack. 16mm, videotape, color, 25 minutes. Directed by Elizabeth Barret. Whitesboro, Kentucky: Appalshop, 1974.

STANLEY HICKS

Bibliography

McGowan, Thomas. "Stanley Hicks: Jack of Many Folk Arts." *The Arts Journal* (May 1985): 46–47.

Wiggington, Eliot, ed. *Foxfire 3*. Garden City, New York: Doubleday Anchor Press, 1975.

_____. *Foxfire 4*. Garden City, New York.: Doubleday Anchor Press, 1977.

_____. *Foxfire 6*. Garden City, New York: Doubleday Anchor Press, 1980.

_____. *Foxfire 8*. Garden City, New York: Doubleday Anchor Press, 1984.

Discography

Hicks, Stanley. *It Still Lives*. Foxfire Records.

VIOLET HILBERT

Bibliography

Auerbach, Susan. "Skagit Elder Brings Stories Back to Her People." *Northwest Ethnic News* (May 1985) 2, 4.

Godden, Jean. " 'Seattle' Is Like Wind in the Trees." *Seattle Post Intelligencer* (September 5, 1984).

Herman, Rick. "Writing an Unwritten Language." *North West Book Arts* (June/July 1981) 1, 6.

Hess, Thom, and Vi Hilbert. *Lushootseed: The Language of the Skagit, Nisqually, and Other Tribes of Puget Sound.* Seattle: Daybreak Star Press, 1980.

Hilbert, Vi. *Haboo: Native American Stories from Puget Sound.* Seattle: University of Washington Press, 1985.

Hilbert, Vi, and Crisca Bierwelt. *Ways of the Lushootseed People: Ceremonies and Traditions of Northern Puget Sound Indians.* Seattle: Daybreak Star Press, 1980.

Hilbert, Violet, and Thomas M. Hess. "Recording in the Native Language." *Sound Heritage* (1975) 4:, 3 and 4.

_____. "The Lushootseed Language Project." In *Language Renewal Among American Indian Tribes*, Robert St. Clair and William Leap, eds. Washington, D.C.: National Clearinghouse for Bilingual Education, 1982.

Discography

Hilbert, Vi. *Coyote and Rock.* HarperCollins cassette CPN 1895.

Filmography

Sharing Legends at Upper Skagit. Videotape, color, 28 minutes. Produced by Crisca Bierwelt. Seattle: Lushootseed Research, 1985.

JOHN DEE HOLEMAN

Bibliography

Belans, Linda. "Stepping Out All Over." *News and Observer (Raleigh)* (November 25, 1990): H1.

Cornatzer, Mary. "Piedmont Blues from North Carolina's Heart." *News and Observer (Raleigh)* (January 9, 1987).

Pearson, Barry Lee. "John Dee Holeman: Bull City Blues." *Living Blues* (January/February 1993): 31–32.

Saturday Night and Sunday Morning. Program notes for a National Black Heritage Tour of Blues, Gospel, Buckdancing and Storytelling. Silver Spring, Maryland: National Council for the Traditional Arts, 1986.

Seeger, Mike. *Talking Feet: Buck, Flatfoot and Tap,* pp. 53–54. Berkeley, California: North Atlantic Books, 1992.

Discography

Holeman, John Dee. *Bull City After Dark.* Silver Spring, Maryland: National Council for the Traditional Arts, SS211.

_____. *Piedmont Blues de Caroline du Nord.* Paris: Maison des Cultures du Monde. Auvidis W260043.

Holeman, John, et al. *Voices of the Americas Series: The Blues.* World Music Institute WM1001.

Filmography

Masters of Traditional Music. Videotape, color, 58 minutes. Directed by Alan Govenar and Robert Tullier. Dallas: Documentary Arts, 1991.

BOB HOLT

Bibliography

Hubbell, Sue. "Farewell 'Do-si-do,' Hello 'Scoot and Counter . . . Percolate!'" *Smithsonian* (February 1996) 26, 11: 92.

Discography

Holt, Bob. *Got a Little Home To Go To.* Rounder 0432.

JOHN LEE HOOKER

Bibliography

DeVinck, Richard, ed. *Vital Blues Guitar.* Ventura, California: Creative Concepts Publishing Corporation, 1995.

John Lee Hooker—A Blues Legend, with Notes & Tablature. Milwaukee: Hal Leonard Corporation, 1991.

Murray, Charles. *The Healer's Song, the Authorized Biography of John Lee Hooker.* New York: Hyperion, 1999.

Murray, Charles Shaar. *Boogie Man, Adventures of John Lee Hooker in the American Twentieth Century.* New York: Saint Martin's Press, 2000.

Pareles, Jon. "Blues Guitarist John Lee Hooker Dies at 83." *New York Times* (June 22, 2001) 150, 51792: B7.

Discography

Hooker, John Lee. *Alone.* Specialty 14027.

_____. *The Cream.* Tomato 269609–2.

_____. *Detroit.* United Artists UAS–127. Three-record set.

_____. *House of the Blues.* Chess CHD9258.

_____. *John Lee Hooker & Friends 1984–1992.* Vestapol VEST 13054.

_____. *Rare Performances 1960–1984.* Vestapol VEST 13035.

_____. *16 Selections Every One a Pearl.* King 727.

Filmography

Mark Natalfin's Blue Monday Party: John Lee Hooker and Charlie Musselwhite. Videotape. Produced by Michael

Prussian and Starr Sutherland. New York: Rhapsody Films, 1990.

Solomon and Richard Ho'opi'i

Bibliography
Corliss, Richard. "Hawaii's Man of Steel." *Time* (July 31, 2000) 156, 5: 61.
Laidlaw, Bob. "10 Lulu Hawaiian CDs (and No Don Ho, Brah!)." *Forbes* (September 18, 2000) 166, 8: 165.

Discography
Ho'omau—To Perpetuate. Mountain Apple Company MA 2037.

Wenyi Hua

Bibliography
Fei, Faye Chungfang. *Chinese Theories of Theater & Performance from Confucius to the Present*. Ann Arbor: University of Michigan Press, 1999.
Mercado, Mario R., and Robert Hilferty. "In Review: From Around the World." *Opera News* (November 1999) 64, 5: 74.
Mitchell, Emily. "Made in America." *Time South Pacific* (August 17, 1998) 33: 60.
Murphy, Ann. "Cunningham and Morris World Premieres in Berkeley." *Dance Magazine* (March 1999) 73, 3: 39.
"Opera Everywhere." *American Record Guide* (May/June 1999) 2, 3: 40.
Riding, Alan. "A 'Peony' Thrives in Hybrid Form Near Paris." *New York Times* (December 16, 1998) 148: E1.

Janie Hunter

Discography
Hunter, Janie, the Moving Star Hall Singers, and Alan Lomax. *Been in the Storm So Long*. Smithsonian Folkways SF 40031.

Zakir Hussain

Bibliography
Ouellette, Dan. "Percussion Maestros of North & South India & Pharoah Sanders." *Down Beat* (August 1996) 63, 8: 69.
"Out of the Tradition." *Down Beat* (January 1993) 60, 1: 43.

Discography
Hussain, Zakir, and Ustad Alla. *Tabla Duet*. Moment Records MR 1001.

Hussain, Zakir, and the Rhythm Experience. Moment Records MR 1007.
Hussain, Zakir, John McLaughlin, Jan Garbarek, and Hariprasad Chauraisa. *Making Music*. ECM 1349.

Filmography
Contributions to sound tracks of *Apocalypse Now* and *Vietnam: A Television History*.

Khamvong Insixiengmai

Discography
Insixiengmai, Khamvong. *Bamboo Voices: Folk Music from Laos*. World Music Institute Latitudes LT 50601.

John Jackson

Bibliography
Carlson, Lenny. *John Jackson—Don't Let Your Deal Go Down*. Pacific, Missouri: Mel. Bay Productions, 1998.
Sonnier, Austin, Jr. *A Guide to the Blues*. Westport, Connecticut: Greenwood, 1994.

Discography
Jackson, John. *Country Blues & Ditties*. Arhoolie 471.
_____. *Deep in the Bottom*. Rounder 203.
_____. *Don't Let Your Deal Go Down*. Arhoolie 378.
_____. *Step It Up and Go*. Rounder 2019.
Jackson, John, et al. *Country Blues Live*. Document DLP525.
_____. *The Harry Smith Connection, a Live Tribute to the Anthology of American Folk Music*. Smithsonian Folkways 40085.
_____. *National Down Home Blues Festival, Vol. 2*. Southland Records SLP–23.
_____. *Voices of the Americas Series: The Blues*. World Music Institute WM1001.

Nathan Jackson

Bibliography
Dunham, Mike. "Jackson Hacks on a 30-Footer." *Anchorage Daily News* (June 7, 1998): E8.
_____. "New Pole in Ketchikan." *Anchorage Daily News* (August 29, 1999): H9.
_____. "Silent Tutors: Museum Quality Art at Tyson Elementary Motivates Students." *Anchorage Daily News* (October 6, 2000): D1, 4.
Jackson, Nathan. "Carving Traditions." *Alaska Geographic* (1995) 23, 2: 81–83.
Lester, Patrick. *Biographical Dictionary of Native American Painters*. Tulsa, Oklahoma: Sir Publications, 1995.
Saari, Matias. "Tlingits Build History That Floats: South-

east Carvers Turn Cedar Log into Traditional Canoe."
Anchorage Daily News (May 18, 1996): D3.
"Wisdom Keepers." *Anchorage Daily News* (May 7, 2001).

NETTIE JACKSON

Bibliography
Jackson, Nettie, with Elsie Thomas and Marie Stockish. *The Heritage of Klickitat Basketry: A History and Art Preserved.* Portland: Oregon Historical Society Press, 1982, 1988.

Filmography
. . . *And Woman Wove It in a Basket.* 16mm, color, 70 minutes. Directed by Bushra Azzouz, Marlene Farnum, and Nettie Jackson Kuneki. New York: Women Make Movies, 1989.

TOMMY JARRELL

Bibliography
Neff, Bettye. "Documentary, Special Day Salute the Master of Old-Time Music." *Mount Airy (N.C.) News* (November 6, 1984): A7.
"Tommy Jarrell, Old-Time Fiddler, Dies at Age 83." *News and Observer (Raleigh)* (January 29, 1985): C3.
Wheeler, Charles. "Old-Time Music's Disciples Come Home." *Winston-Salem (N.C.) Journal* (April 14, 1980): A1.
Rich, Alan. "Pickin' on Tommy's Porch." *Newsweek* (September 17, 1984).

Discography
Jarrell, Tommy. *Back Home in the Blue Ridge.* County 713.
_____. *Come and Go with Me.* County 748.
_____. *Down at the Cider Mill.* County 723.
_____. *Pickin' on Tommy's Porch.* County 778.
_____. *Rainbow Sign.* County 791.
_____. *Stay All Night.* County 741.
Jarrell, Tommy, Frank Bode, et al. *Frank Bode: Been Riding with Old Mosby.* Smithsonian Folkways FTS 31109.

Filmography
Homemade American Music. 16mm, videotape, 42 minutes or 30 minutes. Directed by Yasha Aginsky. Mendocino, California: Lawren Productions, 1980.
My Old Fiddle: A Visit with Tommy Jarrell in the Blue Ridge. Videotape. Directed by Les Blank. El Cerrito, California: Flower Films, 1994.

Sprout Wings and Fly. 16mm, videotape, color, 30 minutes. Directed by Les Blank, with Cece Conway and Alice Gerrard. El Cerrito, California: Flower Films, 1983.
Tommy Jarrell. Videotape, black and white, 32 minutes. Directed by Margaret McClellan. Johnson City, Tennessee: Southern Appalachian Video Ethnography Series.

JIMMY JAUSORO

Bibliography
"Idaho Basque Wins National Heritage Award." *Idaho Arts Journal* (winter 1985).

SANTIAGO JIMENEZ, JR.

Bibliography
De la Torre, Chito. "Tejano's 'Main Squeeze' Turns Sixteen." *Hispanic* (May 1997) 10, 5: 12.
Morthland, John. "Walser Across Texas." *Texas Monthly* (March 1996) 24, 3: 60.
Pareles, Jon. "Tish Hinojosa and Her Texan Friends." *New York Times* (May 8, 1995) 144: C12.
Werner, Louis. "Singing the Border News." *Americas* (November/December 1994) 46, 6: 3.

Discography
Jimenez, Santiago, Jr. *El Corrido de Esequiel Hernández.* Arhoolie 9016.
_____. *El Mero, Mero de San Antonio.* Arhoolie 317.
_____. *Purely Instrumental.* Arhoolie 466.

CLAUDE JOSEPH JOHNSON

Discography
Johnson, Claude Joseph. *Babylon City Is Falling Down.* Savoy 14338 A.
_____. *Go On. There's Something Telling Me to Go On.* Savoy 14460.
_____. *Hold My Hand While I Run This Race.* Melton Records 1350.
_____. *I Heard the Voice of Jesus Say.* Savoy SL14617.
_____. *I'm Going to Wait Till My Jesus Comes.* Savoy 14531.
_____. *You Can't Do Wrong and Get By.* Savoy G14288.

BESSIE JONES

Bibliography
"In Retrospect: Bessie Jones." *The Black Perspective in Music* (spring 1985) 13: 1.
Jones, Bessie, and Bess Lomax Hawes. *Step It Down: Games, Plays, Songs and Stories from the Afro-American Heritage.* New York: Harper and Row, 1972.

Discography

Jones, Bessie, *Put Your Hand on Your Hip, and Let Your Backbone Slip: Songs and Games from the Georgia Sea Islands*. Rounder 11587.

_____. *So Glad I'm Here*. Rounder 2015.

_____. *Step It Down: Games for Children*. Rounder 8004.

Jones, Bessie, et al. *American Folk Songs for Children*. Atlantic SD–1350. Anthology of field recordings by Alan Lomax.

Filmography

American Folklife Company, Part I. Videotape, 30 minutes. Lincoln, Nebraska: NETCHE, 1971.

Georgia Sea Island Singers. Black and white, 12 minutes. New York: Film Images, a division of Radim Films, Inc., 1974.

Yonder Come Day. 16mm, color, 26 minutes. Washington, D.C.: Films for Anthropological Teaching, American Anthropological Association, 1976.

MEALI'I KALAMA

Bibliography

Nogelmeier, Puakea. "Hawaiian Crafts." In *Folklife Hawai'i*. Festival program. Honolulu: The State Foundation on Culture and the Arts, 1990.

Filmography

Mealii Kalama, Hawaiian Quilter. Produced by Tip Davis, 1974. Available for viewing at the Hawaii State Library Film Unit.

DANONGAN SIBAY KALANDUYAN

Bibliography

"Berkeley-Based UP Group Cops NEA Award." *Philippine News (San Francisco)* (April 25–May 1, 1990): 11.

"Kulintang: Artists for Peace Perform for RP." *Philippine News (San Francisco)* (December 2–8, 1987): 11.

"UPAA Holds Kulintang Workshop." *Philippine Bulletin* (June 1–15, 1991): 10.

Wong, Laura. "Asian Artists Get Ovation in Capital." *Asian Week* (July 15, 1988): 21.

Discography

Kalanduyan, Danongan. *Mga Kulintang Sa Mindanao at Sulu*.

_____. *Song for Manong*.

NALANI AND PUALANI KANAKA'OLE KANAHELE

Bibliography

Durbin, Paula. "No Flowers as Hula Activism Blooms." *Dance Magazine* (April 2000) 74, 4: 41.

_____. "Hula's Dance of Legislation." *Dance Magazine* (April 1998) 72, 4: 34.

RAYMOND KANE

Bibliography

Gordon, Mike. "The Guitar Man." *Honolulu Star-Bulletin* (August 17, 1987).

Discography

Kane, Raymond. *Kane Kapila, Vol. 1*. Dancing Cat Records DC–3022.

_____. *Kane Kapila, Vol. 2*. Dancing Cat Records DC–3023.

_____. *Manakulis Raymond Kane*. Tradewinds Recording TS–1130.

_____. *Master of the Slack Key Guitar*. Rounder 6020.

Kane, Raymond, et al. *Hawaiian Rainbow*. Rounder 6018.

Filmography

Hawaiian Rainbow. 16mm, videotape, color, 95 minutes. Directed by Robert Mugge. Mug-Shot Productions, 1987.

EVERETT KAPAYOU

Bibliography

Torrence, Gaylord. *Art of the Red Earth People: The Mesquauakie of Iowa*. Seattle: University of Washington Press, 1989.

GENOA KEAWE

Bibliography

Burlingame, Burl, and Robert Kamohalu Kasher. *Da Kine Sound*. Kailua, Hawaii: Press Pacifica, 1978.

Harada, Wayne. "Hitting a High Note: Hawaii's Auntie, Genoa Keawe, Celebrates 80 Years of Song." *Honolulu Advertiser* (October 29, 1998).

"Old Friends: Genoa Keawe." *MidWeek* (July 8, 1998).

Sinnex, Ceil. "Auntie Genoa Keawe Has Been Charming Hawaiian Music Lovers for Five Decades." *MidWeek* (November 27, 1991).

Discography

Keawe, Genoa. *Hana Hou!, Vol. 1*. Hula Records CD HS–586.

_____. *Maui's Sunset Music*. Hula Records CS HS–590.

Filmography

Hawaiian Rainbow. 16mm, videotape, color, 95 min-

utes. Directed by Robert Mugge. Mug-Shot Productions, 1987.

MAUDE KEGG

Bibliography

Kegg, Maude. *Portage Lake: Memories of an Ojibwe Childhood.* John D. Nichols, editor and translator. Minneapolis: University of Minnesota Press, 1993.

ILIAS KEMENTZIDES

Bibliography

Anderson, Susan Heller. "Learning Ethnic Dances at a Festival in Queens." *New York Times* (June 4, 1982).

"Epirotan and Pontian Music to be Featured at Ethnic Festival." *Hellenic Chronicle* (May 27, 1982).

Goldman, Ari. "Greek Music Beyond the Bouzouki." *New York Times* (December 3, 1982).

WILL KEYS

Bibliography

Keys, Jerry. "Will Keys Interview." *Banjo Newsletter* (November 1993).

Discography

Keys, Will, et al. *Masters of the Banjo.* Arhoolie 421.

ALI AKBAR KHAN

Bibliography

Bamberger, Bradley. "Honor for Ali Akbar Khan." *Billboard* (July 1, 1997).

Hitt, Jack. "Night of the Living Geniuses." *Esquire* (November 1995) 124, 5: 92.

Jenkins, Mark. "Ali Akbar Khan: Rajah of Ragas; Master Teaches Music of India in Northern California." *San Francisco Examiner* (June 13, 1997).

Maitra, R. "Song of India." *UNESCO Courier* (May 1991) 44, 3: 35.

McLellan, Joseph. "Raga Riches from India's Ali Akbar Khan." *Washington Post* (August 18, 1997).

Ratliff, Ben. "Father Leads Son Through Indian Complexities." *New York Times* (August 15, 2000) 149, 51481: E5.

Sengupta, Somini. "Beatings and Worry in a Life of Music." *New York Times* (December 24, 1997) 147: E12.

Discography

Khan, Ali Akbar. *Ali Akbar Khan—Traditional Music of India.* Prestige PRCD 24157–2.

_____. *Garden of Dreams.* Triloka 7199–2.

_____. *Into the Mystic.* Triloka 7213–2.

_____. *Legacy: 16th–18th Century Music from India.* Alam Madina Music Productions/Triloka 7216–2.

_____. *Passing on the Tradition.* Alam Madina Music Productions 9608.

PEOU KHATNA

Filmography

Dance of Tears: The Dance Lives. The Story of the Khmer Classic Dance Troupe. 16mm, videotape, color. Produced by Richard S. Kennedy. Silver Spring, Maryland: National Council for the Traditional Arts, 1982.

DON KING

Bibliography

Evans, Timothy. *King of the Western Saddle: The Sheridan Saddle & the Art of Don King.* Jackson: University Press of Mississippi, 1998.

Gorzalka, Ann. *The Saddlemakers of Sheridan County, Wyoming.* 1984.

RILEY "B.B." KING

Bibliography

Beatty, Mary Lou. "B.B. King Drops In." *Humanities* (May/June 1999) 20, 3: 2.

"The Bluesman." *Vanity Fair* (November 2000) 485: 306.

DeCurtis, Anthony. "B.B. King." *Rolling Stone* (September 14, 2000) 849: 60.

Frank, Jeffrey A. "B.B. King's Blues Realm: The Veteran Finds a New Audience." *Washington Post* (February 23, 1989).

Keil, Charles. *Urban Blues.* Chicago: University of Chicago Press, 1968.

Kostelanetz, Andre. *The B.B. King Companion.* New York: Music Sales Corporation, 1997.

Discography

King, B.B. *The Best of B.B. King.* Ace CHD 198, 199.

_____. *Live at the Regal.* MCA 27006.

_____. *One Nighter Blues.* Ace CHD 201.

_____. *The Rarest King.* Blues Boy 301.

King, B.B., and Eric Clapton. *Riding with the King.* Reprise 9–47612–2.

Filmography

Saturday Night, Sunday Morning. Videotape. Produced and directed by Louis Guida. San Francisco: California Newsreel, 1993.

FATIMA KUINOVA

Bibliography

Pareles, Jon. "Shashmaqam: The Music of a Crossroads of Cultures." *New York Times* (January 1, 1988).

ETHEL KVALHEIM

Bibliography

Martin, Philip. *Rosemaling in the Upper Midwest*. Mount Horeb: Wisconsin Folk Museum, 1989.

Riley, Jocelyn. *Ethel Kvalheim, Rosemaler: A Resource Guide*. Madison, Wisconsin: Her Own Words, 1995.

Teske, Robert T., James P. Leary, and Janet C. Gilmore, eds. *From Hardanger to Harleys: A Survey of Wisconsin Folk Art*. Sheboygan, Wisconsin: John Michael Kohler Arts Center, 1987.

PETER KYVELOS

Bibliography

Alarik, Scott. "Their Mission: To Keep Folk Crafts Alive." *Boston Globe* (May 28, 2000).

Montgomery, M. R. "A Journey Through the World of Greek Music." *Boston Globe* (April 3, 1998).

LILY MAY LEDFORD

Bibliography

Wolfe, Charles K. *Kentucky Country: Folk and Country Music of Kentucky*. Lexington: University Press of Kentucky, 1982.

Discography

Ledford, Lily May. *Banjo Pickin' Girl*. Greenhays Records GR0712.

_____. *Gems: Lily May Ledford*. June Appal Recordings JA0078.

Ledford, Lily May, and the Coon Creek Girls. *Coon Creek Girls: Early Radio Favorites*. CS–142.

Filmography

Homemade American Music. 16mm, videotape, 42 minutes or 30 minutes. Directed by Yasha Aginsky. Mendocino, California: Lawren Productions, 1980.

Lily May Ledford. Videotape, color, 29 minutes. Directed by Anne Johnson. Whitesburg, Kentucky: Appalshop Films, 1988.

ESTHER LITTLEFIELD

Bibliography

"Nationally Known Treasure Esther Littlefield Passes On." *Anchorage Daily News* (June 29, 1997).

KEVIN LOCKE

Bibliography

Erbacher, Kathy. "Indian Art in Boulder: Annual Festival Provides Outlet for Self-Expression and Economic Survival." *Denver Magazine* (June 1986).

Havnen-Finley, Jan. *The Hoop of Peace*. Happy Camp, California: Naturegraph Publishers, 1994.

Lifson, Amy. "Around the Nation." *Humanities* (March/April 1998) 19, 2: 33.

"Love One Another—Soar Free!" *Christian Science Monitor* (August 18, 1999) 91, 184: 19.

Filmography

Masters of Traditional Music. Videotape, color, 58 minutes. Directed by Alan Govenar and Robert Tullier. Dallas: Documentary Arts, 1991.

ROBERT JR. LOCKWOOD

Bibliography

Cummerow, William. "Living Blues Interview: Robert Jr. Lockwood." *Living Blues* (August 1974).

Drexler, Michael. "Robert Johnson Tribute Full of Devilish Fun." *Down Beat* (January 1999) 66, 1: 20.

Hadley, Frank-John. "Four Wise Men." *Down Beat* (February 2001) 68, 2: 40.

Oliver, Paul. *Conversation with the Blues*. New York: Horizon Press, 1965.

"Robert Jr. Lockwood: Unlocking Some Secrets." *Living Blues* (March/April 1990).

Discography

Lockwood, Robert Jr., et al. *Blues Routes: Heroes and Tricksters: Blues and Jazz Work Songs and Street Music*. Smithsonian Folkways 40118.

_____. *Folk Masters: Great Performances Recorded Live at the Barns of Wolf Trap*. Smithsonian Folkways 40047.

_____. *The Mississippi: River of Song: A Musical Journey Down the Mississippi*. Smithsonian Folkways 40086.

_____. *What's the Score*. Lockwood Records (Cleveland).

Filmography

Hellhounds on My Trail. Videotape, color, 95 minutes. Directed by Robert Mugge. Mug-Shot Productions, 1999.

VALERIO LONGORIA

Bibliography

Cicchetti, Stephen J. "Stand Up and Play It Right." *San Antonio Monthly* (September 1984).

De la Torre, Chito. "Tejano's 'Main Squeeze' Turns Sixteen." *Hispanic* (May 1997) 10, 15: 12.

Morthland, John. "Unsung." *Texas Monthly* (October 2000) 28, 10: 112.

Peña, Manuel. *The Texas–Mexican Conjunto: History of a Working Class Music.* Austin: University of Texas Press, 1985.

Ratliff, Ben. "Valerio Longoria, 75, Conjunto Musician." *New York Times* (December 19, 2000): A32.

Reyna, José R. "Tejano Music as an Expression of Cultural Nationalism." *Tonantzin* (May 1989) 6: 2.

Salas, Lesley, and Melanie Cole. "Conjunto Connections." *Hispanic* (July 1995) 8, 5: 9.

Walljasper, J. "Music." *Utne Reader* (November/December 1990) 42: 136.

Discography

Longoria, Valerio. *Caballo Viejo.* Arhoolie 336.

_____. *Texas Conjunto Pioneer.* Arhoolie 358.

Longoria, Valerio, et al. *San Antonio's Conjuntos in the 1950s.* Arhoolie 376.

Filmography

Masters of Traditional Music. Videotape, color, 58 minutes. Directed by Alan Govenar and Robert Tullier. Dallas: Documentary Arts, 1991.

GEORGE LOPEZ

Bibliography

Briggs, Charles L. "The Role of *Mexicano* Artists and the Anglo Elite in the Emergence of a Contemporary Folk Art Form." In *Folk Art and Art Worlds*, John Michael Vlach and Simon Bronner, eds., pp. 195–224. Ann Arbor: University of Michigan Research Press, 1986.

_____. *The Woodcarvers of Córdova, New Mexico.* Knoxville: University of Tennessee Press, 1980.

Glassie, Henry. *The Spirit of Folk Art: The Girard Collection at the Museum of International Folk Art.* New York: Harry N. Abrams, 1989.

ISRAEL "CACHAO" LÓPEZ

Bibliography

Burr, Ty. "A Star Is Reborn." *People* (December 4, 1995) 44, 23: 26.

Cota, J. C. "Cachao." *Down Beat* (January 1991) 58, 1: 14.

Discography

Lopez, Israel, et al. *Cuban Classics 2, Luaka Bop.* Warner Brothers.

_____. *Master Sessions, Vol. 1.* Crescent Moon/Epic Records.

RAMÓN JOSÉ LÓPEZ

Bibliography

Brown, Patricia Leigh. "A Renaissance of Hispanic Artistry." *New York Times* (July 15, 1999) 148: F1.

Conover, Kirsten A. "National Endowment for the Arts Honors American Folk Artists." *Christian Science Monitor* (June 30, 1997) 89, 150: 15.

Fleming, Jeanie Puleston. "Crafting a New Mexico Tradition." *Sunset* (November 2000) 205, 5: 52.

Harris, Patricia, and David Lyons. "Memory's Persistence." *Americas* (November/December 1993) 45, 6: 26.

ALBERT "SUNNYLAND SLIM" LUANDREW

Bibliography

"Legendary Blues Pianist 'Sunnyland Slim,' 87, Dies." *Jet* (April 10, 1995) 87, 22: 62.

"Sunnyland Slim." *New York Times* (March 20, 1995): D10.

"Sunnyland Slim." *Variety* (April 17, 1995) 358, 11: 40.

Whiteis, David. "Bluesman Sunnyland Slim 1907–1995." *Down Beat* (June 1995) 62, 6: 10.

_____. "Sunnyland Slim." *Down Beat* (May 1991) 58, 5: 28.

Discography

Luandrew, Albert "Sunnyland Slim." *Blues Jam.* Storyville 245.

_____. *Blues Piano Orgy.* Delmark DMK 626.

_____. *Blues World of Little Walter.* Delmark DMK 648.

_____. *Chicago Ain't Nothing But a Blues Band.* Delmark DMK 624.

JOAQUIN "JACK" LUJAN

Bibliography

"Bibi Guam Quincentennial Celebration." *Kantan Kottura* (February 1992): 8.

"Guam Blacksmith Named National Heritage Fellow." *Pacific Magazine* (September/October 1996).

Pabalinas, Ed. "Chamorro Smithy Wants to Pass on Skills." *Guam Tribune* (September 13, 1985).

"Public Market." *Kantan Kottura* (January 1992): 4.

"6th Annual Guam/Micronesia Island Fair." *Kantan Kottura* (summer 1993): 8.

WADE MAINER

Bibliography

Malone, Bill C. *Country Music, U.S.A.* Austin: University of Texas Press, 1968.

Tribe, Ivan M., and John W. Morris. "J. E. and Wade Mainer." *Bluegrass Unlimited* (November 1975): 12–21.

Discography
Mainer, Wade. *Early Radio, Vol. I.* Old Homestead OHCS124.
_____. *First Time in Stereo.* Old Homestead 90002.
_____. *Mountain Sacred Songs.* Old Homestead 90016.
_____. *Old Time Banjo Tunes.* Old Homestead 90168.
_____. *Old Time Sacred Songs.* Old Homestead 700665.
_____. *Old Time Songs.* Old Homestead 90123.
_____. *Sacred Songs of Mother and Home.* Old Homestead OHCS135.
Mainer, Wade, and Julia Mainer. *In the Land of Melody.* June Appal Recordings JA 0065.

MARY JANE MANIGAULT

Bibliography
Ferris, William. *Afro-American Folk Art and Crafts.* Boston: G.K. Hall, 1983.
Rosengarten, Dale. *Row upon Row: Sea Grass Baskets of the South Carolina Low Country,* rev. ed. Columbia: McKissick Museum of the University of South Carolina, 1987.

ELLIOTT "ELLIE" MANNETTE

Bibliography
Mannette, Ellie. *Teaching Music* (June 2001) 8, 6: 46.
Wu, Corinna. "Science Catches up with the Shimmering Sound of Steel Drums." *Science News* (October 10, 1998) 154, 15: 236.

FRANKIE MANNING

Bibliography
"Frankie Manning." *Dance Magazine* (September 1999) 73, 9: 53.
"Lindy Hopping at the Savoy: The Man Who Invented the Aerial." *New York Folklore Newsletter* (winter/ spring 1998).
Millman, Cynthia R. "Frankie Manning Swings into His Eighties." *Dance Magazine* (May 1994) 68, 5: 16.
Stewart, Doug. "This Joint Is Jumping." *Smithsonian* (March 1999) 29, 12: 60.
Waldman, Amy. "Dancer Tries to Save Site of First Hesitant Steps." *New York Times* (February 25, 2001) 15: 24.

Filmography
The Call of the Jitterbug. Color, with black-and-white sequences. Directed by Jesper Sorensen, Vibeke Wind-ing, and Tana Ross. Middlesex, England: Green Room Productions, 1988.
Eye on Dance. New York: WNYC-TV, 1989.
New Worlds, New Forms. Episode 6 in the History of World Dance, produced for PBS, aired in 1992.

MIGUEL MANTEO

Bibliography
Gold, Donna Lauren. "Plucky Puppets Are the Stars in One Family's Saga." *Smithsonian* (August 1983).
Grogan, David. "Chivalry Lives as Mike Manteo Revives Knights to Remember." *People* (June 1, 1987).
Hufford, Mary, Marjorie Hunt, and Steven Zeitlin. *The Grand Generation: Memory, Mastery, Legacy.* Seattle: University of Washington Press, 1987.
Kalcik, Susan. "Gifts to America." In *Festival of American Folklife.* Program. Washington, D.C.: Smithsonian Institution, 1976.
Kirshenblatt-Gimblett, Barbara. "Manteo Sicilian Marionette Theater." *New York Folklore Newsletter* (1982) 3, 2: 1, 10.

Filmography
It's One Family—Knock on Wood. 16mm, videotape, color, 23 and 1/2 minutes. Produced and directed by Tony De Nonno. Brooklyn: De Nonno Productions, 1982.

NARCISO MARTÍNEZ

Bibliography
Avila, Alex. "Tune in to Songs of the Homeland." *Hispanic* (September 1995) 8, 8: 8.
Drag, Katharine A. "The Hot New Sound of Tradition." *Hispanic* (January/February 2000) 13, 1: 28.
Holston, Mark. "From Conjunto to Reggae and Samba." *Americas* (October 1999) 51, 15: 58.
Morthland, John. "Unsung." *Texas Monthly* (October 2000) 28, 10: 112.
_____. "Conjunto Artist of the Century." *Texas Monthly* (December 1999) 27, 12: 182.
_____. "Wasted Days." *Texas Monthly* (October 1995) 23, 10: 64.

Discography
Martínez, Narciso. *Father of the Texas–Mexican Conjunto.* Arhoolie 361.
Martínez, Narciso, et al. *Borderlands: From Conjunto to Chicken Scratch.* Smithsonian Folkways 40418.
_____. *Norteño and Tejano Pioneers.* Arhoolie 7016.

Filmography

Chulas Fronteras, 16mm, videotape, color, 58 minutes. Directed by Chris Strachwitz and Les Blank. El Cerrito, California: Brazos Films, 1976.

SOSEI SHIZUYE MATSUMOTO

Bibliography

Okakura, Kakuzo. *The Book of Tea*. Boston: Shambhala Publications, 2000.

Plutschow, Herbert. *The Tea Master: A Biography of Soshitsu Sen XV*. Trumbull, Connecticut: Weatherhill, 2000.

"Steeped in Tradition." *Los Angeles Times* (September 29, 1996): E1.

Tanaka, Seno. *Tea Ceremony*. Tokyo: Kodansha International, 2000.

EVA McADAMS

Bibliography

Hafner, Jennifer. "Holding onto Tradition: Eva McAdams Is Glad She Learned Shoshone Craft." *Riverton (Wyo.) Ranger* (July 22, 1996) 90: 100.

MARIE McDONALD

Bibliography

Bethell, Tom. "Include Me Out." *American Spectator* (March 1993) 26, 3: 16.

McDonald, Marie A. *Ka Lei: The Leis of Hawaii*. Honolulu: Topgallant, 1985.

BROWNIE McGHEE

Bibliography

"Died: Walter Brown McGhee." *Jet* (April 1, 1996) 89, 20: 64.

Guitar Styles of Brownie McGhee. New York: Music Sales Corporation, 1997.

Himes, Geoffrey. "Brownie McGhee 1915–1996." *Rolling Stone* (April 4, 1996) 731: 39.

"Last Licks." *People* (March 5, 1996) 45, 9: 62.

Pareles, Jon. "Brownie McGhee, 80, Early Piedmont Bluesman." *New York Times* (February 19, 1996): B5.

Stambler, Irwin, and Grelun Landon. *Encyclopedia of Folk, Country, and Western Music*. New York: St. Martin's Press, 1969.

Traum, Happy. "Brownie McGhee." In *Festival of American Folklife*. Program. Washington, D.C.: Smithsonian Institution, 1971.

Discography

McGhee, Brownie. *Born with the Blues 1966–1992*. Vestapol VEST 13060.

_____. *Brownie Speaks*. Paris-Album 28513.

_____. *Sings the Blues*. Smithsonian Folkways 3557.

_____. *Traditional Blues, Vol. I*. Smithsonian Folkways 2421.

_____. *Traditional Blues, Vol. II*. Smithsonian Folkways 2422, 1960.

McGhee, Brownie, and Sonny Terry. *Brownie McGhee and Sonny Terry Sing*. Smithsonian Folkways 40011.

_____. *The Folkways Years, 1945–1959*. Smithsonian Folkways 40034.

Filmography

Dimensions of Black. Videotape, 59 minutes. Produced by KPBS, San Diego, California: PBS Video.

HUGH McGRAW

Bibliography

Boyd, Joe Dan. "The Sacred Harpers and Their Singing." In *Festival of American Folklife*. Program. Washington, D.C.: Smithsonian Institution, 1970.

Dodge, Timothy. "From Spirituals to Gospel Rap: Gospel Music Periodicals." *Serials Review* (winter 1994) 20, 4: 67.

Discography

McGraw, Hugh. *How to Sing Sacred Harp*. Bremen, Georgia: Sacred Harp Publishing Company.

SYLVESTER McINTOSH

Discography

McIntosh, Sylvester. *Blinky and the Roadmasters: Crucian Scratch Band Music*. Rounder 5047.

McINTOSH COUNTY SHOUTERS

Bibliography

Palmer, Robert. "Gospel: McIntosh Shouters." *New York Times* (November 29, 1987).

Santoro, Gene. "The McIntosh County Shouters Give a Stirring Show." *New York Observer* (December 7, 1987).

Discography

McIntosh County Shouters. *Slave Shout Songs from the Coast of Georgia*. Smithsonian Folkways 40061.

WALLACE McRAE

Bibliography

Cannon, Hal, ed. *Cowboy Poetry: A Gathering.* Layton, Utah: Gibbs Smith, 1985.

_____. *New Cowboy Poetry: A Contemporary Gathering.* Layton, Utah: Gibbs Smith, 1990.

Crowley, Carolyn Hughes. "Ropin' and Rhymin'." *Saturday Evening Post* (January/February 1995) 267, 1: 74.

Davidson, Sara. "Git Along, Little Doggerel." *New York Times* (January 15, 1995): 38.

McRae, Wallace. *Things of Intrinsic Worth,* Jeri D. Walton, ed. Bozeman, Montana: Outlaw Books, 1985.

_____. *It's Just Grass and Water.* The Oxalis Group, 1986.

McRae, Wallace, and Jeri D. Walton. *Up North Is Down the Crick.* Bozeman, Montana: Outlaw Books, 1985.

See, L. "Gibbs Smith on the Lonesome Trail." *Publishers Weekly* (May 4, 1992) 239: 21.

Discography

Cannon, Hal, ed. *Favorite Cowboy Recitations: Cowboy Poets and Their Poems.* Salt Lake City: Western Folklife Center.

Filmography

Wally McRae Live (More or Less). Videotape. Grizzly Gulch, Montana: Last Chance Recordings, 1993.

JIM AND JESSE McREYNOLDS

Bibliography

Edwards, Claudia. "'Jim and Jesse' Are Feted with Highest NEA Award, Stipend." *News-Examiner (Gallatin, Tenn.)* (June 18, 1997).

Ewing, Tom. "Jim & Jesse: 50 Years and the Future Is Just Beginning." *Bluegrass Unlimited* (July 1997).

"Jim and Jesse Celebrate 50; Jim & Jesse McReynolds Are 1997 National Endowment for the Arts National Heritage Fellows." *Bluegrass Now* (May 1997).

Roland, Tom. "Jim & Jesse Named Heritage Fellows." *Tennessean (Nashville)* (September 13, 1997).

Statman, Andy. *Bluegrass Masters.* New York: Music Sales Corporation, 1979.

Watson, Bruce, and Catherine Karnow. "This Here's All for Foot Tappin' and Grin Winnin'." *Smithsonian* (March 1993) 23, 12: 68.

Discography

McReynolds, Jim and Jesse. *Epic Bluegrass Hits.* Rounder SS20.

_____. *Music Among Friends.* Rounder 0279.

McReynolds, Jim and Jesse, and the Virginia Boys. *In the Tradition.* Rounder 0234.

LANIER MEADERS

Bibliography

Burrison, John A. "Quillian Lanier Meaders (1917–98)." *Journal of American Folklore* (winter 1999) 12, 443: 83.

_____. *Brothers in Clay: The Story of Georgia Folk Pottery.* Athens: University of Georgia Press, 1983.

Ferris, William. *Afro-American Folk Arts and Crafts.* Chapel Hill and London: University of North Carolina Press, 1983.

Glassie, Henry. *The Spirit of Folk Art: The Girard Collection at the Museum of International Folk Art.* New York: Henry N. Abrams, 1989.

Rinzler, Ralph, and Robert Sayers. *The Meaders Family: North Carolina Potters.* Smithsonian Folklife Studies, No. 1. Washington, D.C.: Smithsonian Institution Press, 1980.

Wadsworth, Anna. *Missing Pieces: Georgia Folk Art, 1770–1976.* Exhibition catalogue. Tucker: Georgia Council for the Arts and Humanities, 1976.

Filmography

The Meaders Family: North Carolina Potters. 16mm, color, 30 minutes. Washington, D.C.: Smithsonian Folklife Studies, Smithsonian Institution.

Missing Pieces: Georgia Folk Art, 1770–1976. 16mm, color, 28 minutes. Directed by Steve Heiser. Tucker: Georgia Council for the Arts and Humanities, 1976.

JOHN HENRY MEALING AND CORNELIUS WRIGHT, JR.

Bibliography

"Three Blacks Receive National Heritage Fellows Award." *Jet* (October 21, 1996) 90, 123: 63.

Filmography

Gandy Dancers. 16mm, videotape, color, 30 minutes. Produced and directed by Barry Dornfield and Maggie Holtzberg. Atlanta: Georgia Council on the Arts, 1994.

LEIF MELGAARD

Bibliography

"Georgia Vernacular, a Bridge to the Past." *Early American Homes* (April 1997) 28, 2: 20.

Henning, Darrell D., Marion J. Nelson, and Roger L Welsh, eds. *Norwegian-American Wood Carving of the*

Upper Midwest. Decorah, Iowa: The Norwegian-American Museum, 1978.

"Lanier Meaders 1917–1998." *Ceramics Monthly* (May 1998) 46, 5: 24.

D. L. MENARD

Bibliography

Ancelet, Barry Jean. *The Makers of Cajun Music: Cadiens et Créoles.* Austin: University of Texas Press, 1984.

"D. L. & Lou Ella Menard." Program for 42nd National Folk Festival at Wolf Trap (July 1980).

Farley, Christopher John. "Sounding the Waters." *Time* (January 11, 1999) 153, 1: 95.

Discography

Menard, D. L. *Cajun Saturday Night.* Rounder 0198.

_____. *No Matter Where You At, There You Are.* Rounder 6021.

Menard, D. L., and the Louisiana Aces. *D. L. Menard and the Louisiana Aces.* Rounder 6003.

NELLIE STAR BOY MENARD

Bibliography

MacDowell, Marsha. *To Honor and Comfort: Native American Quilting Traditions.* Santa Fe: Museum of New Mexico Press, 1997.

LYDIA MENDOZA

Bibliography

Broyles-Gonzalez, Yolanda. *My Life in Music (Mi Vida en la Musica); Lydia Mendoza: Norteño Tejano Legacies.* New York: Oxford University Press, 2001.

Gil, Carlos B. "Lydia Mendoza: Houstonian and First Lady of Mexican-American Song." *Houston Review* (summer 1981).

Martin, Cliff. "Tex-Mex Music." *Whole Earth Review* (winter 1994) 84: 51.

Mendoza, Lydia, Chris Strachwitz, and James Nicolopolus. *Lydia Mendoza: A Family Autobiography.* Houston: Arte Publico Press, 1993.

Morthland, John. "Unsung." *Texas Monthly* (October 2000) 28, 10: 112.

Patoski, Joe Nick. "Voices of the Century." *Texas Monthly* (December 1999) 27, 12: 142.

Peña, Manuel H. *The Texas–Mexican Conjunto: History of a Working Class Music.* Austin: University of Texas Press, 1985.

Discography

Mendoza, Lydia. *The First Queen of Tejano Music.* Arhoolie 392.

_____. *La Gloria de Texas.* Arhoolie 3012.

_____. *Mal Hombre and Other Original Hits from the 1930s.* Arhoolie 7002.

_____. *Vida Mia.* Arhoolie 7008.

Mendoza, Lydia, et al. *Crossroads: Southern Routes.* Smithsonian Folkways 40080.

_____. *15 Tex-Mex Conjunto Classics.* Arhoolie 104.

_____. *The Women.* Arhoolie 343.

Filmography

Chulas Fronteras. 16mm, videotape, color, 58 minutes. Directed by Chris Strachwitz and Les Blank. El Cerrito, California: Brazos Films, 1976.

ELMER MILLER

Bibliography

Buckaroos in Paradise: Cowboy Life in Northern Nevada. Exhibition catalogue. Washington, D.C.: American Folklife Center, Library of Congress, 1980.

Oki, Dr. Steve. "Local Western Craftsman." *Idaho Press Tribune* (February 1987).

Siporin, Steve. "Elmer Miller: Buckaroo Bit & Spurmaker." *Western Horseman* (July 1987): 20.

"We Came to Where We Were Supposed to Be": Folk Art of Idaho. Exhibition catalogue. Boise: Idaho Commission on the Arts and the United States Information Agency.

Weiser, Jim. "Elmer Miller's Bits and Tasty Pieces." *Horsetimes* (April 1983).

ARTHUR MOILANEN

Bibliography

Leary, James P. "Reading the 'Newspaper Dress': An Expose of Art Moilanen Musical Traditions." In *The Michigan Folklife Reader,* C. Kurt Dewhurst and Yvonne Lockwood, eds., pp. 205–223. East Lansing: Michigan State University Press, 1998.

Discography

Moilanen, Arthur, et al. *Accordions in the Cutover: Field Recordings of Ethnic Music from Superior's South Shore.* Madison: Inland Sea Records (The Wisconsin Folk Museum).

MICK MOLONEY

Bibliography

Johnson, Janis. "Out of Ireland." *Humanities* (January/February 1994) 15, 1: 10.

Turbide, Diane. "Pennies from Heaven." *Maclean's* (September 1, 1997) 110, 35: 74.

Discography
Moloney, Mick, et al. *Celtic Thunder*. Green Linnet 1029.
_____. *Mick Moloney with Eugene O'Donnell*. Green Linnet 1010.
_____. *Roll Away the Reel World*. Green Linnet 1026.
_____. *Slow Airs and Set Dances*. Green Linnet 1015.
_____. *Strings Attached*. Green Linnet 1027.

BILL MONROE

Bibliography
Bill Monroe: 16 Gems; Authentic Mandolin Transcriptions. Milwaukee: Hal Leonard Corporation, 1999.
DeCurtis, Anthony. "Bill Monroe." *Rolling Stone* (October 31, 1996) 746: 20.
Eremo, Judie, ed. *Country Musicians, The Carter Family, Charlie Daniels, Waylon Jennings, Bill Monroe, Willie Nelson, Ricky Skaggs, Merle Travis, & 27 Other Great American Artists—Their Music & How They Made It*. New York: Grove/Atlantic, 1987.
Ewing, Tom. *The Bill Monroe Reader*. Champaign: University of Illinois Press, 2000.
Grisman, David. ". . . In Another, a Reminder of Our Roots." *New York Times* (September 22, 1996) Arts & Leisure section: 30.
Hitchner, Earle. "Bill Monroe Remembered." *Wall Street Journal* (September 16, 1996): A16, eastern edition.
Jones, Malcolm, Jr. "The Passing of a Patriarch." *Newsweek* (September 23, 1996) 128, 13: 75.
Malone, Bill C. *Country Music, U.S.A.* Austin and London: University of Texas Press, 1968.
Pareles, Jon. "Bill Monroe Dies at 84; Fused Musical Roots into Bluegrass." *New York Times* (September 10, 1996): D22.
Rooney, James. *Bossmen, Bill Monroe & Muddy Waters*. New York: Da Capo Press, 1991.
Rosenberg, Neil V. *Bill Monroe & His Blue Grass Boys: An Illustrated Discography*. Nashville: Country Music Foundation Press, 1974.
Smith, Richard. *Can't You Hear Me Calling, the Life of Bill Monroe, Father of Bluegrass*. Cambridge, Massachusetts: Da Capo Press, 2001.
Wolfe, Charles K. *Kentucky Country: Folk and Country Music of Kentucky*. Lexington: University Press of Kentucky, 1982.

Discography
Monroe, Bill. *Bean Blossom*. MCA Records MCA2–8002.
_____. *Best of Bill Monroe*. MCA Records MCAC2–4090.
_____. *Bill Monroe: Bluegrass 1950–1958*. Bear Family Records BCD 15423, with 65-page booklet.
_____. *Bill Monroe: Off the Record, Vol. 1: Live Recordings 1956–1969*. Smithsonian Folkways 40063.
_____. *Columbia Historical Edition*. Columbia Records FCT–38904, CK–38904.
_____. *I Saw the Light*. MCA Records MCAC–527.
Monroe, Bill, and Doc Watson. *Off the Record, Vol. 2: Live Recordings, 1963–1980*. Smithsonian Folkways 40064.
Monroe, Bill, Lester Flatt, and Earl Scruggs. *The Original Bluegrass Band*. Rounder SS06.
Monroe, Bill, et al. *Bill Monroe and Friends*. MCA Records MCAC–949.
_____. *MCA Records, 30 Years of Hits, 1958–1988*. MCA Records MCA2–8025.

Filmography
Discovering Country and Western Music. 16mm, videotape, color, 24 minutes. Produced by Bernard Wilets. Santa Monica, California: BFA Educational Media, 1977.
The High Lonesome Sound: Kentucky Mountain Music. 16mm, black and white, 30 minutes. Stillwater: Oklahoma State University Audio-Visual Center.

ALLISON "TOOTIE" MONTANA

Bibliography
Martinez, Maurice M., Jr. "Delight in Repetition: The Black Indians." *Wavelength* (February 1982).
Smith, Michael P. *Mardi Gras Indians*. Gretna, Louisiana: Pelican Publishing, 1994.
_____. "Introduction and Interviews by Alan Govenar." In *Joyful Noise*, pp. 57–68. Dallas: Taylor Publishing, 1990.

Filmography
The Black Indians of New Orleans. 16mm, videotape, color, 30 minutes. Produced by Maurice Martinez. Franklin Lakes, New Jersey: Bayou Films, c/o Transit Media.

ALEXANDER H. MOORE, SR.

Bibliography
Govenar, Alan. *Meeting the Blues*, pp. 30–33. New York: Da Capo Press, 1995.
Govenar, Alan, Alan B. Brakefield, and Jay F. Brakefield. *Deep Ellum and Central Track: Where the Black and White Worlds of Dallas Converged*, pp. 108–120. Denton: University of North Texas Press, 1998.

Discography

Moore, Alex. *"Whistlin'" Alex Moore: From North Dallas to the East Side.* Arhoolie 408.

_____. *Wiggle Tail: Original, Eccentric, Legendary and Lascivious Piano Playing and Stories.* Rounder 2091.

_____. *Then and Now.* Documentary Arts DA 105.

Filmography

Black on White/White and Black: The Piano Blues of Alex Moore. 16mm, videotape, color, 28 minutes. Directed by Alan Govenar. Dallas: Documentary Arts, 1990.

VANESSA PAUKEIGOPE MORGAN

Bibliography

Greene, Candace S. "The Tepee with Battle Pictures." *Natural History* (October 1993) 102, 10: 68.

Mayeux, Lucie. "Carrying on a Kiowa Tradition." *New Mexican* (August 20, 1989).

GENEVIEVE MOUGIN

Bibliography

Hufford, Mary, Marjorie Hunt, and Steven Zeitlin. *The Grand Generation: Memory, Mystery, Legacy.* Seattle: University of Washington Press, 1987.

Ohrn, Steve, ed. *Passing Time and Traditions: Contemporary Iowa Folk Artists.* Ames: Iowa State University Press, 1984.

BOUA XOU MUA

Bibliography

"Fighting to Keep Their Faith." *Portland Oregonian* (February 27, 1985).

"Little Bua and Tall Jan." *Portland Oregonian* (August 1984).

Discography

Mua, Boua Xou. *The Music of the Hmong People of Laos.* Produced by Documentary Arts. Arhoolie 446.

Filmography

Masters of Traditional Music. Videotape, color, 58 minutes. Directed by Alan Govenar and Robert Tullier. Dallas: Documentary Arts, 1991.

MARTIN MULVIHILL

Discography

Mulvihill, Martin. *Traditional Irish Fiddling.* Green Linnet 1012.

Mulvihill, Martin, et al. *The Flax in Bloom.* Green Linnet 1020.

_____. *Irish Traditional Instrumental Music from the East Coast of America, Vol. I.* Rounder 6005.

MABEL E. MURPHY

Bibliography

Everts-Boehm, Dana. "Center Programs Play Key Role in 25th Anniversary of Missouri Arts Council." In *Tradition* (University of Missouri Cultural Heritage Center, fall 1990): 7.

Hunt, Marjorie, and Boris Weintraub. "Masters of Traditional Arts." *National Geographic* (January 1991) 179, 1.

Milacek, Barbara. "Times Have Changed, But Art of Quilting Has Not." *Independent–Marshall, Minnesota* (April 28, 1979).

"Patchwork and Paint." *The Entertainer* (November 3–9, 1991).

Roberson, Margot. "The Meetin' Place." *Quilter's Newsletter Magazine* (January 1985).

JOHN NAKA

Bibliography

Naka, John. *Bonsai Techniques.* Santa Monica, California: Dennis-Landman Publishers, 1973.

_____. *Bonsai Techniques II.* Santa Monica, California: Dennis-Landman Publishers, 1982.

"Reception Launches American Bonsai Pavilion Fund Drive." *Fona News* (June 1984).

SEISHO "HARRY" NAKASONE

Bibliography

"Good Attendance at Okinawan Music Workshop." *Hawaii Pacific Press* (November 1, 1984).

"A Tribute to Hawaii's Living Treasure." *Artreach* (July/August 1991), 7, 3.

Discography

Nakasone, Harry. *Harry Seisho Nakasone.* Motown MTN–2003.

JULIO NEGRÓN-RIVERA

Bibliography

Holston, Mark. "Percussionists on an Organic Beat." *Americas* (March/April 1997) 49, 2: 4.

Doc Tate Nevaquaya

Bibliography

"Doc T. Nevaquaya, Comanche Artist, 63." *New York Times* (March 6, 1996): D21.

Hobson, Geary. "The Literature of Indian Oklahoma: A

Brief History." *World Literature Today* (summer 1990) 64, 3: 427.

Meredith, Howard. "World Literature in Review: Native American." *World Literature Today* (spring 1995) 69, 2: 410.

Discography

Nevaquaya, Doc Tate. *Comanche Flute Music.* Smithsonian Folkways F–4328.

_____. *Indian Flute Songs from Comanche Land.* Native American Music NAM401C.

NG SHEUNG-CHI

Bibliography

Takaki, Ronald. *Strangers from a Different Shore: A History of Asian Americans.* Boston: Little, Brown, 1989.

Zheng, Su De San. "From Toissan to New York: Muk'Yu Songs in Folk Tradition." *Chinoperl* (1993) 16: 165–206.

PHONG NGUYEN

Discography

Nguyen, Phong. *Eternal Voices.* New Alliance Records.

_____. *From Rice Paddies and Temple Yards.* World Music Press.

_____. *Music of Vietnam—The Phong Nguyen Ensemble.* The New Americans Series, World Music Institute.

_____. *Song of the Banyan: Folk Music of Vietnam.* World Music Institute Latitudes LAT 50607.

YANG FANG NHU

Bibliography

Bethell, Tom. "Include Me Out." *American Spectator* (March 1993) 26, 3: 16.

Lambrecht, Winnie, and Carolyn Shapiro. *Blue Hmong Loom and Weaving.* Pamphlet. Providence: Rhode Island State Council on the Arts.

"Laotian Weaver to Receive National Honor." *Detroit Free Press* (September 29, 1989).

McCabe, Carol. "National Endowment Calls Hmong Woman, Formerly from Rhode Island, a 'Cultural Treasure.' " *Providence Journal* (October 16, 1988).

"She Weaves Past into Present." *Detroit Free Press* (July 19, 1988).

"Yang Fang Nhu—Blue Hmong Weaver." In *49thNational Folk Festival, July 24–26, 1987.* Program notes. Washington, D.C.: National Council for the Traditional Arts, 1987.

GLENN OHRLIN

Bibliography

Ohrlin, Glenn. *Hell-Bound Train: A Cowboy Songbook.* Champaign: University of Illinois Press, 1989.

_____. *The Hellbound Train, A Cowboy Songbook.* Ann Arbor, Michigan: Books on Demand.

Young, D. "They Sing of the South." *Southern Living* (November 1988) 45, 11: 80.

Discography

Ohrlin, Glenn. *The Cowboy Tour: A National Tour of Cowboy Songs, Poetry, Big Windy Stories, Humor, and Fiddling.* Rounder 82161–0473–2.

_____. *1986 Cowboy Poetry Gathering: Funny Situations.* CP2–039.

_____. *1986 Cowboy Poetry Gathering: Plains States Poets.* CP2–004.

_____. *1987 Cowboy Poetry Gathering: Modern Cowboy Songs.* CP3–309.

_____. *Stone Country Singing.* Shoestring Tape SGB–1.

_____. *The Wild Buckaroo.* Rounder 0158.

Ohrlin, Glenn, et al. *The Cowboy Tour.* Rounder 82161–0473–2.

JOÃO OLIVEIRA DOS SANTOS

Bibliography

Downing, Ben. "Jogo Bonito." *Southwest Review* (autumn 1996) 81, 4: 545.

Dunning, Thad. "Blame Is on Brazil." *Village Voice* (May 23, 2000) 45, 20: 76.

Jowitt, Deborah. "Play It." *Village Voice* (June 27, 1995) 40, 26: 87.

LUIS ORTEGA

Bibliography

Ortega, Luis B. "The California Falsarienda." *Western Horseman* (December 1953).

_____. "California Hackamore Tips." *Western Horseman* (February 1954).

_____. "The Headstrong Horse." *Western Horseman* (June 1951).

_____. "El Mecate: The Hair Rope." *Western Horseman* (April 1955).

_____. "An Old Ranch Custom." *Western Horseman* (February 1951).

_____. "Tying the Mecate." *Western Horseman* (October 1954).

Scopinich,, Jill. "Luis Ortega: The Artist, the Vaquero, and the Man." *Pacific Coast Journal* (May 1985).

NADJESCHDA OVERGAARD

Bibliography
Past and Present in Shelby County, Iowa, Vol. III. Harlan: Shelby County Historical Society, 1976.

JACK OWENS

Bibliography
Fraher, James. *The Blues Is a Feeling.* Mount Horeb, Wisconsin: Face to Face Books, 1998.
Palmer, Robert. *Deep Blues.* New York: Viking Press, 1981.
Pearson, Barry Lee. "'When You're Born and Raised in the Delta, You Just Write Hate You See!' Delta Blues Stories." *Arkansas Review: A Journal of Delta Studies* (1998) 29, 1: 30.

Discography
Owens, Jack. *It Must Have Been the Devil: Mississippi Country Blues by Jack Owens and Bud Spires.* Testament TCD 5016.

Filmography
Deep Blues. 16mm, videotape, color, 91 minutes. Directed by Robert Mugge. Mug-Shot Productions, 1991.

VERNON OWENS

Bibliography
Morrison, Jim, and Kelly Culpepper. "Fired with Finesse." *Smithsonian* (October 1998), 29, 7: 109.
"Owens Among NEA Winners." *Charlotte Observer* (August 4, 1996).
Sweezy, Nancy. *Raised in Clay: The Southern Pottery Tradition,* pp. 211–217. Washington, D.C.: Smithsonian Institution Press, 1984.

HARILAOS PAPAPOSTOLOU

Bibliography
"It Will All Be Greek Next Week as Club Two Welcomes 'Greek Echo.'" *Washington Post* (December 1991).

EDDIE PENNINGTON

Bibliography
O'Brien, Tim. "Cincinnati's Appalachian Fest Eclipses Record." *Amusement Business* (June 14, 1999) 24, 42: 1.
_____. "Cincinnati's Appalachian Festival Provides Music, Fun, Food & Folklore." *Amusement Business* (May 25, 1998) 110, 21: 20.

IRVÁN PÉREZ

Bibliography
"A Singing Champion for Louisiana's Isleños." *National Geographic* (December 1991) 180, 6: 1.

JOE WILLIE "PINETOP" PERKINS

Bibliography
Caligiuru, Jim. "Back to the Blues." *CMJ New Music Report* (June 21, 1993).
Dahl, Bill. "Pinetop's Boogie." *Living Blues* (May/June 1991): 10.
Deffa, Chip. "Pinetop Perkins: Portrait of a Delta Bluesman." *Entertainment Weekly* (June 11, 1993).
Delgrosso, Maureen. "Pinetop Perkins: Hopson Homecoming." *Living Blues* (May 1999).
Hinckley, David. "Hear, Hear for a Long-Playing Recording Artist." *New York Daily News* (May 14, 1993).
Joyce, Mike. "Performing Arts: Pinetop Perkins." *Washington Post* (April 18, 1988).
Pareles, Jon. "Unhurried Old-Time Blues: Pinetop Perkins." *New York Times* (October 7, 1993).
Sandmel, Ben. "Portrait of a Delta Bluesman." *Rolling Stone* (June 24, 1993).

Discography
Perkins, Pinetop. *Pinetop Perkins: Portrait of a Delta Bluesman.* Omega Record Group.
Perkins, Pinetop, et al. *After Hours.* Blind Pig BP–3088.
_____. *Legends.* Telarc 83489.
_____. *Live at 85.* Shanachie 9022.
_____. *Live Top.* Deluge Records D 3010.

ELIJAH PIERCE

Bibliography
Connell, E. Jane. *Elijah Pierce: Woodcarver.* Seattle: University of Washington Press, 1993.
Horwitz, Elinor Lander. *Contemporary American Folk Artists.* Philadelphia and New York: J.B. Lippincott Company, 1975.
Hufford, Mary, Marjorie Hunt, and Steve Zeitlin. *The Grand Generation: Memory, Mastery, Legacy.* Seattle: University of Washington Press, 1987.
Olcott, Susan, Barbara Hoffert, et al. *Self-Taught Artists of the 20th Century: An American Anthology.* New York: Chronicle Books, 1998.
Roberts, Norma J., and Merribell Parsons. *Elijah Pierce, Woodcarver.* Columbus, Ohio: Columbus Museum of Art, 1992.
Wadsworth, Anna. *Missing Pieces: Georgia Folk Art,*

1770–1976. Exhibition catalogue. Tucker: Georgia Council for the Arts and Humanities, 1976.

Filmography

Elijah Pierce, Woodcarver. 16mm, color, 20 minutes. Produced by Carolyn Jones. Columbus: Ohio State University.

Sermons in Wood. 16mm, videotape, color, 27 minutes. Produced by Carolyn Jones Allport and Raymond L. Kook. Memphis: Center for Southern Folklore.

KONSTANTINOS PILARINOS

Bibliography

"Labor of Love." *Post-Gazette (Washington, D.C.)* (December 18, 1994).

ADAM POPOVICH

Bibliography

Marshall, Dan. "Our Fathers' Music." *World & I* (March 1998) 13, 3: 204.

Raim-Zinser, Ethel, and Martin Koenig. "Tamburashi Tradition." In *Festival of American Folklife.* Program. Washington, D.C.: Smithsonian Institution, 1973.

Discography

Popovich, Adam. *Serbo-Croatian Tamburizas, Vols. 1 and 2.* Arhoolie/Folklyric 7046, 7047.

_____. *Sing with Teddy and the Popovich Brothers, Vols. 1–8.* Festival Records.

Filmography

The Popovich Brothers of South Chicago. Videotape, 60 minutes. Directed by Jill Godmilow in collaboration with Ethel Ruim and Martin Koenig. New York: Ethnic Folks Art Center, 1978.

Ziveli: Medicine for the Heart. 16mm, videotape, color, 51 minutes. Directed by Andre Simic and Les Blank. El Cerrito, California: Flower Films, 1987.

QI SHU FANG

Bibliography

Orenstein, Claudia, and Denise Walen. "Performance Review." *Theatre Journal* (October 1999), 51, 3: 322.

BUCK RAMSEY

Bibliography

Morthland, John. "Range Writer." *Texas Monthly* (June 1993) 21, 6: 38.

Ramsey, Buck. *And As I Rode Out on the Morning.* Lubbock: Texas Tech University Press, 1993.

Weeks, Jerome. "Cowboy Poet Honored." *Dallas Morning News* (June 9, 1995).

Wilkinson, Andy. "The Cowboy Spirit." *Texas Techsan Magazine* (July/August 1992).

Wolmuth, Roger. "Hail, Poets Lariat!" *People* (March 18, 1996) 45, 11: 80.

Discography

Ramsey, Buck. *And As I Rode Out on the Morning.* Cassette. Texas Tech University Press.

HYSTERCINE RANKIN

Bibliography

Campbell, Sarah. "Hystercine Rankin." *American Craft* (February/March 1994) 54, 1: 6.

Conover, Kirsten A. "National Endowment for the Arts Honors American Folk Artists." *Christian Science Monitor* (May 30, 1997) 89, 150: 15.

Freeman, Ronald L. *Communion of the Spirits: African American Quilters, Preservers, and Their Stories.* Nashville: Rutledge Hill Press, 1996.

Przybysz, Jane. "A Familiar Pattern." *Women's Review of Books* (June 1997) 14, 9: 23.

OLA BELLE REED

Bibliography

Camp, Charles, and David E. Whisenant. "A Voice from Home." *Southern Exposure* (1977) 5, 2–3: 80–90.

LeBlanc, Larry. "Bluegrass Thrives in Northern Niche." *Billboard* (April 11, 1998) 110, 15: 72.

Marti, Judy. "A Banjo Pickin' Girl: The Life and Music of Ola Belle Campbell Reed." *The Old-Time Herald* (winter 1992/1993): 17–22.

Discography

Reed, Ola Belle, et al. *All in One Evening.* Smithsonian Folkways FA2329.

_____. *My Epitaph.* Smithsonian Folkways FA2493.

_____. *Ola Belle and Alex.* Starday Records SLP–214.

_____. *Ola Belle Reed.* Rounder 0021.

_____. *Ola Belle Reed and Family.* Rounder 0077.

_____. *Travel On.* Starday Records. SLP–342.

ALMEDA RIDDLE

Bibliography

Abrahams, Roger, ed. *A Singer and Her Songs: Almeda Riddle's Book of Ballads.* Baton Rouge: Louisiana State University Press, 1970.

McNeil, W. K. "A Northeast Arkansas Ballet Book."

Arkansas Review: A Journal of Delta Studies (December 1999) 30, 3: 179.

Discography
Riddle, Almeda. *Sounds of the South: A Musical Journey from the Georgia Sea Islands to the Mississippi Delta.* Atlantic 782496–2 (4 CDs).

GEORGEANN ROBINSON

Filmography
Ribbons of the Osage: The Art and Life of Georgeann Robinson. Videotape, color, 28 minutes. Tulsa, Oklahoma: Full Circle Communications.
Native American Master Artists. Four videotapes, color, 24–38 minutes. Tulsa, Oklahoma: Full Circle Communications.

LAVAUGHN ROBINSON

Bibliography
Frank, Rusty E. *Tap! The Greatest Tap Dancers and Their Stories, 1900–1955.* New York: Da Capo Press, 1990.
Works-in-Progress: Newsletter of the Philadelphia Folklore Project (1989) 2: 3.

EMILIO AND SENAIDA ROMERO

Bibliography
Alba, Victoria. "The Romeros Transform Tin into Gold." *New Mexican, Pasatiempo* (October 23, 1987).
Hazen-Hammond, Suzanne. "Art from Poor Man's Silver." *New Mexico Magazine* (December 1984).
Lyon, Laura Hinton. "The Tinsmiths." *Santa Fe Reporter* (summer 1979).

EMILIO ROSADO

Bibliography
"Don Emilio Rosado." *Sing Out* (fall 1990): 40.
Siporin, Steve. *American Folk Masters: The National Heritage Fellows.* New York: Harry N. Abrams, 1992.

MONE AND VANXAY SAENPHIMMACHAK

Bibliography
Traditional Arts in Missouri. St. Louis: Cultural Heritage Center, 1990.

Filmography
Mone's Skirt: The Lao Weaver's Art. Videotape, 10 minutes. St. Louis: International Institute, 1992.

MARC SAVOY

Bibliography

Ancelet, Barry J. *The Makers of Cajun Music: Musiciens Cadiens et Créoles.* Austin: University of Texas Press, 1984.
Bessman, Jim. "Arhoolie Raises Savoy-Doucet's 'Rooster.'" *Billboard* (March 4, 2000) 112, 10: 26.
Campbell, Dana Adkins, and Carolanne Griffith Roberts. "The Way It Was, Is, and Shall Be." *Southern Living* (July 1999) 34, 7: 100.
Hochman, Steve. "Cajun's Top Crusader Takes Center Stage." *Los Angeles Times* (May 29, 1992).
Horne, Jed, and Bob Sacha. "Cajun Country." *Travel Holiday* (November 1994) 177, 9: 56.

Filmography
Everything But the Squeak! Videotape, color, 30 minutes. Directed by Alan Govenar. Produced by Documentary Arts and The Arhoolie Foundation. Dallas: Documentary Arts, 1998.

EARL SCRUGGS

Bibliography
Beard, Jonathan. "Finger Pickin' Good." *New Scientist* (November 8, 1997) 2107: 28.
Carney, George O. "Western North Carolina: Culture Hearth of Bluegrass Music." *Journal of Cultural Geography* (fall/winter 1996) 16, 1: 65.
Flippo, Chet. "Earle & Partners to Start a Mutiny; Toby, Clint, Tractors in Xmas Spirit." *Billboard* (October 7, 1995) 107, 40: 34.
Malone, Bill C. *Country Music, U.S.A.* Austin and London: University of Texas Press, 1968.
Smith, Hazel. "The Insider." *Country Music* (April/May 2001): 18.
Watson, Bruce, and Catherine Karnow. "This Here's All for Foot Tappin' and Grin Winnin'." *Smithsonian* (March 1993) 23, 12: 68.

Discography
Scruggs, Earl, and Lester Flatt. *Columbia Historic Edition.* Columbia CK–37469.
_____. *Don't Get Above Your Raisin'.* Rounder SS08.
_____. *Folk Classics (Roots of American Folk Music).* Columbia CK–45026.
_____. *The Golden Era.* Rounder SS05.

DUFF SEVERE

Bibliography
Hufford, Mary, Marjorie Hunt, and Steven Zeitlin. *The Grand Generation: Memory, Master, Legacy.* Seattle: University of Washington Press, 1987.

Hunt, Marjorie, and Boris Weintraub. "Masters of Traditional Arts." *National Geographic* (January 1991) 179: 1.

Jones, Suzi, ed.. *Webfoots and Bunchgrassers: Folk Art of the Oregon Country*. Salem: Oregon Arts Commission, 1980.

MORGAN SEXTON

Discography

Sexton, Morgan. *Rock Dust*. June Appal Recordings JA 0055.

Filmography

Morgan Sexton: Banjo Player from Bull Creek. Videotape, color, 28 minutes. Directed by Anne Johnson. Whitesburg, Kentucky: Appalshop Films, 1991.

SIMON SHAHEEN

Bibliography

"Interview with Simon Shaheen." *New Routes, Traditional Music in America* (spring 1994).

Moore, David W. "Kinship." *American Record Guide* (September/October 2000) 63, 5: 244.

Rule, Sheila. "A Man and His Oud. How's That Again?" *New York Times* (October 29, 1994) 144, 49864: 14.

Discography

Shaheen, Simon. *The Art of Improvisation*. Lyrichord.

_____. *Kinship*. Koch 7464.

_____. *Traditional and Contemporary Music of the Near East for Solo Violin and Oud*. EMI.

JOE SHANNON

Discography

Shannon, Joe, et al. *Irish Traditional Music from Chicago, Vol. 2*. Rounder 6006.

_____. *Joe Shannon and Johnny McGreevy*. Green Linnet 1023.

HARRY V. SHOURDS

Bibliography

MacKey, William F., Jr. *American Bird Decoys*. New York: Dutton, 1965.

KENNY SIDLE

Discography

Sidle, Kenny. *Favorite Fiddle Tunes*. Rome Recording RLP 1128.

_____. *Fiddle Memories*. Starr SLP–72589.

PHILIP SIMMONS

Bibliography

Feddoes, Sadie. "Philip Simmons' Ironworks Are Delicate Works of Art." *New York Amsterdam News* (July 17, 1997) 85, 46: 9.

Ferris, William. *Afro-American Folk Art and Crafts*. Boston: G.K. Hall, 1983.

Hunt, Stephanie. "Ironman." *Charleston Magazine* (January/February 2000) 14, 1: 54.

Lyons, Mary E., and Mannie Garcia. *Catching the Fire: Philip Simmons, Blacksmith*. New York: Houghton Mifflin, 1997.

"South Carolina Blacksmith, Age 86, Keeps His Vintage Craft Alive." *Jet* (June 21, 1999) 96, 3: 34.

Vlach, John Michael. *The Afro-American Tradition in Decorative Arts*. Cleveland: Cleveland Museum of Art, 1978.

_____. *Charleston Blacksmith: The Work of Philip Simmons*. Columbia: University of South Carolina Press, 1992.

Watson, Tom. "Hammering Out a Vision." *Southern Accents* (September/October 1997) 20, 5: 104.

HOWARD "SANDMAN" SIMS

Bibliography

Brennan, Mary. "Tapping Rich Resources of Dance." *Glasgow Herald* (October 3, 1980).

Canemaker, John. "Previews and Reviews . . . No Maps on My Taps." *Film News* (summer 1980) 37, 2.

Clarke, Mary. "No Maps on My Taps." *The Guardian* (October 9, 1980).

Dupont, David. " 'Happy Feet' Dazzle Vermont." *Vermont Vanguard Press* (March 20–27, 1981).

Fitzgerald, Sharon. "Amateur Night at the Apollo." *American Visions* (August/September 1992) 7, 4: 26.

Genné, Beth. "Tap Dance from Harlem." *Dancing Times* (December 1980).

Kernan, Michael. "Clickityick'ityclick! Sandman Sims, a National Treasure, Taps into Town." *Washington Post* (September 9, 1980).

Santiago, Chiori, and Theo Westenberger. "Ziggedy Bop! Tap Dance Is Back on Its Feet." *Smithsonian* (May 1997) 28, 2: 86.

"Talk of the Town: Pass It On." *New Yorker* (October 1, 1984).

Welch, Anne Marie. "Talented Trio of Tappers." *Washington Star* (September 9, 1980).

Filmography

No Maps on My Taps. 16mm, videotape, color, 58 minutes. Produced and directed by George T. Nierenberg. Los Angeles: Direct Cinema, Ltd., 1978.

WILLIE MAE FORD SMITH

Bibliography

Campbell, Patricia Shehan. "Mellonee Burnim on African American Music." *Music Educators Journal* (July 1995) 82, 1: 41.

Hardy, James Earl. "Hip Deep in Gospel." *American Visions* (December 1995/January 1996) 10, 6: 46.

Petrie, Phil W. "Making a Joyful Noise: Music or Ministry?" *Crisis (The New)* (September/October 2000) 107, 5: 50.

Discography

Smith, Willie Mae Ford. *I'm Bound for Canaan Land.* Savoy Records 14739.

Smith, Willie Mae Ford, et al. *Say Amen, Somebody.* DRG Records CDSBL–12584.

Filmography

Say Amen, Somebody. 16mm, videotape. Directed by George T. Nierenberg. New York: MGM/UA, 1982.

EUDOKIA SOROCHANIUK

Bibliography

Klymasz, Robert B., ed. *Art and Ethnicity: The Ukrainian Tradition in Canada.* Quebec: Canadian Museum of Civilization, 1991.

Nebesh, Daria L. *Because It's Ours: Constructing Identity in the Ukrainian Disapora Through Hutsul Music and Dance.* Ph.D. dissertation. Baltimore: University of Maryland, 1998.

DOLLY SPENCER

Bibliography

Russ, Chris. "Summer Art Season Kicks Off Tomorrow at Lighthouse Gallery." *Homer (Alaska) News* (May 29, 1997).

Schuldberg, Jane B. "All I Had for Hair Was Pink Yarn: A Survey of Doll Art from Alaska and Canada." *Inuit Art Quarterly* (fall 1996) 11, 3: 4–14.

"Spencer Dolls on Exhibit at Carrie McLain Museum." *Bering Strait (Alaska) Record* (November 12, 1997).

Spencer, Dolly. "A Dollmaker's Tale." *Native Wind: Good News for Native People* (1997) 1, 2: 12.

Stadem, Catherine. "Artisan Receives National Honor." *Alaska* (November 1996) 62, 9: 14.

Filmography

In Our Own Image: Alaska Native Doll Makers and Their Creations. Videotape, 28 minutes. Directed by Leonard Kamerling. Fairbanks: Alaska Center for Documentary Film, University of Alaska Museum, 1999.

ROBERT SPICER

Bibliography

Beasley, Kay. "Meet Mr. Spicer." *Steppin' In Time* (fall 1987) 1, 1: 1, 7.

Christian, Jacky. "Robert T. Spicer: Goin' Around with the Dancing." *Steppin' In Time* (winter 1987) 1, 2: 3–8.

_____. "Robert T. Spicer: Folk Master." *Steppin' In Time* (spring 1988) 1, 3: 1, 3–4, 11.

East, Jim. "Dickson Man Dances Way to National Award." *Tennessean (Nashville)* (June 18, 1990) 85, 146.

Orr, Jay. "National Honor Awaits Dickson Buck Dancer." *Nashville Banner* (June 18, 1990).

CLYDE "KINDY" SPROAT

Bibliography

Martin, Lynn J., ed. *Na Paniolo o Hawai'i.* Honolulu: Honolulu Academy of Arts, 1987.

Discography

Sproat, Clyde "Kindy." *Na Mele o Paniolo: Songs of Hawaiian Cowboys.* Honolulu: Hawaii State Foundation on Culture and the Arts.

Sproat, Clyde "Kindy", et al. *Clyde Halema'uma'u Sproat Sings. . .* Pololu PPCD195–1.

_____. *1989 Cowboy Poetry Gathering: Yodeling Workshop.* Reno, Nevada: Worldwide Communications.

Filmography

Paniolo o Hawaii: Cowboys of the Far West. Videotape, 79 minutes. Produced and directed by Edgy Lee. Honolulu: Filmworks, 1997.

SIMON ST. PIERRE

Discography

St. Pierre, Simon. *Fiddler from Maine.* Renovah Records RS–926.

_____. *The Joys of Quebec.* Renovah Records RS–915.

_____. *Music of French America.* Rounder 6010.

_____. *The Woods of Maine.* Renovah Records.

RALPH STANLEY

Bibliography

Hitchner, Earle. "Bluegrass Legend and Brother's Keeper." *Wall Street Journal* (October 8, 1998) 232, 70: A16, eastern edition.

Macnie, Jim. "The Sloppier Verities." *Village Voice* (December 15, 1998) 43, 50: 138.

Malone, Bill C. *Country Music, U.S.A.* Austin and London: University of Texas Press, 1968.

Price, Deborah Evans. "Rebel Set Pays Tribute to Bluegrass Master Ralph Stanley." *Billboard* (April 24, 1998) 110, 17: 28.

Ratliff, Ben. "Going to the Top in Bluegrass, and Honoring the Old Ways." *New York Times* (May 20, 1998) 147: E1.

Wright, John. *Traveling the High Way Home: Ralph Stanley & the World of Traditional Bluegrass Music.* Champaign: University of Illinois Press, 1995.

Discography

Stanley, Ralph. *Down Where the River Bends.* Rebel 1579.

Stanley, Ralph, and Carter Stanley. *Bluegrass in Concert.* King K864.

_____. *Everybody's Concert Favorites.* King K690.

_____. *The Stanley Brothers: Sacred Songs from the Hills.* Starday 122.

Stanley, Ralph, and the Clinch Mountain Boys. *Country Pickin' and Singin'.* Stetson Hat 3125.

Filmography

The Banjo of Ralph Stanley: From Old-Time to Bluegrass. Videotape, 90 minutes. Washington, D.C.: Smithsonian Folkways, 1990.

Gather at the River. Videotape, color, 101 minutes. Directed by Robert Mugge. Mug-Shot Productions, 1994.

RALPH W. STANLEY

Bibliography

Anderson, Cindy. "Marking Time on Little Cranberry Island." *Yankee* (May 2000) 65, 5: 68.

Budiansky, Stephen. "The Quality Craftsman: Not Made in Japan." *U.S. News & World Report* (August 26–September 2, 1991) 111, 9: 73.

Spectre, Peter H. "Pure Craftsman: Ralph Stanley, One of Maine's Last Full-Time Wood Boatbuilders." *Maine Boats & Harbors* (August/September 1994).

Thorndike, Virginia L. *Maine Lobsterboats: Builders and Lobstermen Speak of Their Craft.* Camden, Maine: Down East Books, 1998.

ROEBUCK "POPS" STAPLES

Bibliography

Pareles, Jon. "Pops Staples, 1914–2000." *Rolling Stone* (February 1, 2001) 861: 15.

Sprague, David. "With 'Father Father,' Point Blank Brings Back a Gospel Staple." *Billboard* (July 2, 1994) 106, 27: 17.

Weider, Jim. "The Spirit of Pops Staples." *Guitar Player* (November 1996) 323, 11: 146.

Discography

Staples, Roebuck. *Father, Father.* Pointblank 39638.

_____. *Peace to the Neighborhood.* Pointblank 86286.

The Staples Singers. *Uncloudy Day.* Charly CPCD 8087.

ALEX STEWART

Bibliography

Anderson, Clay, Andy Leon Harney, et al. *The Craftsman in America.* Washington, D.C.: National Geographic Society, 1975.

Henry, Bill. "Alex Stewart: A Personal Reminiscence." *Tennessee Folklore Society Bulletin* (June 1981) 67, 2: 48–66.

Hufford, Mary, Marjorie Hunt, and Steven Zeitlin. *The Grand Generation: Memory, Mastery, Legacy.* Seattle: University of Washington Press, 1987.

Irwin, John Rice. *Alex Stewart: Portrait of a Pioneer.* West Chester, Pennsylvania: Schiffer Publishing, 1985.

Wigginton, Eliot, ed. *Foxfire 3.* Garden City, New York: Doubleday Anchor Press, 1975.

Woodside, Jane Harris. "From Farm to Festival: Crafts in the Clinch River Valley." *Tennessee Folklore Society Bulletin* (winter 1987) 53, 4: 118–129.

Filmography

Alex Stewart: Cooper. 16mm, color, 13 minutes. Produced by Tom Burton and Jack Schrader. Johnson City, Tennessee: East Tennessee State University, Instructional Media Center.

CHRIS STRACHWITZ

Bibliography

Mendoza, Lydia, Chris Strachwitz, and James Nicolopolus. *Lydia Mendoza: A Family Autobiography.* Houston: Arte Publico Press, 1993.

Ward, Ed. "Music: From Cotton Fields to Dance Halls, an Outsider's Journey." *New York Times* (October 8, 2000).

Discography

Strachwitz, Chris. *The Journey of Chris Strachwitz,*

Arhoolie Records 40th Anniversary Collection: 1960–2000. Arhoolie 491.

MARGARET TAFOYA

Bibliography

Blair, Laurence R., Mary E. Blair, and Susan McDonald. *Margaret Tafoya: A Tewa Potter's Heritage & Legacy.* Atglen, Pennsylvania: Schiffer Publishing, 1986.

Dillingham, Rick, Richard W. Lang, and Rain Parrish. *The Red and the Black: Santa Clara Pottery by Margaret Tafoya; A Retrospective Exhibition at the Wheelwright Museum of the American Indian.* Santa Fe: Wheelwright Museum of the American Indian, 1983.

Fleming, Jeannie Puleston. "Pueblo Pottery: Renaissance of an Ancient Art." *Sunset* (March 1994): 84–89.

Hufford, Mary, Marjorie Hunt, and Steven Zeitlin. *The Grand Generation: Memory, Mastery, Legacy.* Seattle: University of Washington Press, 1987.

Martin, Douglas. "Margaret Tafoya, 96, Pueblo Potter Whose Work Found a Global Audience." *New York Times* (March 5, 2001) 150: B6.

SEIICHI TANAKA

Bibliography

Cummings, Melanie. "Turn the Beat Around." *Horizons* (winter 1999) 12, 4: 24.

Fromartz, Samuel. "Anything But Quiet." *Natural History* (March 1998) 107, 2: 44.

LIANG-XING TANG

Bibliography

Liang-xing, Tang. "Observations on Chinese Music Today." *Music from China Newsletter* (spring/summer 1993) 3, 1.

Rothstein, Edward. "Ancient Works with Modern Touch." *New York Times* (June 29, 1993).

Discography

Liang-xing, Tang. *High Mountain, Flowing Water: Traditional Chinese Pipa Music.* Shanachie 65012.

DAVE TARRAS

Bibliography

Davidow, Ari. "Klezmer." *Whole Earth Review* (fall 1995) 87: 92.

Ferraro, Susan. "The Clamor for Klezmer." *American Way* (July 1983).

London, Frank. "An Insider's View: How We Traveled from Obscurity to the Klezmer Establishment in Twenty Years." *Judaism* (winter 1998) 47, 1: 40.

Lornell, Kip, and Anne K. Rasmussen, eds. *Musics of Multicultural America.* New York: Schirmer Books, 1997.

Slobin, Mark. "The Neo-Klezmer Movement and Euro-American Musical Revivalism." *Journal of American Folklore* (1984) 97.

Discography

Tarras, David, et al. *David Tarras, Vol. 1.* Global Village 105.

_____. *Dave Tarras, Vol. 2.* Global Village 106.

_____. *Dave Tarras: Yiddish-American Klezmer Music 1925–1996.* Yazoo 7001.

_____. *Master of the Jewish Clarinet.* BA US 1002.

SANDERS "SONNY" TERRY

Bibliography

Ball, Tom. *Sonny Terry Licks for Blues Harmonica, 50 Famous Licks.* Anaheim, California: Centerstream Publishing, 1995.

Oliver, Paul. "Sonny Terry." In *The New Grove Dictionary of American Music.* New York: Grove Dictionaries, 1986.

Terry, Sonny, Kent Cooper, and Fred Palmer. *Sonny Terry's Country Blues Harmonica.* New York: Music Sales Corporation, 1975.

Terry, Sonny, and Kent Cooper. *The Harp Styles of Sonny Terry.* New York. 1957.

Discography

Terry, Sonny. *The Folkways Years, 1944–1963.* Smithsonian Folkways 40033.

_____. *Gotta Move Your Baby.* Prestige P7831.

_____. *On the Road.* Smithsonian Folkways 2369.

Terry, Sonny, with Brownie McGhee. *Brownie McGhee and Sonny Terry.* Smithsonian Folkways 40011.

_____. *Whoopin' the Blues, 1958–1974.* Vestapol VEST 13057.

Filmography

Dimensions in Black. Videotape, 59 minutes. Produced by KPBS, San Diego, California: PBS Video.

A Musical Journey: The Films of Pete Toshi and Dan Seeger, 1957–1964. Vestapol Productions 13042. Distributed by Rounder Records, 1996.

JENNIE THLUNAUT

Bibliography

Dauenhauer, Nora Marks, and Richard Dauenhauer, eds. *Haa Tuwunáagu Yís, For Healing Our Spirit: Tlingit Oratory.* Seattle: University of Washington Press/Juneau: Sealaska Heritage Foundation, 1990.

_____. *Haa Kusteeyí, Our Culture: Tlingit Life Stories,* pp. 583–602. Seattle: University of Washington Press/Juneau: Sealaska Heritage Foundation, 1994.

"Piece of Culture Comes Home to Stay." *Anchorage Daily News* (August 22, 1999).

Worl, Rosita, and Charles Smythe. "Jennie Thlunaut: Master Chilkat Blanket Artist." In *The Artists Behind the Work,* Suzi Jones et al., eds. Fairbanks: University of Alaska Museum, 1986.

ADA THOMAS

Bibliography

Gregory, H. F. "'Pete.' A Promise from the Sun: The Folklife Traditions of Louisiana Indians." In *Louisiana Folklife: A Guide to the State,* Nicholas K. Spitzer, ed. Baton Rouge: Louisiana Folklife Program, 1985.

Wilby, Ruth Trowbridge. "The Weave Goes On." *Dixie* (November 7, 1976).

DOROTHY THOMPSON

Bibliography

"Dorothy Thompson Wins Nation's Art Award." *Parsons (W. Va.) Advocate* (May 31, 2000) 104: 35.

"A Lifetime at the Loom." *Charleston (W. Va.) Daily Mail* (June 21, 2000).

PAUL TIULANA

Bibliography

Fienup-Riordan, Ann. *The Living Tradition of Yup'ik Masks Agayuliyararput: Our Way of Making Prayer.* Seattle: University of Washington Press, 1996.

Tiulana, Paul, and Vivian Senungetuk. *Wise Words of Paul Tiulana: An Inupiat Alaskan's Life.* Danbury, Connecticut: Franklin Watts, 1998.

Senungetuk, Vivian, and Paul Tiulana. *A Place for Winter: Paul Tiulana's Story.* Anchorage: CIRI Foundation, 1987.

LUCINDA TOOMER

Bibliography

Ferris, William. *Afro-American Folk Art and Crafts.* Boston: G.K. Hall, 1983.

Vlach, John Michael. *The Afro-American Tradition in the Decorative Arts.* Cleveland: Cleveland Museum of Art, 1978.

Wadsworth, Anna. *Missing Pieces: Georgia Folk Art, 1770–1976.* Exhibition catalogue. Tucker: Georgia Council for the Arts and Humanities, 1976.

Wahlman, Maude Southwell, and Ella King Torrey. *Ten Afro-American Quilters.* Exhibition catalogue. University of Mississippi Center for the Study of Southern Culture. University: University of Mississippi Press, 1983.

HENRY TOWNSEND

Bibliography

Charters, Sam. "Seeking the Greatest Bluesmen." *American Heritage* (July/August 1991) 42, 4: 50.

Hadley, Frank-John. "Four Wise Men." *Down Beat* (February 2001) 68, 2: 40.

Pearson, Barry Lee. "'When You're Born and Raised in the Delta, You Just Write Hate You See': Delta Blues Stories." *Arkansas Review: A Journal of Delta Studies* (1998) 29, 1: 30.

Discography

Townsend, Henry. *Blues in St. Louis No. 3.* Smithsonian Folkways 3816.

Townsend, Henry, et al. *Blues Rediscoveries.* Smithsonian Folkways RBF11.

_____. *St. Louis Blues, 1929–35.* Yazoo 1030.

Filmography

Blues Like Showers of Rain. Videotape, black and white, 31 minutes. Rhapsody Films, 1986.

Hellhounds on My Trail. Videotape, color, 95 minutes. Directed by Robert Mugge. Mug-Shot Productions, 1999.

DOROTHY TRUMPOLD

Bibliography

Mandelbaum, Robb. "Time Warp in the Heartland." *Travel Holiday* (May 1999) 182, 4: 40.

Nikitas Tsimouris

Bibliography

Ferris, W., and D. Young. "Treasures of Southern Sound." *Southern Living* (April 1992) 27, 4: 108.

FRED TSOODLE

Bibliography

Ellison, C. " 'Truly Dancing Their Own Way': Modern Revival and Diffusion of the Gourd Dance." *American Indian Quarterly* (winter 1990) 14, 1: 19.

OTHAR TURNER

Bibliography

Jacobson, Mark. "Those Front Porch, Backyard, Juke Joint, Fife and Drum Blues." *Natural History* (October 1996) 105, 10: 66.

Keepnews, Peter. "Two Kinds of Blues, Urbanized and True." *New York Times* (February 16, 1990).

Morris, Chris. "Music of Othar Turner Is Worth 'Hollerin' About." *Billboard* (February 28, 1998) 110, 9: 60.

Nelson, David. "Drums Is a Calling Thing: North Mississippi Fife and Drum Bands." *Living Blues* (November/December 1991).

Steber, Bill. "They Say Drums Was a Calling." *Living Blues* (March/April 1999).

Watrous, Peter. "Up from the Delta, Blues and Its Home-Grown Roots." *New York Times* (February 19, 1990).

Discography

Turner, Othar, and the Rising Star Fife and Drum Band. *Everybody Hollerin' Goat.* Birdman BMR 018.

CLEOFES VIGIL

Bibliography

" 'The Grand Generation,' a Film You Ought to See." *Aging* (1994) 336, 32: 2.

Discography

Vigil, Cleofes. *Buenas Dias, Paloma Blanca.* Taos Recording and Publication TRP122.

FELIPE GARCÍA VILLAMIL

Bibliography

Thompson, Robert Farris. *Face of the Gods: Art and Altars of Africa and the African Americas.* Munich: Prestel/Museum for African Art (New York).

Velez, Maria Teresa. *Drumming for the Gods: The Life & Times of Felipe García Villamil, Santero, Palero & Abakua.* Philadelphia: Temple University Press, 2000.

T. VISWANATHAN

Bibliography

"Music of South India." Program notes, February 23, 1986. New York: Metropolitan Museum of Art.

LILY VORPERIAN

Bibliography

Couzian, Diane. "Armenians' Struggle Inspires Artist." *Horizon, Armenian Weekly* (June 3, 1996) 2, 1: E2.

Stanley, T. L. "Woman's Needlework Sews Up Grant." *Daily News (Woodland Hills, Calif.)* (June 10, 1994): 3.

DOUGLAS WALLIN

Bibliography

"Balladeer of the Mountains." *News and Observer (Raleigh)* (August 7, 1988).

Scherman, Tony. "A Man Who Mined Musical Goals in the Southern Hills." *Smithsonian* (April 1985): 173–196.

Discography

Wallin, Doug, and Jack Wallin. *Family Songs and Stories from North Carolina.* Smithsonian Folkways 40013.

Wallin, Doug, et al. *Smithsonian Folkways American Roots Collection.* Smithsonian Folkways 40062.

DON WALSER

Bibliography

Burr, Ramiro. "Rising Stars in the Lone Star State." *Billboard* (September 23, 2000) 112, 39: 28.

Himes, Geoffrey. "Don Walser Keeps the Music Alive." *Country Music* (November/December 1989): 56.

Truman, Skip. "Rising Star Brings Fans Back to Country's Roots." *Christian Science Monitor* (March 11, 1997) 89, 72: 14.

Discography

Walser, Don. *Archives I.* Watermelon Records.

_____. *Archives II.* Watermelon Records.

_____. *Down at the Sky-Vue Drive-In.* Sire Records.

_____. *Here's to Country Music.* Sire Records.

_____. *Rolling Stone from Texas.* Watermelon Records.

_____. *Texas Top Hand.* Watermelon Records.

LEM WARD

Bibliography

Berkey, Barry, Velma Berkey, and Richard Eric Berkey. *Pioneer Decoy Carvers: A Biography of Lemuel and Stephen Ward.* Cambridge, Massachusetts: Tidewater Publications, 1977.

Lawson, Glenn, and Tricia Veasey. *The Story of Lem Ward as Told by Ida Ward to Glenn Lawson.* Atglen, Pennsylvania: Schiffer Publishing, 1984.

Mackey, William F., Jr. *American Bird Decoys.* New York: Dutton, 1965.

Shaw, Robert. "American Decoys." *Early American Homes* (October 1997) 28, 5: 8.

Newton Washburn

Bibliography

Beck, Jane. *Always in Season: Folk Art and Traditional Culture in Vermont.* Montpelier: Vermont Council on the Arts, 1982.

"Newton Washburn: Traditional Basketmaker." In *Traditional Craftsmanship in America.* Washington, D.C.: National Council for the Traditional Arts, 1983.

Arthel "Doc" Watson

Bibliography

The Best of Doc Watson for Guitar. Miami: Warner Bros. Publications, 1993.

Bruce, Dix. *Doc Watson & Clarence Ashley—Original Folkways Recordings '60–62.* Pacific, Missouri: Mel Bay Publications, 1999.

Kaufman, Steve. *The Legacy of Doc Watson.* Pacific, Missouri: Mel Bay Publications, 1999.

Kochman, Marilyn, ed. *The Big Book of Bluegrass Music.* New York: William Morrow & Co., 1984.

Reidy, David. "Doc Watson." *Guitar Player* (September 1999) 33, 9: 41.

Watson, Doc, and Richard Rinzler. *The Songs of Doc Watson.* New York: Music Sales Corporation, 1997.

Discography

Watson, Doc. *Essential Doc Watson.* Vanguard VSD–45/46.

_____. *Essential Doc Watson, Vol. 2.* Vanguard VSD–73121.

_____. *Red Rocking Chair.* Flying Fish Records FLY 252.

Watson, Doc, and Merle Watson. *On Stage.* Vanguard VSD–9/10.

Filmography

Doc and Merle. Boone, North Carolina: Front Porch Productions, 1986.

Gather at the River. Videotape, color, 101 minutes. Directed by Robert Mugge. Mug-Shot Productions, 1994.

Gussie Wells and Arbie Williams

Bibliography

Leon, Eli, and Andrea Hesse. *Arbie Williams Transforms the Britches Quilt: Contemporary Britches Quilts in the African-American Tradition.* Santa Cruz, California: Mary P. Sesnon Art Gallery, 1993.

Filmography

Recycled, Re-Seen: Folk Art from the Global Scrap Heap. Videotape, color, 35 minutes. Crystal Productions, 1997.

Francis Whitaker

Bibliography

Alexander, Tom. "The Anvil Chorus Is Ringing Loud and Clear Again." *Smithsonian* (May 1993) 24, 2: 46.

Martin, Douglas. "Francis Whitaker, Blacksmith, Dies at 92." *New York Times* (October 31, 1999) 149: 51.

Claude Williams

Bibliography

" 'Pops' Staples, 'Fiddler' Williams Among National Endowment for the Arts 'Heritage Fellows.' " *Jet* (July 27, 1998) 94, 9: 32.

Discography

Williams, Claude. *Live at J's, Vol. 1.* Arhoolie 405.

_____. *Live at J's, Vol. 2.* Arhoolie 406.

_____. *Masters of the Folk Violin.* Arhoolie 434.

_____. *Swingin' the Blues.* Bullseye BEYE 9627.

Dewey Williams

Bibliography

Boyd, Joe Dan. "The Sacred Harpers and Their Singing." In *Festival of American Folklife.* Program. Washington, D.C.: Smithsonian Institution, 1970.

Hunt, Marjorie, and Boris Weintraub. "Masters of Traditional Arts." *National Geographic* (January 1991) 179, 1.

Discography

Williams, Dewey, et al. *Wiregrass Notes: Black Sacred Harp Singing from Southeast Alabama.* Sound of Birmingham.

Filmography

Dewey Williams. 16mm, color, 14 minutes. Produced by Landon McCrary. Huntsville: Alabama Film Makers Cooperative.

Horace "Spoons" Williams

Bibliography

Scheinin, Richard. "The Rhymes and Rhythms of Spoons Williams." *Philadelphia Inquirer Magazine* (December 8, 1985).

"Spoon Tunes." *Philadelphia Inquirer* (January 28, 1983).

Chesley Goseyun Wilson

Bibliography

Lokenvitz, J. E. "Keepers of Tradition." *Cobblestone* (August 1991) 12, 8: 38.

Elder Roma Wilson

Bibliography
Young, Alan. *Woke Me Up This Morning: Black Gospel Singers and the Gospel Life*. Jackson: University Press of Mississippi, 1997.

Discography
Wilson, Elder Roma. *This Train*. Arhoolie 429.

Joseph T. Wilson

Bibliography
Cheakalos, Christina, and Macon Morehouse. "Strum Major." *People* (April 23, 2001) 55, 16: 83.
Gerlach, Jerry. "The Economic Geography of Regional Festivals." *Focus* (summer 1994) 44, 2: 30.
Lewis, George H. "Celebrating Asparagus: Community and the Rationally Constructed Food Festival." *Journal of American Culture* (winter 1997) 20, 4: 73.
Udall, Lee, and Joe Wilson. *Presenting Folk Culture: A Handbook on Folk Festival Organization and Management*. Washington, D.C.: National Council for the Traditional Arts.
Walle, A. H. "Folk Festivals Are an Overlooked Marketing Tool." *Marketing News* (December 6, 1993) 27, 25: 12.
"With a Banjo on Their Knees." *Mother Earth News* (August/September 1993) 139: 10.

Melvin Wine

Bibliography
Beisswenger, Drew. *Fiddling Way Out Yonder*. Jackson: University Press of Mississippi, 2002.
Leffler, Susan. "Melvin Wine." *Goldenseal* (summer 1991): 10–16.
Milnes, Gerry. *Play of a Fiddle: Traditional Music, Dance and Folklore in West Virginia*. Lexington: University Press of Kentucky, 1999.

Discography
Wine, Melvin. *Hannah at the Springhouse*. Augusta Heritage Series AHR 021.

Nimrod Workman

Bibliography
"Nimrod Workman." *New York Times* (November 29, 1994) 144: D20.

Discography
Workman, Nimrod. *Mother Jones' Will*. Rounder 0076.
_____. *Passing Through the Garden*. June Appal Recordings JA0001.

Filmography
Nimrod Workman: To Fit My Own Category. 16mm, black and white, 35 minutes. Directed by Scott Faulkner and Anthony Stone. Whitesburg, Kentucky: Appalshop Films.

Emily Zuttermeister

Bibliography
Hunt, Marjorie, and Boris Weintraub. "Masters of Traditional Arts." *National Geographic* (January 1991) 179, 1.
McKinzie, Edith. "Hawaiian Performing Arts." In *Folklife Hawai'i*. Festival program. Honolulu: The State Foundation on Culture and the Arts, 1990.

Discography
Zuttermeister, Emily Kau'i. *Musics of Hawaii: Anthology of Hawaiian Music*. Smithsonian Folkways 40016.

Resource List

Numerous organizations and businesses provide information and products useful for further study of the Heritage Fellows. The following selected list provides addresses and Web sites.

American Folklife Center, Library of Congress, Washington, D.C. 20540, http://lcweb.loc.gov/folklife/afc.html.

American Routes, 1118 Royal Street, New Orleans, Louisiana 70116, www.americanroutes.org.

Appalshop, 91 Madison Avenue, Whitesburg, Kentucky 41858, www.appalshop.org.

Arhoolie Records, 10341 San Pablo Avenue, El Cerrito, California 94530, www.arhoolie.com.

Augusta Heritage Center, 100 Campus Drive, Elkins, West Virginia 26241, www.augustaheritage.com

Biograph Records, P.O. Box 110, Somerville, Massachusetts 02143, www.biograph.com.

City Lore and The Culture Catalog, 72 East 1st Street, New York, New York 10003, www.citylore.com.

County Records, Main Street, Floyd, Virginia 24091, www.countysales.com/main.htm.

Davenport Films, 11324 Pearlstone Lane, Delaplane, Virginia 20144, www.davenportfilms.com

Delmark Records, 444 N. Wabash Avenue, Chicago, Illinois 60611, www.delmark.com

De Nonno Productions, 7119 Shore Road, Brooklyn, New York 11209.

Document Records, Eipeldauerstr. 23/43/5, A-1220, Vienna, Austria.

Documentary Arts, P.O. Box 140244, Dallas, Texas 75214, www.docarts.com.

Downhome Music, 10341 San Pablo Avenue, El Cerrito, California 94530, www.downhomemusic.com.

Ethnic Folk Arts Center, 131 Varick Street, #907, New York, New York 10013.

Fantasy, Inc., 2600 10th Street, Berkeley, California 94710, www.fantasyjazz.com.

Flower Films, 10341 San Pablo Avenue, El Cerrito, California 94530, www.lesblank.com.

Green Linnet Records, 43 Beaver Brook Road, Danbury, Connecticut 06810 www.greenlinnet.com.

Malaco Records, P.O. Box 9287, Jackson, Mississippi 39286, www.malaco.com.

Mug-Shot Productions (Robert Mugge), mugshot@att.net.

National Council for the Traditional Arts, 1320 Fenwick Lane, Suite 200, Silver Spring, Maryland 20910, www.ncta.net.

National Endowment for the Arts, 1100 Pennsylvania Avenue N.W., Washington, D.C. 20560, http://arts.endow.gov/explore/heritage/nhfintro.html.

Nauman Films, Inc., Box 232, Custer, South Dakota 57730.

Rounder Records, 1 Camp Street, Cambridge, Massachusetts 02140, www.rounder.com.

Seattle Folklore Society, P.O. Box 30141, Seattle, Washington 98103, www.seafolklore.org.

Smithsonian Folkways Recordings, 750 Ninth Street N.W., Suite 4100, Washington, D.C. 20560-0953, www.si.edu/folkways.

Utah Folk Arts Program, 617 E. South Temple, Salt Lake City, Utah 84102, www.utahfolkarts.org.

Western Folklife Center, 501 Railroad Street, Elko, Nevada 8980, www.westernfolklife.org.

World Music Institute, 49 West 27th Street, Suite 930, New York, NY 10001, www.heartheworld.org.

Index

(Note: page citations in **bold** type indicate biographies.)